CÉZANNE

and the End of Impressionism

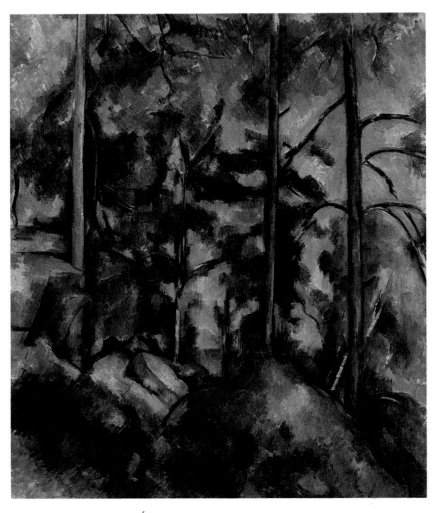

PAUL CÉZANNE, *Pines and Rocks*, ca. 1896–1900.
The Museum of Modern Art, New York. Lillie P. Bliss Collection.

CÉZANNE
and the End of Impressionism

A Study of the Theory, Technique, and
Critical Evaluation of Modern Art

RICHARD SHIFF

THE UNIVERSITY OF CHICAGO PRESS

Chicago and London

The University of Chicago Press, Chicago 60637
The University of Chicago Press, Ltd., London

LIBRARY OF CONGRESS CATALOGING IN PUBLICATION DATA

Shiff, Richard.
 Cézanne and the end of impressionism.

 Includes bibliographical references and index.
 1. Impressionism (Art)—France. 2. Modernism (Art)—
France. 3. Painting, Modern—19th century—France.
4. Cézanne, Paul, 1839–1906. 5. Painters—France—
Psychology. 6. Visual perception. I. Title.
ND547.5.I4S52 1984 759.4 83-18142
ISBN 0-226-75305-0

RICHARD SHIFF is associate professor of art history at the University of North
Carolina at Chapel Hill. He is a practicing painter and has published in a range of
journals, including *Critical Inquiry, New Literary History,* and *Yale French Studies.*

To my parents

Contents

PART THREE • SEEING CÉZANNE

PART FOUR • CONCLUSION: MAKING A FIND

List of Illustrations

Acknowledgments

THE PECULIAR QUALITIES OF CÉZANNE'S ART were first brought to my attention by two painters at Harvard College, Albert Alcalay and Robert S. Neuman. My view of Cézanne took an art-historical form in a seminar conducted by Frederick Deknatel in 1966; it expanded into a doctoral dissertation at Yale under the insightful direction of Robert Herbert. The scope of my research widened while I was teaching at the Tyler School of Art and at the University of Chicago. I learned a great deal from colleagues at these institutions, who helped me shape this research into the present book, especially Ted Cohen, Elizabeth Cropper, Robert Ferguson, Joyce Feucht-Haviar, Elizabeth Helsinger, Gloria Kury, John Paul Russo, and Joel Snyder. At Chicago, I had a fine example of productive scholarship to follow, that of my chairman, Herbert Kessler. But perhaps I learned even more from my students; they asked the most difficult questions and often offered the elusive answers. Among the great many who should be acknowledged, I wish to mention individually a few whose areas of research have been particularly close to my own: Becky O'Connor Chandler, Efi Costopoulos, Kineret Jaffe, Naomi Maurer, Margaret Olin, Monika Patel. In addition, I have refined my ideas through conversations with colleagues in the field of modern art; thanks are due especially to Jacqueline Falkenheim, Michael Fried, Clement Greenberg, Anne Hanson, Steven Levine, John McCoubrey, John Rewald, and Leo Steinberg.

The completion of my book was facilitated by the award of a Mellon Fellowship in the Humanities at the University of Pennsylvania (1979–80) and by generous grants from the University Research Council at the University of North Carolina at Chapel Hill (1981–83). At Chapel Hill, John Dixon, Sima Godfrey, and Carl Pletsch offered perceptive comments on my work. I am grateful to Sima Godfrey for checking my translations and for pointing out many nuances in the original French that I never would have detected. I also profited from her extensive knowledge of French literature and intellectual history. John Rewald kindly allowed me to consult the notes for his forthcoming catalog of Cézanne's oil paintings and graciously responded to my inquiries over a number of years. To Albert Boime, I owe special thanks for essential aid in acquiring photographs. I am grateful also to Linda Docherty and Mary Sheriff for editorial improvements.

The contributions of three people should be emphasized. I thank Robert Herbert for continuing to offer advice and resources long after the completion of my studies at Yale; his knowledge, generosity, and modesty make him an ideal teacher. For my sense of what a book should be and for the development of my expository style, I am indebted to John Paul Russo, who continues to set the highest standard for me in the quality of his writing. Finally, I thank Barbara Esbin for a great many things, especially the example of her integrity.

Preface

AS SUCCESSIVE GENERATIONS VIEW AN OBJECT OF ART, it acquires layers of interpretation. A knowledge of such interpretation—if not of a specific work, then of its type—normally precedes any actual experience of viewing. The changing state of interpretation thus seems to transform a work of art in advance of its being seen, even as it preserves the work by keeping it before the public's attention, in the public eye. In recognition of this process, the history of the way a given painting has appeared usually records many more changes in its public reception than in its physical substance. Yet an issue of "conservation" remains relevant: Is it possible, or desirable, to strip away the interpretive varnishes and return to the original vision of the artist and his time?

This question is asked, at least implicitly, by many art historians who investigate primary sources—works of art, artists' statements, initial critical reviews—with the aim of recovering authorial intentions, immediate reactions, and an intellectual and social context for a painting or a style. My book may seem to belong to such a category of art history in that it relies almost exclusively on primary documents. But I regard such documents as having independent importance; their interpretation is an end in itself, as well as a means to the interpretation of what might be the conservationist's interest—the physical objects, Cézanne's paintings. In other words, I am concerned with the meaning of the layers of interpretation superimposed on Cézanne's art as much as with any "original" meaning that might be ascribed to his work. These added layers affect what one sees even after they have been identified and have seemingly become transparent. To use a different, but equally familiar, metaphor: my understanding of Cézanne is both constrained and enhanced by an interpretive discourse already in play, a discourse to which the painter himself is but one of many contributors.

Although I believe that more than one interpretation of Cézanne can be valid, I do not accept all interpretations as feasible, or intelligent, at the present time. One particularly common view of the artist, part of an interpretive strategy that seems to have played itself out, sees Cézanne through an overlay of so-called dehumanized abstraction, initially added during the first decades of the twentieth century. According

to this retrospective scheme, Cézanne and a few of his contemporaries are the precursors of a severely formalized mode of representation; they dispense with detailed imagery to concentrate on the whole. As one writer observes:

> By c. 1890 both Monet and Cézanne were restricting the range of effects they sought, focusing, respectively, on the atmosphere and the structure of the scene, *with less and less reference to specifically human values.*[1]

Had this statement been written in 1910 or 1920, it might have indicated unqualified approval of a tendency in "modern" art. But it was written in 1979. In this later context, it approaches an art-historical cliché often employed to discredit modernism. It implies that Monet and Cézanne solved pictorial problems (the relationship of colors, the composition of elemental forms) as if these matters of picture making—or, more generally, of artistic creation—were independent of "human" values. The statement inhibits any attribution of "meaning" to the paintings, other than their value as objects of formal perfection, and opens them to charges of elitism and hermeticism. It maintains the art-historical antinomy of "form" and "content," where "content" is conceived as whatever is represented iconically, a subject matter to be interpreted as if seen outside the picture, in the world. This distinction between form and content is the legacy of earlier generations of scholars, many of whom, such as Roger Fry, admired Cézanne fervently. The earlier viewers, however, did not necessarily perceive so wide a gap between form and content; they did not always see form as picturing a preexisting meaning, but regarded it instead as an active demonstration of the experience of meaning or human value. Certainly, the qualities that nineteenth-century painters and critics defined as "sincerity," "truth," "originality," and "self-expression" are "human" values. My contention is that painters such as Monet and Cézanne represented these values not only in their pictures, but inside their picture making, within their technical practice itself. The painters' techniques were largely determined by their concern for expressing such values—living them out, experiencing them. Form, or rather technique, could both represent and embody content, and not in any obscure or mysterious manner. As a result, the art of Monet and Cézanne features exactly what the quoted statement claims is lacking: reference to specifically human values.

This book investigates some of the issues and values to which modern art makes general reference; toward this end, it focuses on the impressionist painting of Paul Cézanne (1839–1906), regarded as a characteristically "modern" art. The scope of the research oscillates between two objects of art-historical study that are customarily assigned fixed places in separate chapters or even separate books—not content and form, but theory and practice. My interest lies in the interaction of theory and practice. In particular, I study the attempt to "represent" originality through the medium of painting. Such picturing of the quality of originality—wherever its own original, or origin, might be—presents an inherent difficulty: it seems that any representation must have its model, and that technique "renders" or translates the model according to some mediating scheme. When originality is represented in a painting, painting it-

self operates as such a scheme. One can specify the type of painting and thereby define the mode of representational translation with varying degrees of precision. One concludes that painting technique tends to standardize representation, or at least to stylize it. It is as if any given technique operates as a metaphor, not only transferring the meaning of the "original" to its representation, but also transforming the original by giving it a new representational context. (Familiar "academic" styles often appear so natural as to be dead metaphors.) Now, if technical practice transforms its object— that is, its "subject" matter—the "original" is in some sense lost. But perhaps technique merely transfers the original, carrying its essence, so to speak, from one location to another, as if it could pass unchanged from nature to culture. Even so, originality is diminished; it is weakened in that the original is repeated. Existing in two places, or in two formal states, it becomes not only reiterative, but static. Repetition of this "essence" multiplies and fixes that which must appear transient in its singularity. In sum, to the extent that one conceives of the original as singular, the representation of originality becomes paradoxical by either of the two estimations of pictorial metaphor: the act of painting either transfers or transforms its model (or has both effects at once); in either event, painting's "original" suffers.

Yet the very possibility of a representation and reiteration of originality forms part of the mythology of modern art (and of the modern sense of the "classic"). The paradox of representation can be resolved by the modern artist's act, regarded as original in itself. As if linked to a unique and immediate experience, artistic originality emerges within a painting that seems to have no definite model, despite its references to art and nature. Painting becomes self-referential and self-expressive, pointing to itself and to the self that generates it. The artist becomes a vehicle of discovery, one who finds what cannot be made, locating what representational technique cannot touch. Yet the modern "master" finds his "original" with such frequency that he appears able to create (make) it at will. Hence a second paradox arises, one on the level of artistic practice, as opposed to the level of a general theory of representation: a found "original" can be made. Cézanne and the impressionists were born into a culture that defined artistic production in terms of creating the original. This myth of artistic originality and creativity, this productive play of finding and making, had already assumed a high degree of reality within their world. Despite the paradox, Cézanne and the impressionists accepted this reality and their record of achievement could only confirm it. I believe these modern artists acted self-consciously; nevertheless, historical "accident" plays a part in the critical response Cézanne's technique provoked. He may have exercised control over his painting, but not over his historical fortune. To be sure, some of his admirers entertained notions of originality at variance with his own, and interpreted him accordingly, adding transformative nuances of meaning to his works. Cézanne's painting was not only brought forth from a historical moment, but cast into one; it was polysemous at its origin.

From chapter to chapter, my discussion allows the central concepts of the theoretical, technical, and critical discourse of late nineteenth-century French painting to acquire multiple layers of meaning; the book itself imitates and illustrates the histori-

cal process of interpretive change and accretion. In all instances, the essential terms of
the discourse—such as "original," "classic," "impression," "sensation," and "expres-
sion"—are used with regard to specified historical contexts. As my analysis of con-
texts and of individual concepts develops and becomes more complex, the meanings
of the terms and their interrelationships alter accordingly; but their significations
grow without loss of the initial, simpler definitions. Within the text, "impression" is
a dominant term in the earlier chapters, displaced to some extent by "sensation" in
the later chapters. With a similar sense of transition, the earlier chapters reveal the
congruence of major elements of the doctrines of impressionism and symbolism,
both with each other and with elements of their antecedents (romanticism and real-
ism), whereas the later chapters emphasize the manner in which impressionism and
symbolism "returned" to classicism.

The book has four parts. The first three parts pass from the general to the particu-
lar, from an analysis of the environment in which Cézanne developed his art, to a de-
scription of his painting as the exemplary "modern" art of its time and a detailed ac-
count of the terms of its public reception. The brief conclusion returns to the general
to venture observations relevant to the interpretation of all modern art.

To be more specific: part 1 provides a definition of the "expressive" aim or "end"
of impressionist painting, one consistent with the evaluation of impressionism given
by symbolist artists and critics of the late nineteenth century; it establishes a context
for viewing Cézanne's art, which for the symbolists represented the crowning
achievement, transformation, and termination (or "end") of impressionism. Part 2
investigates the importance of origins and "originality" within the modern theory of
art and defines the technical means developed by painters in order to "represent"
originality. In this section, Cézanne's art, primarily his landscape painting, is seen as
avoiding or subverting conventional hierarchical differentiation, the kind of compo-
sitional order that would signify a "made" image rather than a "found" (or "origi-
nal") one. This discussion of the theory and technique of originality is followed by an
analysis of the critical evaluation of Cézanne's art offered by Émile Bernard, Maurice
Denis, and Roger Fry—the three artist-critics most responsible for establishing the
standard assessment of the painter's achievement. Their observations and conclu-
sions have been repeated so often that they seem to be accepted in their essentials
even to this day. I am concerned with the logic of the formation of this enduring "Cé-
zanne legend" and its success in fixing a reading of such problematic painting. I also
aim to reinterpret the artist's intentions and self-evaluation. Consequently, my em-
phasis in part 2 falls on the concept of originality as a central factor in the production
of both the (multiple) images that seem to appear in the paintings and the image of
the artist and his oeuvre that others created. In the writings of Bernard, Denis, and
Fry, Cézanne's painting becomes the "classic" model for all great "modern" and
"original" art.

Part 3 brings the conclusions of parts 1 and 2 to bear in a more detailed fashion on
a description and explanation of Cézanne's manner of painting and the manner in

which it was perceived—as both "classic" and "modern." My purpose is to show how this painting corresponded to an impressionist mode of theory and practice, which I associate with the artist's self-image and intentions, and how it simultaneously appeared in agreement with a symbolist mode of theory and practice, which I link to Cézanne's appreciative critics and to subsequent art historians. Because of the affinity of impressionism and symbolism, because of the artist's unusually successful "representation" of originality, and because of a perceived ambiguity and incompleteness in his art, Cézanne could satisfy a broad spectrum of critical demands. Despite his isolation, he became a father figure for modern art, one of its "classic" sources—perhaps even the most procreative of all such mythic masters of creation. Given the painter's lasting reputation, part 4 draws some conclusions about the nature of modern art and the position of the "artist" within a structure of modern culture.

The investigation just outlined (from part 1 to part 4) parallels another "visual" one, a study of Cézanne's "style." Usually, I choose to employ the term "technique" within this study, even where others might regard the term "style" as more appropriate. This preference for "technique" is intended to indicate that the external appearance of a painting, the "style" that may result from the application of technical procedure, should be seen as "made" rather than "found"—as the product of means sufficiently social to be imitated and appropriated by others, rather than the result of a singular and inborn manner. This distinction follows through the entire book. The etymologies of "technique" and "style" instruct on the matter: "technique," from *technē* (Greek), craft, skill; "style," either from *stylos* (Greek), column, specific decorative order, or from *stilus* (Latin), marker, writing instrument, index of an author. Within the nineteenth-century literature of art, "technique" carried the connotation of a skill that could be acquired by many (to facilitate making), whereas "style" often, but not always, implied the (found) presence of a unique individual.

My analytical description of Cézanne's style derives from my "reading" of his technical procedure. The "language" of this technique is first studied (in chapter 8) as if in ignorance of what the painter's critics had to say about it, but informed by a general theoretical context that distinguished what could be "made" ("invention" and "composition") from what might be "found" ("originality" and "self-expression"). Subsequently (in chapters 9, 10, and 11), Cézanne's major early critics—Bernard, Denis, and Fry—speak on this subject. The artist's style is then reinvestigated in conjunction with his "legend" (in chapters 12, 13, and 14). A final summary description of his technical evolution (in chapter 15) runs *counter* to much of what later critics and historians have seen and to much of what is generally understood of the accounts offered in the earlier commentary. In other words, I have sought to reinterpret not only the artist's "style," but also his earlier critics' reading of the "language" of that style; I do not dispute their visual acuity, but rework their translations.

John Rewald's histories of impressionism and postimpressionism and his biography of Cézanne have served as my initial guides to factual information.[2] For my un-

derstanding of artistic representation in France during the nineteenth century, I have turned to the primary sources—artists' letters, critical reviews, texts on aesthetics, and the like, as well as the paintings of the period. In almost every case I consulted this documentation in the "original" text or object, and avoided the use of later translations, excerpted quotations, or photographic reproductions. Secondary textual sources are cited only sparingly, but often to signal that a point has been well established or is considered more extensively elsewhere. Since my interest has not been directed toward a psychological reading of individual works of art nor toward strictly iconographical issues, a number of scholars who have contributed to the Cézanne literature are not cited at all, or only minimally.

Most of the terms of my descriptions of the appearance of nineteenth-century paintings derive from the discourse of the art of that period, recorded in both its theory and its practice; hence, I sometimes deviate from present, more familiar modes of visual analysis. The particular paintings I discuss have been selected because they are characteristic examples and because they were available to me for repeated viewings over a period of several years. Such reiterative experiences never really remain the same, and the following accumulation of interpretation—momentarily fixed—will acquire its own added layers of revision.[3]

Part One

The End of Impressionism

They are *impressionists* in the sense that they render not the landscape, but the sensation produced by the landscape.

JULES ANTOINE CASTAGNARY, *1874*[1]

1

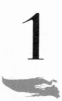

Introduction:
The Subjectivity of Impressionism

THROUGHOUT HIS CAREER, the critic Jules Antoine Castagnary brought the issues of a "naturalist" art before the French public. In the course of reviewing the Salon of 1863, he defined the "école naturaliste" as an expression of contemporary life; subsequently he repeatedly called for an honest and direct manner of painting that would reflect modern man in his modern society.[2] When Castagnary viewed the works of a diverse group who assembled in 1874 under the rubric "independents," he focused his attention on a number of the younger artists—Pissarro, Monet, Sisley, Renoir, Degas, and Morisot. These painters, as well as a few others, he wrote, should be characterized by "the new term *impressionists*. They are *impressionists* in the sense that they render not the landscape, but the sensation produced by the landscape." Castagnary's statement seems to have been the first serious attempt to define "impressionism" by a critic both favorably disposed to it and familiar with its technical, philosophical, and psychological dimensions.[3] His remark, however, is anything but clear, since he alludes to a distinction between a natural world, the "landscape" that exists independently of one's perception or experience of it, and the "sensation produced" by this landscape. Is this sensation available for all to have? Or is the landscape necessarily seen differently by different artists?

John Rewald, whose *History of Impressionism* remains the most comprehensive source of information on the movement, quotes Castagnary's remark in conjunction with his own account of the first impressionist exhibition and the significance of the new style.[4] But Rewald's interpretation does not resolve the ambiguity of Castagnary's definition. He writes that the impressionists "renounced even the pretense of recreating reality. Rejecting the objectivity of realism, they had selected one element from reality—light—to interpret all of nature . . . the impressionists . . . knew that they had accomplished a great step forward in the representation of nature."[5] Following the earlier analysis of Lionello Venturi, Rewald argues in effect that the impressionists represent a light seen directly or immediately, rather than objects in space seen indirectly by means of the interpretation of patterns of light.[6] Their success depends on "the careful observation of colored light appearing in a scene at a particular

moment."[7] Many questions remain unanswered. Does the light that is observed exist objectively for all to see? Is the light seen differently by different observers? If light is part of "objective reality," why is impressionism unrelated to a conventional "realism"? And if sensations are subjective, in what sense can observation be "careful"—by what standard might it be judged accurate?

The cumulative force of Rewald's commentary pushes impressionism in the direction of an art of objective or "accurate" observation, if not of nature (the "landscape"), at least of one's own sensation of light; and this light is described as if existing for all to see. Such an assessment of impressionism is representative of recent scholarship; but it is not in fact the position which was taken by Castagnary, one of the major sources on the ideological concerns of the time. His cryptic definition of impressionism is considerably clarified by a remark he adds almost immediately (which most scholars do not quote): "[the impressionists] leave reality and enter into full idealism." For Castagnary, "idealism" did not signify a world of universals lying behind a world of appearances or "reality," but rather a world of *individual* ideals, sensations, and imagination, a world he associated with the aims of earlier romantic artists. The critic claimed that the impressionists differed from their predecessors only in the exaggeration of the sketchlike technique, "le non fini." Castagnary regarded the rendering of a tentative, sketchlike "impression" as a mode of expression suitable for some artistic subjects but not for others. As for those who "pursue the impression to excess," he warned (pointing to Cézanne as his example):

> From idealization to idealization, they will arrive at that degree of romanticism without bounds, where nature is no more than a pretext for dreams, and the imagination becomes incapable of formulating anything other than personal subjective fantasies, without any echo in general knowledge, because they are without regulation and without any possible verification in reality.[8]

Here Castagnary seems to make a distinction central to the psychology of his contemporary, Hippolyte Taine; implicitly he contrasts sensation generated in contact with the external world—that is, sensation subject to verification by others, which Taine ironically called "hallucination vraie"—with the completely private, idiosyncratic sensation of dreams and fantasies.[9] For Castagnary, a concentration on the impression, the personal "idealized" sensation, can lead only to extreme subjectivity, not, as Rewald and others have argued, to the "representation of nature." Castagnary feared that impressionism might result in a departure from naturalism and its reflection of human values and social conditions; it might, in effect, constitute a return to the fantastical romanticism the critic had himself forcefully rejected.[10]

Was Castagnary's response to impressionism itself anomalous and idiosyncratic or did it have some foundation or potential verification in the intentions of the artists or in the beliefs of the age? Certainly, many artists and critics of the late nineteenth century spoke of impressionism as an art of depicting nature and modern life, but they also repeatedly spoke of it as an intensely personal art that could not be judged by the familiar standards which ranged from accomplished academic paintings to seemingly

automatic and objective photographs. For many artists and critics, impressionist painting seemed *both* objective and subjective. How this could be so is not adequately understood today, nor, consequently, is the relationship between impressionist and symbolist art. For many, symbolism embodied an extreme of subjectivity; it was an art of "idealization" and "fantasy," one Castagnary could not have approved. But (as Castagnary indicated) impressionism, too, could be an art of subjectivity. When the sense of the impressionists' subjectivity and idealization becomes clear, so does the meaning that their art held for the symbolists.

<p style="text-align:center">《 》</p>

The "symbolism" of which critics around 1890 spoke was the product first of a number of young poets and writers who were seeking to establish their own place in the history of literary schools; in general, they sought relief from the dominant thematic motifs of many of their immediate predecessors (such as Zola) who, in the eyes of these younger writers, had depicted only the material aspects of culture and society. The younger generation sought a new *style* as well as new subject matter, a style of purified language in which the play of words might run as free as the play of the most liberated artistic imagination. The poet Jean Moréas introduced the term "symboliste" to designate the new school of literature in an article of August 1885; his "symbolists" included Mallarmé, Verlaine, and Moréas himself.[11] About a year later, Moréas published his symbolist manifesto, stressing that the new poetry would evoke immaterial "Ideas" by means of a departure from (or distortion of) the "objective" view of the naturalists.[12] Moréas and the other young symbolists were highly polemicized, oriented toward the public display that their many ephemeral journals provided; and they were often in disagreement among themselves as each group or individual vied for prominence. Frequently, it seems, their disputes were quite artificial, as they held more ideas in common than they were willing to admit.[13] From this circle of poets and critics emerged two figures of special importance for the history of art. The first was Félix Fénéon, who was responsible for defining publicly the break that Seurat made between his own form of idealized art and that of the earlier impressionists.[14] The second, Albert Aurier, the early champion of both Van Gogh and Gauguin, developed in 1891 a basic definition of "symbolism in painting"; this precocious intellect drew on his experience of both literature and the visual arts, as well as his study of aesthetics and the theory of criticism.[15]

Aurier's attention had been directed to Gauguin by Émile Bernard, a young artist who had campaigned to publicize what he and Gauguin had begun to call "synthetic" or "synthetist" painting. Bernard looked upon the more mature Gauguin as a spiritual leader. Unusually inventive and possessing a facility for theoretical construction, the younger man may have suggested as much to Gauguin as Gauguin did to him. Eventually, especially after Aurier pronounced Gauguin the creator and guiding force of the new "symbolism in painting," a slighted Bernard came to dispute Gauguin's prominence, claiming to have been an essential influence in the formation of the style; and Gauguin himself bitterly denounced Bernard as an unoriginal imitator.[16] Although Gauguin was the more accomplished artist, the degree to which he

may indeed have learned from Bernard remains unclear.[17] The two painters worked especially closely during 1888 (and also maintained close contact with Van Gogh), and their style of that year has since been considered characteristic of the "synthetism" or symbolist-oriented art developed by members of the generation following the impressionists. Gauguin's *Lutte de Jacob avec l'ange* (1888; fig. 1) is the best-known example: it displays the simplified rendering of volumes, the broad outlining, and the flat, unmodeled passages of brilliant color that signified, for Aurier and others, the motivating force of an "Idea" or mystical vision; this painting seemed to turn from the observation of an external, mundane reality to reveal, by way of a purified language of visual forms, the world of symbolic correspondences.[18]

In 1889 Gauguin exhibited the *Lutte de Jacob* and other works at the Café Volpini, just outside the grounds of the Exposition universelle. Bernard and several others associated with Gauguin hung their paintings in the same large room in an attempt to provoke major critical comment. The artists called themselves the "groupe impressionniste et synthétiste." In his account of the event, Rewald notes that Aurier may have suggested this title; the result was that many viewers, *disassociating the two terms*, wondered who in the Volpini exhibition was an "impressionist" and who was a "synthetist."[19] Yet around this time and even later, Gauguin often referred to his own manner and to avant-garde art in general as "impressionniste," while simulta-

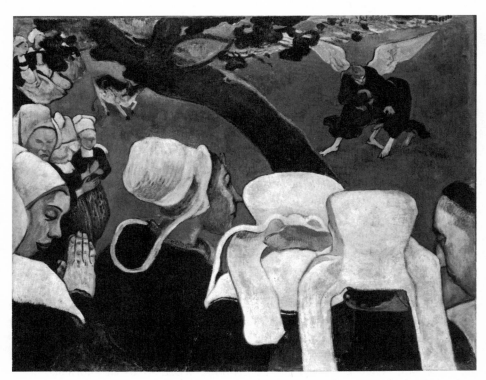

1. PAUL GAUGUIN, *Lutte de Jacob avec l'ange*, 1888. The National Gallery of Scotland, Edinburgh.

neously professing his concern for "synthèse."[20] It was left to Aurier to make a formal distinction; in 1891 he argued in his essay on Gauguin that the artist's quality of synthesis, the expression of an immaterial "idea" in material, visible form, definitively linked his work to the aims of literary symbolism (as opposed to naturalism or impressionism). Subsequently, Maurice Denis and other symbolist artists and critics commonly spoke of "synthétisme" and "symbolisme" as synonymous terms; in his own statement on Gauguin, Denis wrote that *"synthétisme* [in painting] became, through contact with the literary figures, *symbolisme."*[21] Such "literary figures" included Stéphane Mallarmé, Gustave Kahn, Jean Moréas, Charles Morice, Félix Fénéon, and, of course, Albert Aurier.[22]

A year before publishing his comments on Gauguin, Aurier had written a penetrating essay on Van Gogh that defined this artist, too, as a symbolist. According to the critic, Van Gogh considered his material means of color and line as "expressive," not imitative, and as *"techniques [procédés]* of symbolization," "a kind of marvelous language destined to translate the Idea."[23] This was the essence of "symbolism in painting": to direct pictorial means toward the expression of "Ideas" rather than the representation of objects. Aurier wrote in his essay on Gauguin that the artist's technical devices, through simplification and reduction to elements of line and color, should become "signs . . . the letters of an immense alphabet with which the man of genius alone can spell." The critic's sense of the "Idea" was Neoplatonic and mystical—an essence, a universal and eternal truth that might be known through the contemplation of its sign or symbol. For Aurier, artists became seers or visionaries; they did not limit themselves to immediate appearances as did impressionists and realists, nor did they create idealized images of the conventional sort. For this reason, the critic chose to call Gauguin's art *idéiste,* not *idéaliste:* "idealistic" art was the province of the academy, an art of a "conventional objectivity" as much tied to the rendering of objects (as opposed to "signs") as was realism.[24] In a summary statement, Aurier wrote that Gauguin's art could be described with five related terms: it was *idéiste, symboliste, synthétique, subjective,* and *décorative.*[25]

Gauguin's symbolist art was thus "subjective" in several senses; above all, for Aurier, it revealed the "idea perceived by the subject." The critic insisted that Gauguin should not be viewed as an impressionist. Nevertheless, he made it clear, when he defined the character of impressionism, that that art, too, was subjective.[26] I shall come to investigate the position of Aurier and others on this issue in more detail; and the accumulation of documentary evidence will indicate that *symbolism and impressionism, as understood around 1890, were not antithetical,* especially if the term "impressionism" is to signify the art of Monet, Renoir, Pissarro, and those closely related to them. Despite the concern of Aurier and others to identify a distinct group of symbolists, symbolism and impressionism cannot be set in opposition with respect to many of the central critical issues.

When symbolist artists and critics spoke against those variously described as "impressionists," "naturalists," or "realists," they generally did not have artists such as Monet, Renoir, or Pissarro in mind. Aurier actually praised those he called the "im-

pressionist" painters—specifically Manet, Degas, Cézanne, Monet, Sisley, Pissarro, and Renoir—for their "attempts at expressive synthesis." Those "naturalists" of whom he categorically could not approve were the popularly successful Jean Béraud (a painter of "la vie moderne"; fig. 2), Bouguereau (known for his lifelike figural groups; fig. 3), and Detaille (who rendered military scenes; fig. 4).[27] To these three artists, both Aurier and Maurice Denis would readily add Detaille's honored master, Meissonier (d. 1891), the fastidious recorder of detail (fig. 5). Aurier once exclaimed: "I would not swear that [the photographer] Nadar's lens does not have more *soul* than does [Meissonier himself]."[28] Béraud, Detaille, Bouguereau, and Meissonier were not traditional painters of idealized ennobling subjects, but rather, in the general sense, naturalists and realists, even "impressionists." To symbolist critics, their works lacked "soul" or emotion and were limited by both their conventional technique and their materialistic goal of imitating nature. Impressionists such as Monet and Renoir, in contrast, were regarded as having developed a much more liberated technical procedure, one that allowed for personal emotional expression. Accordingly, Monet and the symbolist Gauguin could share mutual literary friends and admirers; and Gauguin was, in effect, the pupil of Pissarro and Cézanne. Furthermore, symbolists and impressionists alike saw themselves as appropriating aspects of the French romantic tradition; both groups appreciated the works of Delacroix, Stendhal, and Baudelaire.

For many critics and artists, impressionism seemed to merge so readily into symbolism that symbolist elements could be detected in what might, from an earlier historical perspective, appear a pure impressionism.[29] In 1892, Maurice Denis could not decide whether Renoir's art should be considered "idéaliste" or "naturaliste"; Renoir, he wrote, was content to "translate his very own emotions, all of nature and all the dream with his very own technique."[30] Another critic associated with symbolist journals saw in Pissarro's works evidence of "philosophical synthesis," and in 1895 Monet's painting was said to have evolved toward "le surnaturel de la nature."[31] Indeed, recent studies by Steven Levine and Grace Seiberling have demonstrated that during the 1890s Monet's nominally impressionist art was often viewed in terms of symbolism.[32] At an earlier date, in his general study of impressionism, Pierre Francastel called attention to symbolist and "pantheist" elements in Monet (and also in Renoir and Degas); he noted that "the definitions given by the symbolists to their poetic art are curiously adaptable to Monet's . . . impressionism is a return to the personal poetry proscribed by the Parnassians as well as by the realists." Francastel was following a manner of interpretation suggested by Gustave Geffroy in his publications on Monet and impressionism, especially those which appeared during the 1890s when Geffroy met frequently with Monet at Giverny.[33]

Cézanne's art, like Monet's, was regarded in the 1890s in both impressionist and symbolist terms—seen, on the one hand, as an art of naturalism and the individualized expression of the artist's temperament, and, on the other hand, as an art of intense emotionalism directed toward the expression of primary, universal truths. Although in Monet's case one could claim that it was exclusively his recent work—the

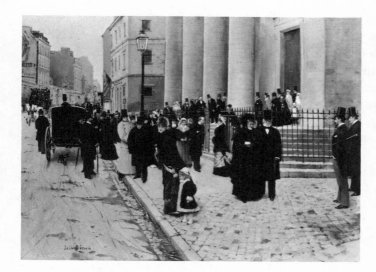

2. JEAN BÉRAUD, *The Church of Saint-Philippe-du-Roule*, 1877. The Metropolitan Museum of Art. Gift of Mr. and Mrs. William B. Jaffe, 1955. (55.35)

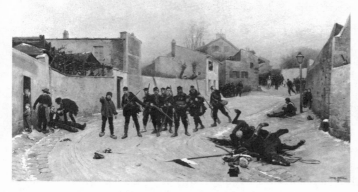

3. JEAN BAPTISTE ÉDOUARD DETAILLE, *En reconnaissance*, 1876. Yale University Art Gallery. Gift of C. Ruxton Love, Jr., B.A. 1925.

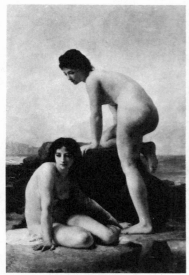

5. JEAN LOUIS ERNEST MEISSONIER, *Friedland, 1807*, 1875. The Metropolitan Museum of Art. Gift of Henry Hilton, 1887. (87.20.1)

4. WILLIAM ADOLPHE BOUGUEREAU, *Bathers*, 1884. Courtesy of the Art Institute of Chicago.

brilliantly colored series paintings with their radically simplified compositions (*Les Meules*, for example)—which elicited the symbolist response, the same cannot be said about the case of Cézanne. The judgment of Cézanne as, for some, an impressionist, while he became for others a symbolist, was based on a familiarity with the whole range of his work from his formative years in the 1860s onward. Because he was an obscure figure whose painting had received almost no significant comment before the 1890s, critics were inclined to regard his oeuvre in its entirety, rather than to highlight some recent developments to be compared with earlier achievements. In part 3, I shall argue that Cézanne considered the whole body of his art, his life's work, as the product of impressionist "sensation." Yet, during the 1890s, it clearly served as a model for the younger symbolists.

In 1896 André Mellerio published a brief study entitled *Le Mouvement idéaliste en peinture*. He discussed the circle of the symbolists, and (despite his choice of the term *idéaliste* over *idéiste*) he drew on Aurier for his general theoretical remarks. Mellerio cited Cézanne as "highly honored" by the younger generation.[34] While emphasizing the artist's link with "idealism" or symbolism, the critic described his painting in terms related to *both* impressionist and symbolist concerns:

> With Cézanne there is something of the naïve and the refined all together; he presents nature according to a vision particular to himself, where the juxtaposition of colors [and] a certain arrangement of lines make his very direct painting like a synthesis of colors and forms in their intrinsic beauty. One would say that he wished to restore intact to each object, in its primitive force unattenuated by the practices of art, its true and essential radiance.[35]

Mellerio's description of Cézanne is two-faced in a positive sense; it serves two points of view. One can relate the "particularity" of the artist's vision to the impressionist concept of temperament; and the "juxtaposition of colors" may be seen as the basic impressionist technical device. However, the "arrangement of lines" and the "synthesis of colors and forms" is more readily associated with symbolism, as is, of course, the aim of revealing the essence of an object. Significantly, Mellerio also refers to a simultaneous naïveté and refinement which both impressionists and symbolists would appreciate—Pissarro, for example, likened Cézanne to a "sauvage raffiné."[36] And both impressionists and symbolists consciously sought the same freedom from the conventional "practices of art" that Cézanne (according to Mellerio) attained. In fact, Mellerio credited the impressionists with having been pioneers in the "liberation of the artistic personality oppressed by restrictive rules and a limited teaching." In turn he lauded the symbolists for extending and building upon the impressionists' achievement.[37]

Passages of criticism in which the appropriate terminologies and even the practices of impressionism and symbolism are conjoined can be found in the writings of many others of the period; they reveal the extent to which the aims of the impressionist painter were seen as approaching those of the symbolist. Gustave Geffroy's introductory essay to the exhibition of Monet's *Meules* series (1891) is a striking example (fig. 6). Geffroy, a personal friend of the artist, spoke of Monet's colors and

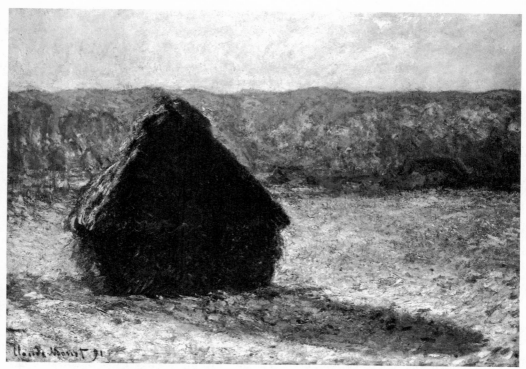

6. CLAUDE MONET, *Haystack in Winter*, 1891. Courtesy, Museum of Fine Arts, Boston. Gift of the Misses Aimee and Rosamund Lamb in memory of Mr. and Mrs. Horatio A. Lamb.

forms as analogous to emotionally expressive gestures; he implied that the paintings revealed symbolic content. Yet, like an impressionist, Monet "gives the sensation of the ephemeral instant" and is the "anxious observer of minutes." He is a "subtle and strong painter," Geffroy concluded, "instinctive and delicately expressive [*instinctif et nuancé*]—and he is a great pantheistic poet." In other words, this painter reveals the spirit or emotion of the totality of nature; he captures universal, permanent truths as well as particularized, transient ones. Furthermore, Geffroy's Monet, like Mellerio's Cézanne, is described as simultaneously naïve and refined, lacking conventional training, yet a master of technical procedure.[38]

The young critic Georges Lecomte, a close associate of both Geffroy and Félix Fénéon, set such complex evaluations of Monet, Cézanne, and the other major impressionists into a general historical context when he spoke in 1892 of the "impressionist evolution." Lecomte argued that the impressionists had initially sought to render specific sites and atmospheric conditions, but "gradually, they withdrew themselves from reality . . . they made compositions, distanced from nature, in order to realize a total harmony." The critic viewed this "evolution" as a very natural one that did not demand any radical reorientation: "The evolution on which [the symbolists] pride themselves had begun long before with the first impressionists."[39] In contrast to Lecomte and many others of his generation, most recent historians

have failed to see the passage from an impressionist style to a symbolist (or "post-impressionist") one as so natural an occurrence; instead they have viewed it as quite a traumatic event, maintaining that during the 1880s impressionism underwent a "crisis."[40] Lecomte, however, in speaking of a *natural* transition, specifically noted the same complex of stylistic changes which recent historians have found problematic in the impressionist art of the 1880s: Cézanne and Pissarro develop a decorative simplification of color and linear design; Renoir becomes involved with "linear beauty and the modeling of human anatomy"; and, to an ever greater degree, Monet "abstracts from manifold appearances the lasting character of things, as he accentuates meaning and decorative beauty with a more synthetic and reflective rendering." According to Lecomte, the younger symbolists took their cues from Monet's developing style and, much more so, from Cézanne's "syntheses and simplifications of colors." It was impressionism that begat symbolism; impressionism itself was no mere copy of material reality or its unfiltered appearance, but an art that expressed "intimate emotions of an intellectual order."[41]

《 》

I do not wish to argue that the impressionists themselves either did or did not perceive the decade of the 1880s as a period of crisis or radical transition. There is much evidence that this was for them a time of deep self-criticism.[42] I wish, rather, to discuss impressionism and symbolism in terms of fundamental principles which may clarify the relationship between the two artistic styles. In this way it should become evident that impressionism, even in its initial form, was never free of concerns later associated with symbolism and that, although the two styles may be opposed in some senses, the extent of their commonly defined ground may be of equal or greater import. As critics such as Lecomte and Mellerio indicated, impressionism, ostensibly a study of an external nature, could lead into a more abstract and subjective symbolism. My contention is that impressionist art cannot be adequately understood without sufficient reference to its own subjectivity, the element to which Castagnary and other early critics were sensitive, and to its own definition of "truth."

Both impressionist and symbolist art exemplified ways of investigating the world, of discovering the real or the true, of experiencing life. The *mode* of perception, of vision, was of greater consequence to the impressionist or symbolist artist than the view seen or the image presented. In this respect both impressionists and symbolists placed themselves in opposition to what they regarded as "academic" art, for such art found its reality and truth in the object of its own creation—its representation—the character of which was determined by the academy's rules and standardized technical procedure. The "academy" (whether considered as an elite group of artist-members, or as all members of an institutionalized culture) normalized vision through its specific (technical) code of representation; the code would remain an essential mediating device, because without it one could neither interpret nor record vision. In contrast, impressionists and symbolists sought the elusive and perhaps chimerical *immediate*. The impressionist's "impression"—just as the symbolist's "symbol"—represented a vision and a reality which (ideally) involved no extrapersonal or cultural mediation.

The truth which the impressionist sought could be found in any act of perception that had (or seemed to have) the idiosyncratic character associated with a personal, spontaneous "impression." Nevertheless, the impression, as an image or an object of vision, was not the end of impressionist art, but the means to that end, the means to an *experience* through which the true could be apprehended in an act of seeing.

Accounts of impressionism presented by art historians of the twentieth century have generally posited as the goal of the artist a more "accurate" and "objective" representation of nature, and have linked the rendering of the impression to such objectivity.[43] This emphasis on objective truth or fidelity to a nature available for all to observe oversimplifies and distorts the decisive impressionist notion of "truth." In addition, most recent historians have cryptically associated impressionism with "positivism" or "Comtean positivism." The term "positivism" has so many meanings that further qualification is demanded before it is to be used at all, and the more specific brand of positivism derived from Auguste Comte speaks clearly against an art of simple observation or realism: if impressionism was indeed merely an art of direct observation, it would not have satisfied Comte.

Much of the course that my study follows in part 1 has been determined by both the points of concentration and the areas of neglect in the large body of previous scholarship. Despite the careful attention that has often been given to this broad subject, fundamental definitions—which allow theory to be related to artistic practice—have only rarely been offered. In order to define the relationship between impressionism and symbolism, impressionism itself must first be defined.

2

Defining "Impressionism" and the "Impression"

THERE ARE TWO WAYS to avoid defining a term: withdrawing from the difficulty, or assuming it unnecessary. Proper names and general classifications render things familiar. Often a name or a term becomes so widely used that one thinks its range of reference could be no clearer. "Impressionist" is such a title, employed by art historians and critics with great ease and rarely if ever given the exclusive definition that one assumes it could readily receive. The historical record, however, reveals no single moment at which a definition of the term became bounded and fixed. Indeed, partial or nonexclusive definitions have been derived from several areas of study; and these interrelate in a confusing manner. In order to determine exactly who might be a genuine "impressionist," both the initial and the more recent commentators have considered one or more of the following: (1) the social group to which the artist belonged; (2) the artist's subject matter; (3) style or technique; and (4) the artistic goal or purpose. Each category has presented its own peculiar difficulties.

First, the social group. While this area provides some clear distinctions, they are of only limited application to the general problem of definition. An artist might be labeled a genuine impressionist in recognition of his having voluntarily united with others: in effect, he demonstrates that he considers himself an impressionist by participating in one or more of the eight independent exhibitions called "impressionist" by the press and by the artists themselves. In other words, the title "impressionist" is conferred on anyone who associates with the group; and, by a principle of commutation, such an individual's style becomes exemplary of the group style (unless it is radically deviant). Given a strict application of this criterion of professional affiliation and personal sympathy, Degas remains an impressionist, even though some nineteenth-century critics claimed that his style necessarily excluded him; and Cézanne must be included even though, for many twentieth-century viewers, his style appears antithetical to impressionism. Acknowledging how problematic these two cases have always been, one might argue that, at the very least, the emergence of the loosely organized exhibiting group provided a focus for the original definition of the impressionist position. "Impressionism," however, also existed outside this social boundary,

even within the elite society of the "Salon," the annual government-sanctioned presentation of works for public viewing. Ironically, it appeared there in the person of the elderly Corot, who gave moral support to the young independent painters but continued to exhibit among the officially honored and privileged. On the basis of elements of both subject matter and style, Corot was described in 1875 as a superior, poetic kind of "impressionist."[1] And he was not alone in introducing aspects of the "new" art to the Salon audience; in 1877, a critical review bearing the title "L'Impressionnisme au Salon" discussed an extensive movement with almost no reference to the members of the independent group.[2] A somewhat later review distinguished members of two parallel movements, the impressionists of the Salon and "les impressionnistes purs des expositions indépendantes."[3] During the 1870s and 1880s, much of what could be seen in Monet, Pissarro, or Degas apparently could also be seen elsewhere. Categorization based on membership in an exhibiting group could never have been definitive since it was from the very start confused by independent considerations of subject matter and style. Once named, "impressionism" seemed ubiquitous.

Second, subject matter. Definitions of impressionism determined by subject matter, just as those based on social affiliation, lead to awkward inclusions and exclusions. Critics and historians alike have stressed the significance of plein air subjects— views of the sea, the landscape, city streets, and the *vie moderne* of Parisian cafés. By this standard, however, one would be forced to include a number of artists who at the Salon of 1872 exhibited views of the environs of Paris notable for their simple and direct execution.[4] One of them, Stanislas Lépine, showed later with the independent impressionists, the others did not; but even Lépine is today only rarely discussed as a genuine impressionist, for he lacks a major stylistic characteristic—unconventional bright color. Théodore Duret, who tended to use stylistic criteria in order to classify the various painters, excluded Lépine for just this reason when he wrote his early account of the impressionist movement.[5]

Third, style or technique. Like definitions determined by subject matter, those dependent on observations of style present difficulties. Critics and historians have repeatedly called attention to the bright color and sketchlike finish of impressionist paintings, but again too many works of the late nineteenth century display these same qualities. Some nineteenth-century critics, most notably Charles Bigot and Henry Houssaye, attempted to define impressionist color more precisely, linking it to the elimination of effects of chiaroscuro; but such considerations led to the exclusion of Degas from the impressionist camp.[6] It was quite common for Degas to be denied any central role in the development of impressionism for reasons related to his technical procedure, despite his long association with the group that participated in the independent exhibitions and his innovative representation of motion and of modern urban life—clearly aspects of "impressionist" vision.[7] When viewed in isolation, style does not identify impressionists with ease. (I shall explore the more detailed specifics of impressionist technical procedure in parts 2 and 3.)

Fourth, the artistic goal or purpose. It might seem consequently that an adequate definition of impressionism would have to be more comprehensive and synthetic, the result perhaps of a determination of the artistic aim behind the formation of a group of artists who (along with others) shared an interest in a certain kind of subject matter and certain stylistic innovations. The definition of the goals of impressionist art may indeed inform more purposeful distinctions in the other areas of investigation, but one must take into account the fact that early observers who knew the impressionist painters—among them Jules Castagnary, Théodore Duret, and Georges Rivière—either insisted that the aims of these artists were not unique at all or spoke hardly a word about aims. Instead, technique often became the focus of their commentary. Castagnary, for example, discussed the impressionist paintings exhibited in 1874 with regard to technical innovation: "the object of art does not change, the means of translation alone is modified"; impressionism should be noted for its "material means," not its "doctrines."[8] Similarly, in writings of the late 1870s, Théodore Duret and Georges Rivière, who were on close terms with the independent group of artists, stressed the technical innovations of the radically sketchlike surface, and noted especially the juxtapositions of touches of unusually bright color. While Castagnary warned of the danger of such technique becoming idiosyncratic and "idealized," Duret and Rivière implied that it had simply been necessitated by the concern for a more accurate observation of nature. In their different manners, both Duret and Rivière allowed for variation in an individual's sensation of nature but emphasized that impressionist color was in fact derived from a nature directly observed, a nature that everyone could experience. In this sense impressionist color was more "natural" or "true to nature."[9] Neither critic explained openly how the notion of individualized sensation could be reconciled with that of an objective naturalism. This question remains unresolved, usually even unasked, and is of central importance to an understanding of both impressionism and symbolism.

How does one come to understand the apparent contradiction implicit in the notion of an art of specific and perhaps innovative techniques, which seems nevertheless to lack goals particular to itself? In investigating the aim or purpose of impressionism, one encounters in the early critical comments a substitution of means for ends. Critics distinguished impressionist art for the *manner* in which it attempted to render nature, or more specifically, to render the "impression." Of course, this manner or style was directed at something, at the expression of a fundamental truth, the "vérité" so often mentioned in the theoretical and critical documents of the period. When impressionism was seen in the most general terms, as a naturalistic art aiming at truth, its purpose, as Castagnary and others recognized, could hardly be considered new. The independent artists' preoccupation with the "impression," however, seemed to set them apart, so that their technical devices for rendering the impression—sketchlike brushwork, lack of conventional drawing as well as modeling and composition, and, especially, unconventionally bright, juxtaposed hues—were described as if sought as ends, effects difficult to achieve, having meaning in themselves.[10] These effects were often found in the work of naïve or untrained artists, yet

they could be praised as the product of a most scrupulous and "advanced" observation of nature if seen in the context of an exhibition of "naturalistic" painting. As Zola wrote of Jongkind's art in 1868, "one must be particularly knowledgeable in order to render the sky and the land with this apparent disorder . . . here . . . everything is true [*vrai*]."[11]

In summary: if the art for which the term "impressionist" is now usually reserved is to be defined with some precision, it must be understood with regard to specific technical devices applied to a very general problem of both discovery and expression, a problem so fundamental to the art of the late nineteenth century that it often went unstated. The problem is that of the individual's means of arriving at truth or knowledge and the relation of this individual truth to a universal truth. Impressionists and symbolists shared this traditional concern. The impressionist artists distinguished themselves by the *manner* in which they conceived and responded to the issue. For the impressionist, as the name implies, the concept of the "impression" provided the theoretical means for approaching the relation of individual and universal truth. The artists' characteristic technical devices, such as accentuated ("spontaneous") brushwork and bright color, are signs of their practical application of the theory of the impression.

<div align="center">« »</div>

The term "impression" can bear very physical signification, as when it is synonymous with "imprint." It suggests the contact of one material force or substance with another, resulting in a mark, the trace of the physical interaction that has occurred. Photographs are often referred to as impressions, as are the images of one's own vision. In both cases the term "impression" evokes a mechanistic account of the production of images by means of light; light is conceived as rays or particles which leave their marks or traces upon a surface, whether the photographic film's chemical coating or the eye's retina. The impression is always a surface phenomenon—immediate, primary, undeveloped. Hence, the term was used to describe the first layer of an oil painting, the first appearance of an image that might subsequently become a composite of many such "impressions."[12]

As primary and spontaneous, the impression could be associated with particularity, individuality, and originality. Accordingly, any style, if regarded as the sign or trace of an individual artist, could also be the impression left by that artist's true nature upon any surfaces with which he came into contact. By following this line of reasoning, Émile Deschanel (in 1864) explained that the word "style" derived from "stylus," the writing tool which leaves a characteristic mark corresponding to the personal touch of the individual; and he could then consider style a true impression: "Style is . . . the mark of the writer, the impression of his natural disposition [*l'impression de son naturel*] in his writing."[13] In Deschanel's usage, the term "impression," which one might first regard as a reference to very concrete external events (one object striking another), is extended into the more internalized realm of character, personality, and innate qualities.[14] The romantic critic Théophile Thoré similarly allowed the term to bridge the gap between the external and the internal, the phys-

ical and the intellectual or spiritual, when he used it to explain how "poetry" (the most transcendent artistic quality) differed from "imitation." Thoré associated imitation with a photographic imprinting that amounts to a mere copying; "poetry," in contrast, is "invention, it is originality, it is the manifested sign of an individual impression [*une impression particulière*]. Poetry is not nature, but the feeling that nature inspires in the artist. It is nature reflected in the human mind."[15]

The impression, then, can be both a phenomenon of nature and of the artist's own being. In his study of the practice of painting in nineteenth-century France, Albert Boime defines the term "impression" as it came to be used by painters and their critics, and stresses its dual association with an "accurate" view of nature and an individualized or "original" sensation belonging to a particular artist. Boime also notes the importance of the related concept of the "effect" (*effet*) for both academic artists and independents such as Jongkind and Monet. He states that the term "impression" was nearly interchangeable with "effect." Consequently, a painting entitled *Effect of Sunrise* might also be labeled *Impression of Sunrise*; but, as Boime writes, "the distinction is this: the impression took place in the spectator-artist, while the effect was the external event. The artist-spectator therefore received an impression of the effect; but the effect seized at any given instant was the impression received."[16] Boime proceeds to ask why impressionists such as Monet tended to describe their works as impressions rather than effects: "The answer resides in the subjective connotation of this term."[17] The impressionist, that is, wished to call attention to the particularity or originality of *his* sensation of nature. It was his sensation; yet, as Boime writes, it was considered to represent the external effect with "accuracy." Boime leaves aside the epistemological issue of the impression at this point in order to pursue the significance of the nineteenth-century notion of originality (to which I return in part 2). His discussion raises two perplexing questions which remain unanswered: To what extent can the rendering of an admittedly subjective impression be thought of as revealing an external effect? And how can the "accuracy" of the presentation of this effect (and the artistic sincerity and originality associated with it) ever be evaluated by a critical observer? To deal with the first question entails an investigation of the concept of the impression as it is found outside artistic circles, in the field of psychology; and to approach the second involves a consideration of the concept of "truth" (*vérité*) among painters and their critics.[18]

It was not until the nineteenth century that psychology, the study of sensation, emotion, and thought, came to be generally regarded not merely as a branch of metaphysics but as a natural science, an area of empirical research into the physiology of perception.[19] Terms such as "physiologie psychique," "psychophysiologie," and "psychophysique" were commonly used. One of the standard definitions of the word "impression," in accord with David Hume's use of the term, was of direct relevance to the new psychologists: the impression is the "effect produced on the bodily organs by the action of external objects" or, more specifically, the "more or less pronounced effect that external objects make upon the sense organs."[20] The latter quotation is from the dictionary written by Émile Littré, the noted positivist who was him-

self involved with studies in the new psychology. In 1860 he published a general statement on the problem of perception and knowledge of the external world. For Littré, an external object cannot be known; only the individual's impression of it is known as real or true. In other words, one can never have absolute knowledge of the external world in the manner that one does have absolute knowledge (or experience) of an impression; one's view of the world is induced from one's experience of impressions and is necessarily relative.[21] The significance of Littré's argument for the questions under discussion lies in the implication that the most personal impression, if somehow presented publicly (say, by means of a painting), would reveal as much "truth" about the world as would any other genuine impression.[22] As a result, the rendering of an impression could be an "accurate" expression of both the artist and his natural environment.

Littré put special emphasis on the primacy of the impression:

> Yes, there is something that is primordial, but it is neither the [internal] subject nor the [external] object, neither the self nor the nonself [*non-moi*]: it is the impression perceived [*l'impression perçue*]. A perceived impression does not in any sense constitute the idea of the subject or of the object, it is only the element of these ideas [which develop] only when the external impression [i.e., physical resistance or contact] and the internal impression [i.e., pleasure or pain] are repeated a certain number of times.[23]

The impression, in other words, is the embryo of both bodies of one's knowledge, subjective knowledge of self and objective knowledge of the world; it exists prior to the realization of the subject/object distinction. Once that distinction is made, the impression is defined as the interaction of a subject and an object. An art of the impression, the primordial experience, could therefore be seen as both subjective and objective.

Littré's position on the significance of the impression was not an unusual one. Both Théodule Ribot, who helped introduce British psychology to France, and Hippolyte Taine, who also was familiar with the British school, discussed the impression as the "phénomène primitif" or the "fait primitif" which depended on conditions both internal and external, subjective and objective.[24] Littré, Ribot, and Taine tended to equate the impression with sensation. Others, however, distinguished sensations as impressions that were actually felt rather than subliminal.[25] Hence, Littré himself, as if aware of this possible distinction, spoke of the "perceived" impression, one actually sensed or noticed; and in the early critical commentary on impressionism the phrases "l'impression perçue" and "l'impression reçue" appear frequently.

In 1904, a number of years after critics had begun to discuss specific impressionist works in terms associated with symbolist art, Fernand Caussy published an article entitled "Psychologie de l'impressionnisme." He identified impressionism as an art of rendering the first impression but made a basic distinction between Manet's "visual realism" and the "emotional realism" of Monet and Renoir. As Castagnary had done thirty years earlier, Caussy stated that Monet and Renoir presented a distorted idio-

syncratic image in accord with their own emotional responses to nature; and for him, as for Castagnary, this would lead to a subjective "idealism." In other words, Manet's rendering of the impression was objective, while Monet's was subjective. Nevertheless, Caussy argued, the two arts are intimately related, and differ only in that one is the product of an inactive nervous system passively recording visual observations while the other is the product of irritability and attendant strong emotion.[26] In Caussy's overextended analysis, one sees the full implications of Castagnary's original comment: "[These artists] are *impressionists* in the sense that they render not the landscape, but the sensation produced by the landscape."[27]

The conclusion to be drawn from the writings of Deschanel, Littré, Castagnary, Caussy, and others is this: an art of the impression (or of sensation) may vary greatly from artist to artist, in accord with the individual's physiological or psychological state or, in other terms, with his temperament or personality. Whatever truth or reality is represented must relate to the artist himself as well as to nature. Indeed, one might say that the artist paints a "self" on the pretext of painting "nature."

3

Impressionism, Truth, and Positivism

I N FRENCH ART CRITICISM of the nineteenth century, the word "vérité," truth, had a double sense. On the one hand, it referred to a fidelity or truth to nature, and on the other hand to the artist's own temperament or emotions. In its second sense, the word would often be used in conjunction with "naïveté" or "sincérité." Sometimes the two meanings of "vérité," objective and subjective, were clearly distinguished; at other times, not. As I have indicated, impressionist art was often seen to be related to both kinds of truth.

In his "Salon of 1859," Baudelaire, recalling his early conversations with Delacroix, chose to contrast the two kinds of truth as the respective aims of two kinds of art:

> The immense class of artists . . . can be divided into two quite distinct camps: one type, who calls himself "réaliste" . . . and whom we, in order to characterize better his error, shall call "positiviste," says: "I want to represent things as they are, or as they will be, supposing that I do not exist." A universe without man. And the other type, "l'imaginatif," says: "I want to illuminate things with my intellect [*esprit*] and project their reflection upon other minds."

Here Baudelaire, oversimplifying the theory of positivism, distinguished the truth of a mechanical realism (associated with the photograph) from that of a human, emotional encounter with nature. As Caussy would do decades later, Baudelaire related the unemotional representation of an external reality to a particular psychological type—"[les] esprits paresseux et difficilement excitables."[1]

Other critics who, like Baudelaire, formulated generalizations on the state of modern French art came to make similar distinctions. In 1876, Eugène Fromentin complained that much contemporary painting sought to represent the "absolute truth" of an external reality rather than the fantasies of the imagination. He associated recent landscape painting in particular with the mechanical reproductions of the photograph; in this type of art, he wrote, "any personal interference on the part of sensibility is too much."[2] About a decade later, Georges Lafenestre applied the same distinction specifically to the art of the impression, referring to the great body of naturalistic painting then being produced throughout Europe. Lafenestre chose to link

21

the truth of the impression with the "vérité" of fresh air and sunlight, the observation of the external environment; just as Fromentin before him, he opposed this to the neglected art of the "imagination."[3] And in 1895, Roger Marx described the truth of naturalism as "literal, external, immediate truth," requiring retinal sensitivity and manual dexterity but not "the intervention of the intellect . . . art becomes a mirror."[4]

These three critics need not have conceived of naturalism (or the impression) in so narrow a fashion. Baudelaire himself, when writing about Constantin Guys, the "painter of modern life," took a more flexible position, referring to the "impression produced by things upon the mind of M. G[uys]."[5] And Baudelaire would, in several different passages, admit that "realism" could be justified by a strict adherence to

> what [the artist] sees and . . . what he feels. He must be *truly* faithful to his own nature. He must avoid like the plague borrowing the eyes and the feelings of another man, however great that man may be; for then the productions he would give us would be, in relation to himself, lies and not *realities*.[6]

Following the manner of another seems here a more serious fault than that of a weak or relatively inactive imagination; as long as the artist is true to himself, his vision, even in its banal "realism," will bear the redeeming imprint of his own subjectivity.

If indeed some critics who surveyed the general field of French art during the 1870s and 1880s decided that an objective truth, a fidelity to an external nature, was the aim of most painters, both academic and independent, they may have been influenced in part by some of the supporters of impressionism itself. Armand Silvestre, for example, wrote that Monet's renderings of reflections on water were of "une vérité absolue"; and Théodore Duret claimed that for Pissarro a landscape was the "exact reproduction of a natural scene and the portrait of a corner of the world that really exists."[7] Most of those who commented directly on impressionism, however, seemed to believe that a subjective truth was involved at least as much as, if not more than, an objective one.[8] Duret himself was ambivalent when he wrote on Manet in 1870:

> he brings back from the vision he casts on things an impression truly his own [*une impression vraiment particulière*]; no one more than he has the sense of the *values* and of the accent in the coloring of objects. Everything is summed up, in his eyes, in a variant of coloration; each nuance or distinct color becomes a definite tone, a particular note of the palette. . . .[9]

Here it is not clear whether Manet's rendering of the impression yields a truth of nature that he more than anyone else is capable of seeing, or a truth that is his vision and his alone; Duret seemed to feel that both truths were involved. Manet's art is seen, in either case, to depend on his eyes; and this observation, made repeatedly during the late nineteenth century, refers back to the physiological psychology of the time.

Many critics of the period attributed artistic vision first to the artist's eye and only secondarily to his whole person, his temperament or personality. Jules Laforgue, for

example, stated that every eye saw the world differently and that this ultimately would account for most of the general differences between the art of the academic eye and the art of the ("more advanced") impressionist eye.[10] According to Laforgue's psychology of perception, the truth of the individual's impression would depend on the individual's unique physiology. As each eye was different from any other, so each temperament or personality, the sum product of *all* physiological "facts" in an individual, would be unique and original. Applying this type of reasoning, Émile Zola had set an immediate precedent for Duret by arguing for the acceptance of Manet's unconventional painting on the grounds of its subjective truth. Zola repeatedly asserted that Manet (and each artist this critic championed) painted things "the way he sees them." Zola's emphasis in such statements is obviously meant to be on the subject who sees, not the object seen. In 1867 he wrote: "[Manet's] whole personality consists in the manner in which his eye is organized; he sees blond, and he sees in [broad] masses." Accordingly, Zola could offer an explanation of the painter's unconventional style—Manet sees this way by nature; he is true to himself, sincere. "This daring man who is ridiculed has a well-disciplined technique, and if his works have an individual appearance, they owe that only to the entirely personal manner in which he sees and translates objects."[11]

Zola's acceptance of subjective truth put him in an odd position as a critic, one which warrants detailed discussion. At this point it is enough to note that he found himself necessarily open to all artistic manners, since any one might reveal a truth as individualized as the vision of reality he discovered in Manet: "I accept all works of art in the same way, as manifestations of human genius. And they interest me almost equally, they all possess genuine beauty: life, life in its thousand expressions, ever changing, ever new."[12] Such universal receptivity, however, might lead to an ineffectual anarchy of artistic communication. And so, for some others, such as Castagnary, subjective individualism was not always acceptable, even if thoroughly authentic. As if in agreement with Zola, Castagnary found (in 1874) that "Manet paints as he sees, he reproduces the sensation which his eye brings him: he is above reproach with regard to sincerity." But, as if recalling Taine's psychological theories, the critic went on to say that in perceiving the external world one rectifies the raw "data of [the] eye" according to what one knows to be true by means of a broader base of experience. In consequence, Manet's immediate "summary sensation," although true on a personal, subjective level, would have to be transformed into a public, objective truth if it were to have social significance.[13]

《 》

With so much attention having been directed to the "eye" (both figurative and literal) of Manet and other naturalistic artists, it is no wonder that scholars have brought positivism to bear on the issue of impressionism. Positivism was a philosophical movement popular during the period of impressionism, and it emphasized direct observation as a means to valid knowledge. D. G. Charlton provides a general definition of philosophical positivism in France, one based not only on the theories of Auguste Comte, the founder of the positivist movement, but also on the beliefs of others, such as Littré, who were stricter than Comte himself in adhering to the core

of positivist tenets.[14] According to Charlton, for the positivist, with the exception of knowledge of logical and mathematical systems,

> science provides the model of the only kind of knowledge we can attain. All that we can know of reality is what we can observe or can legitimately deduce from what we observe. That is to say, we can only know phenomena and the laws of relation and succession of phenomena, and it follows that everything we can claim to know must be capable of empirical verification.[15]

Obviously, a positivist might argue, just as an impressionist, that unprejudiced eyes would reveal new truths. However, the most prominent positivistic thinkers believed that the direct observation and recording of external phenomena were the tasks of the scientist, while the artist should instead apply his *imaginative* vision to this world of fact. According to both Comte and Littré (and also Taine), art has its origin in fact but departs from it; the artist must imaginatively "idealize" and "perfect" what he observes; thus art becomes inspirational and leads to the betterment of society. As Comte wrote, "art is always an ideal representation of what exists, destined to cultivate our instinct for perfection."[16]

One can detect certain elements of positivism in Castagnary; but if anyone qualifies as a genuinely positivist art critic, it is Pierre Petroz, who published regularly in the journal edited by Littré, *La Philosophie positive*. Petroz followed Comte's reasoning and stated that art should involve the "act of the mind through which it conceives the things of the physical and intellectual world under a form more perfect, more essentially true than that which they have in nature." The critic contrasted such an "idealized" art to one of simple, direct realism and thus recognized a dichotomy similar to Baudelaire's, even though Baudelaire himself associated positivism with the same banal realism to which Petroz objected. Like Baudelaire, Petroz stated that Delacroix's art was exemplary, revealing genius and imagination. Where Petroz diverged from Baudelaire—and from supporters of a subjective impressionism, such as Zola—was in his assertion that art should reveal general physical and intellectual laws.[17] Such a goal was in accord with the positivist's concern for the development of society as a whole. Baudelaire and Zola, on the contrary, were much too committed to individual expression to consider such an artistic aim valid.[18]

This is not to say that the individual was unimportant for the positivist critic. Petroz also wrote for many years for the journal *L'Art*, which in its introductory editorial statement (most likely authored by Eugène Véron) declared that the comparative study of art would reveal the characters of the various civilizations which had successively dominated history; it would also indicate the "spontanéité intellectuelle" of the various human races. For the contributors to *L'Art*, art manifested human progress; but in periods of decline, artistic activity amounted to "imitation" rather than "creation": "Reduced to the occupation [*métier*] of copyist and plagiarist, restricted within the bounds of the retrospective study of the methods and models of the preceding period, art ceases to live its own life; it loses its drive, its spontaneity, and the creative power that it found in sincerity, in the personality of its own emotions." According-

ly, the editorial introduction advised artists to seek only a *means* in the masterpieces of the past and not an *end*, to maintain both their proper social expression and, above all, individuality: "in the domain of art, in order to accomplish [make] SOMETHING, it is necessary to be SOMEONE."[19] Petroz's own contribution to the first volume of *L'Art* was an article on the need to group works in museums by national, regional, and (especially) chronological distinctions instead of by some aesthetic agreement in dimensions or even frames; in this manner, the correlation of intellectual and aesthetic developments in various societies would be revealed along with the innovative contributions of their great individual masters.[20]

If the impressionists and their supporters were influenced by Comtean positivism, they were not much affected by the notions its followers held on the nature of art.[21] What actually seems closest to their beliefs are those ideas which might have been derived from the psychology of Littré and Taine, both of whom, in these matters, were independent of Comte, drawing primarily upon British sources. The relationships between the concepts of positivism, impressionism, and external or "objective" reality have been repeatedly misrepresented in the recent scholarly literature. For example, in a comprehensive study of nineteenth-century realism, Linda Nochlin makes two common errors: she associates Comtean positivism with an art of simple observation, and she fails to distinguish the "subjective" and "objective" truths of the work of art. The first of these problems is a matter of factual documentation; the second is both the more important and the more elusive. Nochlin defines the "'instantaneity' of the Impressionists" as "'contemporaneity' [modern-life subject matter] taken to its ultimate limits"; this definition confuses what nineteenth-century critics regarded as the "subjective" truth of the immediate or "spontaneous" impression with what they saw as the "objective" truth of a contemporary subject that one might actually observe.[22] In other words, an internalized "reality" or experience is confused with an externalized one. When one realizes the significance of this distinction for painters of the nineteenth century, the difference between the independent impressionists (Monet, Renoir, etc.) and many of their academic counterparts (Detaille, Jean Béraud, etc.) becomes clear. The work of the former group emphasized "subjective" experience of nature and denied itself the kind of observational detail associated with the photograph. In contrast, that of the latter group stressed an "objective" external observation and because of its precision or focus was often said to resemble the photograph (for better or worse).

The distinction was a very common one and was made succinctly by Thoré in reference to Corot, whom this critic considered poetically expressive as opposed to photographically imitative. In defense of Corot's indefinite and summary rendering of figures, Thoré wrote that "this incomplete manner has, at least, the merit of producing a harmonious ensemble and an engaging impression. Instead of analyzing a limb, you experience a feeling [*éprouver un sentiment*]."[23] To paraphrase the critic: although Corot's painting may lack objective truth of detail, it provides subjective truth of emotion. Thoré's comment indicates that the subjective impression (or the sense of "instantaneity") is not necessarily an extension of objective fidelity to the

"facts" of nature, but may, on the contrary, be independent of the rendering of "factual" observations. Obviously, a whole range of representations, from "subjective" to "objective," would be possible. For some critics, the relatively detailed works of impressionists such as Degas or Morisot seemed to represent a mean, a union of subjective and objective truths. In contrast, the more fully detailed pictures of a "realist" (Detaille, for example) might seem limited to material objectivity; and Monet's art, at the other extreme, might seem imprecise, fanciful, and simply too subjective.[24]

Like Nochlin, H. R. Rookmaaker misrepresents positivism, and he fails to note the subjective implications of the concept of the impression when he brings it to bear on impressionist painting. Citing some of Rewald's comments, Rookmaaker states that nineteenth-century experiments with light and color, both in science and in art, were founded on the philosophical principles of positivism and were "related with the attempt to register the direct sensation apart from any emotional interpretation. . . . The [impressionist] artist equalizes the representation of nature with the (unproblematic) notation of impressions or 'sensations.'"[25] For Rookmaaker, the impression becomes the means of arriving at objective truth, pure and simple. Ironically, this view is far from the "truth" that nineteenth-century minds acknowledged. Positivist psychology (Littré's or Taine's) linked the impression to subjective emotion as well as to objective observation; and for the majority of its sympathetic critics, impressionist painting presented a highly individualized and personal view of nature, as if "emotional interpretation" (Rookmaaker's phrase)—even unintended—were inescapable in any "sincere" artistic act. Although the surviving statements by the impressionists themselves often seem ambivalent on this very unstable point, there is much evidence that they, too, conceived of their art as essentially personal and subjective. Monet, for example, once wrote that he "always worked better in solitude and according to my very own impressions [*mes seules impressions*]"; and Pissarro, when he noted the similarity between his own work and Cézanne's, added that "each one kept the only thing that counts, his own 'sensation' [*sa 'sensation'*]."[26]

All the subsequent confusion and ambiguity with regard to subjective and objective truth cannot be blamed on the modern scholar alone, for much of it is built into the field of study itself. The physiological psychologists, as well as many other nineteenth-century theorists, contributed to the breakdown of the distinction between subject and object, especially through their emphasis on the *experience* of the observer. Reality came to be equated with consciousness, and, as so many maintained, the primordial act of consciousness was to perceive an impression; the impression was neither subject nor object, but both the source of their identities and the product of their interaction.[27]

4

The Subject/Object Distinction, Critical Evaluation, and Technical Procedure

ITTRÉ IDENTIFIED THE ELEMENTAL EXPERIENCE or the primordial event with the impression, that which gives rise to the distinction between subject and object. Taine, too, in his fundamental psychological study *De l'intelligence*, conflated the notions of subject and object by speaking of an elemental unitary sensation (that is, the impression) that appeared simultaneously under two irreducible aspects, as both conscious intellectual force and material substance. For Taine, reality consisted not of mind (subject) or of matter (object) but of conscious experience, which manifests itself under both these dependent aspects of reality.[1]

As Taine came to synthesize subject and object via psychology, so did the nineteenth-century "psychophysicists." José Argüelles has noted that Gustave Fechner, Charles Henry, and others concerned with the quantification of aspects of human perception anticipated the essence of the principle of complementarity now usually associated with the work of Niels Bohr—that the observed nature of external "objective" phenomena is dependent on the nature of the perceiving subject.[2] In other words, what may exist in the external world to be observed is contingent on the observer and his manner of observing.[3]

The psychophysicists defined a reality that might be conceived as a luminous center around which both subject and object revolve in reciprocity, and through which each one passes as it is observed by the other. This irreducible relativism accords (except in certain extreme cases) with the fundamental nineteenth-century belief, shared by Hegel and Comte, that man's knowledge of the world corresponds with his stage of historical development. Furthermore, it is closely related to Schopenhauer, at least as he came to be understood in France. According to Charles Lévêque's explication (1874), Schopenhauer's famous statement, "the world is my representation," indicated that the objective world could never be free of the subject perceiving it: the world perceived was a phenomenon of the mind. Lévêque further explained that Schopenhauer sought a way out of this epistemological impasse. To eliminate the illusions created by the mind and to discover a more fundamental reality, he sought the "most immediate perception," the point of experience at which subject and ob-

ject cease to be distinguished and union of the individual and the universal is achieved.[4] This philosophical speculation came to bear upon the subject of art not only for Schopenhauer, but—more significantly for present purposes—also for Jules Laforgue, an admirer of Schopenhauer and his disciple Eduard von Hartmann and a friend of Charles Henry and a number of symbolist critics.

Laforgue wrote in 1883 that in the new impressionist painting "object and subject [that is, either nature and artist, or art work and viewer] are . . . irretrievably in motion, inapprehensible and unapprehending. In the flashes of identity between subject and object lies the nature of genius."[5] In this way Laforgue presented the union of subject and object as an aim or ideal of art, much as Schopenhauer had done.[6] The impressionist was in a position to achieve this aim because he sought what Schopenhauer (through Lévêque) had called the "most immediate perception." Later, in 1895, Maurice Denis would similarly consider the final goal of art as a synthesis of object and subject. Speculating about a group of painters who exhibited as "impressionnistes et symbolistes," he wrote that eventually the work of the younger artists might come to reveal "more of an analogy between the object and the subject, between the world and the image they will have made of it."[7] And still later, Denis would praise Cézanne's art for a "reconciliation between the objective and the subjective."[8]

Both Laforgue and Denis were more sympathetic to the theories of symbolism, but could at times speak warmly of impressionism because they associated it (to varying extents) with the goal of the integration of perceiving subject and perceived object. And even a theorist such as Eugène Véron, who was no champion of the new independent art movements, called at an earlier date for an art of both subject and object. In 1878, Véron wrote a general study entitled *L'Esthétique* that was very much a product of its age: it rejected metaphysical and theological speculation, as did the writings of Comte and Littré; and it advanced determinism and a theory of national and racial expression, as did Taine. It presented as the goal of art "sincerity and spontaneity of emotion," a definition which could actually serve either impressionists or symbolists well. Most significantly, it described three paths open to the artist. First, the "imitation of an interior art" or the "academic method"; Véron rejected such derivation of art from art because its product seemed conventionalized and unoriginal. Second, the "copying of real things" or the "realist theory"; this mode claimed objectivity in its recording of phenomena, but would reduce the artist to a machine. Véron argued that it was in any case an impossibility because the artist cannot be a perfect realist—he always adds something of himself, "his emotion, his personal impression." Third, the "manifestation of individual impressions," that which involves both object and subject, the natural effect and its impression, "l'effet et l'impression"; the artist may be stimulated by nature, but will paint with colors "which will be those of his own nature, of his temperament, of his personality." Véron referred to this last path as "l'art personnel"; it was the only true way.[9] His concern for an originality associated with individuality (and linked to political free-

dom[10]) led him to an art that represented man's nature as well as external nature. Véron regarded man's nature as endlessly variable, revealed through a work of art as the artist's temperament.

The notion of "temperament" was central for a great many theorists of the nineteenth century, who held that an individual's physiological constitution, the source of his temperament, was the cause of a necessary subjectivity of vision.[11] In 1864, Émile Deschanel, who cited both Taine and Stendhal as authorities, defined "temperament" as the "particular state of the physical constitution of each person, caused by the diverse proportion of elements which enter into the composition of his body."[12] One might observe broad distinctions in constitution or temperament corresponding to racial differences, and subtler distinctions among individuals produced by variation in the domestic environment and even diet. Accordingly, Stendhal, for example, had argued that if there are five races of men, there must be five "ideal" beauties. "I strongly doubt," he wrote, "that the inhabitant of the coast of Guinea admires the truth of Titian's color."[13] Alfred Johannot brought the point home to the field of contemporary art criticism when he asserted that every artist had a "point of view" determined by his individual temperament and that his work could be evaluated only from that unique perspective; no fixed standard of judgment could be applied to art.[14]

As the aesthetic theory of Eugène Véron has served to indicate, the individual's *impression* of nature was commonly associated with the subjectivity of a unique temperament. The critic Champfleury wrote that "man is always borne along by his particular temperament . . . which makes him render nature according to the impression he receives of it," and variation in temperament results in variation in impressions.[15] And Delacroix, as if speaking from his own experience, once exclaimed: "Oh! young artist, do you seek a subject? Everything is a subject; the subject is yourself; it is your impressions, your emotions before nature."[16] For Delacroix, individual temperament always revealed itself in the manner in which an observed object might be rendered; or, in other words, the act of depicting an "impression" simultaneously conveyed personal "emotion." Thus, anything observed might be suited to artistic representation, and (as Johannot also understood) no standard of objective realism or universal beauty would ever prove adequate.[17]

Émile Zola inherited these aspects of romantic and realist theory and applied them to the criticism of an emerging impressionism, a manner of painting that made these issues more apparent than ever before. Symbolist critics usually credited Zola with the (common) idea of individual temperament as a source of authenticity and truth in art; they frequently cited his dictum that "a work of art is a bit of nature seen through a temperament." With such an inherently eccentric principle to guide him, Zola could describe Manet's art in terms of Manet's own personal vision: the artist simply painted "as he saw." This was Manet's achievement, to be true to his own unique impressions, to express his own temperament. For Zola, the favorable evaluation of a work of art entailed the recognition of an artistic temperament, the discovery of the

artist's own being. In his first extended essay on the painting of his day, he made a vigorous pronouncement:

> I wish that one should be alive, that one create with originality, outside of all, according to his own eyes and his own temperament. What I seek above all in a picture is a man and not a picture. . . . A work of art is never other than the combination of a man, the variable element, and nature, the fixed element. . . . Make something true [to nature] and I applaud, but above all make it individual and living, and I applaud more strongly.[18]

Here one is reminded again of Castagnary's distinction between the "landscape"—in Zola's terms, the fixed truth—and the "sensation produced by the landscape"—Zola's infinitely variable truth. The latter was "alive" in individual artists, unconventionalized and evolving, subject to no fixed terms of evaluation; "the ridiculous common standard," Zola wrote, "no longer exists."[19] Accordingly, the young critic stated that he was "displeased" by the word "art," which seemed to suggest some absolute beauty that lived on through the ages, insensitive to the passing but penetrating glance of individual personalities.[20]

Zola stated unambiguously that he would apply no preexisting standards or preconceptions to his critical evaluations, and he repeatedly lauded Manet and the impressionists for their independence. This was a kind of negative judgment, the result of a comparison in which the new term, naturalist painting, showed itself to be incommensurable with the old academicism. Yet, as if realizing that a judgment appears to lack full conviction if it makes no reference to a positive principle, Zola retained a concern for what he had called the "fixed element," the truth of nature. He praised Manet and others for their faithfulness to natural effects and the recording of relationships of hue and value. In essence, Zola evaluated aspects of artistic technique *as if they were neither entirely original nor idiosyncratic.* Manet as an individual might tend to "see blond," but he also observed a "law of values," a set of relationships that corresponded to relationships in nature. Zola notes that this same law had been profitably employed by many other painters.[21] Consequently, one must conclude that Manet recorded his unique and original vision within a framework established in the tradition of painting; and the force of the radical artistic liberation of which Zola speaks dissipates when the critic (as surrogate for the painter) confronts the requirements of technical procedure. Can Manet's vision, as represented by his technique, be "original" if his procedure is determined by a "law of values" observed and employed by others?

Not without justification, Zola hedges on this question, which involves a conflict between a theory of unforeseen, original vision and a communal practice of painting. The conflict seeks its resolution as it runs a closed elliptical course around its two poles—technique and originality. Perhaps Zola could have spoken of a "technique of originality," a procedure for both representing and becoming original.[22] By convention, certain reiterative elements of technical procedure might indicate personal, original vision as effectively as a single contour line might signify a human figure.

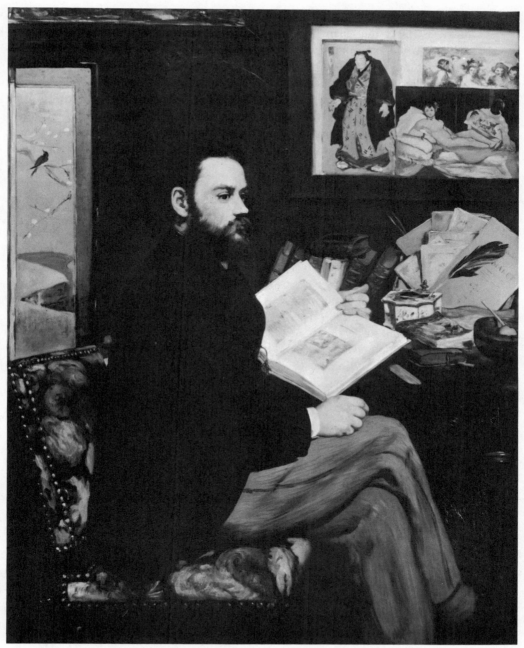

7. ÉDOUARD MANET, *Portrait of Émile Zola*, 1868. Musée du Louvre. Cliché des Musées Nationaux.

The presumption of some communal "technique of originality" would allow Zola to discover Manet the "man," the individual temperament, through his painting; for the critic could seek out predetermined visual features in view of reaching such a conclusion. It may be that Zola's mode of technical analysis was cursory, even superficial. Nevertheless, he seems to have performed some "objective" inspection of qualities of color, value, spatial illusion, and the like, even as he experienced the works of the "man" he trusted implicitly. Manet's artistic personality, revealed in his art, might defy final reductive categorization; yet his critic succeeded in analyzing his paintings in terms that were familiar to others. In sum, although Zola might know the "man" (either personally or by reputation) and might respect his sincerity and be predisposed to accept his art, the structure of his arguments implies the reciprocal procedure: a critic first judges a body of work *technically* and only then judges the artist; he runs the elliptical critical course from the pole of technique to that of originality.

This seems true also of Castagnary's practice of criticism. Like Zola, he valued painting "what one sees" and praised both Courbet (in 1863) and Manet (in 1874) for doing so. But his conclusions may not have come immediately. Castagnary seems to have asked himself how a critic knows that he is viewing "what one sees," that is, its representation. Although he was able to find Manet's art of 1874 acceptable "with regard to sincerity," on another occasion, at the Salon des Refusés of 1863, he did not respond so favorably. At that time, he had decided that Manet, the "man," *lacked* conviction and sincerity; and his judgment hinged on his having observed the results of a faulty technique: "I see clothing without sensing the anatomical framework that supports it and justifies its movements. I see figures without bones and heads without skulls. . . . What else do I see? the absence of the artist's conviction and sincerity."[23]

Zola (and also Castagnary) spoke of the painter's procedure as if it were subject to evaluation by comparison, if not with the technical results visible in other works of art, at least with some established sense of the appearance of nature—the often unacknowledged "standard" could be either an art of nature or nature itself. At the same time, Zola emphasized that an accomplished technique, which met this objective standard, rendered nothing more concrete than the individual's subjective impression. Just as contemporary psychologists defined the impression as both objective and subjective, external and internal, Zola considered the naturalist or impressionist painting as representing both object and subject, nature and man. The work of art revealed, in effect, a special relationship between man and nature, a particular manner of perceiving the world, an artistic manner that yielded both objective and subjective truth. The artist's attention to the rendering of his original and spontaneous impression ensured both fidelity to nature and the expression of his own temperament.[24]

In Zola's most contentious critical writings, his Salons of 1866 and 1868 and his essay on Manet of 1867, he offers relatively little discussion of artists' efforts to develop appropriate technique, and stresses instead the significance of original and subjective vision. In his later, somewhat less polemical writings, he more readily ac-

knowledges the need of any artist to attain a technique that will enable him to achieve his specific ends. A sincere artist, wishing to express his temperament, must still study the practice of painting, although perhaps not as an academic would. In a manner that seems more stubborn than eloquent or convincing, Zola repeatedly attempts to reconcile the subjective impression and an objective rational technique by insisting that the proper technique must be arrived at through long hours of study, but independently, without traditional schooling or the imitation of the styles of others who have themselves attained similar goals. He discredits impressionists of academic background (Bastien-Lepage and Gervex) who are technically competent but have acquired their skills by imitating "naïves" (Manet).[25] For Zola and others, to accept the *possibility* of employing a studied yet independent or unconventional technique to render the spontaneous impression is fundamental to the critical analysis of impressionism. Without the concern for technique, even the ill-defined procedure of which Zola speaks, critical evaluation of impressionist painting would be reduced to questions of personal integrity; and one would be inclined to advocate that artists abandon any active search for the elusive "means of expression," merely to become receptive, attending passively to their most immediate physical sensations.

Such passivity would greatly weaken the foundation of a reliable critical evaluation, for it would seem to eliminate any willful move toward some technical orthodoxy—artists would simply follow their instincts, and, as their temperaments varied, so would their art. How could one determine the true degree of "sincerity" in such a passive art? Would deviance from a norm suffice? Perhaps not, for the insane might then appear as the greatest artists. As if sensitive to all these potential difficulties, Albert Aurier, in writing on Van Gogh, admitted that a reliable judgment of artistic sincerity could never be based on observable qualities in a work. He stated this view in 1890, citing Zola's notion of temperament and referring to the "degrees of the artist's sincerity." In revising this essay on Van Gogh, probably in 1892, Aurier altered his phrase to read: "the degrees of the artist's *passive* sincerity before nature." The critic seems to have wanted to emphasize the association of sincerity with passivity and, concomitantly, the association of technical procedure with deliberate choice. Actually, he had already devised a way to speak of an *active* form of sincerity. In a brief essay on the painter Henner, he had suggested that an artist should not restrict himself to the "immediate sincerity of the realists, [the] absolute copy of impressions perceived *naturally*"; instead, he should proceed "by exaggeration or attenuation of qualities *already natively present*" in order to convert "his original and native temperament" into a willfully created "artistic temperament" no less specific to himself. In other words, a studied technique might be employed to bring one's true vision and one's image of self—one's "sincerity"—into the sharpest focus.[26]

Aurier's concern for a deliberate representation of temperament may have led to his revision of the essay on Van Gogh. There is a revealing case of afterthought in Zola's writing, too. His remarks on Jongkind made in 1868 and 1872 provide an example of the change in tone which characteristically distinguishes his earlier and later critical essays. In 1868 he wrote of Jongkind's very personal vision and of his equally

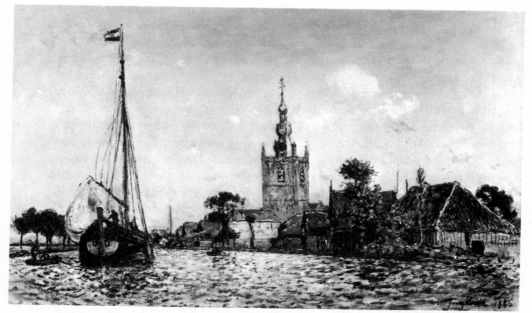

8. JOHAN-BARTHOLD JONGKIND, *The Church of Overschie*, 1866. Courtesy of the Art Institute of Chicago.

original manner of rendering this vision by means of a striking simplicity. He presented his reader with an image of the artist working quickly to capture both the objective truth of nature revealed in the "first impression" and, more significantly, his subjective emotional experience of nature, his "sensation," over a period of time. In 1872, Zola republished these same statements almost verbatim, but added an important qualifying remark: "The truth is that the artist works slowly [*longuement*] on his canvases, in order to arrive at this extreme simplicity and unprecedented refinement."[27] Thus, in his later version, Zola linked the rendering of the spontaneous impression to a lengthy and deliberate process of painting. Similarly, in his Salon review of 1880, he defined impressionism in terms of seizing "nature in the impression of a minute"; but, he added, "it is necessary to fix this minute on the canvas for all time, by a technique [*facture*] well studied." To capture the impression entails observing the light of the open air—"easy enough to say," Zola wrote, "but the difficulties begin with the execution." Indeed, when he evaluated Monet and the other independent impressionists with an eye to their technical accomplishments, he found them wanting. He felt the need to remind Monet that "it is study that makes solid works," and he concluded that none of the impressionists was master of his chosen form of art.[28]

Zola did not argue that the impressionists' technical failure was due to a lack of sincerity. Monet, Pissarro, Cézanne, and the others were indeed expressing their individual temperaments, but, Zola would claim, not with the artistic mastery that could come only with further achievements in the area of execution. He made a clear dis-

tinction, then, between *what* was expressed and *how* it was expressed, between something deemed subjective and idiosyncratic and something perhaps inventive and original yet still subject to objective evaluation and criticism. Although sketchlike effects, bright color, and a general simplification of drawing and composition were evidence of the artist's concern for rendering the impression, the mere presence of these technical devices did not guarantee that the attempt, however sincere it might appear, would be judged successful.

The creation and evaluation of a technique suited to an art of the impression, of sincerity, and of originality, is the subject of part 2. At this point, however, the course of my argument calls for some brief observations on the issue. There are many indications that artists and critics did generally distinguish between the technique that could be studied and the spontaneous expression of impressions and emotions that it made possible. Accounts of Delacroix given after his death by both Baudelaire and the theorist Charles Blanc refer to this artistic dialectic of regular and idiosyncratic elements. According to Baudelaire, Delacroix's passionate emotions could be communicated only after he had discovered appropriate rational means. The poet-critic quoted Delacroix as having stated that the artist needs to be "armed in advance" with the technical means of translating his impression of nature.[29] Similarly, Charles Blanc discussed Delacroix's remarkable color as a calculated means of passionate expression. Blanc stated that Delacroix's sense of color was intuitive; yet, for purposes of his artistic communication, he needed to learn the scientifically formulated laws which predicted color's actions.[30]

Manet, too, apparently thought of technical mastery as a prerequisite to an art of "spontaneity"—his term, according to his friend Antonin Proust, for an art of the impression.[31] Another of Manet's friends, Stéphane Mallarmé (who appreciated both impressionist and symbolist painting), described Manet's technique as one of skilled artifice calculated to give the *appearance* of spontaneity. For Mallarmé, as for the later Zola, there was nothing inconsistent in working thoughtfully and deliberately to achieve the expression of the momentary. Nor should one expect traditional technical devices to be completely abandoned in the new art. Mallarmé wrote (in a text that exists now only in this ineloquent English translation):

> As no artist has on his palette a transparent and neutral color answering to open air, the desired effect can only be obtained by lightness or heaviness of touch, or by the regulation of tone. Now Manet and his school use simple color, fresh, or lightly laid on, and their results appear to have been attained at the first stroke. . . . But will not this atmosphere—which an artifice of the painter extends over the whole of the object painted—vanish, when the completely finished work is as a repainted picture?

Mallarmé answered his own question in a way reminiscent of Zola: he noted that Manet eschewed traditional composition and perspective, regarding it as unnatural, but still the painter maintained a coherent pictorial unity, in particular by means of

Japanese "perspective" and the cropping of figures to suggest the instantaneous directed glance. Mallarmé concluded:

> Some will probably object that all of these means have been more or less employed in the past, that dexterity—though not pushed so far—of cutting the canvas off so as to produce an illusion—perspective almost conforming to the exotic usage of barbarians—the light touch and fresh tones uniform and equal, or variously trembling with shifting lights—all these ruses and expedients in art have been found more than once, in the English school, and elsewhere. But the assemblage for the first time of all these relative processes for an end, visible and suitable to the needs of our times, this is no inconsiderable achievement in the cause of art, especially since a mighty will has pushed these means to their uttermost limits.[32]

Here, Manet's artistic effects are regarded one by one and the critic admits that there are precedents for each of them. They are neither the results of an empirical study of nature nor the products of "passive sincerity"; instead they derive from a relatively internalized study of the painter's discipline. Such a study (at least for Mallarmé) would be worthy of a symbolist as well as an impressionist.

Baudelaire, Zola, Mallarmé, and others who evaluated either romantic or impressionist art had to face the issue of the communication of personal, individualized sensation. They found it necessary to speak of technical devices drawn from tradition or accumulated knowledge, even while they were advocating an unconventional art of emotional immediacy. The artist's technique, his means of expression, was seen as translating the particular and idiosyncratic into terms of general understanding. As Gustave Geffroy wrote in his "Histoire de l'impressionnisme" (1894), the impressionists could never be genuinely "naïve," for they knew well what past masters had accomplished in the field of painting.[33] Another critic, Charles Bigot, as he confronted the issues raised by impressionism, linked the success of this individualistic art to its conformity to a preexisting (although not necessarily manifest) ideal. Bigot reached this position through his consideration of Bastien-Lepage, whose style he discussed in the familiar terms of naturalism: the capturing of plein air effects, the use of a simplified palette, the expression of a subject simply as the painter "saw" it. Bigot felt that Bastien-Lepage succeeded where the more radical impressionists failed because of his superior technical powers. Just as many critics of his generation, Bigot seemed to reflect Taine's teachings when he concluded that every painter has his own vision and must use color accordingly, but those who succeed are those whose use of color conforms to some generally recognizable sense of harmony: the individual must strike a universal chord.[34] For the symbolists, the important question following upon such reasoning was this: Under what circumstances will an expression of a particular temperament result in an art of universal import? When does the subjective truth of the individual's impression or sensation become an objective truth known to all?

《 》

A full comparison of the impressionist and symbolist conceptions of artistic expression demands some reflection on an inherently evasive subject—the expressive device of distortion (*déformation*), the departure from accepted norms for rendering natural effects. Not surprisingly, the late nineteenth-century viewer saw that distortion could be of two kinds: subjective (idiosyncratic, spontaneous, even "passive") and objective (universally expressive, reflective, perhaps deliberate).

It must be emphasized that "distortion" in impressionist or symbolist art was conceived not so much as a departure from nature but from the *conventional view of nature*. And in its unorthodox deviation distortion might actually reveal *truths*, either of external nature or of the artist's own nature, truths that would have been camouflaged by a conventional rendering. Obvious distortions of form, color, or perspective, awkwardness in handling, and any other stylistic barbarisms were often taken as signs of the artist's sincerity: the artist's awkwardness, in other words, could be attributed to the direct and unattenuated manner in which he expressed his immediate emotional response to his subject. Indeed, the "positivist" poet and theorist Sully-Prudhomme regarded awkward execution as the "guarantee of sincerity"; and the symbolist critic and painter Maurice Denis wrote that "awkwardness [*gaucherie*], for the moderns, consists in painting objects according to the consciousness one has of them naturally, instead of painting according to a preconceived idea of the picturesque or the aesthetic."[35] Denis also remarked: "I call awkwardness this sort of maladroit affirmation through which the personal emotion of an artist is translated outside of accepted formulas."[36]

In these statements Denis seems to imply (and elsewhere clearly indicates[37]) that awkwardness or distortion results from an inadequacy in technical procedure, however commendable that may be with regard to the sincerity of the effort toward artistic expression. Such distortion Denis labeled "subjective," for it was the product of an attempt at expressing an individual emotional response to nature and was in accord with the "doctrine of *homo additus naturae*, Nature seen through a temperament."[38] Here Denis referred both to Francis Bacon and to Zola's famous formulation of naturalist and impressionist art; and he regarded impressionism itself as a case of "subjective distortion." Denis, however, spoke also of a second type of distortion, which he called "objective"; it was generated not by the artist's idiosyncrasies but by his search for a valid technique, for the immutable laws of visual expression. Denis associated this type of distortion primarily with the symbolist artists who sought the "laws of expression" both in the traditions of past art and in the advanced sciences of physics and mathematics. Symbolism, according to Denis, affirmed the "possible expression of emotions and human thoughts by aesthetic [more specifically, visual] correspondences" which could be comprehended by all and were, in this sense, "objective."[39]

Albert Aurier, who seems to have been the source of many of Denis's formulations, had discussed the issue of distortion a few years in advance of his younger colleague.[40] In articles of 1890 and 1891, he reiterated the distinction that Castagnary

had made in1874, arguing that the impressionists did not render the natural object itself but its "perceived form"; their aim was the "translation of instantaneous sensation with all the distortions of a rapid subjective synthesis." As Denis would do, Aurier drew on Zola's notion of "nature seen through a temperament" to justify his position that an artist does not represent nature's truth, but "his truth, his own"—the "distortion [is] variable according to the [artists'] personalities." Aurier concluded that the resultant work of art, "distorted by a temperament," became the "visible sign of this temperament," its "symbol." Here, Aurier is essentially in agreement with Zola, who would seek "the man" in the work of art; but he pushed his argument further, forcing what Zola seems to consider subjective and personal to become objective and universally meaningful. There was in art, Aurier wrote, a language of the correspondences between ideas and essences and their sensual manifestations. The symbolists had studied this language, which enabled them to go beyond the expression of nature distorted by a temperament to the expression of a more permanently meaningful abstraction, "a particular idea, a dream, a thought." The apparent distortion of natural forms which one saw, for example, in the art of Gauguin, might have been generated not only by "personal subjectivity" but also by the "needs of the Idea to be expressed."[41]

In effect, Aurier, like Denis after him, argued that distortion need not arise spontaneously as a product of temperament but could be used deliberately as a means of self-conscious artistic expression: the "distorted"—or, as one might be more inclined to say today, "abstracted"—formal elements of line and color become the means of converting the particular sensation or emotion into a concretely manifest "idea" (to use Aurier's term), a realized image of generalized meaning.[42] For the symbolist, an artist's success is clearly linked to a technical procedure, itself subject to critical evaluation. The artistic process that Aurier describes is the same one the symbolist poet Gustave Kahn conceived when he wrote in 1886 that "the essential goal of our art is to objectify the subjective (the exteriorization of the Idea) instead of subjectifying the objective (nature seen through a temperament)": rather than presenting an internalized subjective experience of an objective world, the symbolist would express his personal intuitions or emotions to form a linguistic or pictorial world of universal knowledge.[43] Nevertheless, the antithetical effects that Denis, Aurier, Kahn, and others called subjective and objective distortion fuse whenever the artist's personal vision (his "ideal"[44]) is in immediate correspondence with an image of universal expressive power (the "Idea"). The individual artist would at that moment feel and express (*spontaneously*) what all can feel and come to know. In such a case, the art of the individual impression would merge with the art of the universal symbol.

5

Impressionism and Symbolism as Modes of Artistic Expression

T HE SYMBOLIST WRITERS Aurier and Kahn seem to conceive of the "Idea" (*Idée*) as an objective essence to be discovered and expressed by the artist, an abstraction that bears universal significance. But this is at once the artist's own "idea," perhaps known by introspection, as well as an "Idea" belonging to all. Romantics and impressionists had spoken of the related artistic "ideal"(*idéal*), the external objectification of the artist's own subjective sense (or "idea") of the world, the public expression of a personal view. To "idealize" was to render the world in conformity with one's own view of it; and in this sense of the word Castagnary wrote in 1874 that the impressionists would move from "idealization to idealization."[1] Previously, in 1863, this same critic had defined the ideal almost as one might define the impression, not as something remote and never to be fully realized, but as the present and immediate product of human experience: "The ideal is the free product of each person's consciousness put in contact with external realities, in consequence an individual conception which varies from artist to artist."[2]

Hippolyte Taine offered an account of the relation of an "ideal" to an "idea" in one of the courses that he conducted at the École des Beaux-Arts. Taine had already established himself in the field of literary history, and during his first years as professor of aesthetics (he was appointed in 1864), he became something of a hero to the young naturalist critics; in contrast, he later served many symbolists as the straw man for their antimaterialist arguments.[3] His comments on the "ideal" were characteristically clearly formulated and self-assured, yet ultimately enigmatic. Taine stated that the artist forms an idea of the essential character of his subject, and when he renders that subject in conformity with this idea, the subject (in its artistic representation) becomes ideal. Indeed, this was for Taine the goal of art—to render "real objects" ideal: "things pass from real to ideal when the artist reproduces them in modifying them according to his idea."[4] The statement is ambiguous since Taine does not specify whether the expressed character of the represented subject is a product of the artist's own particular experience or somehow the essence of that subject itself. And through this ontological haziness, another question appears: Does a "subject" (that which is represented) have *any* essence independent of its realization in the artist's ex-

39

perience of it? Or, to put it another way, does the world exist only in the forms one creates, only in its "idealization"? Is the "ideal" the only (but manifold) "reality"?[5]

Such fundamental questions lead from aesthetics to speculation on the nature of subjectivity itself, and the issue of idealization soon presents the critic with unnerving difficulties. Perhaps the use of the word "subject" to mean the *object* of an artist's representation is more than just a "quirk of language."[6] One can say that art *represents* subjectivity. To be more direct about the matter: artistic creation expresses the individual subject (either artist or model—or their interaction); art is the experience and realization of subjectivity; art is experience; art *is* subjectivity. This, at least, is implied in the discourse of many nineteenth-century artists and critics; usually, they do not approach the problem of subjectivity with the aim of annexing or rebuilding existing philosophical structures, but wish simply to affirm the inherent individuality and originality of a work of art or of any human expression.

Before Taine issued his decree on the interrelation of the artistic subject (the "real" model in nature) and the artistic object (the artist's representation, his "end," his "ideal"), Baudelaire had stated that any work of art necessarily embodies elements proper to both artist and model: "An ideal is the individual ["subject" or model] reflected [*redressé*] by the individual [artist]."[7] In other words, the temperaments or characters of both the perceived and the perceiver will be expressed in any artistic rendering. In his formulation, Baudelaire typically emphasized individuals; Taine would stress instead the general society, its material climate and spiritual atmosphere. He had an ingenious way of preserving artistic individuality within a world conceived in such a manner that it demanded conformity: while he clearly acknowledged that individual temperament plays a role in determining an artistic ideal, Taine added that a *great* artist possesses no ordinary temperament but rather one specially marked by all that defines the essence of his culture. Thus, what distinguishes an artistic genius is a temperament that is indeed singular, but eccentric only in its being so *normal*, or normalizing. One might claim, in consequence, that artistic genius not only reflects reality but creates it. Taine, however, preferred to think of the artist as accommodating himself to his environment, acting in favorable reaction to it. With the great artist, the personal ideal comes into correspondence with the ideal to be derived from any "real object" in the environment; such an artist, expressing himself (his nature), expresses the universal truths or conditions of his society.[8] For a symbolist, artistic genius—whether socially integrated or alienated—produces an art of universally meaningful content; for Taine, such content constitutes a specific expression of the high nobility of the artist's temperament. The naturalists' mentor and the symbolists who later ridiculed him could agree on this point: the greatest art brings forth emotions latent in others of the artist's time, emotions which characterize human life in the "real" world, and with which others of all times might conceivably sympathize.

Although the ideal was identified as the product of the artist's temperament, given the "idealized" relationship between the artistic master and the "real" world, the expressed ideal would gain in stature as it (inevitably) moved away from the domain of

the individual to that of the general society. Such an observation allowed a potential *social* value to be reserved for the products of even the most eccentric geniuses. And this social significance, according to one of Taine's close associates, owed its life to aesthetics—that is, the work of art created a social bond not otherwise fully manifest. The point was made by Armand Sully-Prudhomme, known as the "positivist poet," a man committed to "l'esthétique par la psychologie." Sully-Prudhomme held the common belief that art was expressive simply in that it represented the "temperament of the artist, his ideal." In accord with its psychological foundation, artistic expression took its proper form as it established the correspondence between sensations and the emotions they arouse. Formal (technical) elements would serve as the vehicle of such correspondences, which constituted a universal language; and one's appreciation of another's artistic expression would increase in proportion to the strength of the recognition that the artist's personal vision could also be one's own. In sum, Sully-Prudhomme wrote:

> To enjoy a work of art is to experience, by means of formal elements [*au moyen de la forme*], the delight of sympathizing with the ideal of another. . . . When this ideal is also our own . . . this enjoyment is for us that of a revelation, because the artist gives body to our ideal which was floating amorphously in our own imagination.[9]

Hence, in the case of the greatest art, the expressed ideal would be universally recognized; such an ideal, subjectively generated, would appear as a revealed objective truth. To repeat: in the great work of art, the subjective (individual) becomes objective (universal).

As should already be apparent, this pattern of reasoning was not confined to "positivists" (Taine, Sully-Prudhomme, etc); it was appropriated by symbolists who might be labeled "idealists" (in that they thought of themselves as Platonists and Neoplatonists). The symbolist writer and theorist Rémy de Gourmont argued that the proper goal of the artist was to discover a "relative absolute," an ideal that conveyed the "eternal in the personal": "as personal as symbolist art may be, it should . . . reach the nonpersonal."[10] And Maurice Denis noted this double aspect of the ideal when he wrote of the precursors of the symbolist painters (Cézanne and others):

> That which they expressed was surely their ideal, their vision of life, their emotion in the face of things, but they expressed it only through pictorial means [i.e., through elements of visual sensation (line and color) rather than through choice of "literary" subject matter]. This was their virtue: they transposed their sensations into Beauty.[11]

What Denis here termed "sensations" others were calling "impressions"—both terms referred to the vision that actualizes a *personal* ideal. And when Denis spoke of the "Beauty" that may result from vision represented by purely "pictorial means," he referred to an eternal and *universal* ideal. The symbolist is praising a group of painters for their conversion of personal vision into universal art.

Denis's remarks appeared in a review of an 1895 exhibition of paintings by Armand Séguin, a minor but loyal member of Gauguin's enclave in Brittany, the "école de Pont-Aven" which formed the core of early synthetism/symbolism (cf. above, pp. 5–7). Gauguin had written the introduction to the catalog of Séguin's show, Denis cited it appreciatively, and then Gauguin returned the compliment, calling Denis's article "excellent."[12] In his own statement, Gauguin, like Denis, stressed the transformation of a personal vision into universal "Beauty," and noted that Séguin's expression depended on the formal elements of linear arabesque and strong color, rather than on any definite subject or literary reference. By way of the "eternal laws of the Beautiful," Séguin's personal idiosyncrasy would be converted into an art of significance for all.[13] Likewise, in the following year (1896), Denis—seeming to recall not only Gauguin, but also both the "positivist" Sully-Prudhomme and the "idealist" Rémy de Gourmont—defined symbolism as artistic expression by means of an exact and universal correspondence between formal configurations (of line and color) and emotional states. He perceived and acknowledged the intellectual context, claiming that such symbolism came into being with the aid of both "des philosophies positives" and a related empirical psychophysics; and he suggested that the psychological studies of Taine and others had led eventually to this symbolist painting of "equivalents."[14] The implication is obvious: symbolism had a *method*; it could be conceived as generating a universal truth or ideal (of "Beauty") from the particular experience of an individual artist by way of a knowledgeable, even "scientific," technical procedure. *Technique would facilitate the passage from the personal to the universal.*

Did the impressionist artist seek a goal analogous to that of the symbolist? And did he employ analogous means to attain his end? He, too, made manifest an ideal, although Zola and other critics usually emphasized this ideal as a sign of individuality, not universality. Yet there is also the impressionist's "effect" (*effet*) to consider, the objectification of his impression of nature (see above, pp. 17–18). Supposedly, the effect was "true" to nature, something anyone would be able to see if his vision were liberated from the constraints of convention and prejudice (for many, such liberation would be no simple matter). While the impressionist's ideal varied with the individual personality, his representation of nature—the effect—paradoxically assumed a universal validity. In this sense, impressionist art, during the period of its currency, was interpreted as *both* subjective and objective. The truth of the ideal depended—or so it seemed—on the artist's intangible sincerity, while the truth of the effect depended on his science. Consequently, in the writings of Zola and others, critical evaluations of technique were at times directed toward establishing proof of the artist's sincerity (by way of references to spontaneity, awkwardness, avoidance of academic convention, and other general qualities) and at other times directed toward establishing proof of his fidelity to nature (by way of references to bright color, atmospheric unity, and other specific features). In either case, the nature of the impressionist's expression, like the symbolist's, was known by way of his technical procedure.

《 》

The relationships among the most important concepts that have been discussed thus far can be translated into a simplified graphic form to illustrate the manner in which they were conceived by both impressionists and symbolists. The concepts are these: temperament (*tempérament*), nature (*nature*), emotion (*émotion*), impression (*impression*), technique or means of expression (*moyens d'expression*), ideal (*idéal*), effect (*effet*).

In the diagram, the arrows indicate that both emotion and impression were considered as products of the interaction of temperament and nature, self and world (or, in Littré's terminology, self and nonself). Temperament and nature were usually regarded as preexisting givens, fundamental entities, subject and object (although if known only in their interaction, their "preexistence" becomes problematic). Emotion and impression exist in the realm of human experience. Both the impression and its attendant emotion—for Taine, the priority could be reversed—appear immediately or spontaneously to the individual. They cannot be separated one from the other.[15] They appear as the truths of immediate personal experience and are otherwise known by a single term, *sensation*. "Sensation" signifies both emotion and impression.[16]

In the graphic representation, technique or the "means of expression" occupies the central, or rather, the mediate position, serving as the means to the end. Impressionism and symbolism may be conceived as analogous theories of expression, differing primarily in the role they assign to mediation, to technique. Clearly, both impressionists and symbolists employ technique to perform expression. The artist's technique or means of expression was regarded as a system (perhaps merely a collection) of signs capable of translating, expressing, or making manifest[17] the immediate truths of emotion and impression. The arrows indicate that artistic expression takes the dual form of ideal and effect, both of which constitute the work of art, or the (conventionalized) communication. One can discover universal "truth" in both the ideal and the effect: the ideal is verified through intuition (all may respond to it) and the effect through attending to the empirical (all may observe it).

In the diagram, the top group of elements—temperament, emotion, ideal—are "internal" and constitute an image of the self; they relate to mental, psychic, or imaginative activity. The bottom group of elements—nature, impression, effect—are "external" and form an image of the world; they relate to physical or sensory activity.[18] The elements located "before" the means of expression—emotion and impression—are individual, subjective, and private; those located "after"—ideal and effect—are (if the work of art is optimally successful) universal, objective, and public.

The relationships between the elements in the diagram hold true for both impressionists and symbolists, with differences only of emphasis. It is evident that a distinction of great significance for both groups was that between the internal and the external: while the impressionists tended to regard their impressions of nature as the primary source of their art, the symbolists looked to their internal emotional experience as the origin and stressed the expression of the ideal, often belittling the significance of the effect.

The symbolists' concentration on emotion and internalized psychic life led them often to criticize impressionist art as materialistic because of its apparent concern with the pure impression, the sensory response to the external environment. Characteristically, however, the symbolists excluded from their harshest criticism the independent impressionists such as Monet and Cézanne, for they recognized in them a sympathetic subjectivity.[19] In any event, the artist to be condemned beyond all others was he who simply registered natural phenomena like a photographic plate—his "impression" was not a felt, human one but mechnical, the result, as it were, of an external process. "In art," the symbolist poet Charles Morice wrote in 1889, "there is no external truth." The work of art begins, Morice argued, with the departure from external appearances, "according to the predilections of [the artists'] temperaments . . . [according to] the feeling of the artist, the personal impression he receives of universal nature. . . . [Things] have truth only in him, they have only an *internal truth [vérité interne].*" Morice linked internalized experience to artistic "style" and a visionary art.[20] Jean Moréas did the same when he composed his symbolist manifesto, describing the desired "roman symbolique" in terms of temperament, subjective distortion, and hallucination (a significant notion, to be sure): "a unique character moves through an environment deformed by his own hallucinations, his temperament; the only *reality* lies in this distortion [*déformation*]." Recognizing that impressionism, too, was an art of temperament, Moréas referred at one point to the hybrid "roman symbolique/impressionniste"; both impressionism and symbolism were opposed to the "puerile method of naturalism."[21] The "impressionism/symbolism" that Moréas advocated would turn from the external environment of naturalism toward an internalized experience affording an inward escape from an oppressive materialistic culture.

Almost inevitably, such liberating experience included dreams, mystical visions or revelations, and the apperception of universal principles or harmonies underlying all significant sensation. Symbolists sought to subvert Zola's "naturalistic" association of sincerity with the direct representation of "what one sees." Gauguin, for example, implied that the dream must replace the external view as origin of artistic vision and truth: "to paint what one dreams is a sincere act."[22] For the symbolist, the dream was as real as anything else, perhaps more intensely real because of its seeming independence from the other phenomena of experience; at any rate, it was, as Moréas's associate Gustave Kahn wrote, "indistinguishable from life." Kahn explained that the symbolists wished to replace the examination of the external world, the "decor of city squares and streets," with the study of "all or part of a brain"; the mind itself,

rather than nature, was to be the subject matter of symbolist art.[23] The symbolists therefore emphasized the expression of emotion generated primarily from within, whereas the impressionists, *to the extent to which they were directly associated with naturalism*, were identified with an impression generated from without, albeit emotionally charged and varying according to the individual temperament. This was indeed the essence of the argument Aurier made in 1891 in order to distinguish Gauguin as symbolist from the impressionists with whom he was often linked: the label "impressionist" should be applied only to those concerned to render "an exclusively sensory impression," not to those seeking to present internalized "ideas" by way of external manifestations of correspondence or analogy.[24] And with regard to the dream, Aurier asked this confounding question: "Isn't a literature of the dream a literature of true life, of real life as much as is realism? Aren't the dreams that we have while quite awake, logically determined—even according to the physiologists [e.g., Taine and Sully-Prudhomme]—by the material facts of our existence?"[25]

Aurier refers here to those contemporary theories of psychology and physiology (temperament) that contributed to the formulation of both the impressionist and symbolist positions. Of particular interest to symbolists were studies of abnormal states of consciousness, which empirical psychologists regarded as invaluable guides to "normal" psychic life: one investigated dreams and various states of illusion to uncover aspects of the mind not manifest under ordinary circumstances. Ironically, the most influential account of abnormal psychological states came from Hippolyte Taine, the historian and critic whom the symbolists vilified for the deterministic views expressed elsewhere in his work. In his *De l'intelligence* (1870), Taine sought to demonstrate that a dream or illusion, in terms of the physiology of psychology, was just as "real" as any other conscious experience. He argued that perception had three components: (1) a mental image, labeled the "hallucination"; (2) an antecedent sensation or activation of the nervous system; and (3) a more remote antecedent, an external object corresponding to the hallucinated image. His crucial observation was that the external object need not exist—sensation and a resultant hallucination could be generated from within. Taine stated that subjects are capable of sensation or feeling without the presence of that which they imagine themselves to feel, and yet such a sensation seems no less vivid than any other. In the case of most everyday experiences, there do exist external objects or events that correspond to one's conscious "hallucinations"; and such "true" hallucinations can be verified through continuing contact with the external world. But "false" hallucinations, generated, say, by dreams or hypnosis, are not subject to verification. Yet these two kinds of perception, *as immediate experience*, are indistinguishable. Taine chose his terms in such a way as to call attention to the unsettling fact that all consciousness is hallucinatory and that distinctions between normal and abnormal states of consciousness are not immediately apparent: "Our external perception is an internal dream which is found in harmony with external things; and instead of saying that hallucination is a false external perception, it is necessary to say that external perception is a *true hallucination*."[26] In sum, the "positivist" Taine presented an image of a world in which dream and reality

seemed to merge in the mind, much as the "idealist" Gustave Kahn did later when he asserted that the dream was "indistinguishable from life."[27]

Among the precedents for the critical position that the symbolists adopted during the late 1880s and the 1890s is Joris Karl Huysmans's *A rebours* (1884). This novel includes at least one passage (and probably a second) where the author parodies the analytic method Taine employed in his *Philosophie de l'art*.[28] Taine wrote of a social situation or a work of art as the effect of natural causes related to a natural environment; Huysmans explains everything in terms of the artificial. *A rebours* proclaims the power that the mind exerts over the senses, art over nature, the artificial or imaginary over the natural or observed. But even though Huysmans objected to Taine's reliance on the external in the explanation of historical events, he could sympathize with Taine's psychology and its emphasis on the reality of "hallucination" and internal states of consciousness.

Just as Huysmans had done, Albert Aurier criticized Taine's method of analyzing art and yet treated perception in a manner reminiscent of the "determinist."[29] Aurier's defense of Gauguin is typical in this respect. The critic pointed out that the public's inclination to label Gauguin an impressionist led to false expectations and an improper evaluation; specifically, when confronted by works such as *La Lutte de Jacob avec l'ange* (which Aurier himself described as an imaginary "vision" called up by a priest's oratory; see fig. 1), the public would accuse Gauguin of painting "impressions that no one could ever have experienced." Aurier argued that the public's mistake was to assume that artistic expression must be generated by material reality. Instead, the greatest art always expresses an inner mystical vision—Gauguin should not be compared to "impressionists" in search of a transient external reality, but to an "inspired hallucinated" mystic, Swedenborg.[30]

In referring to Swedenborg's hallucinatory vision, Aurier may have reflected back on the "hallucinations" of Taine's *De l'intelligence*, but he also raised the issue of the "correspondences" that the mystic had sought to discover, the immutable relationships between abstract ideas, human emotions, and expressive sensory phenomena (sounds, colors, smells, etc.). If such absolute correspondences existed, they would be the foundation of an ideally expressive artistic technique that would provide the desired bridge between an individual emotion or impression and an ideal or effect of universal significance. Here, the relationship between sign and "meaning" (signifier and signified) would not be arbitrary and conventional, but natural and "original." And through the conception of the search for the necessary technique or means of expression, one encounters another broad area in which impressionists and symbolists show related, but differing, concerns.

The impressionist sought a technique or means of expression that would convey his own spontaneity, originality, and sincerity; above all he wished to avoid traditional academic conventions because they would link his art to a communal school rather than to a unique temperament. Through his radical naturalism he could express his individuality: painting in outdoor light was itself considered an unconventional undertaking for which there were few, if any, predetermined rules of procedure. If im-

pressionist technique, judged by comparison of one painting to another, appeared inconsistent or haphazard, little was lost—this could be taken as a further indication of the idiosyncrasies of the spontaneous impression. Artistic "truth" might be guaranteed more by the suggested sincerity of the technical procedure than by any claim that technique might have to accuracy of representation or precision of communication.

The symbolists, on their part, concentrated much more on the character of the final artistic expression and on its potential for communication; this is why they criticized their impressionist predecessors for a thoughtless choice of subjects and an incoherent manner of rendering them. It will be shown in part 2 that both Émile Bernard and Maurice Denis eventually came to reject Cézanne for a *technical* failure of expression, even though they credited him with having surpassed the achievements of the (other) impressionists. The neoimpressionists, who drew praise from symbolist critics just as Cézanne did, had earlier attempted to make specific improvements on the impressionist use of color; with the aid of the theoretical and experimental studies of Charles Henry they had mastered principles of color harmony and would employ them rigorously to achieve a more permanent and universal artistic language. Henry himself sought to define the elemental functions of contrast, rhythm, and measure on which all existence, both organic and inorganic, was based; artistic expression would attain universality in the employment of these functions, which were analogous to the correspondences of which Swedenborg, Baudelaire, and others had spoken.[31]

The symbolists' emphasis on technique (the means of expression) led them often to distinguish between symbol and allegory: an art of the symbol was an art of "style" and expressive form, while allegorical expression remained bound to the use of conventionalized subject matter. Allegory could neither be as personal as the symbol (because it was conventional rather than individual) nor could it be as universal (because it demanded acquired knowledge of the particular cultural tradition to which the allegorical figure belonged). Hence, Denis and Aurier would exclude Gustave Moreau from the ranks of the true symbolists, even though scholars today often interpret his imagery as characteristic of symbolism. For the French symbolists of 1890, Moreau worked in an allegorical mode, and despite his importance for Huysmans in *A rebours,* this painter could only be regarded as an interesting predecessor who had broken away from the more traditional academic subjects.[32]

Although some scholars have considered it improper, the firm distinction between allegory and symbol allows one to understand the logic of the symbolists' rejection of *academic* classicism along with the academicized forms of a "materialistic" naturalism.[33] Classical themes, as represented by academic painters, were conventional allegories, images bound to the limits of expression of the subject matter itself; such images were not idealizations in the strictest symbolist sense, for the true "Idea" was to be conveyed directly by way of expressive form (line and color). I have noted (above, p.7) that Aurier chose the term *idéiste* to refer to Gauguin's art because the academics had already appropriated the term *idéaliste* to describe their own allegories.

Such symbolist anxiety over both "literal" rendering and "literary" subject matter may have stemmed from a utopian desire to unite all humanity within a single form of expression; such a need arose as Europeans became increasingly familiar with a confusing diversity of cultural traditions, both their own and those of the non-European societies they were colonizing. A symbolic language—more universal than any allegorical one—could serve either to liberate a society from a set of allegorical conventions imposed upon it, or to restrict a society even further by superimposing a more general code on the specific one already in place. Undoubtedly, motivations, as well as self-consciousness concerning motivations, varied. At any rate, the rejection of "subject matter" on grounds of its cultural specificity, its severely limited power of signification, had wide-ranging consequences in the history of criticism. Roger Fry (whose influential views on Cézanne will be investigated in part 2) extended the arguments of Aurier and Denis by stating flatly that in any proper work of art the expressive power of the subject matter is either negligible or subordinate to formal (technical) expression.[34] Fry's position, linked with that of the symbolists, provided a foundation for much of the modern criticism of visual art, with its emphasis on analysis of the formal elements of design—what Denis and Aurier viewed simply as the "moyens d'expression." Since impressionist painting did not seem to make its own formal structure explicit, both symbolist critics and the "formalists" of the early twentieth century (such as Fry) felt justified in insisting that something approaching an artistic revolution had occurred around 1885 or 1890 with the shift from impressionism to symbolism. (And Cézanne, of course, became the central figure in the recorded history of that revolution.)

Artists and critics repeatedly described the formal "language" of expression that the symbolists sought as if it were to be truly universal and elemental. As universal, it would be both ubiquitous and eternal—found in the past through tradition, as well as in the present through Charles Henry's psychophysical research.[35] As elemental, it would appear in things simple or primitive. Accordingly, the symbolist painter Paul Sérusier spoke of "creating a language by purely formal means [of line and color], or rather rediscovering the universal language," the expressive means of past cultures, including the primitive ones.[36] Similarly, Gauguin, in an elaborate metaphor, compared his art to a primitive Oceanic tongue: in such language elements common to all languages were plainly discernible, unlike the modern European languages, where the roots of words were obscured.[37]

The impressionists may not have seemed to employ a basic formal code; but they, too, admired simplicity and directness—yet another aspect of their concern for an unconventional rendering of the spontaneous impression. And like the symbolist, the impressionist thought of his painting in terms of the elements of perception, primarily colors; he never focused on discrete objects, nor observed their color merely to represent them in isolation. He regarded nature *in its entirety* as a stable reference which supplied a sense of permanent universal content; as Zola stated, the painter would achieve an individualized image of this external world, "nature seen through a temperament." The symbolists, however, believed that the permanent reference was

the human spirit itself, not something outside it. They often conceived of this human spirit as integral with a universal world-spirit, and any feelings common to all human-kind (and to the "world") commanded more importance for them than those attributed only to specific individuals. The symbolists held that the means of expression (the objective means of communication) was the universal language to which all minds could respond. To repeat one of their most significant points: their "language" was one of formal elements rather than of the complex images of either realism or allegory.

In the search for direct and elemental expression, impressionist and symbolist techniques might seem to converge. As a consequence of this inherent ambivalence, Aurier could argue that the subjective distortion that resulted from the influence of a temperament (present even in works of a pronounced "realism") appeared itself as a "symbol"—or, to use another of the critic's terms, as an "idea-ist" (*idéiste*) reference back to the essential character of the artist's mind.[38] Clearly, there was much of "symbolist" value in impressionist naturalism.

<div align="center">《 》</div>

Regardless of the number of fine distinctions that can be drawn between the impressionist and symbolist conceptions of artistic expression and the points of their intersection that can be defined, the issue of their relation remains a perplexing one. I believe the artists themselves were often confused, not so much with regard to their actual artistic practice but in their ancillary theorizing. In 1888, for example, Van Gogh wrote to his brother Theo that he

> should not be surprised if the impressionists soon find fault with my way of working, for it has been fertilized by Delacroix's ideas rather than by theirs. Because instead of trying to reproduce exactly what I have before my eyes, I use color more arbitrarily, in order to express myself forcibly. Well, let that be, as far as theory goes. . . .

Van Gogh went on to discuss three portraits that he wished to paint as he "felt" them—with unusually bright colors.[39] Apparently he had chosen to stress his emotion rather than his impression.

Van Gogh's commentary raises two significant problems. First, *both* the impressionists and the symbolists conceived of the artistic process very much as Delacroix did—Van Gogh appears to have exaggerated the extent to which the impressionists ever thought they could either render nature "exactly" or eliminate personal expression from their work. Second, one must ask in what sense expressing oneself can be distinguished from reproducing what one sees—if indeed one's vision, as both impressionists and symbolists held, expresses one's individual temperament. Was not Van Gogh, in aiming for expression, reaching a conclusion to which impressionist theory itself would lead?

The writer and critic Octave Mirbeau had this problem of expression in mind when he published an article on Van Gogh in 1891, not long after the artist's death. Like Huysmans, Mirbeau associated art with artifice; and he stressed the fact that

Van Gogh seemed to have imposed his will upon nature instead of simply experiencing nature. Mirbeau made a distinction similar to that which symbolist critics made between subjective and objective distortion, the former passive and automatic, the latter active and willful. He wrote that Van Gogh, who accentuated his stylistic elements "to the point of signifying the symbol,"

> did not allow himself to become absorbed into nature. He had absorbed nature into himself; he had forced her to bend to his will, to be molded to the forms of his thought, to follow him in his flights of imagination, to submit even to those distortions [*déformations*] that specifically characterized him. Van Gogh had, to a rare degree, what distinguishes one man from another: style . . . that is, the affirmation of the personality.[40]

In the same month that he published his article on Van Gogh, in praise of a personal expressive style, Mirbeau wrote analogously of his intimate friend Claude Monet, but referred in this case to the expression of a pantheistic dream-vision: "The landscapes of Claude Monet are, so to speak, the illumination of the states of consciousness of the planet, and the supersensible forms of our thoughts." With Monet, as with Van Gogh, expression takes precedence over representation and, in Mirbeau's words, "the dream becomes reality."[41]

Regardless of the fact that paintings by Van Gogh and Monet produced around 1890 have their own special character and may evoke a description of formal elements different from that to be drawn from impressionist works of the 1870s, one suspects that Mirbeau arrived at his critical station not by way of a discerning vision, but by following the shortest route left open in a continuing discussion of artistic expression. The debate that enmeshed Mirbeau was perennial; it had its modern origin in the question of romantic subjectivity and its somewhat skewed restatement in Zola's definition of naturalism and impressionism. By 1890, any short routes through the maze were no longer easy to discover; the critical course had taken to meandering. To complicate matters and to make final distinctions difficult, impressionist painters and critics had usually spoken of expressing *emotions* as well as impressions.[42] And, as Aurier wrote as if in a state of exasperation, insurmountable obstacles would face the critic who attempted to determine whether a particular artist had represented external nature with objective accuracy; nor did the hypothetical artistic act seem at all possible.[43]

Indeed, for Aurier and his contemporaries, artists could not fail to be subjectively expressive. Nevertheless, subjective expression, even in extremes of self-expression, seemed to require some active and applied means. (Hence, the emphasis on willful or "objective" distortion among Aurier, Denis, Gauguin, Mirbeau, and others.) One had to conclude that expression could not be regarded as entirely passive—a purely mechanistic "impression," a physical imprinting, would simply not constitute artistic representation. Such dead repetition, stillborn, amounted to what some theorists called "copying" as opposed to artistic mimesis ("imitation"). The true work of art would have to differ from its model or source, revealing its mark of temperament and

originality, the indication of human action.[44] The significance of the term "creation" becomes apparent within the parameters of this critical discourse: to call artistic activity *creation* (as opposed to "representation" or "expression") conveys most clearly its willfulness—"living is living," wrote Gustave Kahn, "only when creating or preparing creation."[45] In sum, artistic creation constitutes an active assertion of the self. But the matter cannot rest here. In proceeding to an extended study of artistic technique (as below, part 2), one encounters many claims to *passivity* by artists, and by critics on their behalf, especially those such as Zola who supported the impressionist project—there is even talk of originality in copying. And yet the passage from Zola's naturalism to Aurier's symbolism is not a shift from subjectivity to objectivity or from the passive to the active. One cannot scout the path of transition by looking in only one direction; the field is full of traps.

This much is evident: nineteenth-century critics (including both Zola and Aurier) recognized that technique can never be entirely uninformed or unintended; it cannot be *found*, but must be *made*. Given the evidence of an impressionist painting, a critic might judge the artist "innocent" of much of the inherited convention of his cultural tradition, but such an evaluation would result only if the critic were convinced that the artist had indeed taken a radically naïve approach to representing his impression of nature.[46] The impressionist, however, would have to have worked actively to give the appearance of this kind of passivity. To attain his goal, he would have depended on the skillful use of his technique to convey his intention, an intention to convey no intention, to have no "ideas," perhaps even to be "absorbed by nature." Alternatively, one might state that the impressionist painter actively creates (or even "fabricates") his own naïveté by entering a discourse of naïveté; he not only representes naïveté, but uses his own representation as the means of experiencing naïveté. In either case, the painter's technically proficient expression of innocence, naïveté, or originality does not amount to a passive art found in nature; through its technique, this representation becomes instead a creation of man, genuinely personal and reflecting individual achievement. And such creation is, simply and tautologically, the *use* of technique.[47]

During the nineteenth century, those who discussed artistic technique, the *moyens d'expression*, which I have just associated with individual creative difference, often argued that it promoted standardization and inhibited individuality and originality. Hence, the path to be scouted, one leading toward Cézanne's "original" impressionism, must now follow, even pursue, the paradoxical notion of a "technique of originality," an active means of discovering an originality that can only be passively "found."

At this point of transition in my own argument, a certain conclusion can be stated with regard to those interrelated elements of the impressionist/symbolist discourse that have been brought into view: originality, naïveté, technical procedure, subjective and objective truths. Hypothetically, any genuinely innocent or original artist works independently of others, perhaps as removed from the institutions of a modern society as is a "naïf" or a primitive. He is thus in a position to render truths that

he alone can know; others, not sharing his experiences, may not be able either to discover these truths or to comprehend them. But if others do comprehend, if wholly effective communication is achieved, the artist who claims a naïve and original vision—*the impressionist*—through an independent struggle to express himself, to paint "what he sees," comes (in effect) to express universal truths, truths recognized by all others. *Such an artist is a symbolist.* The impressionist, although not sharing the symbolist's initial aim, might be seen as attaining the symbolist's end. Conversely, the fact that Monet—or Van Gogh—may appear as a symbolist does not preclude his remaining an impressionist. By this reasoning, the distinctions between impressionism and symbolism do not become irrelevant; but in some, even many, cases, these general categories converge or simply collapse.

Part Two

The Technique of Originality

6

Introduction

Matisse and Origins

DURING THE SUMMER OF 1905, while Matisse was painting in the manner that would soon earn him the title *fauve* (wild beast), the symbolist writer Charles Morice was completing an inquiry into the changing state of the visual arts. A set of questions had been distributed to a large number of artists, and their replies, often quite lengthy, were published in *Mercure de France*, forming a kind of symposium. Morice asked whether impressionism had come to an end or might be renewed; what was the significance of the works of Whistler, Gauguin, and Fantin-Latour (all recently deceased); and how one should view Cézanne, who was at the time probably the most widely discussed painter among the "avant-garde." In addition, Morice posed this final question: "Should the artist expect everything from nature or ask of it only the plastic means to realize the idea [*pensée*] in himself?"[1]

Matisse was not one of Morice's respondents, but his many recorded statements reveal the position he would have taken. At a much later date—in the context of recollecting that Pissarro had regarded Sisley's painting, and not Cézanne's, as typical of impressionism—Matisse made this pithy remark: "A Cézanne is a moment of the artist [whereas] a Sisley is a moment of nature."[2] In other words, Sisley depicts nature, Cézanne *represents himself*. In accord with the great majority of his artistic generation, Matisse clearly preferred Cézanne's method to Sisley's; and, in his own quest for originality, he emulated this painter's practice. At a relatively early date (1899), he even purchased one of Cézanne's small studies, *Trois Baigneuses* (see fig. 36, p. 169), which he never ceased to admire. His paintings, modeled after Cézanne's, became "moments" of their creator. Matisse realized the "idea in himself," his "self," rather than an external nature.

As I have implied, Matisse's attitude toward "master" Cézanne characterized his generation. But how does one define this group of individuals and Matisse's place within it? Does his opinion weigh more heavily than that of others? Matisse maintained an especially high level of professional "credibility." At the time of his death in

1954, his practice—although not his theory—belonged as much to the avant-garde as ever before; he was producing the remarkable large-scale paper cut-outs that have been said to prefigure many aspects of American abstract painting of the following years. Such works marked a dignified end to a long life that had begun in 1869, when Cézanne and Sisley (both born 1839) had reached early maturity. Matisse outlived most other distinguished members of his chronological group: Albert Aurier (1865–1892), Roger Fry (1866–1934), Wassily Kandinsky (1866–1944), Émile Bernard (1868–1941), Maurice Denis (1870–1943), Piet Mondrian (1872–1944). Like Kandinsky and Mondrian, he had a relatively late start as a public figure, attaining prominence within the art world only around 1905. In contrast, Denis and Bernard, who would proudly refer to their own precocity, exercised a significant influence by 1890. Bernard's career, and to a lesser extent Denis's, quickly rose to a peak and then declined; as a result, both spent much of their literary energies recalling early views and achievements.[3] Unlike these contemporaries, Matisse preferred not to look back—and this fact is consistent with his own theory of artistic practice: the artist must grow as he lives, never returning to imitate what has already been experienced. The *fauve* painter appreciated the sense of immediacy and incompletion that he discerned in Cézanne's art, just as the critic Roger Fry did. For Matisse, originality and a factor of novelty would be present—always presented—in any valid form of artistic expression.

Matisse serves well, then, to introduce the issue of originality. At the risk of creating an unwieldy historical fiction, one might class him (along with Bernard and Denis) as a member of a *second* symbolist generation, following a group of elder pioneers, from Gauguin (1848–1903) to Seurat (1859–1891). Among his chronological peers, he enjoyed the greatest longevity, at least with regard to maintaining his artistic preeminence; he thus becomes the "last" of his age, the one who has the final word. Indeed, his comment on Sisley and Cézanne comes very late (1950). Nevertheless, he produced his most important theoretical statement only two years after Cézanne's death—"Notes d'un peintre" (1908)—and it appeared at about the same time that Roger Fry began to ponder the new form of expression visible in the paintings of both Matisse and Cézanne, whom Fry was soon to call "postimpressionists" (cf. below, chaps. 10, 11). From a retrospective view, Matisse seems to have been not only chronologically, but also intellectually predisposed to receive and assimilate the artistic currents that run through Cézanne to his major critics (Bernard, Denis, Fry). He is "modern" in ways that define his era; and his entire creative output, both theory and practice, forms a response to the summary question that Charles Morice addressed to his contemporaries: What is the ultimate referent of the work of art—is it nature, or is it the mind and (internalized) vision of the artist?

In 1905, this question must have resounded like an echo within a bounded critical chamber, for it recalled so much of the familiar theoretical discourse of impressionism and symbolism. The answer implied by Matisse's statements remains framed within such discourse. The limited scope of the artist's theory may not be evident, since his comment on Sisley and Cézanne projects such a grand critical space. It ac-

commodates a view of nature (Sisley) and self (Cézanne) in bold opposition. Indeed, this same polarity allowed many of the participants in Morice's survey to distinguish a symbolist—or a classicist, a primitive, or even a *fauve*—from an impressionist: the one draws his art forth from emotions or ideals, the other from nature.[4] In the case of impressionism, nature would seem to determine the ultimate form of the artistic product. But this conclusion must be qualified: Matisse and most of his contemporaries believed that individual temperament leaves its identifying mark even on such outward-looking art.

A modern painter, therefore, having decided to seek the self, could yet capitalize on an "objective" generating force (observation) as well as a "subjective" one (emotion). As the documentation cited in part 1 has indicated, the filtering action of temperament, so widely recognized during the nineteenth century, introduces subjectivity to all artistic imaging and representation. In other words, there could be no single fixed vision of nature, even if one committed oneself to its direct observation. Matisse spoke of Sisley's "moment" of nature, a vision never to be repeated, primarily because effects of nature are transient. Sisley, moreover, could observe such effects only as *he* sensed or felt them; and, although Matisse chose not to emphasize this point, Sisley's painting becomes a "moment" in yet a second way—his own particular impression of nature must be unique, momentary, never recurring.[5]

With respect to the representation of originality, it hardly matters whether Matisse sees in any particular painting an image of nature or a revealed self: both nature and self can represent the desired end of a "modern" artist's search, one that might be conceived as moving backward toward the original truth of a primitive or classic moment, as well as forward into the unknown. Regardless of the direction of his movement, the artist who discovers either true nature or his own inner being cannot be accused of any illusionism or deception, for he sights an unimpeachable *source*. As a result, critics regard his statements as authentic, and judge such a creator "sincere"— true to nature and/or true to himself, a healthy individual in what may be a diseased society. Not only does the representation of "truth" or originality imply artistic sincerity, but, by a principle of commutation, sincerity can lead to originality. Applying the etiology from the artist's standpoint, Matisse repeatedly referred to his own native sincerity and that of others to account for creative powers. "My only strength," he remarked late in life, "has been my sincerity."[6] In this instance, he neglected to mention the contribution of his technical skills. This exclusion is neither unusual nor without its own significance.

When Matisse identified artistic success with sincerity and originality, his position was hardly "original" (in the colloquial sense), but represented the norm. In 1905, Maurice Denis commented on the cumulative result of Morice's inquiry into the state of modern art, and concluded that "it is still generally believed that in order to make a work of art one must above all strive to be original." Two years later Denis argued that superficial evidence of original artistic expression had become so common in his time as to evoke only a perfunctory form of praise—the external signs of originality had, paradoxically, become quite conventional.[7] The symbolist theorist

had been concerned during the 1890s to bring intellectual order to artistic expression; and he felt that Matisse and his cohorts had reacted to and undermined the rational stance he had taken. In response to the *fauve* artist's "Notes d'un peintre," Denis explained that those of Matisse's "generation" were "not so much theoreticians; they believe more in the power of instinct."[8] In other words, they were—or wished to be—spontaneous *finders*, not premeditative *makers*. They located art in a sincerity that facilitated the finding of an origin rather than in a self-conscious process of artifice or making. As absolutes that were neither part of, derived from, nor dependent on anything else, *origins*—nature, self, and perhaps an encompassing divinity—constituted the absolute *ends* of art. Origins were truths to be found, as if blindly, at the end of the individual's artistic search (or life).

There seems to have been no intense concern among artists of Matisse's generation (Denis included) for any radical departure from this rather conventional practice of aiming for origins.[9] To call it conventional refers only to its prevalence—so much of artistic discourse focused on originality. Indeed, it was the usual topic; yet there was nothing easy or obvious about it, despite Denis's astute observations on the superficiality of many artistic works that claimed to have attained the original. Originality proved to be a most difficult "subject matter" for artists; and it presented even greater obstacles to the practice of criticism, at least to criticism as a reasoned discipline. In criticism, the problem was—and is—one of mediation: if, to be successful, art must reveal an absolute originality, a given work should be evaluated through an unprejudiced, immediate encounter; one is simply led to affirm or deny the presence of originality in the specific case; hence, extended argument or analysis becomes moot with regard to qualities that are presumed to be "felt" (immediately) by both artist and viewer.

Matisse himself seemed to call for a direct experiential engagement that would restrict the efforts of critical analysis. As if to warn his public away from any formulated approach to art, he once stated that his distinctive line should never be seen as the product of deliberation or *previous* experience, but rather of simple conviction and unreasoned "impulse" (*élan*).[10] How then could one relate the artist's drawings to an inherited culture, a social world rationally constructed? What was one to say of the presumed continuity and tradition of art "history"? George Desvallières, in composing an introduction to "Notes d'un peintre," evaded the difficulty by choosing to associate Matisse's liberating genius and chance discoveries (*trouvailles*) with the *instinctive* discoveries (*trouvailles instinctives*) of medieval artists, Hindus, and Orientals—groups whose irregular works appeared somewhere at the very limits of the rational order established by European scholarship. In effect, Desvallières suggested that if Matisse had looked to the past for aid, he had been drawn, perhaps instinctively, to those who worked by instinct. Similarly, Desvallières converted the artist's acquired craft into spontaneous instinctive discovery when he spoke of Matisse's responsiveness to the given (or found) demands of the rectangular drawing page, as if all his technical decisions were grounded only in some immediate physical presence, the

page itself. In this manner, the painter could be seen as liberated from his own past, both traditional academic practice and the rigors of conventional illusionistic rendering.[11] Desvallière's remarks, especially his emphasis on the value of the *trouvaille*, merely reconfirm the predications of Matisse's art. The extent to which one might understand the relationship between individual originality or innovation and an inherited cultural tradition cannot be furthered by this type of circular critical "analysis," which merely internalizes appropriate external references—appropriates them— as explanatory devices. The alternative is to claim that Oriental art was not one of Matisse's "sources," but one of his references; he used it.

Modern critics often wish to be "true" to the art they discuss; and Matisse's professed spontaneity seems indeed to call for an appreciation of the master's work limited to a revelation of immediate individualized experience: what the artist offers on the surface, the critic should simply receive and acknowledge. The self-defeating result of this type of "critical" response is that the work remains hermetic even when shared.[12] Roger Fry, the ingenious champion of both Matisse and Cézanne, was among those who put such a critical attitude into operation; accordingly, he left a numinous center of artistic expression untouched by his otherwise probing analysis:

> I seem unable at present to get beyond [a] vague adumbration of the nature of significant form. . . . One can only say that those who experience [the value of the aesthetic emotion] feel it to have a peculiar quality of 'reality' which makes it a matter of infinite importance in their lives. Any attempt I might make to explain this would probably land me in the depths of mysticism. On the edge of that gulf I stop.[13]

Mysticism, however, may reduce to mere mystery; and mystery does not ensure that one is in the presence of mastery. A more skeptical critic, less inclined to let originality lie, might complain that any form impervious to explicit interpretation can only constitute an artistic flaw, a lapse in coherent communication. Ironically, the existence of such "lapses" became the foundation of a modern "science" of connoisseurship in which the mystery indeed seemed to signify mastery. This happened not in response to the equivocations of Fry or Matisse with regard to explicit interpretation, but in reaction to an earlier generation of scholars who had failed to see in a painting's details all that they might. As the result of a long period of study, Giovanni Morelli stated in 1889 that certain visible irregularities—peculiar turns and strokes of the brush, regarded as stylistic idiosyncrasies having no symbolic function—should be scrutinized for purposes of authorial identification. As if autographic, they would serve to indicate a particular generative origin, a hand linked to the master. Among many others active during the late nineteenth century, Morelli thus shifted the focus of the critical investigation of paintings from identification of the subject, theme, or general expressive mood to analysis of elements of technique, especially those that would vary from individual to individual. The artist's "soul," and even the artwork's, might reside in the smallest touch or mark.[14]

A case is often made on the strength of the weakness of the opposing position; and it therefore becomes strategic to choose one's antagonists well. One of Morelli's many distinguished choices (he enjoyed insulting the highest authorities) was Charles Blanc, the French academic theorist, who had written: "in order to judge the authenticity of a painting, it is essential to know the spiritual state [*l'esprit*] of the painter much more than his technical procedures; for procedures are learned, technique is passed on and imitated, but the soul [*l'âme*] cannot be passed on; it is essentially inimitable."15 To be sure, in the proper hands (or eyes), Blanc's method could yield quick results, however much it left the field of connoisseurship open to spurious claims of spiritual affinity between an artist and his appreciative critic. Blanc thought of technique as a made thing subject to competent imitation; in contrast, the spiritual essence of a work of art, as a true origin, could never be duplicated by those who were not present at the very source. It will be seen (chap. 7) that Blanc's attitude toward the mechanism of technique led him to very specific evaluations of the various manners of naturalistic painting, and facilitated his discussion of artistic intent. Morelli, in doubting Blanc's method, assumed no firm distinction between technical procedure and a more "spiritual" style—ultimately, both belonged to the individual and both could be unique. Morelli concentrated on the *found* aspect of technique, investigating those features that seemed to be generated unconsciously, features that converted acquired technical procedure *into individual style*. Such elements of technique rendered style, as a whole, immune to imitation—except perhaps by connoisseurs trained in the Morellian method of stylistic analysis. (This is the greatest irony.)

Morelli accused Blanc and others of a lack of rigor and substance in their attributions; and he generated the substantial corrective force of his own "scientific" connoisseurship. But his reasoned method encouraged its own form of mysticism: it depended on a sense of found (authentic, original) technique; it was "unconscious" technique which propagated the waves of identity that the connoisseurs' antennae would detect. Once released, this kind of wave can pass like a "romantic spasm" through various communicating mediums—the pulse of an identifying originality is transferred from illusionistic painting, to simple handwriting and signature, to the writing of art criticism. Indeed, a critic can detect the force as well as a connoisseur, but, as he passes it on, he often directs it toward a different end. As I shall relate in detail (chap. 10), "unconsciousness" and technical idiosyncrasy figured prominently in Roger Fry's interpretation of Cézanne. And when Fry's analyses could not "get beyond [a] vague adumbration," his own critical style was echoing the frequency that he felt Cézanne's paintings emitted. In other words, Fry could assume that his critical method and Cézanne's painting technique were in sympathetic harmony, even as the one failed to articulate the other beyond a certain limit. (Of course, the same sort of "harmony"—for better or worse—had characterized Desvallière's commentary on Matisse.)

By analogy with the object of its investigation, Fry's criticism thus seems quite "modern"; and there is also something peculiarly modern about Morelli's concentration on insignificant—or, rather, nonsignifying—detail. The father of "scientific"

connoisseurship studied representational elements such as hands, but for their visual configuration or effect, not their conventional communicative gesture. According to the Morellian scheme, the inimitable (found) elements of technique would be visible only as minor aspects of a masterwork; yet much "modern" painting produced during Morelli's lifetime (1816–1891) seemed to consist *primarily* of such elements, personally expressive marks that conveyed little if any representational meaning. Such modern works, including those of the impressionists, render the potential duplicity of the originality of pictorial representations about as visible as it will ever be. They point to a dilemma: Is artistic originality a matter of essence, or appearance? One expects the original to *look* original, and any painting that appears more different from other paintings than it appears like the others possesses a certain distinction that will seem "original." But, if this difference lies largely in the technical details, it is not clear how to determine whether these features are "original" in the stronger sense of being authentic as well as different. There arises the possibility of some deep artistic deception—beyond the appropriation of authorial identity that concerned Morelli—because an artist might acquire the ability to imitate the general look of "inimitable" technical idiosyncrasy. The underlying issue is whether one could deliberately *make* an art of finding, an art of the discovery of origins.

Much of this tension between the artist-maker and the artist-finder dissipates whenever technique is credited with its fullest potential. In this light, originality can

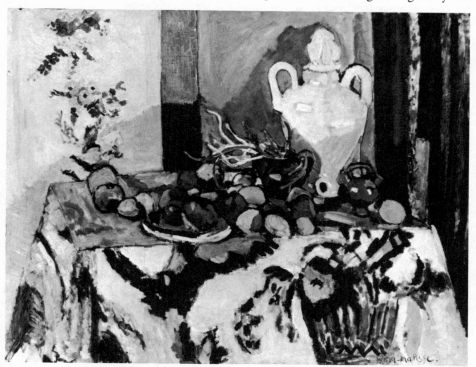

9. HENRI MATISSE, *Blue Still Life*, 1907. Photograph copyright 1984 by The Barnes Foundation.

be regarded as the *intended product* of artistic technique; and works of art can be interpreted as communicating the importance of originality without necessarily being original, without the burden of appearing unlike other works or of being identified with an individual author.[16] Originality can be upheld as the ideal to which all art refers, rather than the reality or the attainment of any given work.[17] Indeed, originality can function within a cultural system without its presence ever being assured.

<div align="center">《 》</div>

An artist such as Matisse, the self-assured master of several traditional artistic crafts, could not easily ignore the potential of technique even while he expounded a doctrine of individuality and originality. Matisse stressed discovery and instinct, yet seemed to recognize the artist's power to make, not merely find, his own direction. In a remarkable passage from "Notes d'un peintre," he associates artistic mastery with a feat of self-control, a willful deployment of the artist's emotions and temperament:

> I think one can judge the vitality and power of an artist when, having received impressions of nature directly, he is able to organize his sensations and even to return repeatedly and under different natural conditions [*à des jours différents*] in the same state of mind, to prolong these sensations: such an ability is indication of a man master enough of himself to subject himself to a discipline.[18]

Elsewhere, however, Matisse more typically describes the artist as a finder. He writes that he cannot "copy" nature, for he is "forced to interpret it and submit it to the spirit of the picture [*tableau*]."[19] Moreover, he is "entirely led along by [his] subconscious"; and, as a result, his "picture" directly reflects his temperament.[20] As he proceeds to paint, "finding"[21] the relationships of color, he witnesses the discovery of his own self as an origin of expression, even as he may "deviate" from nature.[22]

Matisse seems unable to decide the central question: Does an artist actively control his own enterprise? Having suggested that technique must derive involuntarily from temperament, he adds that the artist must simply believe he has painted what he has seen, that he has, in a sense, merely "copied" nature. As his contemporary Henri Bergson might do, Matisse distinguishes between deliberating on or reflecting back on painting, and performing the act itself.[23] His argument is complex; what follows is its essence: in reasoning about his own painting, the artist will recognize the fictional quality of his creation and his own departure from nature; yet this deviance must not have been preconceived; and while he paints, the artist must retain the conviction that he is doing no more than copying nature, finding nature as it is, not recreating it to serve his own will. With regard to this paradoxical adherence to and departure from nature, Matisse first quotes Chardin as saying, "I lay on color until there is a likeness"; then he quotes Cézanne: "I want to make a likeness [*faire l'image*]"; then Rodin: "copy nature"; and finally Leonardo: "He who is able to copy, is able to make [or create]."[24] In sum, Matisse states that although the artist's "techniques [*moyens*] should derive almost inevitably from his temperament" and he should nevertheless "believe he has painted only what he has seen," he may still upon

reflection consider himself a maker of fictions.[25] Matisse, in other words, wants to establish three somewhat conflicting claims. (1) The artist's temperament is the origin of his technical means; in expressing himself artistically he manifests his own temperament as if involuntarily; he finds his inner self.[26] (2) All the while, however, the artist must regard himself as finding the color relationships that faithfully "copy" nature; nature is also found in his work. (3) Yet the artist is capable of controlling his own techniques and actively creates his images of self and nature.[27]

I do not propose to extricate Matisse from the theoretical morass into which he was drawn, or perhaps drew himself. Rather, I wish to investigate the third of Matisse's claims within a culture obsessed by the other two, and to look at naturalistic "impressionist" painting of the sort that eventually gave rise to Matisse's distinction between nature and self, Sisley and Cézanne. How was this painting made? How does one create a type of painting that is intended to convey the message that art is not made, but found? And what techniques can be consciously adopted in order to facilitate unforeseen discovery?

There is more to be learned about the extent of this problem in a brief return to "Notes d'un peintre." At the beginning of his theoretical statement, Matisse must hesitate; he fears giving the "appearance of contradicting myself, [for] I do not repudiate any of my paintings, yet there is not one I would not paint otherwise, if I had it to do over again."[28] Matisse here refers to his belief that paintings should express inner feelings and these, along with the living self, continually change and grow. The artist's techniques evolve, too; but Matisse insists that his earlier means are not necessarily inferior to his later ones. Instead, they reflect the changes in his own life. Hence, variance in his manner of execution does not imply a "contradiction" or rejection of his past, but the response of technique to emotion: "I cannot distinguish between the feeling I have of life and the manner in which I translate it."[29] For Matisse, the demands of self-expression and originality seem to determine an unstable technique that must remain responsive to unpredictable developments. Such technique may never be "mastered" because it continues to evolve, and it can be imitated by others only at their risk of assuming an alien identity or of fixing in place what must always move onward. No wonder that Matisse and other modern artists have been so anxious about maintaining the individuality and exclusive possession of their technical means. Imitation of one artist's style by another has often seemed an irreverent act of theft, rather than homage to an acknowledged master.

The rhetoric of "Notes d'un peintre" is familiar. Many artists before and after Matisse have spoken of a sincere search for the individualized means to express emotion, whether in the form of naturalistic representation or "nonobjective" abstraction. Matisse feels free to attribute so much of his achievement to (passive) instinct, discovery, or sincerity because of his fundamental concern for origins—self and nature—and originality. He must call the creative power of his technical mastery into question because his conception of the "self" requires it to be an object of discovery or found expression, not made representation. In other words, the innate rules over the acquired: the painter's self-expression and originality must dominate his technique.

As a result, Matisse's theoretical plot can be no orderly formal garden; and his practice, if assumed to be as willful and controlled as he nevertheless sometimes claims, *cannot follow his theory*, which stresses originality. Accordingly, in "Notes d'un peintre," the painter becomes somewhat contradictory in his discussion of composition, seeming at one moment to attribute it to a groping discovery, and at another to an initial apprehension of order or a guiding "impression." Indeed, "composition" should have caused Matisse some concern, for the very concept suggests a making, a technical process. One readily asks of what component parts an art work is composed. During the eighteenth century, when painting was more clearly associated with the imitation and (subsequent) idealization of nature, the term "composition" most often signified a process of combining beautiful elements that might have existed separately in actual unidealized "scenes."[30] Judicious choice and organization would ensure artistic success.[31] Thus composition could entail "original" *invention*, defined as the construction of a new whole; and the relation of technical procedure to originality might seem unproblematic.[32] Matisse, however, states that his compositional elements are simple colors, not objects or qualities of nature. In making this implicit distinction, he reveals interests in agreement with Morelli's method of connoisseurship and Fry's manner of critical analysis. And Matisse seems to recognize the originary "mystery" of the modern artist's mark which so complicates connoisseurship and criticism—he speaks ambivalently with regard to whether his tones are chosen according to an established technical procedure, or are simply seen in nature, or are derived "inevitably" from the artist's own temperament.[33] For Matisse, a most skillful painter, it may be that the function of technique was much more easily *performed* than *conceived*.

Impressionism as "Modernism"

What I will do here has at least the merit that it will not resemble [the work of] anyone else . . . because it will be simply the expression of what I shall have personally deeply felt.

CLAUDE MONET TO FRÉDÉRIC BAZILLE, *1868* [34]

Nobody wants my work because it is different from that of others (strange, illogical public which demands the greatest possible originality from a painter and yet will not accept him unless he resembles all the others . . . I do resemble those who resemble me, that is those who imitate me). . . .

PAUL GAUGUIN TO THE DEALER AMBROISE VOLLARD, *1900* [35]

The word "source" has great currency in the discourse of art history. It seems such a natural term, native to the discipline, that it is frequently used without much self-

consciousness or sense of its historiographical ancestry. Perhaps this is proper: sources are origins; they bear on questions of originality; the original is both native and naïve. But those who reflect on their own activity—whether art historians, critics, or even artists (such as Monet, Gauguin, or Matisse)—seek to identify the "sources" of an art work with a certain theoretical discrimination. At the very least, they recognize that "sources" are of two kinds, *representations* and *originals*. Sources as representations are antecedent artistic images on which the work of art seems to have been modeled—and they have their own antecedents. In contrast, the "ultimate" origins of a work can not have been transformed by any representational process; one might claim that they can be found only in the immediate expression of self and nature at the very moment that these original sources are experienced in their interaction.[36] Representational sources (which art historians often identify as motifs "borrowed" from older masters) serve a most welcome role as means of visualization. But an artist deeply committed to discover *original* sources, either the self or nature (or both), must take care to restrict his use of the *representations* of the "old masters"; he must prevent his own focused vision from dissolving within the broad pictorial field established by inherited techniques.[37] For such an individual, the mediating character of the tradition of artistic representation renders all acquired technical procedure problematic; this artist fears that technique may distance him from nature and self rather than affording a closer and clearer view.

For the purposes of my exposition, I will label as "modernist" the theoretical stance characterized by the pattern of reasoning described above, especially when it leads to primitivism and a pronounced affectation of naïveté. This fixation on sources and origins seems to have guided the course of the history of art and its criticism during the nineteenth and early twentieth centuries; and, although vigorously challenged by "poststructuralists," it remains as a navigational base for most of the art-historical accounts of the era, and even of previous eras, written to this day.[38] Simply stated, the "modernist" artist or critic values originality and original sources over representations (sources in tradition or convention).[39] Accordingly, the modernist will excuse a reliance on an antecedent visual image only when that source appears in an original or individualized form, deformed in some way by the presence of the artist who "borrows" it, deformed by his self (or his moment in history) as ultimate origin. Just as both Delacroix and Ingres would insist that Raphael had borrowed from the past *with originality*, so even recently art historians have commonly embodied the residual force of such an argument. For example, H. W. Janson, as part of his effort to distinguish the work of "art" from other types of pictorial representation, discusses another matter concerning Raphael, the famous case of Manet's use of the Renaissance master's figural group in his modern *Déjeuner sur l'herbe*: "True, [Manet] is indebted to Raphael; yet his way of bringing [Raphael's] forgotten old composition back to life is in itself so original and creative that he may be said to have more than repaid his debt."[40] And Janson's remark on Dürer's representation of a Mantegna engraving reiterates the well-established modernist position even more

forcefully: "Dürer here gives us a highly original view of Mantegna, a view that is uniquely Dürer's."[41] The copy becomes an original.

The history of French impressionist art, as related by both its earliest and its subsequent critics, seems a "modernist" history of original discoveries concerning both nature and artistic expression. Although Matisse distinguished between Sisley and Cézanne, he remained nevertheless within the scope of the impressionist project, merely separating what he considered Sisley's part, the expression of nature, from Cézanne's, the expression of the artistic self. As I have stated, nineteenth-century critics had thought any firm distinction unnecessary since both nature and self are the acceptable ends of a modernist art in search of ultimate origins—the desired end is the beginning.

The following investigation of impressionist techniques and the theory that both generates and accrues to them will concentrate on the impressionists' use—and deviant misuse—of convention, the primary means of making. Consequently, some violence may be done to the claim impressionism might lay to "modernism," its claim to an art originating in a decidedly unique and transient historical situation, and in the authentic, unmediated experience of an individual. Such modernism must entail an avoidance (perhaps, ideally, a childlike ignorance) of what is now to be studied, conventionalized elements of style. The modernist claims freedom from any grounding in convention—other than the "conventions" that identify *his own* style, the very personal manner of visualization he discovers. If his works should resemble those of past masters, he would maintain that this indicates no dependency, but a sensitivity to an immutable and original truth, rediscovered in his own sensation.

To the extent that any historical account of works of art must accord with perceived changes within some structure (a framework conceived as the "tradition"), modernism and the history of art (as a history of artistic styles and a taxonomy of works of art) seem incompatible. That is, modernism cannot itself be recognized as a style in any usual sense of that term; and the modernist work becomes indefinable outside its specific historical circumstances. Its identity seems to depend on its difference from, rather than agreement with, the norm. As the norm changes, it, too, must change. In other words, if anything defines the success of modernism, it is its standard of individual "quality," rather than some standard quality to which it aspires. In this sense (but not in some others), the "modern" seems more "romantic" than "classic." The modernist artist resists the fix of familiar stylistic constellations (that guided even the ancients) as he conducts his exploration of origins. His willful individualism often leads to the use of techniques which, in their peculiar resistance to configuration, translation, and interpretation, risk a wanderer's incomprehensibility.[42]

Eventually, however, "modernism" found its properly detailed discourse and charting of technical features in the writings of Clement Greenberg. Significantly, Greenberg described the artist as, to a great degree, *led* to his discoveries by the demands and integrity of his medium.[43] (One is reminded of Desvallières's discussion of Matisse.) Within such critical discourse, the medium acquired the modernist values

of sincerity and "truth-to-self" which previously had been almost exclusively the domain of the artist. In the shift from illusionistic representation to "abstraction" and to (especially) "nonobjective" representation—an evolution associated with the "modernist" movement of the nineteenth and twentieth centuries—the origin of the art work in nature was replaced by an origin in "art" or, more precisely, in the "medium."[44] The artist's "self" remained as the complementary element of an artistic *double origin*, and it provided a factor of continuity as the discourse of modernism developed from Baudelaire to Zola to Fry to Greenberg—from a concern for self and nature to a concern for self and medium. One of Greenberg's conclusions with regard to Cézanne centers on this sustained factor of self, in the form of the artist's own sense of self-expression. Greenberg wrote that "Cézanne's honesty and steadfastness are exemplary . . . [he believed that he could] feel and paint only the way [he] must . . . it was a more heroic artist's life than Gauguin's or Van Gogh's. . . ."[45] One might add that this self-imposed "heroic" integrity constitutes a very major part, perhaps the essence, of Cézanne's "modernism."

As I indicated in part 1, not all of the initial commentary on impressionism lacked the dimension of technical analysis that became progressively more authoritative among later critics who made the importance of the medium so explicit. Manet's friend Théodore Duret had as much to say as anyone about technical procedure, and he typifies the earlier "modernist" position that I will explore and analyze in chapter 7. In his critical essays, Duret repeatedly praised artists who develop innovative techniques to express their originality; he asserted provocatively that the conservative public rejects such artists simply because their manners are individual and distinctive. According to Duret, the public's criterion for artistic excellence is quite concrete: correspondence with "what is found on the canvases of earlier painters; anything different must be bad."[46] Mindful of the public standard, Duret at times advised the impressionists to exhibit their most systematically organized works in order to gain recognition by means of a resemblance to the compositional norm.[47] For the public, a simple visual comparison of stylistic manners and compositional arrangements would seem to provide the basis for a definitive judgment. Would Duret's own dual standard of excellence—innovation and originality—operate just as efficiently? Would difference, as opposed to the public's criterion of likeness, serve him as the sure sign of success? The critic could not take such a simple and straightforward course, but his emphasis on original finding pushed him in that direction. He wrote that the "original" artist must have his own "personal" technique corresponding to his own "original manner of feeling." Original artists must above all "find themselves [*se trouvent eux-mêmes*]" and "come to formulate the visions which ferment in the unknown darknesses inside them; they must draw everything from their own depths, without acknowledging conventional models or predecessors to be imitated." Finally, such artists produce "new forms, original creations."[48]

Duret attempts to assert the "truth" of the original artist's findings without formularizing the artist's method of reaching this end, because any standardization or codi-

fication of technique would lead to just the sort of "imitation" the critic rejects. Yet a closer inspection of Duret's writings reveals that he does indeed identify a technical procedure that has facilitated an art of originality; it is as if the critic recognizes that some detailed account of a technique proper to a modern artist will allow him to base his evaluative judgments on a persuasive rational foundation.[49] As I have shown, both Zola and Aurier faced the same problem: without some accounting of technique, a critic who values the unconventional cannot easily distinguish the statements of an original or "sincere" artist from those of a socially deviant madman.[50] For some who later seized on this thought, such as the surrealists, any lack of reasoned differentiation held fascination; but Duret's commitment to nonrational artistic origins was not so extreme. He did not go so far as to assume that the natural course of human desire was blocked by rational language and culture; he wished instead to ensure that the unique curve of an individual expression would escape being straightened out of its own true form by an orthodoxy of technical procedure.

Just as Matisse would do a number of years later, Duret defined the aim of art as expression of both self and nature—art represents a search for a double origin.[51] And like Matisse, Duret had difficulty in assigning technique its proper role within the artistic process. In chapter 7, I will argue that instruction in composition and painting technique, as formulated around the time of the development of the impressionist style, reveals the very same conflict implicit in the pronouncements of critics such as Duret or artists such as Matisse, a conflict between the theory of an original art and its technical practice.

Making and Finding

In the following investigation of the development of painting technique in response to a demand for a radical originality, and in the subsequent discussion of the evaluation of Cézanne's art, the opposition of making and finding will be used as an integrative theme. There are several reasons to settle on this particular antinomy.

1. Statements by theorists, critics, and artists of the period under consideration abound in references to the problematic encounter of making and finding; and among those who advocate an art of radical originality and self-expression, the imagery and vocabulary of finding (*trouver, trouvaille,* etc.) is quite common.[52] It is clear that the notion of finding—a found nature, a found self, a found art, even a found technique—was regarded as especially pertinent to the description or explanation of artistic means and ends.

2. Making and finding represent a very general and fundamental distinction which takes many particularized forms. Within much of the theoretical discourse of the later nineteenth century, various abstractions were brought to life and familiarized through association with the making/finding dichotomy (the following are typical examples; there are many exceptions): the craftsman is said to make, the artist

finds; the academic or traditional painter makes, the independent or contemporary painter finds; to think or philosophize is to make, to see is to find; to refer or relate a given thing to another is to make, to present or express some thing is to find. Human qualities also were distinguished as associated either with making or finding: the maker may be sophisticated, reflective and active, but also perhaps deceptive; the finder may be naïve, spontaneous and passive, and also genuine. Even the technical procedures, materials, and qualities of painting were connected with making and finding (usually in quite obvious ways): the hierarchical composition was made, the uniform surface found; the finished surface seemed made, the unfinished found; the historical or allegorical subject was made, the modern-life or landscape subject was found; makers used line, finders preferred color.

3. Some further important yet elusive distinctions can be given definition in terms of making and finding, and the shift in signification of a single concept can sometimes be described as a move from one of these polarities to the other. It can be shown, for example, that the sense of "copy" shifted for some artists and critics from a making to a finding. Once this shift occurred, the simple, direct "copy" could embody a found originality. Similarly, the opposition of making and finding appears linked to some closely related concepts which may at times seem to merge and at other times drift apart: "inventiveness" leads to making, the related "genius" to finding; the maker is "creative," but it is the finder who is "original."

4. The conflict and tension between a (conventional) technical *means* of expression and an originality of expression—between, perhaps, the mediated and the immediate—seems encapsulated within the broader problematic of making and finding. As the issue of making and finding is eventually explored in the concluding statement (part 4)—in connection with the distinction between reference and expression—it can be used to characterize the problem of the evaluation of modern art in general. My investigation of the response to Cézanne's art may serve as a case study of the evaluation of a "technique of originality" by those "modernists" who were (or are) predisposed to applaud any art of "sincere" self-expression.[53]

7

Academics and Independents:
Theories of Making
and Theories of Finding

RGUMENTS OVER THE NATURE OF ART sometimes appear disarmingly
simple, sometimes unmanageably complex and broad in scope. A certain
manner of articulation can produce the two effects at once. Nineteenth-
century critics approached the most difficult problems with a plain lan-
guage nearly free of jargon. They spoke of "originals," "imitations," and "copies," of
the "real" and the "ideal," of "sketches" and "finished" works, of "line" and "color,"
and, of course, of "making" and "finding." The liveliness of their debate lent a fresh-
ness to superannuated issues which many predecessors had failed to resolve. The crit-
ics have passed; their culture and these issues survive.

My purpose in selecting a body of critical commentary for close inspection is to
isolate a discourse of artistic technical procedure (mediation) and artistic originality
(immediacy) at the time of the development of impressionist painting, including Cé-
zanne's. I have chosen to emphasize the opposing views of "academics" and "inde-
pendents" (or "anti-academics") as they were formulated during the 1860s. Specifi-
cally, I concentrate on a number of publications by Charles Blanc, Thomas Couture,
Théodore Duret, and Émile Zola. This consideration of theory and criticism is in-
tended to prepare the reader for the analyses of paintings that follow in chapter 8.
There I focus on the development of modes of "composition" that lay outside the
limits of acceptable technical procedure as defined by "academics," modes sanc-
tioned nevertheless by "independents" as suited to the representation of originality.

The titles "academic" and "independent" have a certain literal appropriateness
since the former group advocated the absorption of inherited technical procedure
through the filtering medium of academy and studio masters, while the latter often
rebelled against their teachers and resisted conventional doctrines. Such resistance to
the past and the concomitant call for change gave rise, of course, to an "avant-garde,"
itself the subject of many scholarly studies conducted not only by art historians but
also by sociologists. Although I intend no evaluation of the secondary literature on
the relation of independent "avant-garde" painting to its "academic" background, I
will begin by discussing a limited but fruitful issue raised by many, and particularly
cultivated by Albert Boime: the use of the sketch, and of sketchlike techniques asso-

ciated with originality and spontaneity. While acknowledging the value of Boime's formulations and conclusions, I wish to register disagreement on certain points and to weave some additional information and analysis into the fabric of his comprehensive study.[1]

Boime makes a rewarding distinction between initiatory "generative" procedure (sketching) and "executive" procedure (refining, finishing), and argues that during the course of the nineteenth century the focus of both theory and practice shifted from executive refinement to expressive, generative spontaneity. He calls attention to this change as it was manifested in 1863 in reforms proposed for the teaching program at the École des Beaux-Arts. At that time the architectural theorist Eugène Viollet-le-Duc, as well as others, advocated fostering a maximum of "originality" as individual self-expression. Accordingly, Viollet-le-Duc wished to terminate any academic exercises that encouraged standardization or the strict imitation of artistic models. His program met strong opposition and set off a debate that centered on conflicting notions of originality. Originality itself maintained its sacrosanct character, while various theories competed in claiming to comprehend its true interests.

Viollet-le-Duc and other reformers who wished to encourage generative procedure contended that originality would be indicated by the "mark of identity": any sign of an individual manner of expression, traced to or identifying the artist, would serve to guarantee an original presence. For Viollet-le-Duc's more conservative adversaries, among whom Ludovic Vitet was eminent, originality would instead inhere in a "mark of distinction," a sign of unusual achievement—original genius would reveal itself *in* and *beyond* the mastery of conventional techniques; and hence an academic tradition could serve only to further, not inhibit, individual artistic accomplishment. In opposing radical reform, Vitet implied that emphasis on the "mark of identity" (he called it "l'originalité personnelle") would lead to a search for novelty for its own sake and the teaching of "what cannot be taught."[2] The aspiring artist would be reduced to imitating the external signs of the individual "originality" of others.

The dispute in which Viollet-le-Duc and Vitet figured prominently parallels many similar theoretical debates conducted throughout the nineteenth century. The role of Viollet-le-Duc recalls that of earlier advocates of the use of the live model (a source of individuation) and, in general, his position is "romantic." Vitet resembles those who demanded imitation of a model ready-made in art, usually in the antique (a source of a universal ideal), and his position calls for the "classic." Both "romantic" and "classic" value the original—but where and how is it to be found?

David's pupil, Étienne Delécluze, an "academic" who wrote a treatise on the practice of painting (1828), understood that the positions of both the romantic and the classic could be abused: the romantic would seek novelty to excess and lapse into an incoherent idiosyncrasy; the classic would become dulled by his blindly repetitive imitation of the ancient authorities. As Delécluze noted, to call someone either *romantique* or *classique* was "not exactly complimentary."[3] Nevertheless, for Delécluze and other academics, the path to an original vision traversed the realm of classic art—

that of the ancients, of Raphael, and of others who had understood nature in its essential wholeness. To imitate the vision of past genius was to regain originality, not to sacrifice it. Academics such as Delécluze (and perhaps Vitet) stressed the perfection of received "original" ideas through a technical mastery of representation; they discounted innovation as an indication of willful, insincere individuation. Their argument often made reference to Homer, whose "original" genius was preserved in the imitations by those modern geniuses who recognized the eternal truth of his originality; Ingres gave visual form to this theory of recycled genius in his *Apotheosis of Homer* exhibited at the Salon of 1827.[4] For the supporter of the academic tradition, the imitation of genius by genius produced a desirable compounding of originality: Ingres wrote that "Raphael, in imitating [the ancients] endlessly, was always himself."[5]

Academics codified the conventions of antique and other "classic" art as a means of maintaining the presence of this "original" vision in their own work. Technical convention served as a communicating medium to link the present to the past; in its ideal form this medium allowed no refraction, no problem of translation. The same could be said of the medium viewed from its opposite end, as the link to the modern individual: technique as "mark of identity" should reveal the personality clearly and directly. This "romantic," self-reflective aspect of technique dominates the thought of the "modernist" artist and critic, for whom originality entails self-expression.

The two ends of technical procedure, a universal "classic" ideal and a particularized reality, are often regarded as extremes that must stand in opposition. The one seems to diminish individuality; the other, to exaggerate it. If the modern artist is in fact concerned first with his own identity, he needs a technique designed to free him from his culture, a technique weighted toward one end of the balance, that of the individual, the real, the particular. As I have stated, such is a *technique of originality*, which, when mastered, assures personal liberation from any technical restriction or convention. Such technique presumes to preserve the originality of a direct experience of self and nature (with the loss, perhaps, of the eternally re-created originality of a "classic" cultural tradition).

To return to Boime's contribution to the study of this problematic of originality: he explains how notions of individual identity, artistic excellence, intellectual acuity, and the like, could call forth specific technical procedures. An "aesthetics of the sketch" evolved in answer to the demand for an art of "spontaneity and sincerity," qualities linked to originality in the sense of "mark of identity." In this modern "original" art, technical procedure had to begin and end with methods traditionally associated with the spontaneous individual expressiveness of the sketch. Boime summarizes his argument in a concluding statement:

> As tastes changed, emphasis was shifted from the executive, refining phase [of painting], to the generative, spontaneous phase. But this shift could not have occurred if the Academy had not already separated the two phases, and already allocated to each its autonomous role. The qualities eventually associated with the aesthetics of the sketch were exactly those which had been assigned to the

preparatory sketch throughout the history of the Academy; the independents [who stressed individuality] had only to shift emphasis from the executive to the generative phase and *systematize* the sketching procedures.[6]

Boime's account of the aesthetics of the sketch demonstrates many points of value; but his conclusion can cause the same uneasiness that had troubled Ludovic Vitet. If the independents—artists such as Couture, Manet, and Monet—should actually "systematize" their techniques, would this not amount to an attempt to codify and to teach what (as Vitet put it) "could not be taught"? Indeed, if the sketching procedure were valued because it facilitated unforeseen discovery (finding) rather than affording compositional articulation (making), to systematize this process would be self-defeating. Vitet had premonitions of a style of *conventional* originality neither technically sound nor expressive of original genius. He was not alone in referring to the path to original discovery as one ultimately independent of systematized instruction in technical procedure. Some years earlier, the distinguished academician Quatremère de Quincy, a supporter of David and Ingres, had made the same argument. Quatremère advocated the theoretical analysis of past accomplishments of genius but opposed any practical prescription calculated to ensure such creativity in the future. Moreover, he attributed the impossibility of teaching how to create like a genius to the fact that the student could only perceive the genius's inventions as found, not made: "What the genius finds, and what we call invention, he shows us [already] fully found [*tout trouvé*] in his works, but he does not instruct us at all in how to discover it [*à le découvrir*]."[7] The teachings of Quatremère and Vitet amount to a kind of conventional wisdom repeated by both adherents to academic training and those who had abandoned it. The impressionists held this same view: when Pissarro's son Lucien engaged in the study of art, his father specifically warned him against the use of a "formula" or a "preconceived system."[8]

It is true, as Boime suggests, that the distinction between generative spontaneous sketching and subsequent executive procedure might become effaced in the painting of the independent naturalists, leaving only the appearance of a sketching technique; but, as Pissarro probably recognized, a sketch resulting from systematic and standardized procedure could no longer be considered genuinely spontaneous. When Boime indicates that *something* must be systematized, he implies, in effect, that a compelling concern for originality does not eliminate the need for a code of visual communication; the student or apprentice must observe and comprehend some general principle, even if a principle of particularity. The academic argument that the "independent" heroes of Boime's account staunchly resist thus retains its obvious merit: conventionalized technique of some sort will be present even in the most original art; such technique can be recognized, systematized, and taught as a foundation for meaningful communication. It will neither ensure originality of a "higher," absolute sort, nor preclude it.

The more extreme reforms in artistic training and practice were rejected by academics such as Vitet who refused to believe that instruction in the methods of past

masters would seriously inhibit originality. A statement taken from the entry for the term "copie" in the *Dictionnaire de l'Académie des Beaux-Arts* reveals the essence of this conflict over artistic education: "by a return to a truer conception [of the copy] we have [in recent years] regarded the exact imitation of the work of a master as a means of study . . . *copies* are of genuine importance in the education of artists . . . it would be deeply regrettable to see [the method of learning by copying] progressively abandoned in the vain pursuit of individual originality taking precedence over mature understanding and indispensable technical experience."[9] To learn by faithfully copying others is, of course, an extreme among the possible methods of learning from the past, and (seemingly) the most antithetical to the concern for the expression of individual temperament. But individuality surfaces even in the copy. While the academy's dictionary stressed the value of "exact imitation," it also repeated the nineteenth-century truism that one artist cannot make a perfect copy of another's work because of difference in the "état psychologique particulier."[10] It seems that all participants in the debate recognize originality and individuality not only as desirable, but even as unavoidable; at issue is how to attain some acceptably stable compound of the elements of public communicative technique (which is made) and private artistic identity (which is found).

Boime's conclusion that generative techniques came to dominate executive ones might indicate a solution to the problem. He suggests that a fundamental simplification or reduction of technical procedure occurred across a broad range of artistic practice. He recognizes the consequent need to define the different types of generative technique, in particular the various kinds of sketches, and distinguishes these according to degree of contrivance or artifice. The *esquisse* (or *esquisse peinte*) is a compositional sketch, the arrangement or construction of a picture. This type of sketch was usually held to reveal intellectual originality and genius, including what Boime might call the "mark of distinction." Like the *esquisse*, the traditional *étude*, a quick study from nature, "concentrated on compositional harmony," but it lacked a decidedly intellectual character: the *esquisse* "was the result of spontaneous inspiration arising from the artist's imagination [whereas] the *étude* grew directly out of nature."[11] The *esquisse* therefore carries the connotation of invention, an intellectual ordering of given elements; the *étude* seems less self-consciously creative, more of a passive finding or discovery.[12]

All sketches have one characteristic in common: their unfinished quality, usually indicated by freely handled and loosely defined brushwork. Academic theorists, however, usually considered the surface of brushwork as the *least* significant element in the hierarchy of expressive devices that included composition, line, chiaroscuro, and color.[13] Thus the most apparent aspect of the sketch and its clearest reference to spontaneity was a quality of only subordinate import. Certain types of sketches (especially the *ébauche* and the *esquisse peinte*) might appear today as evidence of a primary concern for spontaneous generative discovery because art historians have become so sensitive to the issue of "finish" and "lack of finish" in brushwork. Yet, to the nine-

teenth-century viewer, these same sketches could actually have signified the oppo-
site: the artist's commitment to a fully controlled and self-conscious development of
an orderly composition. This concern for composition would be indicated by quali-
ties *other* than brushstroke.

Boime's discussion of the *esquisse* and the *étude* demonstrates that he understands
that some nineteenth-century sketches were regarded as "made" or invented compo-
sitions whereas others were "found" or natural. Yet in describing actual paintings of
the period, he sometimes loses this distinction because he concentrates on the surface
quality of brushwork, and ignores the degree of compositional articulation. For ex-
ample, he compares the *esquisse* for Bouguereau's *Youth of Bacchus* of 1884 to the fin-
ished work (figs. 10 and 11) and writes:

> Here Bouguereau actually drew with his paint, and the animation and vivacity
> of the figural poses are due in large measure to the liberty of his execution. At
> the right, the trees are rapidly brushed in with broken strokes of thick paint; in
> other areas of the background a scumbling technique has been used. A dazzling
> array of greens and browns effectively conveys an autumnal mood. It is conjec-
> tural whether his more familiar and traditional methods could have rendered
> Bouguereau's sensuality with such authenticity. [In the finished work,] the vi-
> vacious curvilinear rhythms and exuberent brush technique have been modi-
> fied, and the gay abandon of the original movements [was] exchanged for self-
> conscious and artful poses.[14]

Is Boime correct in his observations? Granted that the finished work contains "self-
conscious and artful poses," but so does the sketch. It, too, is an artfully composed
study; it differs from the finished work primarily in its superficial layer of brushwork,
not its fundamental arrangement of forms. This point can be demonstrated through
reference to an area of foliage at the extreme right that Boime describes as "rapidly
brushed in with strokes of thick paint." In the sketch, the pattern of light and shade
established by these paint strokes is essentially identical to the pattern of foliage and
sky in the finished work. *Compositionally*, sketch and finished painting look alike.
They differ in that the finished painting exhibits a complexly detailed contour of leaf
forms silhouetted against a lighter sky. In both the sketch and finished work, howev-
er, the angle of penetration of a band of light (part of the background sky) stands in a
contrived reciprocal relation to the angle of the centaur's pipes. As a result of this and
other evidence of careful organization, the sketch, like the finished work, clearly ap-
pears planned and deliberated upon as a composition; its brushwork evokes sponta-
neity, but its compositional organization, its fitting of part to part, does not. Bou-
guereau's sketch must be seen as a product of skill and learned craft, not "sensuality"
and "exuberence."[15]

The "genuinely" spontaneous sketch, the painted rendering of an immediate "ef-
fect" (*effet*), was easy enough to conceive during the nineteenth century.[16] It would
look nothing like Bouguereau's study for the *Youth of Bacchus*; for it would appear

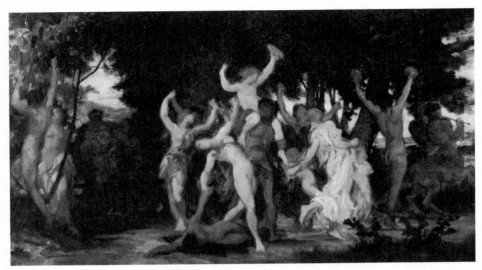

10. WILLIAM ADOLPHE BOUGUEREAU, *Youth of Bacchus* (sketch), 1884. Photograph copyright André Morain.

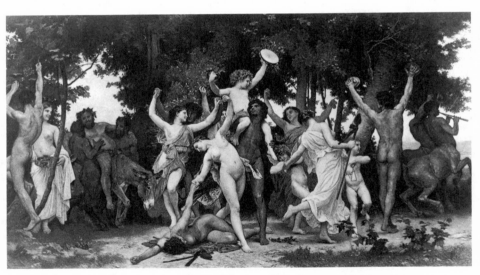

11. WILLIAM ADOLPHE BOUGUEREAU, *Youth of Bacchus*, 1884. Courtesy of Albert Boime.

spontaneous not only in its brushwork, but compositionally, too. The critic Ernest Chesneau wrote in 1864 that if present trends continued, he would expect to see exhibited a painting consisting merely of two broadly brushed areas of color, a green and a blue. These two colors would constitute only a minimal arrangement, but could be taken to represent a landscape with sketchlike "precision." Chesneau did not call for such an extreme solution to the problem of artistic immediacy, but he

could see it on the horizon. Such a picture would be deficient because (as Chesneau stated) it would lack the quality of the *made*, the willfully completed.[17] Despite Chesneau's misgivings, it was just this factor, of course, that attracted so many artists to sketchlike images: they seemed not made and completed—nor even preconceived— but found and in process.

As Chesneau imagined it, the ultimate modern painting takes the form of a radically simplified *étude*. For Boime, too, this type of sketch has special significance. In order to show how the aesthetics of the sketch came to emphasize originality in the sense of "mark of identity," Boime traces the development of the landscape *étude* and locates its apparent culmination in finished works of the impressionists, works that resemble unfinished, generative studies. The procedural technique of the *étude* seems relatively passive; the artist derives both his image and his means of expression, the chiaroscuro effect, from nature. Boime can thus argue that the "aesthetics of the sketch," with the sketch specified as an *étude*, generated painting having what I have called a "double origin," that is, painting created as if spontaneously from the immediate interaction (in vision) of an individual and nature. Boime concludes that artistic interest in the sketch, in the rendering of the "impression," and in originality are interrelated parts of a single cultural syndrome.[18]

Traditionally, the *étude* served to represent a chiaroscuro "effect" observed in nature. According to Boime, over the course of the nineteenth century "[the use of] the term 'effect' had shifted from an emphasis on artificial contrivance to one upon natural perception."[19] Is impressionist painting, then, as an art of the effect, to be considered genuinely original, rather than merely suggestive of originality? Does such painting resemble the *étude* because it expresses the natural effect spontaneously, or does it employ the device of the *étude* as a *convention*, to relate a sense of originality and spontaneity to the viewer? Boime does not give any definitive answer to this question. Instead he states that the use of chiaroscuro values (the effect) is always dependent on some "scheme," either "a scheme of natural perception or a scheme of arbitrary arrangement."[20]

The notion of a "scheme of natural perception" is just as problematic as the sense of a "systematized" sketch. Such a scheme must amount to a body of convention, indeed an "arbitrary arrangement"; for even if keyed to some specific observation, it could not be found complete in nature; the painter's scheme would be relational and would have to be linked to the code of his previous experience. Émile Zola referred to such a scheme when he defended Manet's technique in 1867. Manet's tones, Zola wrote, express his own temperament, but are bound to an objective vision of nature by a system of correspondence, the "law of values."[21] This "law" assures that the painting's internal relationships reflect those obtaining in nature externally—but as if at a distance or through a filter. For example, a range of value contrast might be established in the picture in order to evoke a similar variation in natural light, but a point to point identity between the tones registered in the painting and those to be found in its represented object would not be required. The "law of values" is thus a method

of painting, not a law of nature. It is conceived collectively by the community of artists, rather than discovered only in a personal and singular experience of nature. Zola states that Corot and Courbet, as well as Manet, share the mastery of this technique.

« »

Manet's teacher, Thomas Couture, also mastered techniques or systems of this sort. Because of his concern for originality, however, he tended to locate the proper source of any valid artistic technique in an individual experience of nature, not in the tradition of art. (Usually, Zola's explanations followed this course, too.) For Couture, to turn to nature was to discover an original source; in contrast, to study art was to risk becoming enmeshed in sequences of misdirected imitations; a pattern of man-made images that deviated from the truths nature offered up for the finding.

Famous as both artist and teacher during the middle decades of the nineteenth century, Couture had many American students and patrons as well as French ones, and his books on theory were widely read. His paintings have the look of system or pedagogical principle. Boime states that "even though [Couture] paid lip service to spontaneity and impulse, his major works betray the need for reflection and deliberateness in the traditional sense of 'completion.' "[22]

Boime's comment might apply even to Couture's "minor" works. His *Little Confectioner (Petit Gilles*; fig. 12), painted around 1878 at the end of his career, may at first glance seem a rapid, unrestrained sketch.[23] A simplified modeling of middle-value and light tones is set against dark, thinly painted areas of ground; and the range of color is reduced to a few basic earth tones (or "broken," neutralized primaries), highlighted by touches of a pure red. The impasto of the lighter areas evokes a fluid handling of the brush, responsive either to an observation of transient lighting effects or to changes in mood; and the edges of this thick paint are ragged where they meet the darker thinly painted ground. Yet some of these illuminated areas, especially the face and hand, are modeled to a fine degree of detail, modeled with a care which may seem inconsistent with the casual application of the broader strokes that define the more general forms. The pattern of illumination is itself clearly controlled, a studio light entering from one direction and differentiating parts of the figure. Couture, in other words, may loosen his grip on the brush, but his use of chiaroscuro remains convention-bound. He carefully models the dark background of *Petit Gilles* to a lighter tone in the area adjacent to the darker side of the figure's face.[24] In general, Couture seems self-consciously to incorporate references to spontaneity within compositions that largely conform to conventional modes of presentation. In his earlier *Portrait of Alice Ozy*, for example, he renders clothing with fluid impasto; yet the essential features of the figure appear meticulously modeled.[25]

Although Couture's manner may often look systematic or deliberative to the point of lacking a sense of spontaneity, it is clear that the artist himself regarded his own technical mastery as a means to unforeseen discovery and originality. And although this teacher of painting devoted much energy to writings on theory and practice which are rich in specific technical recommendations, they nevertheless picture

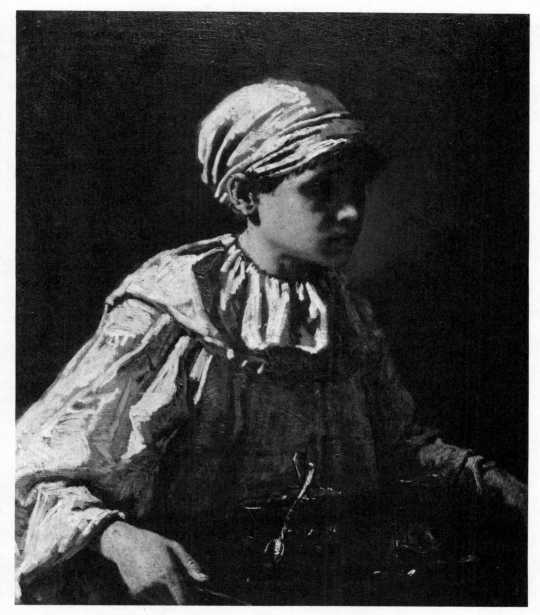

12. THOMAS COUTURE, *The Little Confectioner (Petit Gilles)*, ca. 1878. The Philadelphia Museum of Art, William L. Elkins Collection.

the artist as one carried along by forces beyond his complete control, a finder rather than a maker. According to Couture, the artist finds his originality in three sources: nature, his individual self, and God.[26] Technical procedures serve to facilitate this finding rather than to enable an unrestrained creativity or power to make; and, as Matisse, too, would claim, technical mastery does not lead to a series of repetitive works executed with the same degree of refinement, but to original images that may diverge unpredictably from the conventional.[27] Hence, Couture refuses to retouch a sketch when a patron requests it; his technique cannot determine his own expression, nor can he return to an expressive path once taken. He compares artistic expression to a leap into an unknown space, where "we are no longer masters of [our own] direction."[28]

In his series of writings on theory and practice, produced during the 1860s and 1870s and known collectively as *Entretiens d'atelier*, Couture provides much detailed advice with regard to materials and techniques. Yet he insists repeatedly (especially in his later revisions, published posthumously) that the most reliable techniques are not learned from others, but discovered as if by chance. Ironically, Couture's teaching "method" seems to deny the need for systematic study. His very first introductory remarks serve to set himself in opposition to those who have a university education: "in all circumstances, naïve and sincere expression, deprived of all erudition, is preferable to literate expression." This teacher claims to follow God and nature rather than the mediated tradition of learning and scholarship.[29]

Many of Couture's observations are remarkable. He states, for instance, that Poussin and Claude did not develop an idealized, conventional manner of landscape composition, but simply "copied" nature. He thus redirects their art from an actively controlled making to a passive finding in nature: "It is generally believed that [Poussin] interprets, creates a style that recalls nature somewhat, but which is nevertheless conventional. No, he copies."[30] Similarly, Claude is a naïve "child," a "simple" man who belongs to no school of painting and whose technique defies analysis. Despite an apparent manipulation of color, the selective emphasis on amber tones, Claude's painting seems to "remain completely faithful [*sincère*] to nature."[31] In accord with his remarks on Poussin's and Claude's reliance on nature, Couture in 1867 speaks of direct observation as the source of his own technical methods—the knowledge that a simplified lighting effect was the principle of successful composition came to him only when, in a state of intellectual distraction, he attended to a view outside his window.[32]

By 1878, a year before his death, Couture was willing to go much further in suggesting that successful techniques are found rather than made (or learned) from an inherited body of convention. His revision of the *Entretiens d'atelier* contains his most specific technical recipes, but also his most emphatic disclaimer: "[whenever] it had been given to me to find one of the secrets of nature, in this matter, as always, chance did more than [any application of] my intellect."[33] He writes that he has finally realized that the achievements of the masters displayed in the Louvre were not the re-

sults of great mental effort but "a simple, naïve expression of things deeply felt."[34] The old masters, in other words, did not impose technique on their work, but found their art as if passively. All those who "find truth [*trouvent la vérité*]" do so in like manner; their means of execution are "the same because they obey the eternal laws [of nature and art] that the great geniuses always respect."[35] Furthermore, the techniques that manifest these laws are discovered "by instinct" or as if "unknowingly." Couture writes that his own techniques correspond to those of the old masters not because he has learned from them, but because he has made the same naïve discoveries that they once did. His method for increasing the spontaneity of his own execution came as "a discovery or, if you prefer, and to be more modest, a lucky find [*une trouvaille*]"—here, another reference to passivity.[36]

Leonardo provides Couture's most striking illustration of the conflict between self-conscious making and naïve finding:

> Leonardo da Vinci gives us his "Mona Lisa," a work of admirable style and remarkable modeling, but this work is black and seems to belong to the domain of drawing rather than painting. Giorgio Vasari, however, tells us of the beauty of its color; this color has disappeared. Why? Because Leonardo, although a sublime artist, did not have the instinctive gift which lets one find [*qui fait trouver*]. Rather he appealed to science, he always examined everything but never found anything.

Couture claims that Raphael, in contrast, "found by instinct" and used techniques that time has not discredited.[37]

To consider Raphael a "finder" may seem odd, especially in view of the long history of modern commentary on the careful structural organization of this painter's compositions. Yet before Couture, Théophile Thoré had held the same view, and probably for the same reason: to credit artistic success to individual sensitivity and expression rather than to the schooling in and mastery of technique. In his "Salon de 1847," Thoré had written that Raphael's ideal forms were not of the artist's own invention; Raphael served only to represent them in their essential character, without the complication of added secondary qualities. Thoré went on to argue that "Nature is the supreme artist who, in her universal gallery, offers to her privileged students the principle of every perfection; it is a matter only of extracting some individuality and creating a second time, with a distinct and original signification." Pushing his point to its extreme, the critic added (in a subsequent chapter): "Nature takes it upon herself to *compose* images, fully ready to be reproduced in a form of art. A landscapist stops along a forest path and finds [*trouve*] there a full picture [*un tableau complet*] with a central effect and well organized lines. He has only to paint the landscape made directly by nature."[38] Here, as for Couture, nature is the maker, and the artist (merely) the finder.

Thoré did not always place so much emphasis on the passive or unsystematic side of artistic genius, nor did Couture.[39] Yet, although Couture's advice on specific technical procedures is often quite concrete (he seems rigorously scientific on the subject

of mixing colors), he insists that a lifetime of uneducated guesses guided by instinctive feelings will lead to the more successful manner of painting, one capable of expressing an originality of self and nature, and perhaps the divine.

«　»

In essence, Couture claims that technique is found; and this assertion distinguishes him clearly from his "academic" contemporaries. One of the most important of these was Charles Blanc, twice director of fine arts, editor-in-chief of the *Gazette des beaux-arts*, and author of the *Grammaire des arts du dessin*. Blanc published this very knowledgeable text on the methods of the architect, sculptor, painter, and graphic artist in 1867, the year of Couture's *Méthode*. As one committed to teaching within a comprehensive system, Blanc stressed rules of art that might conceivably standardize the technical quality of all artistic production. Couture, on his part, was concerned with how valid techniques appear as original discoveries—technique itself must be original. For Blanc, it was sufficient to say that technique was simply part of an inherited body of convention that could be used to express original thought or vision. In other words, artistic distinction would inhere in the traditional sense of "invention," the combination of known elements into new and ideally expressive compositions or meaningful imaginative images.[40] Mastery of inherited "executive" technique would serve the "generative" imaginative vision; the technique itself need not be innovative, nor need the elements of the representational images escape association with antecedent sources, so long as the final integrated product established its own uniqueness. For Couture, in contrast, the "generative" and "executive" aspects of the artistic process merged more completely and assumed similar character; the artist's technique should be marked by the singularity also to be found in the "truth" it expressed. Although Blanc might approve of such an agreement of image and means of expression, he did not make it an essential goal of his theoretical program.

Nevertheless, in accord with so many of his contemporaries, Blanc recognized that the structure of a composition must be doubly original, that is, it must correspond both to the character of the natural subject and to the character of the individual artist.[41] He himself coined the phrase "double originalité" and referred to the "individuality of the painter added to the individuality of the model."[42] For Blanc, however, the problems of composition would not be solved by a simple reliance on direct experience and artistic sincerity; instead, the artist must manipulate the field of conventional means at his disposal. Blanc nearly always takes an active stance toward artistic procedure; he stresses choice and decision as opposed to naïve absorptive vision. Solutions are not to be found in Couture's "method" of simply attending to what one sees, even to the point of staring out a window.

According to Blanc, an active or aggressive posture, with emphasis on intellectual organization, characterizes the creative male; the female discovers by instinct or intuition. This sexual difference assumes special significance in the area of technical procedure since Blanc classifies line as male and color as female.[43] Throughout the *Grammaire*, Blanc follows this hierarchy of gender, speaking first of any technical de-

vices most clearly associated with the "male" principle of controlled creativity and only later of the "female" technical elements that resist systematic ordering. Accordingly, the expressive techniques of the painter come to be discussed in the following sequence: (1) general linear organization; (2) linear design of figures and other details; (3) chiaroscuro; (4) color; and (5) touch or brushstroke.[44] Given this principle of ordering, if Blanc were to discuss sketching, the *esquisse*, or study of general organization, would have to precede the *étude*, or study of chiaroscuro and color. In other words, the sketch as active human invention would assume much greater importance, indeed, priority over the sketch as relatively passive observation of nature.

Blanc regards "unity" as the essence of a successful composition; it is to be achieved primarily by subordinating secondary elements to a dominant one.[45] Hence, the secret of compositional harmony might be described as *differentiation*—all parts of the composition must be rendered intelligibly distinct from one another and ordered hierarchically according to some principle. Blanc mentions two traditional schemes of organization, linear and aerial perspective. The one orders the composition by creating a hierarchy of linear elements; the other achieves a hierarchy in terms of the progressive degradation of chiaroscuro (value) and color (intensity of hue). Although Couture finds principles of compositional order and simplicity ready-made in nature, Blanc stresses their arbitrary creation in the hands of the artist: "True, it is the sun that illuminates the painter's canvas; but it is the painter himself who illuminates his picture. In representing at will the effects of light and shadow he has chosen, he makes the light-ray of his intellect fall there."[46] The academic artist makes his own light; he does not find it. One can accurately predict on the basis of this passage that Blanc will object to the photograph as an instance of a light that is primarily found rather than made, and that he will have a similar complaint about the impressionist painting.[47]

Given his sense that the effect of light in painting is actively controlled by the artist, Blanc can be very specific in stating a rule of unity in composition, to be applied to the use of chiaroscuro: "The picture [*tableau*] should present neither two bright areas of equal intensity, nor two dark areas of equal strength . . . there should be one principal bright area and one dominant dark area. . . . In a painting as in nature, the light should be *unified*, but not *uniform* [*une, mais non pas unique*].[48] This is the traditional law of chiaroscuro modeling, repeated by French theorists from Du Fresnoy to Blanc's contemporary Eugène Véron.[49] It is a law of differentiation, of hierarchy. It suggests that successful pictures can be created through the controlled manipulation of dark and light values.

Blanc states this rule of light distribution appropriately enough in his chapter on chiaroscuro. When he comes subsequently to discuss color (hue), he speaks in terms of new scientific principles of organization rather than traditional artistic conventions. Color (along with brushstroke) is the most "feminine" of pictorial elements, traditionally the most unmanageable. As a theorist committed to a self-conscious creative process, Blanc admits that color is inherently emotional in its content, but ar-

gues that one can yet submit it to intellectual control by means of such principles as the laws of complementary color, simultaneous contrast, and optical mixture. He notes that these laws have only recently been codified by European scientists and takes pains to demonstrate that even color now can become a device in service to an art of careful reflection. The colorist must *choose* the hues that conform to his thought.[50] One *learns* how to do this: "Many people suppose that color is a pure gift from heaven and that it holds incommunicable secrets: this is an error; color is learned just as music."[51] The Chinese, according to Blanc, have for centuries known and employed the laws of color; their works exhibit flawless harmonies. Finally, the academic must ask: "Would this infallibility be possible, if it had not been engendered by sure and invariable principles?"[52]

Blanc's argument seems forced and his reference to Oriental art might actually work against him; for the brilliant hues of the Chinese or Japanese were frequently discussed as antithetical to the "European technique" of chiaroscuro modeling.[53] It seemed to many as if brilliant color must interfere with the subtle gradations of a unity of values. Eugène Fromentin, both painter and man of letters, held such an opinion and remarked that the "so-called original painting" of the 1860s and 1870s amounted merely to "a patchwork, a mosaic."[54] Such an effect of flatness could only seem a product of negligence to Fromentin, since he regarded any illusion of pictorial depth as a definite achievement, something made with the application of a skilled artistic hand. He himself possessed such a hand and brought the radiant colors of his own "orientalist" paintings under the structuring control of chiaroscuro. A simple mosaic, however, a patchwork of juxtaposed colors, would reveal no studied hierarchical pattern and would instead resemble things found in a natural state of confusion. In sum, Fromentin described recent French painting as if it had the character of a dazed and lethargic sun-worshiper: lying flat out on its given planar surface, avoiding the exercise of chiaroscuro gradation, enchanted with the uninflected bright color of the Japanese print.[55]

It is clear, however, that effects of brilliant color might be chosen deliberately by an artist of Fromentin's day, not out of technical lassitude, but as a factor of a concern for naturalism. Among many others, Cézanne observed that a "patchwork" of brilliant color often seemed to characterize nature seen under full illumination. In 1876 (the year of Fromentin's publication), he described his view of the area around L'Estaque, near Marseilles: "It's like a playing card. Red roofs against the blue sea. . . . It seems to me that the objects [here] are defined in silhouette not only in white or black, but in blue, in red, in brown, in violet. I may be mistaken but it seems to me to be the antithesis of modeling."[56] Cézanne here reaffirms what he and the impressionists had probably already recognized implicitly in their art: nature does not always appear in the form of a painting; paintings are not always faithful to nature. Chiaroscuro, the technique of the *étude* and of landscape painting in general, might stifle rather than inspire the originality of the naturalist.

Blanc never fully recognized this dilemma. He considered chiaroscuro modeling adequate to whatever problem of expression an artist might face. Couture, on his

part, had tried to resolve the issue by claiming his technique as a kind of natural discovery (a "trouvaille") in correspondence with natural effects as he observed them. But the response of the young painter Henri Regnault to this technical problem is the most instructive for the understanding of the generation of the impressionists. As Monet would do later in the 1880s, Regnault around 1870 made several trips to the south for the express purpose of finding natural effects that challenged the limitations of his inherited technical procedures.[57] In other words, he forced himself into the position of the finder, one whose observations must necessarily be original, since his culture offers him no conventional images of what he is bound to discover. Although academically trained, Regnault abandoned his inherited techniques for the sake of his own originality. Specifically, he rejected chiaroscuro. He wrote from Tangier to a friend:

> I tell you that I am escaping modeling, I am fleeing the abuse of black. It's our dirty Parisian studios with their gray, dark green, or brown-red walls which have spoiled our eyes and made us see insane shadows that call forth an exaggerated modeling. Since I've been traveling and I see things for myself without being led right or left by the remarks and impressions of such and such an artist, I have been left to follow my own personal impressions naïvely.

Regnault went on to explain that figures in Tangier appeared defined by their flat local color set against the typical background of a white wall; chiaroscuro seemed to play no part in this non-European (perhaps "Oriental") world.[58] Regnault's reasoning is clear: he could find his originality, his "own personal impression," only by leaving the world created for him by conventional artistic practice, the world of Parisian chiaroscuro light.

Regnault exhibited his famous *Salomé* (fig. 13) in the Salon of 1870, the year of his trip to Tangier. A critic later called this painting a "cry of protest against the [academic] prison that [the artist] had just left."[59] In the *Salomé*, Regnault employed a technique that defied the principles of chiaroscuro composition. He differentiated— or perhaps failed to differentiate—the figure of Salomé from her background by painting both figure and ground in variations of brilliant yellow tones. Salomé is clothed in a dress of yellow, gold, and pale orange; the background is gold, and the floor coverings, including a leopard skin, are also dominated by golden tones. Several areas of black lie in abrupt juxtaposition to these brilliant warm hues. This very unusual use of color led René Ménard to make the quite typical comment that the artist had employed no significant chiaroscuro system whatever: "[Regnault] fears shadows and even half-tones, which he adds only enough so that the figure is not absolutely flat . . . one should not ask of him more than the first sensation which is lively, acute, and original; reflection and sentiment are absolutely foreign to his painting."[60] Although Ménard's commentary was intended as a substantial criticism of Regnault's technique, evidently the artist had succeeded in attaining his own goals, at least those that had led him to Tangier; he had painted "spontaneously" and with originality, and had avoided the one technique most clearly linked to an artificial structuring of natural images, chiaroscuro.

13. ALEXANDRE GEORGES HENRI REGNAULT, *Salomé*, 1870. The Metropolitan Museum of Art. Gift of George F. Baker, 1916.

The *Salomé* attracted critical attention repeatedly in the 1870s and 1880s. Although Regnault died in 1871 during the Franco-Prussian war, his several major works, especially the *Salomé*, continued to receive comment on their daring use of color. Victor Fournel, for example, described the technique of the *Salomé* as "lumière sur lumière" in order to indicate the lack of significant light modulation, and concluded that Regnault's approach was the "least classical and academic possible." His comment appeared in a series of essays on contemporary French artists, of whom Regnault was the youngest. He prefaced his essays with a lament for the tradition that Regnault had apparently abandoned: "The times are no longer favorable to discipline and tradition. The master's teaching is out of fashion. One is anxious above all about originality." Fournel stated that the latest style of originality, tradition's great antagonist, was impressionism.[61]

《 》

Regnault, of course, was not an impressionist in the more restricted sense of the term, but clearly he directed his energies to expressing his own first impressions, his own originality. More can be learned about the impressionist view of the problem of technique through the writings of Théodore Duret, who spoke of the specific technical procedures of Manet, Monet, Pissarro, and Renoir. Duret emphasizes two factors: first, the impressionists (or "naturalists") compressed the painting process until the work could be finished entirely before the natural site, as if a sketch; second, the impressionists employed the juxtaposition of brilliant colors, a method derived from the Japanese.[62] In effect, Duret calls attention to the hypothetical spontaneity of impressionist procedure by describing the finished work as an unrefined sketch and by noting the use of unmodulated color (hue) as opposed to deliberately gradated chiaroscuro (value). Like Regnault, the impressionists discovered the technique that facilitated their self-expression in a foreign source. Duret does not refer to any actual traveling that the impressionists may have done, but states that their artistic practice entered a world of brilliant illumination represented by the Japanese prints that reveal the "exact feeling of scenes and the landscape that I [Duret] saw in Japan."[63] The Japanese print thus served the impressionists as Couture claimed a chance view out a window had served him: it revealed an appropriate expressive technique that could not be drawn analytically from the inherited body of technical prescriptions.[64] The foreignness of the impressionists' source permitted them to maintain their air of originality, their sense of independent discovery. It is significant that symbolist critics, although they called for the renewed presence of compositional order, subsequently stressed the great value of this impressionist liberation from academic convention, and indeed often mentioned it in conjunction with references to the Japanese. Maurice Denis, for example, remarked that the impressionist movement was characterized by the "absence of all rule, the negation of academic teaching, the triumph of naturalism, the influence of the Japanese [and the] liberation from all constraint."[65]

Even as Duret (along with Blanc and others) insists that successful painting must express the emotion of the artist as well as the appearance of his subject, he seems to limit the artist's means to the reproduction of natural effects.[66] Nevertheless, Duret's

theory does not lead to a clear image of a workmanlike painter who mechanically records elements of a visual field according to some system of correspondence. For Duret, there is no such system; there is no "law of values," nor any shared mediating technique. The critic states that every artist will develop an individual style that will yet enable him to render nature as it is.[67] He encapsulates the impressionist achievement in one sentence:

> When the impressionists had taken from their immediate predecessors of the French school the direct manner of painting in the open air, all at once, by application of vigorous strokes, and when they had understood the new and daring methods of Japanese color, they departed from these very points, attained for the development of their own originality, and abandoned themselves to their personal sensations.[68]

Duret repeatedly speaks of spontaneity because, in theory, the impressionist paints with such immediacy that no rational mediation seems in operation. The impressionist is a liberated finder, not a maker. The only "technique" he employs is the juxtaposition of brilliant hues, a manner of rendering discovered in the Japanese print, but supposedly also the effect to be observed in nature.[69] Monet, according to Duret, "begins suddenly to cover [the canvas] with patches of color that correspond to the colored spots given by the natural scene." This is not a case of correspondence according to an abstract system, but simple and direct identity—what is seen is painted.[70]

Here then lies the radical "modernism" of impressionism as it was conceived by its champions: the impressionist paints "what he sees" but does not imitate (or "copy"[71]) in any pejorative sense of that term. He paints nature in his own style, expressing his unique temperament; yet he has no specific preconceived means of stylization. Strangely, his own "style" seems unknown, undetermined, even to him. He is then doubly original, true both to nature and to his emerging self in each of his works; his art is continually new. This art cannot be successfully imitated by others, for it claims independence from all systematic technique, and hence immunity from any appropriation by or assimilation into the academy; it cannot be nurtured by or grow on that culture. Furthermore, it owes nothing to ideas, themes, or narrative content; it has no "composition," either of forms or of subject matter.[72]

Eventually (in part 4) it will be necessary to consider that the distinction I have been establishing—between an original, found art and a representational, made art—may be specious or superficial. Nevertheless, in accord with Couture and Duret, Émile Zola's penetrating essays seem to reflect his commitment to this distinction during the 1860s and 1870s. Perhaps Zola is the most clearly associated with the notion of the double origin of art; it leads to his definition of the work of art as "a bit of nature seen through a temperament."[73] This was not an unusual position to take, even among the more conservative theorists. Blanc provided a strikingly similar formulation at about the same time: "[the artist] imitates nature not precisely as nature itself exists, but as he himself exists . . . each artist impresses his personal character on his imitations . . . the temperament of the painter modifies the character of things

... and nature is for him what he wants it to be."[74] For Blanc, as for Zola, the imprint of the artist's personality is a necessity; there can be no man-made equivalent of a hypothetically "perfect" photograph, a depersonalized representation of nature.[75]

Impressionist painting, as Zola (or Duret) describes it in its radical spontaneity, seems precariously close to the automatic mechanical imitation that Blanc would consider a trivial accomplishment. Although the academic theorist speaks of artistic temperament in a manner like that of Zola, he regards it as a force that is *willfully imposed* upon artistic practice, as well as one that cannot be entirely suppressed. The artist "*chooses* in his imitation that which can express his personality."[76] A differentiating choice is the essence of composition and invention.[77] On the link between inventive imitation and personality, Blanc would agree with his contemporary educator Horace Lecoq de Boisbaudran, who was known especially for his concern for originality in art. Lecoq wrote that "invention, by its very nature, is either personal or it does not exist at all: this is why the major preoccupation [in teaching composition] should be the preservation of the [student's] personality."[78] However, within such a formulation, Blanc himself would not wish to suggest that compositional alteration might well be brought to a minimum. For Blanc, artistic practice may commence with a direct imitation of nature, but it will end in an inventive transformation of these given forms that serves the expressive aims of the thinking artist.[79] Now, for Zola, artistic practice *both begins and ends* with "imitation," the direct rendering of one's impression; one discovers oneself in one's own vision. Artistic meaning is not conceived and made, but simply emerges.

Blanc's academicism, as opposed to Zola's modernism, is thus revealed in the unproblematic approach the former takes to conventionalized technical procedure. Blanc makes no inflexible distinction between an art of originality and an art of convention—all art involves the knowledge of standard techniques and a rational process of making. In its lowest forms this making may seem a pure imitation, but such "copying" does not adhere to nature more closely; rather, it represents nature only crudely, without the benefit of the refinement that comes when human ideals and emotions are expressed by the artist in the form either of individualized "character" or generalized "style." Blanc argues against those who would seek to minimize the intervention of an active technical process for the sake of discovering a "natural" truth: "Those who, through love of the natural, defend themselves from the ideal as if from an enemy, and who would confine the artist to rigorous imitation [of nature], imagine no doubt that on one side lie truth and life, while on the other, convention and falsehood: this is a profound error."[80]

The "error" was not only Zola's, but (more notoriously) Courbet's. In his famous open letter to prospective students (25 December 1861), Courbet wrote the following, taking care to distinguish what should be found from what might otherwise be made:

> Imagination in art consists in being able to find [*trouver*] the most complete expression of an existing thing but never to invent or to create [*à supposer ou à créer*] this same thing.

The beautiful is in nature, and appears in reality in the most diverse forms. As soon as one finds it, it belongs to art, or rather to the artist who is able to see it. When the beautiful is real and visible, it has in itself its artistic expression. But the artist has no right to amplify this expression. He can tamper with it only at the risk of denaturing it, and consequently weakening it. The beautiful given [*donné*] by nature is superior to all the conventions of the artist.[81]

Courbet's statement implies a certain genetic identity of the real and the ideal that appealed also to Blanc. The academic theorist, however, saw no reason not to "tamper" with nature to bring forth its (ideal) beauty. His admonition (quoted above) to those whose "love of the natural" might lead to an unnecessary rejection of refined technique culminated in an illustrative analogy: "The ideal and the real have one and the same essence. The rough diamond and the polished diamond are both diamonds; the rough diamond is the real; the polished diamond is the ideal."[82] For Blanc, what lies between the real and the ideal is an acceptable, controlled technical process. The painter who had mastered the representation of the real was not Courbet, but Ingres.[83]

Many academic critics saw the problem of contemporary naturalism in Blanc's terms. Ménard, for example, refused to take sides in what he considered a "purely technical dispute" between those committed to a refined modeling and those whose surfaces lacked finish for the sake of a naturalistic spontaneity or the expression of "temperament." "We believe," he insisted, "that art does not rest in the [craftsman's] tool, but in the thought that directs it"; any technical manipulation might work, if applied intelligently.[84] Similarly, at a later date, the distinguished aesthetic theorist Gabriel Séailles could reconstruct the logic of the impressionists by observing the technical choices they had made: they would render nature as they saw it, eliminating anything entailing reflection, calculation, or deliberation, whether "form, modeling, construction, perspective [or] composition," in order to "find in the unforeseen aspect of a new vision the emotion that creates lively works." Just as Blanc did, however, Séailles considered this program misdirected, an art of reproduction with no interpretation; art must instead transcend nature through the conscious application of a spiritual force—further technical choices must be made, the diamond must be polished.[85]

In general, Blanc's manner of distinguishing the "real" from the "ideal" in terms of the use of technical procedure is in accord with the symbolist generation's understanding of artistic "realism" and the opposing "idealism." Camille Mauclair, for example, stated in 1895 that realism does not aim for a replication of nature devoid of the presence of the artist, but instead incorporates that presence by way of the very techniques employed. The deeper significance of realist images is thus indicated by the technical means chosen. Moreover, because it derives exclusively from the personality of the artist, the technical procedure must seem arbitrary in relation to the object of its representation. It appears, in effect, as if found independently of the end toward which it is employed, the rendering of nature. Hence Mauclair characterized

the years 1865–95 as dominated by fortunate technical discovery ("la trouvaille technique").[86]

The innovative yet arbitrary or accidental character of realist (or impressionist) technique was cited repeatedly in the 1890s by Aurier and Denis to justify their call for a more rational and purposeful expression in an art of the symbol.[87] According to Mauclair, the committed realist would argue in turn that the proper appreciation of art must focus on the manner in which an aspect of nature is transformed to suit the artist's own temperament: "It's in that that he is original. A tree by Corot is not a tree by Claude Monet; [yet] idealism distinguishes nothing, abstractly, between these two trees." In other words, the idealist would discover no symbolic content, nothing of significance in the different realist representations, other than what the techniques themselves might signify; and technique would serve simply as a reference back to the character of the artist. In contrast to the realist, the idealist (for Blanc and Mauclair) is a maker, not a finder; he uses techniques to pursue a specific end and therefore often constructs what could never be found in the world of immediate experience. Although idealism, as well as realism, could be taken to excess, in the end Mauclair advocated a return to abstract principles (as opposed to personalities) to guide the application of technique; just as Blanc did, he advised that the "real" diamond be retained, but exhibited in a polished "ideal" form.[88]

Perhaps the most comprehensive view of the historical conflict between the forces of the "real" and the "ideal" was offered by Raymond Bouyer in a lengthy essay on landscape, published in 1893. Along with Mauclair, Bouyer used terminology that recalled many of the issues once raised by Blanc; and he made some very basic distinctions with regard to the use of willful choice versus passive vision and instinct. He stated that a painter who holds the ideal above the real will create a "paysage composé" or "paysage de style," a result of the action of imaginative invention and technical choices. This will be an art of the "beau," such as that of Poussin, characterized by (masculine) line. If, in contrast, a painter values the real more than the ideal, a "paysage rustique" or "paysage réel" will result from his "copying" of nature. The "paysage réel"—just as a plein air painting—will be characterized by (feminine) color, a strong effect of illumination, and a sense of the particularity of the "vrai." Bouyer wrote that

> the creator of "paysages [de style]" treats nature as an abundant and disorderly quarry where the architect goes to *choose* blocks of marble, whereas the [creator of "paysages rustiques" or "réels"] is able to respect the sublime confusion of things. The one commands in the name of art, the other obeys in the name of nature . . . the pitfall of [active] choice is convention; the pitfall of the [passive] copy is ugliness.

Finally, Bouyer insisted that art must hold itself in opposition to nature because it takes its own active stance: "Before nature, art will be less a copy than an emotion. Imitation, for the artist, is called creation. From passive imitation, the energy of a higher element is generated: even in an art of imitation, *art* is the 'contrary' of *na-*

ture."[89] Along with Blanc and many others, Bouyer dismissed the possibility of a pure finding in nature, and with it the technical conundrums such a notion would evoke.

<div align="center">« »</div>

"Imitation" is difficult to integrate into any modern theory of an expressive and original art. Bouyer would simply replace this term with another that seemed more consistent with the sense of artistic discovery: "*Imitation*, for the artist, is called *creation*." Blanc himself defined the imitation of nature in the most straightforward way, as a "faithful copy." Despite the long history of theories of artistic imitation (mimesis), Blanc could not construct his own system around that concept (or at least not around that *word*); instead of being imitative, art had to be "creative." The academic theorist stated that the true artist would interpret nature and transform an inexpressive silence by giving it a voice, his own language.[90] Art would surpass nature in its evocative power since it necessarily embodied thoughts and feelings. Accordingly, invention, or even simple choice, became the vehicle for creating meaning. In making a composition of figures, the artist would "choose within the immense repertory of [observed] human forms those that serve best to translate his emotion or his thought."[91] For Blanc, even an initial drawing or compositional sketch is no "simple *imitation*, a copy mathematically conforming to the original, an inert reproduction, a superfluity."[92] Indeed, when he referred to specific cases, Blanc insisted that both Poussin and Claude always transformed the nature they viewed, as if they knew that what they found in their direct observation were not in agreement with their own feeling, their source of originality, or (as Blanc wrote) their "genius."[93] For the academic, an original expression of the self could follow only from conscious artistic choice, an active employment of artistic technique.

I have noted, however, that Couture, at about the same time, argued that Poussin and Claude merely "copied" nature, and that this relatively passive act of finding constituted a greater artistic accomplishment than the making of an inventive composition.[94] Couture may have chosen his word "copy" [*copier*] deliberately to call attention to the fact that Poussin and Claude were not involved in a particular kind of "imitation": namely, an intellectualized act of idealization, just what Blanc was advocating. To understand the full significance of Couture's use of the term "copy" entails familiarity with a certain distinction traditionally made between this term and its rival, "imitation." Blanc very likely knew of the distinction, but for the most part suppressed it in his writings.

The Littré *Dictionnaire* (1866) noted that *imiter* and *copier* were synonyms but proceeded to define a difference: "To copy is to reproduce exactly, without departing in any way from the model. To imitate is to reproduce freely, without restricting oneself to accuracy, and in departing from the model wherever it is suitable."[95] Such discrimination did not always inform common usage, but was fundamental to the meaning of these terms as they were employed in theoretical texts on the fine arts. In 1823 Quatremère de Quincy, *secrétaire perpétuel* of the Académie des Beaux-Arts, had published a long treatise in which, recalling both Plato and Aristotle, he identified

imitation as the essence of art and associated it with *imaginative invention*; copying, in contrast, was mere mechanical *reproduction*, craft but not art. The resemblance to nature that copying afforded was one of identity (the "superfluity" that Blanc later called *both* "imitation" and "copy"); the copy presented the "real" in duplicate. The imitation, however, resembled its original always with a difference which manifested the "ideal": the end of imitation is to represent "not what exists as it is, but what exists, as it could and ought to be." According to Quatremère, the painter had the right, and usually the necessity, to "recompose the forms, the contours, the relationships and the proportions of bodies, to modify their effects and colors, to change the locations of each scene, the movements of each action, the characteristics of each expression, in a word, to exchange a type of local truth, individual and limited, for a type of truth seen from a higher and grander perspective."[96]

Blanc's sense of what an artist does resembles Quatremère's, yet he did not call the process "imitation." Despite his academic filiation and the legacy of Quatremère that he acknowledged, Blanc was quite typical of his generation in either expressing uneasiness with the term "imitation" or conflating it so often with "copy" that it lost its special meaning. Generally, the "romantics" had also acted in this manner, perhaps to deprive "classicists" such as Quatremère of their special claim to authority as theorists—the romantics abused the discourse of the classicists. And they did even further damage to the classical theory of an idealizing imitation in simply opposing "imitation" to any imaginative or transformative invention.[97] In the words of romantic critics, the academics' imitation was reduced to an academic copying.

The polemic implied by such an intentional subversion of the term "imitation" involves the question of the proper use of models: Should the model be found in art (the art of past "classic" masters) or in nature? To restate the issue: Does nature come alive only when seen (imitated) through the medium of classic art? Or is all art that is drawn from past art dead, to be revived only in renewed contact with nature?[98] This source of theoretical irritation caused chronic pains in the academy, which flared up during the first decades of the nineteenth century, before the name "romantic" had been applied coherently to any particular group. At that time, there had been vigorous advocacy of such a close resemblance to the model in nature that Quatremère, claiming to speak for the "classic," had repeatedly felt compelled to publish defenses of the *beau idéal*, that is, the "imitative" ideal that would depend on intellectual abstraction (imitation) rather than illusionistic likeness (copying). For Quatremère, the desired artistic ideal could be linked to imaginative insights or *ideas*; for his adversaries, it was to be derived from an externally directed *vision*.[99] This conflict between idea and vision resurfaced again and again; during the 1860s it was personified in Blanc and Zola.

Just as Couture had done when he spoke of Poussin and Claude, Zola took the "romantic" resistance to Quatremère's theory of the ideal to extreme ends. He undermined the traditional notion of inventive imitation in several ways: he associated copying with immediate true *vision*, attributed the act of copying to his favored artists, and insisted that invention amounted to an unnecessary or diversionary intru-

sion. Zola seemed openly against the use of imagination, the source of academic ide-
alization or, more simply, of *ideas*. In defining his critical stance, he opposed not only
those such as Quatremère, but also Blanc; for he suggested, somewhat perversely,
that copying is not at all superfluous, rather composition and thought are. He wrote
with regard to Manet, as if to challenge Blanc's criteria of evaluation published dur-
ing the same year (1867):

> Here it is no longer a question of a search for absolute beauty; the artist paints
> neither the historical nor the spiritual; *what one calls composition does not exist for
> him*, and the task he imposes on himself is not at all to represent this thought or
> that historical event. And for this reason one should not judge him as a moralist
> or as a man of letters; one should judge him as a painter. He treats figural works
> as it is allowed in the schools to treat still-lifes; I mean to say that he groups the
> figures before him, somewhat haphazardly, and he cares subsequently only to
> fix them on the canvas as he *sees* them, with the strong contrasts they make in
> standing out one against the other.
> . . . [Manet] has never been so stupid as to wish to put *ideas* into his paint-
> ing.[100]

It has often been maintained, especially in recent years, that in passages of this sort
Zola reveals his own "formalist" bias and his insensitivity to the wealth of icono-
graphic detail in Manet's work.[101] Although the evidence may seem to support it,
such an observation misses the mark of Zola's critical program. He did not see the
major critical issues of his day in terms of some conflict in which the use of expressive
form or style would necessarily preclude the use of subject matter rich in its own sig-
nification. He was not seeking to deny "meaning" in Manet's work. Rather, he
wished to shift Manet's artistic enterprise from the realm of making to that of find-
ing, just as Couture sought, at the same time, to claim his own technical accomplish-
ments as intuitive discoveries instead of products of an academic system. Zola pre-
sents Manet as the very antithesis of the academic, for he claims that this painter
lacks the academic's two most essential qualities: the power to invent and the facility
to compose. And Zola's Manet is rather deficient in a third important feature as
well—the ability to execute his paintings according to acquired standardized proce-
dures. In the world of the academic, invention would issue from innate genius, com-
position from intellectual development (education and study), and technical skill
from experience (studio training and practice).[102] Manet, seeming neither to invent
nor to compose, and appearing to paint with either an untrained or an undisciplined
hand, was anti-academic *by definition*—at least by Zola's definition of Manet's artistic
aims and practices. Manet had nothing that an academic would want.

Yet he had a very desirable originality. Zola reveals Manet as a master of original-
ity who knows the importance of the difference Blanc must minimize, that between
a natural truth and a technical convention. The critic emphasizes what he calls the
"original language" that Manet derives solely from his direct and spontaneous ap-
proach to the rendering of nature; Zola refers to this process of representation as a

"copying."[103] Thus, direct imitation of nature is not the rude beginning of the artistic process as it is for Blanc; it is no mere inaugural exercise to be transformed into "art" by means of imaginative invention and composition. Instead, "copying" is itself already original interpretation, the immediate expression of a unique artistic personality in the spontaneous recording of its vision.[104] In order for that vision to appear in its purest original form, the artist must maintain his independence from conventional representation, that is, from the translative power of the standard artistic techniques. Hence, Zola reports Manet as saying: "I can do nothing without nature. I do not know how to invent. As long as I wanted to paint according to the instruction I had received, I produced nothing of merit."[105] The painter discredits invention and study at a stroke.

Ironically, some hostile viewers would be quick to second Manet's claim to simple ignorance. Joséphin Péladan wrote that this artist was "without ideal, without conception, without emotion, without poetry, without design, [and] incapable of a composed picture."[106] Nevertheless, Manet's self-assessment is hard to accept, especially in view of the subtle and complex manipulation of imagery evident in works such as his *Déjeuner sur l'herbe* (1863) and even his *Portrait of Zola* (1868; fig. 14). It does not matter, in this context, whether Manet is being entirely honest in his self-evaluation; the important fact is that he—or at least Zola, speaking for him—has made the claim. Manet's technique is to follow nature and find himself: "il s'était trouvé lui-même."[107] Zola insists that Manet does not compose, but records chance groupings, and that his works are marked by strong contrasts (the "juxtapositions" of which Duret would later speak). At every point in his critical analysis he manages to show that the painter's art is as unmediated and unpremeditated as it can be. Zola would later epitomize Manet's achievement in this statement: "In beginning a picture, he could never say how it would come out."[108]

Blanc did not comment on Manet, but he did discover in Henri Regnault much of what Zola had found in his chosen painter of originality. Yet Regnault's status is diminished, not enhanced, by Blanc's observations. Although he included Regnault among those he selected as the greatest artists of the age, Blanc clearly did not sympathize with this painter's methods. His essay on this artist (1876) contains some uncharacteristic factual errors and approaches self-contradiction in its argument. Blanc states (as Zola does in the case of Manet) that Regnault's paintings have no ideas behind them: "[the artist] combined with the sensitivity of a photographic instrument the will to choose and the will to express the object seen, without adding to it any thought, according, however, to his temperament, according to his particular quality of mind . . . [simple] imitation was for him both the means and the end."[109] And with regard to Regnault's choice of subject, Blanc claims that that, too, conveys no specific meaning—the *Salomé* is merely an exotic woman observed.[110] Blanc's analysis of Regnault, then, reads as Zola's appraisal of Manet does. The analogy depends on the technical observations made by the two critics. Regnault, however, is faulted for working in the manner for which Manet is praised.

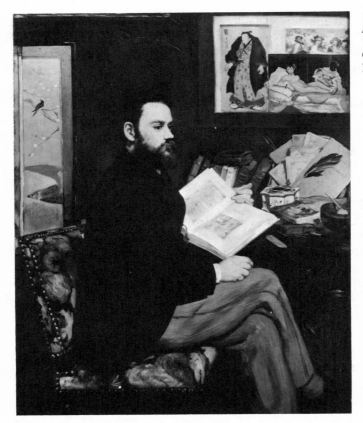

14. ÉDOUARD MANET,
Portrait of Émile Zola,
1868. Musée du Louvre.
Cliché des Musées
Nationaux.

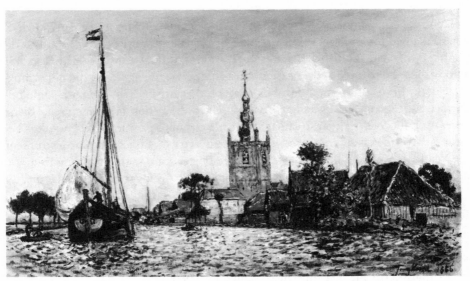

15. JOHAN-BARTHOLD JONGKIND, *The Church of Overschie*, 1866. Courtesy of the Art Institute of
Chicago.

As an "orientalist," Regnault lent himself to comparison with the grand master of Oriental subjects, Delacroix. But Blanc writes that the younger man can only imperfectly reflect his elder; he seems merely to represent an exterior "vision of the eye," whereas Delacroix reveals internal emotions and "visions of the mind."[111] Furthermore, Regnault is criticized for his obsession with "colorism," an undisciplined technical approach that must impede any attempt to attain the greatest heights of artistic expression.[112] Yet, as if wary of denigrating an artist (and war hero) so widely acclaimed, Blanc salvages this reputation with remarks that come as a surprise in relation to his acknowledgment of Regnault's notorious unconventional color: Regnault's drawing is his greatest achievement.[113] This observation, which may strike the reader as gratuitous, allows Blanc to assess Regnault as someone in control of his procedure, who can indeed make meaningful choices. Since Blanc cannot find system in Regnault's color, he must attribute the painter's success to the power of his linear form.

The central observation is that Regnault, the "academic" who abandons conventional practice, is said to paint without expressing any thought, as if his choice of subjects, and even of colors, were guided by passive intuition or perhaps the chance circumstances of nature. Similarly, Manet, according to Zola, does not express ideas; he makes neither poetry nor philosophical statements. Does Manet then "make" anything? Zola's project might seem to be to convert the highest artistic expression from the very willful activity Blanc conceived, to a more passive course of discovery in which one finds oneself only as a result of the artistic process. For Blanc, imitation or copying can never reveal a truth: "the last word in imitation is to produce a copy that one could take for the original; in other words, the masterwork of the imitator would be to make an illusion."[114] Imitation or copying is thus performed when the original is already available; it adds nothing new and, as Blanc states, produces only a potential deception. For Zola, however, art lives and grows as artists do; and so long as art remains independent of convention, its "imitation" of nature will reveal an originality ever changing, an evolving artistic temperament:

> I am not for any school, because I am for the truth of humanity which excludes every clique and every system. The word "art" displeases me; it encompasses certain ideas of necessary arrangement, of an absolute ideal. To make art, is this not to do something outside of man and nature? For my part, I want people to make life; I want people to be alive, to create anew, outside of everything, according to their own eyes and their own temperaments.[115]

Manet, then, becomes an artist in Zola's sense not by making art, that is, not by employing conventional artistic techniques to express his ideas, but by following the chance patterns of nature, *as he sees them*, in his own unique and original manner. He finds both nature and himself in this vision.

Zola writes that he is displeased by the word "art" with its suggestion of artificiality. Yet it was apparent to him that artists were neither natural nor original automatically, but had to strive after a mastery that would ensure their originality. Manet himself, according to his friend Antonin Proust, had reasoned in 1858 that there must be

some method of representing the experience of nature with minimal mediation: "An artist should be a *spontanéiste*. There's the right term. But to have spontaneity, one must be master of his art. Undirected groping never leads anywhere. One must translate what one experiences, but translate it instantaneously, so to speak."[116] The solution, then, is not to eliminate the means of making, not to cede all control, but to arrive at a means of immediacy. Instantaneous translation in terms of some medium would be quite a feat, a mastery that would seem to render negligible the influence of the medium itself. Zola, in speaking of Manet's unrestrained "copying" and freedom from rule and thought, describes the artist's work as if its technical principles had indeed become invisible. And when Castagnary, another champion of naturalism, considered the paintings of the somewhat older landscapist Jongkind (fig. 15), he seems to have made the claim for the attainment of a disappearing technique even more definitively:

> [Jongkind's] craft hardly concerns him, and this results in the fact that, before his canvases, it does not concern you either. The sketch finished, the picture completed, you do not trouble yourself with the execution; it disappears before the power or the charm of the effect.[117]

Whether Jongkind has deliberated over his art or not, the viewer cannot say; the *appearance* of spontaneity, if not its reality, has been achieved.

Despite such enthusiastic response to self-effacing procedures, one must suspect that critics such as Castagnary and Zola knew well that specific identifiable, *visible* techniques had been employed. Just as Duret does, Zola provides clues as to what might define the technique of originality. He notes that Manet's work is characterized by strong oppositions of value and his "composition" appears haphazard, unplanned.[118] Zola also relates that Jongkind paints sky and earth with an "apparent disorder."[119] The technique of originality is thus consistently revealed negatively, as the antithesis of conventional procedure—if the one is deliberate, the other is spontaneous; if the one employs ("artificial") chiaroscuro transitions, the other employs ("natural") violent oppositions of value or hue; if the one is orderly or systematic, the other appears haphazard; if the one is complex in its internal compositional differentiation, the other is simple in its uniformity. The question now is this: How, more precisely, did French artists of the later nineteenth century *make* "original" paintings?

8

Corot, Monet, Cézanne, and the
Technique of Originality

I N THIS CHAPTER, landscapes by Corot, Monet, and Cézanne will be viewed as
if in ignorance of any "private" significance they may have had. A number of
factors on which interpretations are often based will not be considered: the per-
sonal associations of the site for the artist, the place a painting may have occu-
pied in the artist's own sense of his life's course, details of biography or psychology
which might bear on the historian's most comprehensive reading of a work. The
paintings are nevertheless not to be viewed naïvely (as if that were possible). Instead,
they will be observed in their public stance, informed by and responsive to the con-
text of theory and criticism discussed in the previous chapter. They are to be seen as
Blanc, Zola, and others saw and described similar works in their own public state-
ments. In other words, this point of view assumes a relatively extensive familiarity
with nineteenth-century painting, but little if any privileged information concerning
the background or biography of a given artist. Zola knew many painters personally,
but the logic of his critical evaluations was intended to be free of any partisan feeling
arising out of friendship. When he concluded that Manet painted "as he saw," he
needed no private relationship with the artist to discern that.

Certainly, critics did not hesitate to make general pronouncements based on a
kind of visual scanning. When in 1876 Fromentin expressed his dissatisfaction with
the artists of his time, he was reflecting on the output of quite a large group, an
"avant-garde" constituted not only of independent impressionists but also of lapsed
academics such as Henri Regnault. The painter-critic felt that this younger genera-
tion worked without sufficient care, in particular without adequate observation and
manipulation of "values," the chiaroscuro modulation he so much admired in Rem-
brandt and other old masters. In stressing nuance and attention to detail, Fromentin
distinguished those who presented a finely crafted and highly differentiated picture
surface from those who seemed to leave things almost as they found them. For this
viewer, the attempt at removing artifice and convention from modern art had merely
brought about a loss of imaginative invention, a loss of creativity itself.[1]

Fromentin's comments appeared in the context of a historical study of the Dutch
and Flemish masters of past ages; had he focused instead on the French, Claude

would have been his paradigm in the area of landscape art: "we have had in France only one landscapist, Claude Lorrain."[2] For Couture, too, Claude served as a model of excellence: "[his painting] escapes the analysis of its procedure; its technique is so perfect that [any sign of] the worker disappears completely."[3] Couture seems to claim that Claude had achieved a central feature of the technical mastery that Manet and the naturalists were seeking, to render technique itself invisible. This genius had freed himself from all academic practice; yet, as Couture well knew, he became the model for academics. Succeeding generations emulated Claude's refined manner because his well-differentiated light and color corresponded with the academic ideal of a technique subtly responsive to specific expressive aims. Although it may have attained magical effects, Claude's technique was yet subject to academic analysis of the simplest sort, for his compositions quite obviously depended on the interrelationships of their well-defined parts. His light (and the space it created) exemplified an academic principle: as Charles Blanc would say, such pictorial light was properly arranged and judiciously composed of its various elements—"unified, but not uniform."[4]

Analysis of a characteristic painting by Claude, *The Ford* (usually dated 1636[5]; fig. 16), can serve to establish a norm for "academic" compositional differentiation; this painting reveals the hierarchical ordering of composite elements that academics advocated. The structured order of *The Ford* seems internalized, having its own sense of scale and system of spatial recession. When the viewer imagines himself to "enter" this painting, he has no difficulty in moving from part to part, "through the landscape," for he is guided by continuous visual transition or passage. He never confronts spaces or objects (rendered as patches of color) that attract him equally or simultaneously because each area of the painting holds a unique position in the compositional hierarchy. The foreground, for example, reveals patterns of light and shade (primarily warm greens and browns) that shift gradually as one glances either from right to left or from the illusionistic "near" to the illusionistic "far" (bottom to top).

The details of *The Ford* exhibit a well-tempered variety. A group of figures in the central foreground is rendered with a pattern of differentiated light similar to that seen in the surrounding landscape. One female figure, clothed primarily in white and ochre, constitutes the principal highlight. Two pairs of figures are in dimmer illumination, with the female of each pair highlighted and more luminously colored than the male. This pattern of subtle opposition and variation extends into the vegetation of the middle-ground. To the extreme left of the picture an aged tree trunk bearing only a few live branches contrasts with a neighboring mass of healthy foliage.[6] Within that mass, one tree with warm yellowish leaves serves to animate the dominant cool green tones of the others, while the play of highlight and shadow gives definition to each individual tree in the group. In like manner, the presence of a decaying tree beside healthy ones actively differentiates an opposing mass of foliage to the right of the river.

The river itself becomes the scene of additional compositional labor, as Claude tints deep blues off into paler tones in order to create the effect of a gradual spatial

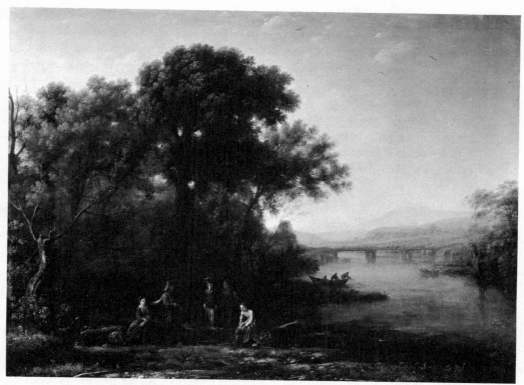

16. CLAUDE LORRAIN, *The Ford*, 1636. The Metropolitan Museum of Art, Fletcher Fund, 1928.

transition. There are two groups of boatmen on the river; here, too, the artist seeks maximal compositional variety by placing one group relatively near (large in scale) and toward the left bank, and the other far (small) and toward the right. A similar systematic variation from larger to smaller forms and from warmer to cooler tones (greens and ochres to blues) characterizes a passage of hills and valleys beyond a bridge. Above the distant bluish mountain slopes the sky is pale and yellowish, its color gradually shifting to a cooler and progressively deeper blue toward the upper margin of the painting. In sum, there are no areas of abrupt juxtaposition and none of the "flatness" of which Fromentin might complain. Nuances of hue and especially of value indicate a compositional ordering likely to be the product of a careful deliberative technique.

This type of composition, associated not only with Claude but also with other French masters, structures many of Corot's landscapes, especially those of his early career. Indeed, Corot was well known for the care with which he established relationships of chiaroscuro values within his naturalistic views. According to Fromentin, his paintings became formularizations of the laws for the use of values.[7] And Blanc, on his part, compared Corot to Claude as an artist capable of presenting the "sense [*sentiment*] of the ideal through the sensation of the real."[8] Corot, in other words, did not merely imitate nature, but maintained control over his technique for

the sake of poetic expression. Most critics recognized "poetry" in Corot's work; this quality had been given a general definition by Théophile Thoré, who called it the "opposite of imitation. It is invention, it is originality, it is the manifested sign of a particular impression. Poetry is not nature, but the feeling [*sentiment*] that nature inspires in the artist."[9]

Notes from Corot's own hand and accounts of the artist's conversations indicate that he thought systematically about his technical procedure as a means to establish his personal vision; in fact, he seems to have followed the same hierarchy of expressive devices that Blanc established in his *Grammaire*. In undated notes, Corot advises the artist to consider first drawing and the general compositional arrangement, then chiaroscuro values (arranged in sequence from dark to light), then color, and finally execution or brushstroke.[10] Corot even employed an abstract system of notation, involving circles and squares, to aid him in arranging the areas of light and dark in his compositions.[11] This device may have facilitated the recording of transient effects of natural illumination, but it is also evidence of the systematic quality of the technical procedure.

The results of Corot's refined and conventionalized approach to rendering landscape effects appear in his *View of Genoa* (1834; fig. 17), a small painting, richly detailed. As Claude often did, Corot locates his primary subject, the city itself, in the central middle-ground, and he frames its illuminated brilliance with contrasting darker areas situated to the left and right. The foreground consists of relatively dark tones of great variety—foliage of greens, ochres, and browns differentiated in terms of both value (dark and light) and hue (warm and cool). As the darker masses to the left and right of the illuminated city recede illusionistically from the extreme foreground (the bottom edge of the painting), they culminate in architectural structures, a villa at the left and a tower at the right, which vary both in form (the relatively massive horizontal opposed to the slender vertical) and scale (the larger and relatively near opposed to the smaller and relatively distant). At any point of comparison between the two landscape masses flanking the city (or rather framing it from the central foreground and sides), differentiation or variation will be noted. For example, in the immediate foreground the central area of landscape is relatively dark, whereas lighter tones characterize the areas to the left and right. And these two areas themselves are dissimilar since the right side appears at a lower spatial level than the left and is defined by a more complex pattern of chiaroscuro modulation. In general, Corot's very simple composition avoids the symmetry one might at first imagine from a verbal description of the arrangement of his subject. The artist accomplishes this through the use of a complex chiaroscuro system, a unified but not uniform light. At the same time he achieves an effective logic of expression by placing his central subject in the composition's highest illumination and by using the surrounding, contrasting forms to direct vision toward it. According to traditional standards, Corot has chosen his subject and his means of expression carefully, leaving little, if anything, to chance.

Along with Delacroix, Corot was one of a few French artists who received nearly universal acclaim in the 1860s and 1870s. His more conservative critics tended to appreciate his "poetry," the expression of his thought through natural effects, while his more radical admirers, such as Zola, emphasized his extreme fidelity to nature.[12] Corot himself, especially in his later years, is recorded as having made remarks that Zola, the impressionists, or any others especially concerned with originality would have applauded. Many of these statements seem inconsistent with the artist's careful account of his own conventionalized technique. In 1872, for example, Corot spoke of interpreting nature "with naïveté and according to your personal feeling, disassociating yourself entirely from what you know of old masters or contemporaries."[13] And in 1874 he claimed: "No one has taught me anything. . . . Yes, I put white in all my tones, but I swear to you that I do not do this according to a principle. It's my instinct that urges me to do this and I obey my instinct."[14] In sum, Corot, like Couture, minimizes the role of system and codified learning, while bringing impulse, instinct, and chance encounter to the fore. Furthermore, his sense of the "impression" is that of the impressionists themselves: he conceives of it as the spontaneous interaction of self and nature; hence, the "first impression," the object of his art, involves both "imitation" of nature and the expression of personal emotion.[15]

Corot's concern for spontaneity seems to have led him to distrust the orderly devices of compositional arrangement, even those he had so carefully studied himself throughout his long career. The conflict he felt was, of course, a common one. Paillot de Montabert, an authority whom Blanc cited many times in his *Grammaire*, had made this pertinent observation in a text completed in 1843:

> The word "disposition" [meaning "willful arrangement," a term used to indicate that an artistic composition had been actively constructed rather than passively copied], although it signifies in the language of art a most essential condition, sometimes frightens the exponents of naïveté and spontaneity, and in consequence they are scared away also by the words "arrangement," "adjustment," "coordinate," "symmetry," "contrast," etc. [*arrangements, agencements, coordonner, symétries, contrastes, etc.*] . . . To be sure, an excellent composition should seem to be a fortunate chance effect; but it will not be at all excellent if, under this appearance of a fortunate accident, it does not allow one to discover the beneficial principle of the beautiful . . . the combinations from which result harmony [and] unity.[16]

Corot might well be included in Paillot's category of those "exponents of naïveté and spontaneity" unnerved by the apparent omnipresence of willful pictorial organization. This painter—both "poetic" and "instinctive"—could see the artifice of composition all around, perhaps in some aspects of nature as well as in art.

As if in verification of the genuineness of Corot's remarks on his own naïveté and his independence from past masters and fixed principles, many of the artist's later works (although enthusiastically praised by conservative critics) are not so easily analyzed as his *View of Genoa*. For example, his *Ville d'Avray* (usually dated ca. 1867–70;

17. JEAN-BAPTISTE-CAMILLE COROT, *View of Genoa*, 1834. Courtesy of the Art Institute of Chicago.

fig. 18) presents a difficulty in that it does not appear to focus on any central feature. Its willow trees occupy the compositional position analogous to that of the city of Genoa in the earlier painting; but, with regard to the spatial scheme, they stand in the foreground, not the middle distance. They are flanked by two other objects of interest, a building complex to the left and a receding river to the right. One must ask what constitutes the primary "subject" of this painting: the foreground composition of trees (with figures)? Perhaps the river itself? Or possibly Corot's general "impression"? Several parts of the image seem to vie for the viewer's final attention without any hierarchical resolution. For a traditional "academic," this situation might be experienced in terms of considerable discomfort; but, for an "independent" painter of originality, such lack of conventional resolution would signify a state of immediate consciousness, a wholeness existing prior to the application of any differentiating concepts or techniques.

In *Ville d'Avray*, Corot presents an unconventional uniformity of elements and reinforces this lack of differentiation through the particular quality of his chiaroscuro. Here light is distributed much more evenly than in Claude's *Ford* or in Corot's own *View of Genoa*. This can be seen, for example, in the sky, which is rendered nearly in monotone. In contrast, the sky of *View of Genoa* exhibits transitions from lighter to darker tones and from warm pinks and violets to cool blues; such conventional variation gives this area of space its vaulted and volumetric character.

18. JEAN-BAPTISTE-CAMILLE COROT, *Ville d'Avray,* ca. 1867–70. Gift of Count Cecil Pecci-Blunt, National Gallery of Art, Washington, D.C.

The river depicted in *Ville d'Avray* once again raises the question of spatial differentiation. Slight variations in tone indicate that this river runs back into an illusionistic distance at the right side of the picture; but in its compositional placement it seems to extend laterally across the picture, separating foreground from middle-ground. Yet Corot confuses this potentially clear spatial distinction by the central position of the trees and by their coloring. The two willows link the near bank of the river to its far side, denying spatial differentiation; these trees have obvious physical roots in the foreground bank, yet their foliage, which extends into the compositional area of the opposite bank, is a cool green more similar to other tones of the middle distance than to the somewhat warmer greens of the foreground grasses. Moreover, a single small building, seen through a gap in the foliage of the left-hand tree, appears to project forward; it further confuses any sense of systematic order to be given to the illusionistic spaces of the painting.

Additional comparative material from Claude's oeuvre sets Corot's "compositional" manner into greater relief—or perhaps greater flatness and uniformity. The general topographical features of the landscape depicted in *Ville d'Avray* resemble those seen in Claude's *Landscape with the Voyage of Jacob* (1677; fig. 19), which shares the technical qualities of Claude's earlier painting, *The Ford.* In the *Voyage of Jacob* composition, a group of trees forms a strong central focus; and an architectural mass at the left and an area of foliage at the extreme right serve as framing elements as well

19. CLAUDE LORRAIN, *Landscape with the Voyage of Jacob*, 1677. Sterling and Francine Clark Art Institute, Williamstown, Massachusetts.

as secondary accents. If one views these paintings by Claude and Corot from left to right as two-dimensional patterns, the corresponding sequences of buildings, trees, and foliage seem quite alike. Furthermore, as in *Ville d'Avray*, a river traverses *Voyage of Jacob* as if flowing from left to right and front to back. Claude, however, defines each segment of his river as it courses "through" his composition in a manner Corot simply does not follow (although one must assume that he had the capacity to do so). Claude uses the flow of the river—in addition to the general modulation of chiaroscuro and color from foreground to background—to establish a spatial progression marked by clear steps; he depicts the river (perhaps in combination with a tributary) as winding around the central trees so that it appears first before them and then behind them, distinguishing a singular location for the trees not only beside the framing elements of architecture and foliage, but decidedly in front of them. As if to reiterate the spatial hierarchy, Claude presents a caravan of camels, sheep, cattle, and goats winding through the illusionistic space of the composition, parallel to the river. The viewer observes a voyage in duplicate—the river's and the caravan's (Jacob's)—and can see all elements of the landscape as specific spatial markers. Corot's composition, in contrast, lacks just this specificity of spatial definition.

In general, in *Ville d'Avray* Corot uses neither a hierarchical ordering of dark and light values nor one of warm and cool hues, nor does he establish the sense of a single spatial sequence from an imagined "front" to an imagined "back" of his depiction of nature. Within the painting's surface of predominantly cool coloration, the noticeably warmer areas are found both in the foreground (in a figure at the left) and in the middle distance (in the building complex on the far bank). The foreground area contains a number of specks of impasto to define highlights on the herbage and foliage. The middle-ground has less of this textured paint, but the difference is slight. Within the foreground, the artist distributes these highlights quite evenly; they do not themselves suggest a variation of compositional parts. In addition, the two trees, along with two human figures, line up across this area, as if the artist had taken no pains to group them in a picturesque or expressive manner. This is the kind of straightforward presentation for which impressionists such as Pissarro were often criticized during their earlier years; it was said simply that they lacked "composition."[17]

Given the evidence of *View of Genoa* and many similarly conventional paintings in Corot's oeuvre, the artist must have known the extent to which much of his later work departed from established norms. This does not necessarily indicate any rejection of the earlier manner. Perhaps Corot, in defense of his own reputation, would have claimed that all of his works had been painted in the same spirit of "naïveté," with the same spontaneity and speed of execution, and the same "sincere" fidelity to nature. Nevertheless, to outside observers, *Ville d'Avray* would seem less conventional and more original than *View of Genoa*. The later painting would appear less differentiated compositionally, and hence less deliberate. It would serve to convince the viewer of the artist's joint discovery of nature and a "self," instead of demonstrating his self-conscious and competent application of technique. Corot's earlier works of the type of *View of Genoa* succeeded according to standards of orderly representation. For some viewers, however, they might fail once their technical link to the tradition of Claude was recognized. Corot would then appear as an imitator—not an imitator of nature, but of art, of Claude.[18] He would seem to present himself as a maker, not a finder. Works of the type of *Ville d'Avray* solve this procedural dilemma and the problem of psychological projection it entails: Corot's technique of originality yields an image that confounds any attempt to translate it retrospectively into the Claudean system of compositional differentiation, and his projected self-image concomitantly establishes its individuality.

Thus Corot's connection with the impressionists would have been discerned even if there had been no personal contact between the older man and the young painters who admired him. The impressionists appreciated the independence they saw in Corot's painting and shared his concern for the development of a personal "style" free of the traces of academicism. And when Théodore Duret, one of their supporters, wrote on naturalism in 1867, he chose Corot as a prime example of an artist whose "original style" stemmed from direct contact with nature, uninfluenced by the art of others.[19] In general, even for critics who did not advocate such a radical break

with the past, Corot appeared as a model of independence and originality. Raymond Bouyer would label him the "petit-fils de Claude," but in its context this remark implied no derivative position. Instead, Bouyer argued that Corot's disavowal of academic "servitude" indicated that he had understood the liberating value of Claude's example; he had honored Claude's original "eloquence" by resisting the stylistic conventions established in the work of the master's own "academic" following.[20] In other words, if Corot resembled Claude, it was not so much with respect to acquired procedures, but rather with respect to originality.

<div align="center">« »</div>

Monet inherited the same "original" spirit. Having isolated himself at Etretat in 1868, he declared that his works would henceforth escape comparison with those of all others and would become "simply the expression of what I shall have personally deeply felt."[21] Specifically, he wanted to avoid the ideas he received in Paris, concepts and procedures that would inhibit his expression. He spoke of rejecting acquired knowledge in order to concentrate on experience.

A year earlier, in 1867, Monet had worked during the summer at Sainte-Adresse and had produced a series of remarkable studies of the coastline. These paintings demonstrate that the artist had already succeeded in abandoning many of the structures of the past; they lack even the reminiscence of hierarchical order visible in Corot's *Ville d'Avray* of about the same date. They are as "modern" as the atmosphere of bourgeois holiday that they depict. One of these canvases, *Beach at Sainte-Adresse* (fig. 20), offers the pictorial negation of Blanc's fundamental program: proceed in orderly fashion from a linear compositional framework, to a systematic application of chiaroscuro, and end with a harmony of expressive color. In opposition to this order, Monet differentiates the parts of his composition primarily by means of color, and, to judge by conventional standards, hardly differentiates at all. The parts of his composition are so similar in visual intensity that his work must appear either entirely uniform or completely fragmented, a juxtaposition of elements never cohering into a whole. In the following analysis, it will be assumed that Monet did not work out of ignorance of the standard, but rather, as he himself implies, with a desire to be as individual as possible for the sake of being true to the double origin, nature and self.

Obviously, Monet's technique, as Duret and others noted, recalls that of the spontaneous outdoor sketch. By employing a very broad brushstroke, the painter—whether working quickly or not—makes reference to a rapid speed of execution and, by implication, to the spontaneity and lack of deliberation in his own response to nature. This technique appears "instantaneous," fast enough to "capture" the transient impression, a momentary shift of mood in nature or in the artist. But Monet's technique is not that of the *conventional* sketch. He avoids an "effect" of the usual sort, a pattern of chiaroscuro that structures a volume of space while it simultaneously identifies a condition of illumination. His surface of color patches fails to provide, even in rudimentary form, the chiaroscuro that might characterize a completed painting. Instead the parts of *Beach at Sainte-Adresse* seem independently observed, at least by conventional standards, without any resolution into a hierarchy. The appearance of

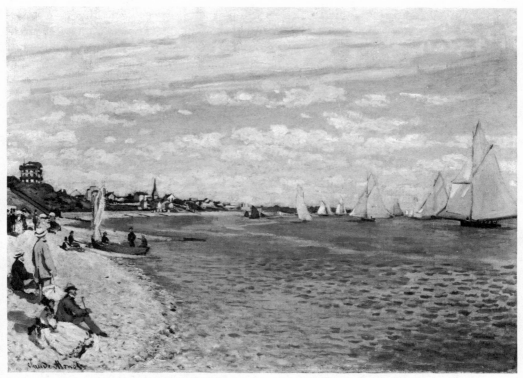

20. CLAUDE MONET, *Beach at Sainte-Adresse*, 1867. The Metropolitan Museum of Art, bequest of William Church Osborn, 1951.

an expansive depth of space in this painting derives not from Monet's application of color but from the nature of the motif itself, a shoreline receding to a distant horizon. There is no constructive "use" of perspective; rather than build a volumetric space, the painter appears to "copy" what is inherent in the natural site. He creates no more volume than what the configuration, or prefiguration, of his viewpoint provides. His aim is to see only "what is there."

The academic sketch, or landscape *étude*, was intended to establish the character of the general illumination *in a picture*. Monet's "naïve" vision is no less calculated than the academic's; and, in addition, he contrives to distinguish his work from theirs. He creates a light that one might consider either as extremely particularized (he carefully renders local shadows, but not a broad contrast of light and shadow) or as extremely generalized (the intensity of his hues remains nearly equal everywhere). By either estimation, Monet seems to present uniformity rather than the hierarchical unification that Charles Blanc and other academics would desire. But in the artist's own terms (of a later date, 1890), he has rendered " 'instantaneity,' . . . the same light spread everywhere."[22] His pictorial effect of spontaneity depends on his conveying the natural effect that he supposes to perceive most immediately—uniform illumination.

Any differentiation or hierarchical variation in this lighting effect, other than the re-
cording of local small-scale variations associated with direct observation, would indi-
cate deliberation and artifice. In other words, Monet must avoid the imposition of
what would be recognized as a familiar pictorial effect of illumination, the broad dif-
ferentiation of light achieved by conventional chiaroscuro, just what the traditional
sketch provided. Because it had been acquired as conventional, the technique of the
traditional sketch could no longer be regarded as a means to originality.

A more concrete description of *Beach at Sainte-Adresse* will further demonstrate
the signified "originality" of Monet's own sketchlike composition. The immediate
foreground of the painting divides into three areas. To the left, the artist has painted
the beach primarily with gray, umber, and ochre. At the center, he has employed dull
yellow-green, dull blue, and green in the water. To the right, the colors of the water
are brighter: green, yellow-green, and blue-green. These three areas of modulated
color can be followed "back into" the seascape (i.e., upward from the bottom of the
painting) according to a shift—itself recognized as conventional—in the scale of the
individual strokes, from larger to smaller, and in their degree of independent articula-
tion, from clear distinction to relative lack of distinction. When the view passes from
one of these areas of color to another, the conventional structure vanishes and the
radical nature of Monet's technique becomes evident: no spatial progression, no sys-
tematic variation in illumination, is indicated. These areas of beach and water do not
lead to a central subject nor do they set one another off in a single orderly sequence.
All seem capable of competing for attention as if, as I have stated, one were viewing
either a fragmented image or an unusually integrated one. In the case of the frag-
mented image, the abrupt juxtaposition of brilliant hues would evoke a "naïve" vi-
sion recording in a simple manner only the colors nature seems to provide; this is the
technique Duret associated with the Japanese, who, it was often said, had never mas-
tered "European" chiaroscuro. In the case of the integrated image, the uniformity of
the illumination would indicate that Monet employed no technique at all, for he im-
posed no devices of differentiation upon his vision. In this light, the *Beach at Sainte-
Adresse* serves to signify only "what the artist sees," a "copying" of nature. Simulta-
neously, such an image must convey what Monet, in his words, "personally deeply
felt," since what he may have learned from others can, supposedly, be nowhere in
evidence in such an ignorant style.[23]. Here the departure from compositional con-
vention is as essential to the depiction of nature and the artist's emotions as is any mi-
metic aspect of the rendering. The viewer's recognition of this deviance allows the
details of the scene to be perceived as "faithful" and "sincere."

A second painting of *Beach at Sainte-Adresse*, also of 1867 (fig. 21), can be analyzed
similarly in terms of the interrelationship, or lack thereof, between its parts. By the
Claudean standard, its composition, too, must fail, or at least appear extremely awk-
ward. Objects of interest within the picture seem either too similar in scale (the
beached rowboats at center and left) or too dissimilar (the figural group by the boats
and the much smaller figures sitting on the beach). Such failure to establish a definite
pattern of variation makes the transition from one area to another difficult, as if no

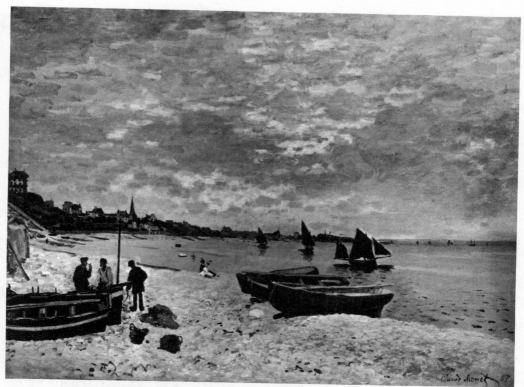

21. CLAUDE MONET, *Beach at Sainte-Adresse*, 1867. Courtesy of the Art Institute of Chicago.

gradual passage were conceivable. Indeed, the composition invokes Zola's description of Manet's painting, given the same year: "he groups figures [or other objects] before him, somewhat haphazardly, and he cares subsequently only to fix them on the canvas as he sees them. . . ."[24] Monet's unconventional composition might qualify as one "found" in nature.[25]

<div align="center">《 》</div>

Robert Herbert has shown that throughout his career Monet deliberated over his choices of color and often consciously disguised the true nature of his technical procedure in order to maintain an appearance of spontaneity. He applied impasto to create, as Herbert writes, a "texture of 'spontaneity.' "[26] Given the history of modern art criticism, Monet must be judged to have succeeded in his deception; he has been immortalized as the painter of the moment. But Cézanne, too, although known in the later critical literature for his reflection and deliberation, developed a style of spontaneity and immediacy; Cézanne, too, employed the technique of originality.

In 1866, Cézanne wrote to his good friend Zola concerning the distinction between artificial studio illumination and natural outdoor light—a distinction which was at that time becoming so important to critics such as Zola and Duret, and artists such as Monet and even Regnault. Cézanne insisted that the old masters' representations of outdoor scenes lacked the "original" quality that characterized nature; having

been painted by traditional studio means, they were "chic," that is, refined in an artificial and conventional manner.[27] By the early 1870s, profiting from the example of Pissarro, with whom he worked closely, Cézanne had developed his own plein air style. He employed unusually bright hues and an unconventional distribution of values.

Cézanne's *View of Auvers*, also called *Auvers: Village Panorama* (ca. 1874), reveals one of the artist's typical palettes and a manner of execution common in this period of his career (fig. 22).[28] As a panoramic view of a town, this painting bears comparison with Corot's *View of Genoa*: both seem to set architectural features against a surrounding landscape and a distant vista. In *Auvers*, Cézanne suggests distance through the progressive diminution of the architectural forms and the relatively loose, broad execution of the background hills and sky. In addition, he uses a somewhat duller coloring in these background areas. Yet *View of Auvers* embodies no clear compositional pattern of differentiation, for its hues, values, and textures are distributed evenly enough to create a sense of uniform illumination, a light that encompasses but does not determine or define. Bright primary hues—red, blue, yellow, brilliant green—range across the picture along with accents of white.[29] Unlike Corot's *Genoa*,

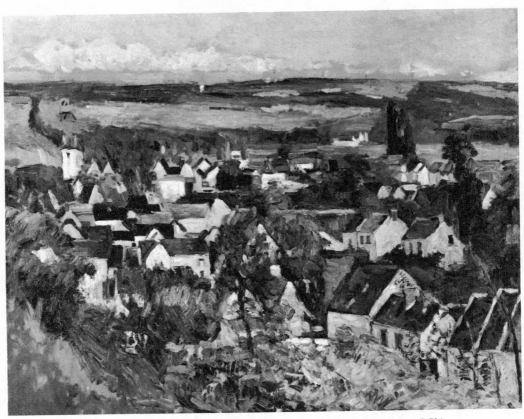

22. PAUL CÉZANNE, *View of Auvers*, ca. 1874. Courtesy of the Art Institute of Chicago.

Cézanne's *Auvers* does not frame a highlighted architectural subject by a contrasting expanse of foliage, nor does it center one element among others of decidedly different visual character. The village itself, like the general illumination, seems expansive and diffused. If the row of houses in the right foreground hints at a differentiating diagonal recession, ultimately this configuration appears only as evidence of the artist's direct observation. Cézanne's viewers would not see it as a preconceived pictorial device, the application of a law of perspective, because there is no corresponding variation in illumination (i.e., chiaroscuro modeling). Similarly, the rising slope of land at the left foreground cannot serve as a conventional *repoussoir* device because of its relative lack of differentiation in terms of value—its green coloration too readily conforms with that of the central area which it might otherwise set off.

Cézanne did not paint his *View of Auvers* out of ignorance of convention, but by way of an intentional forgetting, the kind of attitude that had enabled Monet to see original "truth" at Sainte-Adresse. The artist certainly knew how to employ chiaroscuro modeling; he had done so, albeit in a simplified, condensed form, in many portraits of the late 1860s.[30] If some of Cézanne's later comments may be allowed to bear on the interpretation of *View of Auvers*, they confirm the hypothesis that he wished to reject traditional technique and become an "original" finder, sensitive to whatever nature might lay before him. He advised Émile Bernard in 1905 that nature "falls before our eyes [and] gives us the picture . . . [we must] give the image of what we see, forgetting all that has existed before us."[31] And in several letters to his son in 1906 he complained that Bernard's own art could not succeed because he was too closely bound to what he saw in museums, learned in academies, or merely conceptualized by way of his own theories.[32] Cézanne's flight from artistic convention identified him with the independent impressionists to a degree that Bernard never fully comprehended. At the end of his life, he would probably still have approved the interpretation of impressionism, once offered by Émile Blémont, that he had first endorsed in 1876. Blémont wrote that the impressionists were striving to

> render with absolute sincerity, *without arrangement or attenuation*, by simple and broad techniques, the impression that aspects of reality evoked in them. . . . And as there are probably no two men on earth who perceive the same relationships with the same object, [the impressionists] *do not see the need to modify their personal and direct sensation according to any convention whatever*.[33]

All who avoid conventional practice maintain their native uniqueness; all such artists preserve their originality.

Clearly, Cézanne's own attitude demanded a *technique* of originality, for he never went so far as to deny the importance of technique itself. He accounted for his own lack of "realization," the incompleteness of his art, and his reluctance to exhibit, by noting that he had not yet found the proper means of expression.[34] Even as he stressed fidelity to nature in the same radical manner that Zola had, he spoke also of technical mastery: "One is neither too scrupulous, too sincere, nor too submissive before nature; but one is more or less master of his model, and above all his means of

expression. One must penetrate what lies before him, and strive to express himself as logically as possible."[35]

Cézanne's allusion to logic appears in the context of a letter to Bernard written in 1904; it may come forth because of his having been drawn into a theoretical discourse in which he never felt at home. This matter will be discussed in chapter 9, however; the artist's choice of specific terms is not the present concern. Instead, one must ask—in a rather naïve fashion—whether anything approaching "logic" or a system seems present in the personalized, "original" vision of nature that Cézanne paints. One might observe, with some irony, that the artist exhibits decidedly unconventional aspects of technique, but *repeatedly*, as if they bore some special signification that becomes, at least within his art, "conventional." In Morellian terms, he may merely be revealing his own true idiosyncrasy with an appropriate consistency. And here, as in the cases of other modern artists, personal "style" becomes so prevalent that it dominates, even devours, the base of traditional representational imagery that hosts it—the artist's image becomes all "temperament," "identity," "instinct," or "unconsciousness." But if Cézanne's repetitive (or perhaps systematic) technical procedure is something more than what is found either in the self or in the experience of nature, if it is controlled and made, its repetition would indicate the mastery of an active *representation of originality*. As a maker, the painter becomes free to employ his technique *in any situation*.

Any standardized method can evoke academicism; and at first it may seem that Cézanne acquires an academic habit. When he paints images of his own imaginative invention or those derived from preexisting representations (photographs, graphic illustrations, other paintings), he repeats the same technical features to be seen in *View of Auvers*. He does so despite the fact that there can be no immediate observation of nature *en plein air* involved in this studio practice. For example, his *Bathers* (ca. 1875–76; fig. 23), an "awkward"[36] and clearly artificial arrangement of six female nudes in a landscape, contains the same brilliant yellow-green that accents the foliage in *View of Auvers*. A somewhat later work, one which may have its source in a black-and-white illustration, *The Pond* (ca. 1880; fig. 24), also displays this distinctive color as part of a simple pattern of relatively pure hues.[37] It would be a mistake to interpret the painter's arbitrary technical repetition as an aspect of the academic, because what the artist repeats is the very sign of original and direct observation. His harsh yellow-green, made by mixing blue or green with a pure yellow, exemplifies the type of technical feature that Blémont and other critics interpreted as the trace of an "unattenuated" or spontaneous recording of vision. The association held even when the mark that triggered it was seen in the context of a rather contrived image and within a pattern of systematic "modeling" (Cézanne's repeated sequences of blue-green, green, and yellow-green). Such a yellow-green tends to appear brighter than its position on a scale of values would indicate. Accordingly, it was avoided by those artists, Claude included, who were concerned with an orderly hierarchy of values within their painting; they would employ instead a weaker variation of this color, mixed perhaps from blue or black and a duller type of yellow pigment. Cézanne's unusual color

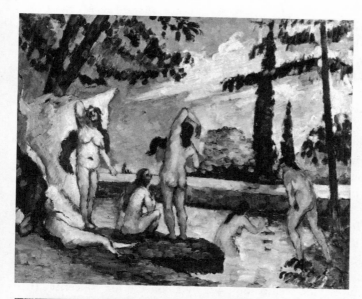

23. PAUL CÉZANNE, *Bathers*, ca. 1875–76. The Metropolitan Museum of Art, bequest of Joan Whitney Payson, 1975. (1976-201-12)

24. PAUL CÉZANNE, *The Pond*, ca. 1877–80. Courtesy, Museum of Fine Arts, Boston. Tompkins Collection, Arthur Gordon Tompkins Residuary Fund.

serves to *signify* in all his painting, whether of observed or imagined subjects, that his technique is original in the double sense: it is derived from his direct "unattenuated" observation of nature and is independent of the technical tradition it clearly defies. In other words, the technique (or resultant style) of Cézanne's art communicates a message of "direct observation" even when the subject matter can be recognized as an imaginative invention.[38]

It might be argued that Cézanne paints in terms of parts rather than wholes. He moves from part to part on his canvases, unifying the whole only by means of the

uniformity of his coloristic illumination, his "atmosphere." "Draw," he said to Bernard, "but [remember that] it's the light-reflection that is *enveloping*; light, by the general reflection, is the envelope."[39] Drawing, the foundation of compositional differentiation, becomes subordinate to unifying color. By working from part to part with patches of color, the artist could avoid the sense of a preconceived compositional hierarchy and would seem to respond only to immediate "sensation."[40] His compositions would appear to materialize only as he submitted his vision to a relatively passive observation, and the order of his picture would be that of lived experience rather than learned convention. Defined by juxtapositions of color, rather than by line or chiaroscuro, Cézanne's technique of originality, like Monet's, develops in opposition to the accepted notion of controlled artistic procedure. Indeed, when the artist-critics R. P. Rivière and J. F. Schnerb observed and questioned the master in 1905, they noted that he worked from part to part on his canvases, allowing one form to define the adjacent one, as if the end of this free process could not be foreseen. Moreover, they discovered that Cézanne was aware of the distortion and fragmentary nature of his image; yet he would make no corrections, being unwilling even to cover awkward bare patches of canvas. He seemed obsessed by a concern for "sincerity" (Rivière's and Schnerb's term) to the point of accepting absolutely the results of his own immediate pictorial expression.[41]

The paintings, whether "finished" or not with respect to covering the entire canvas, frequently do seem incomplete, as if more parts could easily be added. The artist's images often reach the edges of the canvas indecisively, or lack a central focus. This is a factor of his having painted many parts (sometimes simply many strokes) with equal attention and intensity, denying them any differentiating hierarchy.[42] The so-called *Paysage d'hiver* or *Winter Landscape* (now ascribed by Rewald to the autumn of 1894[43]; fig. 25) is obviously unfinished, but it is especially important to note that its individual figurative elements—farmhouse, trees, foreground field—are in themselves incomplete. The "parts" reach no more resolution than the whole, nor do they seem certain to attain individually any integral form. These figurative elements seem to exist only in their interconnections, and the composition appears to expand by addition of details, minor details, adjacent to those already defined. Patches of blue sky, for example, are placed primarily where they border trees or the farmhouse. Moreover, although his total image remains incomplete, the painter seems already to concentrate on adjustments among the details, rearranging the contrasting hues in the foreground field (a pattern of greens and brownish oranges).

Two interrelated features thus define Cézanne's single technique of originality: his concern for detail and his development of a unifying pattern. This combination of forces recalls the paradox of Monet's earlier Sainte-Adresse paintings in that the works appear both fragmented and uniform. The results of this "original" impressionist manner are evident in Cézanne's views of the vicinity of L'Estaque, painted during the mid-1880s. *Saint-Henri and The Gulf of Marseilles* (ca. 1883–85; fig. 26) and *The Gulf of Marseilles Seen from L'Estaque* (ca. 1883–85; fig. 27) are typical examples from the series of studies made or at least initiated at this site. The vantage point

25. PAUL CÉZANNE, *Winter Landscape*, 1894. The Philadelphia Museum of Art. Given by Frank and Alice Osborn.

of the Philadelphia version is farther from the bay of Marseilles than that of the New York version, and the Philadelphia painting remains in a decidedly sketchlike state; but neither work presents an arrangement of the town, bay, and distant mountains that orders these elements into a traditional compositional hierarchy. In both paintings, evidence of the artist's close attention to peculiarities of the site—contour lines of rock against the sky or bay, architectural elements such as chimneys, or the twisting tree branches in the Philadelphia version—serves to indicate "submission" to nature, not the manipulation of form that Blanc might seek as a sign of the studied expression of an artistic ideal. Cézanne does have a definite manner of execution; he chooses his colors carefully and develops patterns of contrasting warm and cool hues to evoke the powerful vibration of a uniform illumination. But all this is done with the artist assuming, even feigning, the role of the finder, avoiding any compositional effects that might be recognized as artifice.

Cézanne began the Philadelphia version by sketching a few pencil lines to indicate the placement of some of the most important divisions in the natural site, the meeting of land and sea, for example. These lines are very tentative, just as those of many

26. PAUL CÉZANNE, *Saint-Henri and the Gulf of Marseilles*, ca. 1883–85. The Philadelphia Museum of Art. Mr. and Mrs. Carroll S. Tyson, Jr., Collection.

of his sketchbook drawings; the formal distinctions that they create remain subject to continual adjustment. The artist subsequently applied his paint with fluid strokes, leaving their directional quality evident. These individual marks are relatively uniform in size; they suggest a uniformity of interest or of detail in the visual field. Nevertheless, as an example of the human transformation of nature, this "field" of observation is quite varied: both natural and cultural structures—foliage, mountains, buildings—are to be seen. The scale of each depicted architectural element corresponds naturalistically to its distance within the implied space of the motif, and thus each element seems isolated in its integrity. But the lack of variation in the brushstrokes that constitute these identifiable objects and their common intensity of coloration contradict this spatial differentiation. As a result, the individual forms and structures dissolve back into the uniform "field"; the architectural elements, along with the patches of foliage, merge into a general pattern of color characterized by a relatively even distribution of contrasts both of dark and light and of warm and cool. Strokes of reds and yellows that depict the architecture become parts of a single set of warm tones which includes areas of exposed earth and rock. This extended range of

warm color opposes the patches of cool vegetation, "modeled" with yellow-green, pale green, green, deep green, and blue-green. Color therefore articulates Cézanne's field of vision more than any variation in the line that shapes form, or in the chiaroscuro that models form. Accordingly, contrasts of hue define the background mountains more than contrasts of value do; this "modeling" ranges from blue-green, blue, and violet, to tones of red-violet and touches of red. Admittedly, the color contrasts in the bay and distant mountains are somewhat subdued; but these areas, as well as the immediate foreground, are the least heavily painted, the least attended to, and perhaps, in Cézanne's terms, the least experienced or felt. They are less characteristic of the artist's "complete" vision than are the other areas of this painting.

The New York version of *L'Estaque* appears quite finished by comparison with the Philadelphia version and many other works of similar date. Unlike Corot's *View of Genoa* or even his *Ville d'Avray*, this image seems a motif seized from nature with genuine immediacy rather than an arrangement of nature chosen in advance for the canvas: the architecture of the town is disrupted by the edges of the canvas itself, as if the composition had been generated part by part, its final extent not to be predicted. The illumination is strikingly uniform. The artist restricts variations in chiaroscuro value to local areas such as patches of foliage and especially the geometric volumes of

27. PAUL CÉZANNE, *The Gulf of Marseilles Seen from L'Estaque*, ca. 1883–85. The Metropolitan Museum of Art, bequest of Mrs. H. O. Havemeyer, 1929. The H. O. Havemeyer Collection.

28. PAUL CÉZANNE, *Mont Sainte-Victoire*, ca. 1885. The Metropolitan Museum of Art, bequest of Mrs. H. O. Havemeyer, 1929. The H. O. Havemeyer Collection. (29.100.64)

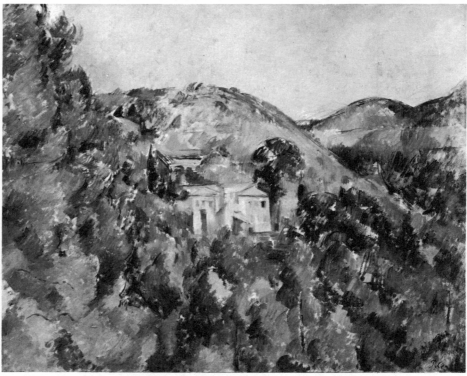

29. PAUL CÉZANNE, *View of the Domaine Saint-Joseph*, ca. 1888–98. The Metropolitan Museum of Art, Wolfe Fund, 1913.

architectural elements; it is to be expected that even a "spontaneous" rendering of nature would record strong shifts in light and shadow where architectural planes stand at right angles to one another.

The colors of the more distant parts of the town do not diminish in intensity, nor is there significant variation in the illumination on the bay from the near shore to the far. The entire landscape area of foreground and middle-ground becomes unified in the repetition of warm ochres and oranges which contrast with cool greens and some accents of blue; similarly, the bay displays a regular pattern of blue and blue-green with some touches of blue tending toward blue-violet. In this painting Cézanne confined the remaining compositional area, the sky, to minor variations of a single hue (blue-green); but in other paintings, especially later ones, his presumably "clear blue" skies exhibit a scintillating pattern of juxtaposed hues (an effect Duret had once deemed entirely characteristic of impressionist originality). For example, in *Mont Sainte-Victoire* (ca. 1885; fig. 28), tones of pale blue-green vibrate among pale blues in the area of the sky to give the sense of luminosity—now as much a part of Cézanne (his "style") as of nature.

Additional examples of the artist's landscape style similarly offer the viewer only meager spatial illusions, but the most generous effects of color and light. In *View of the Domaine Saint-Joseph* (ca. 1888–98; fig. 29) a predominantly pale blue sky displays its own variety in touches of pale blue-green and pale violet. This extended chromatic range, an abundance of hue where perhaps academic convention might have advised a simple stress on value, characterizes the entire rendering of this very reductive compositional motif. The painting as a whole exhibits a full spectral range, with the warmer hues distributed as accents set against the dominant cooler blues and greens. The depicted foliage and background hills consist of patches of blue, blue-green, green, yellow-green, yellow-ochre, orange, red, red-violet, and violet—the list approximates a verbal rendering of a color circle. The architecture at the center of the motif is the only interruption in this pattern. Cézanne accents the details of the estate buildings in strong blue, red, red-violet, and green, all set against the basic yellows and pale oranges of the architectural planes. Over the entire image he maintains such uniformity of light and intensity of color that compositional differentiation and the attendant sense of artistic deliberation either pass unnoticed or indeed are not communicated by such a painting at all.[44]

Like the *Domaine Saint-Joseph*, Cézanne's *Pines and Rocks* (ca. 1896–1900; fig. 30; see also frontispiece) serves as still another example of an image developed in terms of contrasts of hue that are distributed nearly uniformly. In the area of "foliage" in the foreground of this landscape, patches of yellow-green, red-orange, and blue-violet create a coloristic field of brilliance, pure and simple. In the rocks above this area, the artist placed patches of dull green and ochre among the prevalent blues, violets, and red-violets; and in the upper part of the canvas, he added red-orange, ochre, and violet to the blues and greens of the sky and foliage. The red-orange of the tree trunks distributes still more warm color throughout this area of the image so that the cooler colors do not become decidedly dominant. Reciprocally, the linear integrity of these

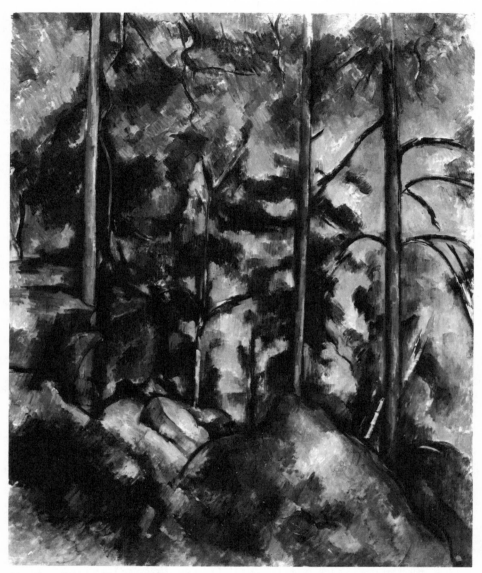

30. PAUL CÉZANNE, *Pines and Rocks*, ca. 1896–1900. The Museum of Modern Art, New York. Lillie P. Bliss Collection.

warmly colored trunks and branches splinters with the addition of contrasting cool color painted over the base of warm tones. In sum, Cézanne preserves the sense of an even distribution, or a tension, of warm and cool colors in nearly every area of his painting. Like the *Domaine Saint-Joseph* and so many other works, *Pines and Rocks* lacks the resolution associated with a spatial hierarchy. Conventional landscapes exhibited extended passages of both dark to light and warm to cool; they invited the eye along a path of illumination that one might follow in a clearly determined direc-

tion. Cézanne's paintings instead offer multiple and competing possibilities for movement. In facing them, a viewer might lose his pictorial orientation; Cézanne simply did not follow the usual visual rules.

The most thorough and reliable eye-witness accounts of Cézanne's mature technical procedure—those of Bernard (1904, 1907), Denis (1907), and Rivière and Schnerb (1907)—concur in stating the importance of the artist's use of contrasts of warm and cool colors and his subordination of both line and chiaroscuro to effects of hue. Like Monet before him, Cézanne thus inverted the conventional hierarchy of procedure established by Blanc and other academics: rather than working from line to chiaroscuro (value) to color (hue), he conceived his paintings in terms of relationships of color from the very start; his working process depended on the manipulation of color, the element traditionally believed to be least subject to rational control, the element of spontaneous expressive power. According to Bernard (and also Rivière and Schnerb), Cézanne believed that "there is no line, there is no [chiaroscuro] modeling, there are only contrasts. These contrasts are not given by black and white, but by the sensation of color." In other words, nature was perceived immediately as contrasts of color; from these relationships of hue, any pictorial order of shape or modeling would follow as if automatically.[45] Denis cited Bernard on this point, and amplified it: "In [Cézanne's] truly concrete perception of objects, form is not separated from color: the one regulates the other, they are indissolubly united. And moreover, in the execution, he wants to realize them as he sees them, by the same stroke of the brush." According to Denis, Cézanne's technique depends on his substitution of "contrasts of hues for contrasts of values . . . his system excludes certainly the relationships of values in the academic [*scolaire*] sense of this word, that is to say, in the sense of aerial perspective." Cézanne, then, eliminates the conventional spatial differentiation that might result from a progressive gradation of chiaroscuro, and favors instead a unifying pattern of brilliant hues. Denis observes that even in the background areas, Cézanne's canvases reveal the scintillating pattern of contrasting colors: "The entire canvas is a tapestry where each color *plays* separately and yet mingles its sonority in the ensemble. The characteristic aspect of Cézanne's painting derives from this juxtaposition, from this mosaic of separate tones gently merging one into the other." As a result of this technique, "the perspective planes disappear, [as do the chiaroscuro] values (in the sense of the École des Beaux-Arts)."[46] This was all for the good since Denis had considered conventional chiaroscuro an "artifice of composition."[47]

In sum, Cézanne's technique of originality was characterized primarily by a unifying and repetitious pattern of contrasting warm and cool colors that seemed to suppress, supplant, or simply supercede a differentiating chiaroscuro. His use of color *appeared* naïvely expressive, spontaneous. But it also could be seen as *signifying* the natural and spontaneous. Although it was a technique suited to an art of immediacy and passive discovery, it might be regarded either as innocently found or as willfully made. Cézanne's most important critics had great difficulty in deciding upon this matter. Their statements must be interpreted before a second and somewhat differently informed look at the painter's style is to be taken, and interpreted in turn.

One must become classical again by way of nature [*par la nature*], that is, by way of sensation.

CÉZANNE'S WORDS *as reported by Émile Bernard, 1904*[1]

9

Bernard and Denis Meet Cézanne:
Classical Tradition without Technical
Convention

C ÉZANNE'S REMARK, repeated in various forms in several of his letters, calls
for a reasoned originality; but it should not be interpreted as the rejection
of impressionism that Bernard attributed to the artist. For Cézanne, as for
Bernard, "classicism" signified any style of art governed by fundamental
principles of communicative expression.[2] Such art held the potential to reach all men
at all moments of history. Classical art, however, seemed dangerously close to the
conventional academicism that Cézanne deplored for its blind imitation—of art, not
nature. He warned Bernard and others to follow the venerated masters of classical
style only as guides to solving technical problems.[3] The modern artist's classicism
should not be *made* in imitation of the masters, but must be *found* in his own sensa-
tion, in his direct experience of nature. In this way one would effect the rejuvenation
of art, a return to the source, to the double origin, to nature and the self. When Cé-
zanne spoke of becoming classical *by way of nature*, he was stressing the role of indi-
vidual sensation and direct experience, just as naturalists and impressionists had
done. He was aware that the need for a renewed classical order had been presumed
by Bernard and others. Cézanne's point was to warn Bernard to attend to *nature* in
his classical art and to preserve it there.[4]

Bernard either did not entirely understand this advice or did not wish to acknowl-
edge the message. Instead of praising Cézanne for returning nature to classicism, Ber-
nard claimed that the artist had led the way in reintroducing classicism to the study of
nature. Cézanne's position was effectively inverted; and in his essay on the artist,
Bernard represented him to the public as no simple naturalist, but a mystic with sym-
bolist concerns.[5] However, when Bernard visited Cézanne at his home in Aix in Feb-
ruary 1904, and before he wrote the account based on this experience, he sent his
mother a letter including what appears to be a more candid assessment. Here he re-
vealed with some disconcertion that his "old Master" Cézanne, although "an excel-
lent man," was also "distrustful . . . misanthropic . . . cranky and strange." Further-
more, the "Master" had some surprisingly mundane notions about art: "Cézanne
speaks only of painting nature according to his personality and not according to [the
idea of] art itself. . . . He professes the theories of naturalism and impressionism. . . ."[6]

Yet in the subsequent published account, Bernard insisted that Cézanne "fundamentally distinguishes himself from impressionism," and seeks stylistic abstraction.[7]

Bernard had been involved with Cézanne's art long before his visit of 1904, and he had also long before rebelled against the impressionist method which he and the other young symbolists had inherited.[8] He was determined to see the rudiments of his own classicism in the authority figure of Cézanne. Bernard associated religious mysticism with an ordered, rational method of painting—the creation of a visible harmony corresponding to the divine order of God's creation.[9] Accordingly, he had stressed Cézanne's mystical character and his strong religious faith as well as the formal order and harmony of his paintings. As early as 1889–90 he had drafted a brief account of this legendary painter, and he repeatedly attempted to use Cézanne to draw himself out from the shadow of Gauguin: he claimed Cézanne as the only great influence on his own work.[10] Finally, on returning to France in 1904 after a long period abroad, Bernard arranged to meet the man to whom he had attributed so much. If at that time his expectations were not confirmed, his reconstruction and manipulation of the "facts" of his "Master's" case are understandable in relation to the theory of art he had already formulated during the preceding fifteen years.

Bernard's "witness" account of Cézanne appeared in the July 1904 issue of *L'Occident*; it followed closely the publication of his essays on Puvis de Chavannes and Redon, both of whom he regarded as symbolists.[11] The article has a curious construction that reveals the gap between Cézanne's notion of a cultivated classicism become natural (original, spontaneous) and Bernard's own conception of a naïve naturalism made classical (systematic, reflective). Clearly Bernard did not compose the essay all of a piece; he incorporated direct quotations from letters Cézanne sent him in May 1904, two months after the March date that the author himself assigned to his article.[12] Bernard wished to give the impression that his account had been written firsthand at Aix in the presence of the artist, and he included a substantial section reporting the theoretical dicta Cézanne personally announced to him. In May, however, when Bernard either sent the artist a draft of the article or simply conveyed a summation of it, Cézanne felt obliged to express once again the relationship he sought between his experience of nature and a technique sufficiently ordered to satisfy Bernard's demand for the classical:

> I always come back to this: the painter should devote himself entirely to the study of nature . . . the painter, by means of drawing and color, gives substance to his sensations, his perceptions. One is neither too scrupulous, too sincere, nor too submissive before nature; but one is more or less master of his model, and above all of his means of expression. One must penetrate what lies before him, and strive to express himself as logically as possible.[13]

Bernard simply added this statement to his list of quotations from the artist. Yet, despite all this accurate reporting, including views attributed to Cézanne that are confirmed in later letters of 1905, the painter's response to the final July publication was merely polite and noncommittal. As if belittling Bernard's enterprise, he felt it

necessary to state that theory became inconsequential when one confronted nature. It is not at all certain that Cézanne approved of Bernard's account, even with its seemingly accurate portrayal of his way of life, his manner of painting, and many of his views.[14]

Why? Had Bernard strayed from the path of his encounter at Aix? It seems so, for the tone of his essay changes distinctly after he concludes the section on Cézanne's opinions. Bernard completes what amounts to Cézanne's view of Cézanne with quotations from the May letters; and then he begins to present his own views, a symbolist view: Cézanne is a mystic; he is more than an impressionist.[15] Until this point, Bernard's account largely corresponds to the image I have been developing of Cézanne as master of a technique of originality. Bernard states that artistic creation must find its origin in nature, not technical formulas. In agreement with both "academic" and "independent" theorists, he claims that the great masters had always known this. He praises Cézanne, as well as Monet and Pissarro, for having ignored conventional styles to purify their vision in nature: "[Cézanne] abandons the studio, goes . . . to the 'motif' . . . analyzes, searches, finds . . . [he] withdraws himself to break away from any influence before Nature [and desires] to forget everything . . . [he draws from nature] an image that will be his own."[16]

But even as Bernard offers a view in sympathy with Cézanne's expressed aims, in a subtle manner and perhaps without realizing that he was pushing the artist in a direction not taken, he begins to imply that Cézanne was doing much more than developing an individual technique—he was discovering the universal laws of nature as well. These laws, once found, could be used to make a "decorative" art of abstraction. This sense of Cézanne's goal justifies Bernard's assertion (in the last three sections of his essay) that the artist transcends impressionism and, "far from being spontaneous, [is indeed] reflective."[17] Bernard writes that Cézanne only *begins* by submitting to his natural model; soon he elevates the "form toward a decorative conception" and "abstracts his painting" which has "no other end but itself." Cézanne discovers the laws that produce natural phenomena, and "with logic, he takes possession of them, and accomplishes his work by means of an imposing, lively synthesis."[18] Bernard's emphasis thus shifts from an appreciation of the artist's independence and originality to an account of his applied "classical" knowledge: Cézanne has discovered universal principles.

In his essay of 1904, Bernard was drawing upon ideas he had developed at least a decade earlier and published in a statement of 1895 entitled "De l'art naïf et de l'art savant" ("On naïve art and knowledgeable art").[19] Here he associated naïve art with a simple naturalism often characterized by awkwardness and by a lack of technical knowledge or "science." A naïve attachment to nature fosters the sincere expression of the artist's soul; the artist immerses himself in a "mysticism of the external [*mysticisme extérieur*]." But gradually this type of naturalistic art (such as that of Giotto) necessarily becomes ruled by scientific principles apparent in nature itself. "Naïf" art becomes "savant."[20] Eventually—and here Bernard is thinking of his own modern age—a learned science of external appearances may come to dominate all art, inter-

fering with the "naïve" expression of the unity of the soul of man and nature. Through this development art becomes a mere copying or imitation (in this context, the two terms are interchangeable and both pejorative). Such art degenerates into conventional forms, those from which Bernard saw Cézanne escaping—"Naïve art [is] a cry of the soul without classification," that is, independent of any conventional means of expression. Cézanne, however, was not entirely naïve; he had science and seemed to employ natural laws. Thus, in Bernard's terms, Cézanne could find like the young "naïf" but also possessed the power to make like the aged "savant." Bernard evaluated the qualities of the arts of the "naïf" and the "savant" as he would the natural and the classical, implying that the latter, a making, must supplant the former, a finding, without passing into mere convention:

> However excellent naïve art may appear, knowledgeable art, the art of genius, dominates it on this point: Power ["Puissance," that is, power, capability, authority].
> The one forebodes, the other sets down in writing; the one gives notice, the other recounts. So the [naïve] child and the [knowledgeable] old man.[21]

As classicism renders naturalism comprehensible and complete, so, Bernard had argued in 1895, the "savant" gives full form to the "naïf."

The science of the "savant" is tradition, a set of revealed natural laws derived from all genuine naïve art; it carries the authority of divine inspiration.[22] For the naïve medieval artist, science is found intuitively as a "natural harmony"; for the knowledgeable Renaissance artist, it becomes a "mathematical harmony," applicable to the controlled making of images. In other words, the origin of the "laws" of classical art is true and absolute; these laws are *found* in nature. But they become the foundation for a making that is rational or "logical" (the term Bernard applied to Cézanne). Here is Bernard's account of the historical process:

> The Byzantines and the Gothics received an entirely internal initiation that revealed to them the order and harmony of things; they did not see in the tree only branches, leaves and trunk; they discovered with the aid of spiritual Revelation the combinations, the charming relationships, the affinities of the *natural harmony*. From their contemplation they deduced the *mathematical harmony*—what you call formulas;—the men of the Renaissance invoked the positive sciences and looked into the bottom of the crucible.[23]

In the context established by Bernard's own rhetoric and the position he had expounded by 1895, Cézanne's remarks, as Bernard reports them in 1904, assume an authority higher than that which might come solely from one man's personal experience; they begin to claim the support of an ageless tradition more compelling than any contemporary convention. Here tradition is more than the inertia of the historical movement of artistic practice, as it had seemed, for example, to Théophile Thoré, who defined it simply as the "manner in which nature has been reproduced by preceding masters."[24] Tradition becomes universal, subject to history only in terms of

the passage from an age characterized by the "naïf" to one formed by the "savant." Tradition need not interfere with originality of expression. Accordingly, Bernard quotes Cézanne as saying, "we must realize our sensations in an aesthetic at once both personal and traditional," that is, in Bernard's earlier terminology, both "naïf" and "savant."[25] Another of Cézanne's statements, which perhaps merely reflects a device of studio practice, a manner of conceiving conventional modeling, becomes for Bernard an absolute law of nature or a mathematical truth: "Everything in nature is modeled according to the sphere, the cone and the cylinder. One must learn to paint with these simple figures; one can then make whatever one would like."[26] And when Cézanne mentions both the classical and nature, in Bernard's interpretation the emphasis will be reversed and will fall on the former term rather than the latter: "One must become *classical* again by way of nature."[27]

In the concluding parts of his essay, those that are likely to have struck Cézanne as flattering but misguided, Bernard begins to speak of natural laws as divine laws.[28] He states that Cézanne has an instinctive feeling for these universal harmonies; he is able to find them, and then to use them. But these laws, the traditional laws known intuitively by all great masters, do not overrule original sensation; they do not predetermine experience.[29] Bernard, perhaps more skilled than Cézanne in the verbal dialectic of finding and making (certainly he exasperated the older man with his theories), argues that the orderly rigor of classical technique will not interfere with an original sensation of nature. If Bernard were more specific at this point, in explaining that the classical can represent the original, he would, in effect, determine the ultimate technique of originality—a technique subject to complete mastery, repeatable at will, yet facilitating rather than inhibiting original expression. Psychophysicists of the late nineteenth century attempted to establish such technical procedure by codifying aesthetic laws or the correspondences between particular sensations and emotions, in order to find a natural (i.e., empirical) foundation for academic artistic training. Such laws, in Bernard's terms, would be both "natural" and "classical," and psychophysics would aim at transforming "naïf" practice into a "savant" mode. A text of 1869 on the science of vision, for example, stated that aesthetic laws had always been realized intuitively by great artists; modern science sought now to specify them precisely and to make them available for general use.[30] The notion that art somehow integrated found principles with self-consciously established rules pervaded academic circles. Charles Blanc wrote that the great artist (Delacroix, in this case) understood the logic of technical procedures both intuitively and scientifically. Blanc defined the ideal artistic style as a classical one that united all traditions and embodied all expressive principles of the past, as if they were to be found as one finds nature, independent of the will and desires of the individual. In the very greatest art, the innate desire and naïve vision of the individual would coincide with the classical principles collectively acquired throughout the ages.[31]

Bernard never came to offer a full set of rules (like those of the more technical academic treatises) that might serve to guide artists of lesser "instinct" to their own origi-

nal expression.[32] Perhaps this was wise; he himself wrote that even the methods of the avant-garde, anti-academic groups seemed to deteriorate into convention when employed, and could not guarantee the proper regard for nature.[33] As the "law" to follow, Bernard offers only the example of Cézanne along with the various accounts of this painter's use of color contrasts.[34] His general theory of "classical" art merits quoting:

> Sensation demands that techniques be constantly transformed, created anew, in order that sensation be expressed in its true intensity. One should not try to make sensation fit within a preestablished technique, but one should put one's genius for inventing expressive techniques at the service of sensation. On the one hand, we are led to the École des Beaux-Arts, which channels everything into a uniform mold; on the other hand, we have continual renovation. *Organize one's sensations*, there's the first principle of Cézanne's doctrine, not at all a sensualist doctrine, but a sensitive one. The artist will thus gain in logic without losing in expression; he will be able to be unpredictable [i.e., spontaneous and revelatory], all the while remaining *classical by way of Nature [classique par la Nature]*.[35]

How does Bernard's formulation bear on the question of Cézanne's relationship to impressionism and to its "end"? One of the ways in which impressionism and symbolism may be distinguished is to associate the former with an emphasis on "nature" and the latter with a predilection for the "classical." Nevertheless, the concerns of both impressionism (Cézanne's affinity) and symbolism (Bernard's primary allegiance) merge in the area of technique, the "moyens d'expression."[36] For the impressionist, proper technique would assure originality by serving to reveal the double origin of nature and self. For the symbolist, technique must follow tradition; it must be "classical" and facilitate the rational expression of timeless "original" truths. For neither artist would a technique identified with contemporary conventions be acceptable. In the completion of the investigation of Cézanne's style and theory (below, part 3), it remains to be shown how the artist could satisfy the demands of symbolists while remaining, in his own eyes, an impressionist. He did indeed come to fix his gaze on the problem of technique much as Bernard represented it in 1904; and there was much truth to Bernard's claim that to "organize his sensations" was Cézanne's daily working concern. Ironically, it was in this endeavor that both Bernard and Cézanne himself noted the "Master's" failure, his lack of realization.[37]

Bernard and Cézanne recognized their common interests as travelers sometimes acknowledge each other at an intersection of roads. As is so often the case with encounters of this kind, the two parties had come from different directions and were not continuing on the same way; the state of their mutual understanding was intense, brief, and ultimately questioned and doubted by both. Cézanne expressed his doubt in letters written to his son during the last year of his life,[38] and Bernard produced a series of published statements evaluating the accomplishments of his "Master" with an ever increasing negativism. Retrospectively, he saw Cézanne as an in-

complete, frustrated "naïf" and, at the same time, a failed "savant," a man of natural gifts, especially with regard to color, whose technical science was nonetheless both restrictive and ultimately ineffectual. Cézanne had either lost or had never attained the proper balance of nature and technique.

In his second major essay on the artist (1907), Bernard argues that originality (associated with naïveté and the ability to find) is far more common among serious painters than an effective expressive power. He states that the works of the very greatest masters successfully integrate elements derived from nature, from "individual creation," and from the "rules of art." Cézanne, however, never achieved such "realization" because, as Bernard now claims, he became *too* reflective, too concerned with procedural questions and technical systems. Cézanne had originality, "but without his being aware of it, his logic had so complicated the mechanism of [his technical means] that his work became extremely irksome and as if paralyzed . . . he went too far in his reflection and reasoning to act."[39] Although he has not resorted to convention, Cézanne (in Bernard's view) begins nevertheless to resemble the degenerate modern artist who allows his rational science to dominate his mystical vision. A hint of convention is not long in coming. Bernard writes that Cézanne's use of color followed strict laws and could be conceived in advance; the painter worked by a "kind of convention" which he applied to the nature he observed.[40]

Bernard ends his essay of 1907 with a footnote giving a definition of the classical which seems to be inspired by Cézanne, but which indicates also the inadequacy of any artist for whom technical issues remain problematic:

> Classical means here: that which is in agreement with tradition. Thus Cézanne used to say: "Imagine Poussin redone entirely after nature, there's the classical that I intend."[41] It is not a matter, in effect, of casting out the romantics, but of rediscovering what the romantics themselves had: the solid rules of the great masters. Still the contribution to make is a more ample observation of nature and in some way to draw one's classicism from it more than from studio recipes. Because if the *laws* of art are fecund, the *recipes* of the studio are deadly, and it is only in contact with nature, and with its constant observation, that the artist is a creator.[42]

Bernard thus repeats arguments made throughout the nineteenth century by both "classicists" and "romantics" as he distinguishes between natural law, found in nature and in the development of naïve art, and conventional law, a studio recipe made by a "savant" who has degenerated. As Bernard now conceives it, Cézanne's project was to find Poussin's principles through the study of nature rather than the academic study of art. Cézanne himself would have agreed to this assessment of his aim. But Bernard has implied that the painter could not succeed fully because his reason weighed upon his passion—Cézanne lacked the "classical" equilibrium of finding and making.

By 1910, in an essay concentrating on the technical misconceptions and "errors" of the impressionists, Bernard could dismiss Cézanne as a seeker who could not find.

To his credit, this flawed "Master" had used a logic of a higher order than had the impressionists, who fixed upon creating a harmony of uniformly saturated colors, a most difficult and artificially conceived procedure. But despite its improvement over impressionism, Cézanne's painting still could not lead to the regeneration of modern art, for

> he was so absorbed by the mechanism of [his own] system of color. . . that the memory of any form . . . became remote from him. It is unfortunate that this fine genius of a colorist should have remained so incomplete; he had the gifts of a master painter and respected the tradition of the Museums. . . . Despite the certain science he acquired of simultaneous contrasts, of planes and of color, I do not advise that one engage in following him. He did not himself—*according to his own testimony*—accomplish the work capable of demonstrating the excellence of his system. . . . Only those who have brought their life's work to perfection are to be consulted; one would seriously risk losing oneself in going to ask for the truth of art from *seekers* who have not themselves accomplished their program. . . . Let us then learn only from *those who find [trouveurs]*, and not from these *eternal seekers*, for whom the search only leads them deeper into the morass; let us seek, but by paths that are sure.[43]

For Bernard, such paths were those of the great masters, both "naïf" and "savant," the paths of tradition and "classicism." By following tradition—and not the technical byway Cézanne seemed to have indicated—one might preserve the sense of original discovery while yet maintaining successful control over one's own creative expression.

Perhaps Bernard was simply attempting to place himself at the center of the history of art by describing his own technique of originality, a more productive one than Cézanne's. Although he could claim Cézanne as his artistic mentor in order to dissociate himself from Gauguin, he still needed to transcend the older master to attain a mastery of his own. His efforts at theory and analysis had to overcome the evidence of his early painting style, so clearly in debt to Cézanne (fig. 31).[44] Retrospectively, of course, it appears that Bernard, not Cézanne, was the failure. Today, Bernard's reputation rests more on the strength of the earlier works and on his initial appreciation of Cézanne than on any later modifications of either his theory or his practice. Nevertheless, he directed his attention to the most important critical issue: Was Cézanne's art essentially a matter of spontaneous finding or of controlled making?

« »

[Cézanne] is so naturally a painter and so spontaneously classical [spontanément classique]!

The unfortunate thing is that it is difficult to say without too much obscurity what classicism is. . . .

Statements by Maurice Denis in his 1907 essay on Cézanne[45]

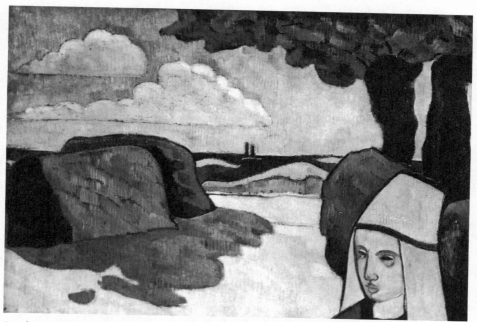

31. ÉMILE BERNARD, *Le Pouldu*, ca. 1886. The Ackland Art Museum, the University of North Carolina at Chapel Hill, Ackland Fund.

Like Bernard, Maurice Denis met Cézanne only after he had already formed a strong opinion of the significance of the artist's work. His major statement of 1907 is supposedly based on direct observations and conversations with the painter that took place during Denis's brief visit to Aix in 1906. Oxymoron abounds in the piece of theoretical writing that resulted: How can Cézanne "naturally" be a painter, when painting is an acquired art? And how can a classical style, presumably the product of thought and reflection, occur spontaneously? Here and elsewhere, Denis seems to be describing Bernard's ideal "naïf" who is somehow also a "savant."[46] Denis wants to see in Cézanne the successful synthesis of many of the opposing values traditionally discussed by artists and critics. He is not merely saying that Cézanne was gifted, that he had a natural talent for painting; he makes instead a stronger claim, that Cézanne's immediate response to nature—his vision—is that of a cultivated work of art: "We have discerned classical spontaneity [*la spontanéité classique*] in his sensation itself."[47] Cézanne's style must therefore follow immediately from his sensation. It is as if his mediating technique had perfected itself only to render itself, *as technique*, invisible— or perhaps, in Cézanne's case, there simply had never been any self-conscious development of technique. Furthermore, as a "classic," Cézanne (for Denis) establishes the "just equilibrium between nature and style."[48] And elsewhere Denis describes the artist as "instinctively classical [*classique instinctif*]."[49] In either case, as instinctive or spontaneous, Cézanne's "classicism" arises naturally—it is found, not made.

In 1909 Denis reiterated a standard bit of critical wisdom in declaring that the "great error of the academies of the nineteenth century [was to] profess a fundamental opposition [*une antinomie*] between style and nature."[50] He continued:

> The word "ideal" is deceptive: it dates from an age of materialistic art. One does not stylize a dumb copy of nature artificially, after the fact. . . . Even when he copies, the true artist is a poet. Technique, material, and the aim of his art inform him well enough not to confuse the *object* he creates with the spectacle of nature which is its occasion. The symbolist point of view is that we should consider the work of art as the equivalent of a sensation received: nature could then be, for the artist, only a state of his own subjectivity. And what we call subjective distortion [*la déformation subjective*], is in practice, style.[51]

Denis identified two types of artistic distortion. He associated "subjective" distortion with the manifestation of individual artistic temperament and "objective" distortion with classical style and reasoned artistic expression—Bernard (with some qualification) might have labeled the two deformations "naïf" and "savant."[52] Both are original in the sense of revealing some ultimate source of truth, whether nature, an individual self, or a universal principle of expression. Both are opposed to artistic convention. Supposedly, the "naïve" precursors of the symbolists employed universal laws of abstract design instinctively; later the symbolists themselves sought consciously to define these laws. According to Denis, Bernard did so by studying tradition, while Seurat turned to science; and by either method, awkwardness (*gaucherie*), the evidence of a departure from convention, entered symbolist art.[53] Denis maintained that a "sincere" art, one of awkwardness, distortion, or deviation from convention, would eventually lead to a full correspondence between nature and its artistic expression.[54] As I have argued, the synthesis of the two types of distortion, subjective and objective, would effect the merger of an art of the individual impression with an art of the universal symbol.[55] Subjective and objective, impression and expression, nature and style,[56] all would become indistinguishable, as would perhaps the most successful examples of impressionist and symbolist painting, seen as sharing a common end.

When Denis writes that Cézanne created a classical form of impressionism, he may seem to imply that the artist added "objective" distortion to a subjectivity already present; he states, however, that this painting involved nothing like a self-conscious compositional process of adding one independently defined element to another. On the contrary, the two types of distortion were "intimately bound up in Cézanne."[57] The artist's painting therefore could not be conceived as the realization of a reproduction of nature, because its act of translation was immediate. Cézanne's technique was not so much a means to a preconceived end as an artistic realization in itself. Here Denis presents a thesis that had often been called upon to explain the emergence of an "original" (i.e., primordial) classic art; and, with regard to the question of Cézanne, this explanatory device had been favored also by Bernard and by Rivière and Schnerb, and would be chosen later by Roger Fry.[58]

Denis identified the subject of a work with its emotional content, its sensation as opposed to its appearance. He stated that formal elements, particularly contrasting colors, convey this emotional theme, this human feeling. Given an expressive freedom and spontaneity, technique could profitably depart from the conventions of representation. Following such principles in 1909, Denis noted how meaningful a void of sky could become in a radically asymmetrical Japanese composition. He went on to justify the strange distortions he observed in Cézanne's art:

> The apparent disorder, the awkward perspectives of a sideboard by Cézanne, tend to locate in the center of the composition the subject of painting, the necessary harmony that Cézanne intends there—harmony by contrasts, the fundamental law of color—the respect for material—the love of clarity and of the definitive—finally, the quality of human feeling that brings forth and sustains the work of art. . . . [We do not] seek the motive [*motif*—both motivating force and consequent design] of the work of art other than in the individual intuition, in the spontaneous apperception of a correspondence, of an equivalence between these states of mind and those plastic signs which must translate them with necessity.[59]

Denis had arrived at the same conclusion in 1906 when he interpreted a remark Cézanne had made to him during his visit to Aix: "The sun is a thing one cannot reproduce [*reproduire*] but may represent [*représenter*]." The painter-critic argued that neither the conventional system of representation taught at the École des Beaux-Arts nor the manner of representation acquired through the attempt to copy the external effects of nature were "representation" in Cézanne's sense, but rather "reproduction." To "represent" artistically was to work in terms of the "symbolism of *equivalents* . . . to represent ourselves, to translate our sensations into beauty [by means of color]."[60] According to this theory, the "representation" or "translation" of sensation could be achieved with immediacy. For Denis, Cézanne's "subjective" states of mind gave rise spontaneously to the "objective" plastic signs (in particular, specific relationships of color) required to express the artist's emotions. Moreover, these signs, the artist's technical means, are recognized as "classic" and meaningful to all. In consequence, Cézanne can be spontaneous—that is, original—in his classicism, even though others may seem to use a similar classical style as a conventional or acquired means of giving form to the accidental encounters of an artistic temperament with a surrounding nature. Cézanne's classicism is not an inherited technique. He discovers it "originally." Yet it recalls all other examples of genuine classical style.

In a review of the Salon d'Automne of 1905, Denis describes Cézanne as the "Poussin of still-life and green landscape."[61] He has many reasons for making this association, which will be explored at greater length in part 3. At this point, it is sufficient to note how Denis contrasts the "classical" Poussin to the modern Puvis de Chavannes, one of Cézanne's rivals for the symbolists' critical affections. According to Denis, Puvis seems to *impose* style on his spontaneous view of nature; his art is dominated by a process of making. Poussin, however, is much like Cézanne; he does

not find and then make, but rather integrates (found) nature and (made) style from the very start. Denis writes:

> We see clearly that Chavannes applied a system, that he deliberately idealized nature. . . . [Poussin] would not oppose style and nature; in the mind of the painter, they should merge. . . . Don't Poussin's drawings and his rare painted sketches [already] have a style equal to that of his [finished] paintings? . . . All the classical masterpieces are simultaneously ideally beautiful and full of the *natural.* . . . Damn the pedants who have taught us to distinguish, in our pictorial language, prose and poetry [i.e., nature and style].[62]

In his essay of 1907, Denis reaches the point of calling Cézanne the "Poussin of impressionism," and speaks of his effort to "create the classicism of impressionism."[63] Such classicism involves an ordering of an individual vision (a "sensibility"), but an ordering, or composition, that grows naturally out of the artist and his work:

> There is nothing less artificial . . . than this effort toward a just combination of style and sensibility. What others have sought and sometimes found in imitating the ancients, the discipline that [Cézanne] himself in his first works asked of the great artists of his time or of the past, he discovers finally in himself. . . . For him, it is not a question of stylizing a study [of nature] as, in effect, a Puvis de Chavannes does. He is so naturally a painter and so spontaneously classical!

According to Denis, the spontaneous nature of Cézanne's classicism manifests his originality, his sense of self; and it brings forth the awkwardness (*gaucherie*) and "blessed naïveté" that signify his sincerity.[64]

What are the implications of such a definition of the classical? The essential point is that classical style must appear natural rather than artificial or conventional. Puvis is discredited for "stylizing a study," for systematically building on a foundation of spontaneous finding; his art loses its purity. With his concerted sense of a natural classicism, Denis provided the antidote for the disorientation that the technique of originality had effected; he could return to the communicative security of a true tradition, while yet maintaining the essence of originality itself, a core of discovery or finding. In Denis's terms, the inherited academic method was actually opposed to the classical tradition; it merely developed sequences of arbitrary imitations, fabrications no more authoritative than individualistic fantasies: "Surely the Tradition is not a matter of scholarly refinement and the study of rhetorical devices."[65] Cézanne's classicism, marked by its irregularity, was anything but academic.

Denis insisted, however, that self-indulgent artistic anarchy should not be the rule to follow. In a series of provocative statements, he claimed that originality (as individualism) had become a cliché of modern art and that critics fetishized any sign of sketchiness or incompletion. He noted, furthermore, that the impressionists' categorical rejection of tradition had the ironic effect of converting personal style into a formula. In turn, Cézanne's imperfections had been too readily accepted as reliable evidence of an original temperament. The concern for individualism and originality had thus, paradoxically, produced its own stylistic conventions.[66] Denis's reasoning

exemplifies the symbolist confrontation with the mythology of the preceding impressionist generation.[67] In effect, he came to view the impressionist position as a rhetorical stance, an artificially imposed order having no special claim to validity, despite its appearance of sincerity. The signs of the "classical" conveyed more authority than those of impressionist "originality."

In a journal entry of 1903, Denis wrote that the "classical artist is he who stylizes, synthesizes, harmonizes, simplifies, not only as he paints—which is not difficult—but as he sees."[68] In his act of making, the painter does more than establish classical "equilibrium," the harmonious agreement that Denis describes variously as an "accord between the object and the subject," "between expression and harmony," or "between nature and idea."[69] The painter not only actively creates this synthesis of nature and style, he also finds it in himself—spontaneously. Thus, Denis can argue for order and principle to be extracted from the artistic tradition without advocating academicism or the formularization of originality; conceivably, both academic and independent artists can serve as models because universal principles will be evident in the works of any true artist, whether trained or untutored.[70] The modern classic will combine a number of qualities in both himself and his work. The sculptor Maillol, for example, is simultaneously "expressive and harmonious"; that is to say, he attends to both self-expression (a finding) and stylization (a making). And Maillol's classical style is instinctive; found in himself, it is his "classical gift."[71] Similarly, Denis sees in Cézanne both the "demand of [stylistic] harmony and the fever of original expression," the signs of both willful creativity (making) and involuntary originality (finding). The symbolist writes that before one of Cézanne's paintings "we cannot determine . . . whether it is an imitation or an interpretation of nature," an objective representation or a subjective emotional response.[72]

Denis once referred to some negative criticism of his own paintings that signaled his awkwardness, naïveté, and maladroit drawing technique. He did not deny these qualities, but attributed them to his "natural expression," something coming forth from within.[73] Later he noted these same features in Cézanne—awkwardness, naïveté, maladroit technique.[74] In order to eliminate his own technical irregularities, Denis turned outward to study the classical tradition; he self-consciously sought a means of making.[75] Could Cézanne, as a greater artist than Denis, simply find his classicism within, as he found his personal expression? Or was there some problem of making, even for so "spontaneous" a classic? In his most searching theoretical essay, "De Gauguin et de Van Gogh au classicisme" (1909), Denis insisted that all artists are formed to some extent by their culture; none is as free of schooling and tradition as the extreme exponents of originality would claim.[76] Denis's argument serves in part to support his nationalistic politics; he cites Poussin as a model more than ever before since Poussin is not only classical, but French.[77] Cézanne, then, may bring Poussin to mind by a double affinity, his genuine classicism and his French character. More specifically, however, Cézanne is the "Poussin of impressionism" because he combines classical tradition (Poussin) with the modern emphasis on individual original expression (impressionism). Yet the paintings complicate the issue; and here Denis hesitates.

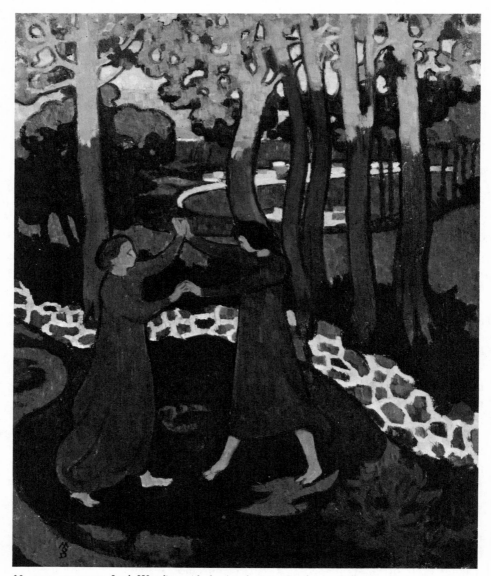

32. MAURICE DENIS, *Jacob Wrestling with the Angel*, 1893. Josefowitz Collection, Switzerland. Photograph courtesy Art Gallery of Ontario, Toronto.

He writes that Cézanne unites aspects of modern and traditional art "naturally and instinctively . . . in his mind, *if not always in his canvases*."[78] Cézanne, just as Denis himself, seems to have a technical problem; his "realization does not proceed without lapses."[79] Like Denis, Cézanne may need to make a self-conscious return to "tradition and discipline."[80]

Just as Bernard did, Denis eventually came to doubt the complete success of Cézanne's technique; and, in accord with many other symbolist critics, he refocused at-

tention on technical procedure as a making, an object of research. Denis's conclusion that Cézanne's art is imperfect came only gradually, as the painter-critic perfected his own theory, both through writing more and more comprehensive and ambitious essays and through carefully reworking those articles he had already published. His collected essays appeared under the title *Théories, 1890–1910: Du symbolisme et de Gauguin vers un nouvel ordre classique*; this volume was published in 1912 and reprinted later that same year and again in 1913. For his retrospective collection, Denis made many minor changes in individual articles, most of which served to regularize his vocabulary and clarify his central concepts so that a single coherent body of theory might emerge. He presented a new edition in 1920 with still more revisions of the same sort—synonymous substitutions, explanatory parenthetical remarks, changes in emphasis, punctuation, and paragraphing. A few of these alterations seem more meaningful than the others—in particular, a change in phrasing that appears in both the 1912 and 1920 editions: instead of Cézanne's striving to "create the classicism of impressionism" (the original 1907 version of this famous statement), the artist is said to seek to "create a kind of classicism of impressionism."[81] Denis's claim for Cézanne's achievement now seems somewhat weakened; the painter's success will not be *the* classicism, but only a "kind of classicism." In effect, Denis put Cézanne into the position French critics had often assigned to Homer: Cézanne was classic without fully understanding it and would not have been able to formulate the rules of his own art.[82] His primitive classicism could become refined only in its own tradition of subsequent critical commentary. Denis's view reflected back on himself with renewed brilliance since it was his purpose to establish just such a tradition.

The organizational theme for Denis's collected essays—"du symbolisme et de Gauguin vers un nouvel ordre classique"—indicates his self-consciousness about his role in creating a "new" art which may not have differed in essence from the old. Like Bernard and many other artist-theorists, Denis reformulated his definitions in order to include rediscovered heroes of the past (Raphael) or to exclude destructive "foreign" influences that might be identified, according to the politics of the moment, with various national or ethnic groups. He may have been concerned with his own place in history as he linked the various artistic causes he championed to an eternal classicism. Usually, he defined symbolism so that its end was consistent with a revival of classical principles. Occasionally, however, he criticized the actual practice of the symbolists as if to project his own vision beyond what he claimed was their excessive individualism and subjectivity; he sometimes argued that the symbolists, in their practice, fared no better than the impressionists at attaining universality.[83]

While symbolist practice might become erratic, its theory could become rigidified. In 1909, Denis noted that the symbolist generation, the "movement of 1890" with which he felt most closely aligned, had gradually created its own "academy," its own fixed rules and procedures. This generation of 1890, despite having "first protested against the academies, came to found one: the wish to communicate a lesson implies that they believe themselves in possession of a truth general enough to be usefully transmitted. . . . The return to tradition and discipline is [now] as unanimous as

was the cult of the self and the spirit of revolt in our youth." Denis defined tradition in this context as a regulative but also liberating force: it is the body of laws perceived through the immediate experience of nature and confirmed through experience of great art both present and past. Lawful technical procedure becomes an object of study by way of the "theory of equivalence or of the symbol":

> we [the generation of 1890] affirmed that emotions or states of mind incited by whatever spectacle, brought about in the artist's imagination signs or plastic equivalents capable of reproducing these emotions or states of mind without the need of furnishing the *copy* of the initial spectacle; that to each state of our sensibility should correspond an objective [formal] harmony capable of translating it.

Denis footnoted his own commentary at this point—the clarifying example is none other than Cézanne, who is described as seeking equivalents for his experiences of nature in patterns of color.[84] Despite Cézanne's gift of a spontaneously classical vision, he must engage in technical matters; for Denis, his art reveals a continuing search for the proper means of expression, a search that does not end.

The broad implications of Denis's theory may now be summarized. Tradition, the embodiment of universal laws of expression, remedies both art that becomes too instinctive and individualized as well as art directed by excessive theoretical abstraction.[85] The classical tradition is *found* in both nature and great art. Although associated with human expression, it does not have its ultimate origin in man; it is not man's invention, but an ideal means or medium available for his employment. When that medium is imperfectly understood or incompletely mastered, it appears as a technique by which objects of art are *made* with deliberation and doubt. Ideally, however, the medium may be mastered to the degree that it appears no self-conscious means at all, but a *natural* vehicle of expression, one that eliminates the distinction between artistic feeling (*impression, émotion*) and artistic effect (*effet, idéal*). Both impressionists and symbolists sought to master such technique, so that, paradoxically, it might merely appear as their involuntary discovery; like Couture, they realized the value of study and reasoned principles, but longed to *find*, as if spontaneously, the answers to their problems.

In expressing doubts about the perfection of his own art and that of Cézanne, Denis indicated that the search for the ideal artistic means must continue; modern artists had no choice but to be makers, despite their desire to be finders. Yet the mysterious figure of Cézanne continued to fascinate Denis by offering the possibility of the "spontaneously" classical. Although Cézanne (*even* Cézanne) must strive consciously to master the technique tradition might afford, his connection to tradition had been established intuitively, not through academic study. Cézanne's technique of originality clearly distinguished itself from (academic) techniques of imitation in being the product of independent vision and research; yet it was "classical" technique, to be found also in the art of the past. Denis allowed finding and making, instinct and technique, to merge in Cézanne's art to a degree that others, most notably Roger Fry, could never accept with such ease, despite the seductiveness of the notion.

Classic art . . . communicates a new and otherwise unattainable experience.

ROGER FRY, *1912*[1]

I call a work "classic" if it depends on its formal organization to evoke emotion.

ROGER FRY, *1924*[2]

Cézanne counts pre-eminently as a great classic master.

ROGER FRY, *1927*[3]

10

Roger Fry:
Found Vision and
Made Design

I N AGREEMENT WITH MAURICE DENIS, Roger Fry felt that Cézanne's art raised the issue of classicism. Although familiar, the problem was not at all simple. Surely, the description of Cézanne's classicism that Denis offered was enigmatic: a manner of painting that is, or becomes, classical "spontaneously." Denis's formulation evoked a synthesis of originality and material creation, a confluence of nature and style or of finding and making. As the symbolist artist and critic himself admitted, this could only seem illogical, drawing the critical observer into a "vertigo of reasoning" from which no way out, no convincing theoretical closure, could be determined.[4]

Fry, like Denis, looked favorably upon artistic spontaneity. He wrote of Cézanne (in December, 1910) that "his work has that baffling mysterious quality of the greatest originators in art. It has that supreme spontaneity as though he had almost *made himself* the passive, half-conscious instrument of some directing power." A problematic notion: to act in such a way that one makes oneself passive. Is Fry claiming that Cézanne's spontaneity is found—or made? Is it to be assumed that others might derive from this painter a proven technique of originality, a way of ensuring discovery, a way of making oneself a finder? Or is Cézanne himself actually doing something of the reverse, finding (discovering) that he is a "classic" maker? Fry is uncertain; perhaps the example of Cézanne renders him somewhat incapacitated as a critic, unsure of his own critical perceptions. He does say, however, that Cézanne's classicism (just as his "spontaneity") ranks "supreme" and is found or inherent—Cézanne has a "supremely classic temperament." In other words, this painter is classic by his very nature. His mixture of spontaneity and classicism constitutes an artistic manner that appears both found and made:

> His composition at first sight looks accidental, as though he had sat down before any odd corner of nature and portrayed it; and yet the longer one looks the more satisfactory are the correspondences one discovers, the more carefully felt beneath its subtlety, is the architectural plan; the more absolute, in spite of their astounding novelty, do we find the color harmonies.[5]

In 1909, not long before he published these observations on the occasion of the first postimpressionist exhibition at the Grafton Galleries, Fry had translated Denis's essay on Cézanne into English for the *Burlington Magazine*.[6] However indebted to Denis Fry might have been, in his own writings he seems to have attempted, whether self-consciously or not, to restore a certain logical balance to Denis's argument; and, in doing so, he may have obscured Denis's message. With regard to Cézanne's spontaneity and classicism, the two painter-theorists are largely in accord, yet Fry generally resists accepting Denis's claim that one can be emotionally expressive and classical all at once. He establishes instead a sense of temporal sequence, implying that making must follow finding; method cannot be discovered spontaneously as if it were a felt emotion.

In Fry's writings, Denis's fluid conception of the dialectic of finding and making within the art of Cézanne and other "classic" masters becomes rigidified (but perhaps more logical), as Fry seems to give a more materialistic interpretation to the observations that Denis made. In particular, the British critic grounds sensation in an experience of the material world and stresses the *subsequent* process of imposing an order or "design" upon that "vision." He characterizes the modern "postimpressionist" movement by a return to "ideas of formal design,"a structural order that may be used to give emotional or spiritual significance to the "exact and literal imitation of nature" supposedly typical of earlier impressionist art.[7] To a greater extent than Denis, Fry ignores the "emotional" aspect of impressionist "imitation," the allowance for spontaneous finding and individual expression present in a technique that aimed to adhere to natural vision so closely that socially mandated conventions of representation could never intervene.

To separate "formal design" from "natural vision" and to assume that one might follow as a corrective upon the other is, in Denis's terms, to take a step backward toward academicism, to conceive the classical as a purely technical model rather than a mode of perceiving, even of being. Fry may have missed the point of some of Denis's most carefully chosen terms. Where Denis spoke of Cézanne's creating a "concrete object, both aesthetic [i.e., beautiful, having beauty] and representative of sensibility [*un objet concret, à la fois esthétique et représentatif d'une sensibilité*]," Fry may not have understood adequately the special force of this opposition. He writes in his translation of Denis's essay that Cézanne creates a "concrete object, at once artistic and representative of a response to sensation."[8] For "sensibilité" Fry chooses the most material sense of the term, referring (in this particular context) to a physical reaction to an external stimulus. Considered in this manner, Denis's language recalls the familiar problem of the translation of a view of the world into artistic form. But the issue that Denis drew forth from Cézanne's art was more specifically "classical." His term "esthétique" (or, alternatively, "beau") refers to the harmony of classical style, whereas "sensibilité" refers to *individualized* sensation and emotion, which can arise either from sensory contact with specific external objects or from an act of the imagination.[9]

Fry's translation of this passage alone would not justify the claim that he failed to follow Denis's argument fully; his words at least approximate Denis's original connotative language. But a subsequent passage in his translation raises doubt more decidedly. Denis writes: "What astonishes us most in Cézanne's work is certainly his study of form, or, more precisely, his distortions[*Ce qui étonne le plus dans l'œuvre de Cézanne, c'est assurément les recherches de forme ou plus exactement les déformations . . .*]." Fry translates this as: "What astonishes us most in Cézanne's work is certainly his research for form, or to be exact, *for* deformation."[10] Fry has Cézanne consciously seeking the proper "deformation" rather than allowing distortion to appear spontaneously (which for Denis would be proof of the artist's sincerity). Fry considers distortion (deviance from conventional representation) as a product of technique, and technique as a studied translation of immediate feeling into ordered formal elements.

Just previously Fry had published a theoretical statement on this complex issue, his "Essay in Aesthetics" (1909). Here and elsewhere he insists that art must have an openly experiential, and even a mystical dimension, that it cannot be reduced to an analytical formula.[11] Yet his readers must be tempted to assume the contrary when he makes statements such as this: "[pictorial] unity is due to a balancing of the attractions of the eye about the central line of the picture . . . a composition is of value in proportion to the number of orderly connections which it displays."[12] Fry attributes the latter notion to a man he had met in 1905, Denman Ross of Harvard University. In his influential *Theory of Pure Design* (1907), Ross distinguished elements of art subject to rational analysis from other factors that could not be so examined. In effect, he located the generative origin of art in a given (or found) personality; and he sought to define artistic expression as a process of technical design:

> The only thing which remains in Art, beyond measurable quantities and qualities, is the personality, the peculiar ability or genius of the artist himself. That, I believe, admits of no explanation. The element of personality is what we mean when we speak of the element of inspiration in a Work of Art. Underlying this element of personality are the terms and principles of the art. In them the artist has found the possibility of expression; in them his inspiration is conveyed to his fellowmen. I propose to explain, not the artist, but the mode of expression which the artist uses.[13]

To explain the technique, not the artist—how different this goal is from that envisaged by Zola, who had described Manet's art in order to arrive at a picture of Manet the man. According to Zola's critical approach, Manet need not have had any particular expressive intention; his message remains (merely) a sign of his self, the original manifestation of his own individuality.

Although Ross and Fry (like Zola) concentrate on externalized stylistic elements to the point perhaps of ignoring purposeful iconographic content, they seem to view aspects of style or design as if made under fully conscious control. One's artistic personality may be given by nature, but one *employs* the elements of design, even though

these, too, may have an origin in a natural order. Design can be constructed not only to please the senses, but to arouse the emotions. Fry writes:

> When the artist passes from pure sensations to emotions aroused by means of sensations, he uses natural forms which, in themselves, are *calculated* to move our emotions, and he presents these in such a manner that the forms themselves generate in us emotional states, based upon the fundamental necessities of our physical and physiological nature. The artist's attitude to natural form is, therefore, infinitely various according to the emotions he wishes to arouse.[14]

By this reasoning, a potential for insincerity or fakery arises because the artist's emotional effects are "calculated"; they do not necessarily derive from his personality in its spontaneous expression. With the return to design that (for Fry) characterized postimpressionism, the emotional content of the picture, borne by its design, might conceivably diverge from the emotional state of the creating artist. Fry would not advocate such false artistic consciousness, but once he had allowed technique to mediate between the artist's emotion and his expression, the possibility of fraud became obvious. Herbert Read, among others, recognized this as an inherent problem in "formalism."[15]

When Fry lectured on the significance of the first postimpressionist exhibition held at the Grafton Galleries (November 1910–January 1911), he stressed once again "arrangements of form and color . . . calculated to stir the imagination." Since such conscious construction could take the form of a deliberate "misrepresentation" or "distortion," Fry suggested that his audience might find the notion more palatable were they to call it "idealization." I have noted that Fry, in his translation of Denis, had referred to Cézanne's "research for form, or, to be exact, for deformation." Although Denis had probably regarded Cézanne's distortion as the unintentional by-product of a sincere artistic method, distortion assumes for Fry the made quality of an effect consciously sought. Fry goes so far as to criticize the painter Walter Sickert for having advocated the *unconscious* pursuit of the distortion of nature; with much justification, Fry labels Sickert's argument an example of "casuistry."[16] In effect, Fry chooses to consider distortion in what Denis or Aurier would call its "objective" form; Sickert's distortion must appear "subjective."

《 》

Such are Fry's earlier thoughts on the problem of Cézanne's mysterious art. But he seems soon to have drifted away from his assurance that (at least in some instances) this painter's design was the product of controlled making. Gradually the mystery deepened; and Fry had to face the possibility that Cézanne, one of his postimpressionist giants, had done exactly what someone like Sickert would have wished: to have come upon expressive distortion by accident, to have found what the accomplished artist should be able to make. Clearly, Fry sought consciously the "laws of [artistic] language"; and indeed Cézanne seemed to reveal evidence of these laws in his formal distortions. In 1911, the critic described a dish of fruit that Cézanne had rendered as a "parallelogram with rounded corners." The form looked familiar, but Fry could not explain how or why the artist came to his invention: "it

would seem that Cézanne has stumbled upon a discovery which was already the common property of early artists. Both in Europe and the East you will find the wheels of chariots, seen in perspective, drawn exactly in this way." In general, Cézanne's originality is

> strange and unaccountable. . . . What he did seems to have been done almost *unconsciously.* Working along lines of Impressionist investigation with unexampled fervour and intensity, he seems, as it were, to have touched a hidden spring whereby the whole structure of Impressionist design broke down, and a new world of significant and expressive form became apparent. It is that discovery of Cézanne's that has recovered for modern art a whole lost language of form and color.[17]

Here Fry approaches Denis's formulation of Cézanne's classicism—the naïve finding of a universal means of making. Cézanne thus appears an original, or originating, genius. One wonders whether he might assume even greater stature were he more of a controlled maker, applying laws instead of merely happening upon them.

Indeed, there are indications in Fry's writings that artists should direct their own vision as much as possible. Fry's concern for the *conscious* manipulation of design elements is most apparent in his extended debate with his friendly rival, the critic, scholar, and artist D. S. MacColl. MacColl argued, perhaps correctly, that any pictorial reference to spatial illusion is in its essence representational, derived from spatial organization in nature. To such spatial pictorial structure, he opposed design on a surface—the organization, say, of balancing elements of line and color distributed left and right or up and down, but not "front" and "back" or "near" and "far." Fry preferred to consider *both* types of design under the control of an artist operating independently of the bounds established by any specific experience of nature:

> Mr. MacColl regards . . . the situation of volumes in spaces [in painting] as belonging to mere representation of a given situation, as being entirely *accepted* from Nature, whereas I consider that it is largely by his *deliberate*, or *perhaps sometimes unconscious*, arrangement of these that the artist expresses and conveys his feeling, and I call this design, meaning that this, if it is successful, obeys certain laws of rhythm and proportion exactly as the happy disposition of the [pattern of formal elements on a flat surface] does—although these laws will be much more complicated and the effects more difficult to analyze.[18]

Significantly, Fry inserts an escape clause into his own argument, the phrase "perhaps sometimes unconscious." He wants to show that design is deliberate, but knows it does not always appear so; and here his attention seems drawn back to Cézanne. But he will use Cézanne to his advantage by claiming that however accidental his design may appear, it is as if his formal distortions were purposefully manipulated. In contrast, MacColl sees Cézanne's art as devoid of this "made" quality; it is "found" in ignorance and plainly looks so. In a characteristic passage, he claims that Cézanne's "deformations . . . are not deliberate or subtly instinctive modifications of known forms to enhance expression, solidity or pattern: they are fumbling shots at something insecurely seen."[19] Fry, however, writes:

I believe that Cézanne did succeed by his peculiar *though perhaps unconscious*, distortions, emphases or exaggerations of both volumes and spaces, in producing harmonies of a strangely moving kind, harmonies which impress us as having a profound import, though we are as little able to give any reason for that feeling of deep significance as we are with regard to a great piece of pure music; whereas, for Mr. MacColl, Cézanne appears as merely a clumsy and unsuccessful recorder of certain appearances on Impressionist lines.[20]

To be sure, MacColl himself was no clumsy critic, and could be penetrating on both Cézanne and Fry. Later, when he reviewed Fry's monograph *Cézanne, a Study of His Development* (1927), he contended both that the paintings did "not exhibit a coherent structure in space" and that Fry was hopelessly confused in many crucial areas of his analysis. Although MacColl does not seem to understand the impressionist "technique of originality" as Zola or Cézanne himself probably did, he comes much closer than Fry to an interpretation of the visual qualities of the paintings consistent with impressionist aims. He recognizes that when color dominates chiaroscuro (as Fry claims is the case in Cézanne's art), the result cannot be a greater plastic or volumetric quality. Instead, an effect of "camouflage," a multicolored flatness, results. MacColl resists seeing Cézanne's unusual distribution of color as a deliberate construction; he claims that this artist is no omnipotent "deity" but has been made into a "totem."[21] In taking this position, MacColl appeared to subsequent generations of critics and scholars to have lacked the sensitivity of Fry. Yet, as I shall attempt to make clearer in part 3, the terms of MacColl's analysis are in closer accord with Cézanne's own notions of technique than are Fry's. Significantly, when MacColl analyzes Cézanne's use of color, he concludes that this "classic" artist "is on this ground a pure impressionist."[22]

MacColl criticized Fry's argument on many grounds other than color and tried to demonstrate logical inconsistencies; he began his review of the essay on Cézanne by pointing to Fry's self-contradictory reference to "learning" a "gift" (i.e., an innate talent).[23] Fry does indeed exasperate the reader who may notice such lapses; he is perhaps most confusing when he wavers between describing Cézanne's technique as found (or unconscious) and describing it as made (or deliberate). Denis, with his fully developed theory of the classical, could deal with this aspect of Cézanne quite effectively. Fry, however, works from practical experience and performs descriptive visual analyses of the paintings; he is often reduced to attributing an effect to instinct when he simply cannot conceive how it came into being. In such instances, despite his concern for the rational analysis of rational procedure, Fry falls into an aesthetic of finding; indeed, he links his own analytical failure to the power of great art. He writes that "it must always be kept in mind that . . . analysis halts before the ultimate concrete reality of the work of art, and perhaps in proportion to the greatness of the work it must leave untouched a greater part of its objective."[24] On the whole, Fry sees Cézanne as someone comparable to Bernard's "naïf," one who must remain unaware of aspects of the logic of his own technical procedure. Thus, just as the critic's reasoning over Cézanne's style may never prove adequate to the task, so the artist's

own powers of analysis must have failed as he confronted his painting in the process of its creation: he does not know where his art comes from, nor where it will lead. As in the cases of Bernard and Denis, Fry's commentary indicates that Cézanne's mastery would be surpassed by an artist whose creation might confound critics, but not the "savant" artist himself. But is this Fry's proper conclusion? On the contrary, the aesthetic of finding might demand even of the most successful artists a blind instinctive procedure, the unending search Fry so often describes. Like many scholars of the earlier twentieth century, Fry is determined to employ a strict analysis, but delights in demonstrating that it cannot operate effectively in the realm of "higher" experience—he plays his game of art by conflicting rules.[25]

Although Fry had been trained in the sciences and had always aimed for analytical clarity, by 1927 he appears resigned to seeing Cézanne's art as dominated by findings over which the painter could not have had full control, findings that seem to lie beyond the scope of any definite method. Ironically, the artist who brought "structure" to impressionism remains immune to the critic's structural analysis. Fry regards impressionism itself, exemplified in the manner of painting Pissarro provided Cézanne, as a "technical method in which all was calculated before-hand, in which one proceeded with methodical deliberation and strict precaution, step by step, touch by touch, towards a preconceived and clearly envisaged goal."[26] Fry could not have made a more damning statement concerning an art that aimed at the effect of spontaneity. Why would Cézanne need to add structure to such an impressionism? Fry here considers it "calculated" and "methodical." Clearly, the critic's purpose is not to illuminate Pissarro's impressionism—he regards that as unproblematic. Instead, he seeks to give form to Cézanne's "development," and the fixed point of reference Pissarro provides can be only one aspect of a viewing of Cézanne that will never seem complete, nor a matter of mere method or execution. As Fry states at the beginning of his essay, Cézanne's synthesis was "incapable of complete realization."[27]

Yet Cézanne's very imperfection, his lack of control, seems to become his greatest asset. For Fry, Cézanne achieves the most skillful effects of structured color and composition while he remains perpetually in the position of the finder. As I have implied, this had not always been the critic's view: in his earlier discussions of Cézanne and other "postimpressionists," he often emphasized the degree of control brought to a more "casual" and even "anarchic" impressionism. In 1908, he wrote that "Cézanne and Gauguin, even though they have disentangled the simplest elements of design from the complex of impressionism, are not archaizers; and the flaw in all archaism is . . . that it endeavours to attain results by methods which it can only guess at. . . . [In Cézanne's painting] the relations of every tone and colour are deliberately chosen and stated in unmistakable terms."[28] Cézanne, in 1908, thus appears more the "savant" than the "naïf." Not so in 1927, as Fry's various remarks indicate:

> It is probable that Cézanne was himself ignorant of these deformations [in the rendering of still-life forms in perspective]. I doubt if he deliberately calculated them; they came almost as an unconscious response to a need for the most evident formal harmony.

Poussin pushed his intense feeling for balance so far that he habitually divided his compositions by a marked central line or gap—as it were a caesura in the line. And here we find Cézanne, probably quite unconsciously, doing the same thing. . . .

In reality, the processes [of the artist's mind] go on simultaneously and unconsciously—indeed the unconsciousness is essential to the nervous vitality of the texture.

We cannot . . . establish a perfectly regular progression in [the] gradual and unconscious change in Cézanne's method.

[The achievement of Cézanne's mature style] lies not by way of willed and *a priori* invention, but through the acceptance and final assimilation of appearance.

One feels that at the end Cézanne reposed a complete confidence in the instinctive movements of his sensibility, broken as it was by the practice of a lifetime to the dictates of a few fundamental principles.[29]

Just as Couture before him, Cézanne seems willing to abandon much of a lifetime of acquired technical skill for the sake of an immediate encounter with nature—and the results are fortunate. Compositional deliberation dominates fresh discovery only in the artist's late compositions of bathers. Fry emphasizes that these works were not rendered from nature, but represent the artist's "old dream of the *a priori* creation of a design which should directly embody the emotions of his inner life." And so the results are not so fortunate. Of the *Grandes Baigneuses* (figure 33), Fry writes:

The point of departure is the pyramid given by the inclined tree trunks on either side. The poses of the figures are clearly dictated by this—too clearly, too obtrusively indeed do they adapt themselves to this elementary schema. In spite of the marvels of his handling and the richness of the colour transitions he has not escaped the effect of dryness and wilfulness which so deliberate a formula arouses. . . .

Those of us who love Cézanne to the point of infatuation find, no doubt, our profit even in these efforts of the aged artist; but good sense must prevent us from trying to impose them on the world at large, as we feel we have the right to do with regard to the masterpieces of portraiture and landscape.[30]

In the large, ambitious compositions of bathers, Fry confronts technical manipulations that he can analyze and explain all too well; making seems to rule over finding. He prefers the "unconsciousness" of the portraits, landscapes, and still-lifes.

Fry goes on to discuss Cézanne's limited powers of invention and his need to borrow motifs from earlier masters. When the artist does not work directly from his experience of nature, he lapses into a relatively dull imitation. The critic contends that when Cézanne seeks to convey a poetic message, an allegory, or satire, his work becomes genuinely clumsy—not charmingly awkward, but disconcerting and unsatisfying. When the artist attempts less, however, his success increases: "In proportion as

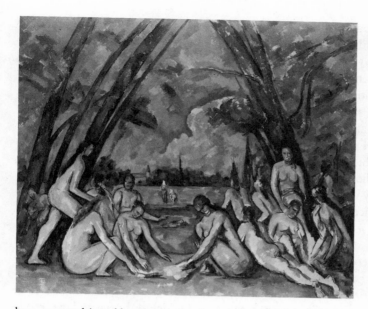

33. PAUL CÉZANNE, *Large Bathers (Grandes Baigneuses)*, 1906. The Philadelphia Museum of Art, W. P. Wilstach Collection.

he contents himself with purely pictorial suggestions of movement and modelling he captivates us by the magic of his touch and the rich harmony of his colour."[31]

As Zola had argued in Manet's case, Fry claims that Cézanne's best work carries with it no associated ideas:

> There is a whole series of still-lifes—most of which are little known—devoted to studies of skulls, sometimes a single skull, sometimes three or four together [cf. fig.42, p. 193]. It is needless to say that for Cézanne a skull was merely a complicated variation upon the sphere. By this time he had definitely abjured all suggestion of poetical or dramatic allusion; he had arrived at what was to be his most characteristic conception, namely, that the deepest emotions could only exude, like a perfume—it is his own image—from form considered in its pure essence and without reference to associated ideas.[32]

In avoiding or eliminating "reference to associated ideas," Cézanne's art satisfied Fry's concern for an appeal to "aesthetic emotion" rather than "practical action"; and it aligned itself with the "modern effort to get to fundamental principles, to purge art of all that is accessory and adventitious."[33] For Fry, the artist's

> creative vision . . . demands the most complete detachment from any of the meanings and implications of appearances. Almost any turn of the kaleidoscope of nature may set up in the artist this detached and impassioned vision, and, as he contemplates the particular field of vision, the (aesthetically) chaotic and accidental conjunction of forms and colours begins to crystallise into a harmony; and as this harmony becomes clear to the artist, his actual vision becomes distorted by the emphasis of the rhythm which has been set up within him. . . . [In such artistic vision] a man's head is no more and no less important than a pumpkin, or, rather, these things may be so or not according to the rhythm that obsesses the artist and crystallises his vision.[34]

An organizing harmony or rhythm becomes the ultimate guiding principle that directs the artist's immediate and casual scanning of nature; consequently, in any given painting Cézanne's vision would move from specific observation to more general sensation, that is, to an emotional effect.[35]

Despite Fry's multiple efforts at formulation, Cézanne's achievement never becomes entirely clear; the critic admits that he must use his expository "language to adumbrate certain states which are not exactly definable in language."[36] This statement itself indicates Fry's faith in or receptivity to "original" experience; he expects to find in art that which lies outside the bounds of his own world of conceptualization. In a passage following his analysis of Cézanne's thematically dissociated skulls, he writes accordingly that the artist's "interpretation of natural form always seems to imply that he is at once thinking in terms of extremely simple geometrical forms, and allowing those to be infinitely and infinitesimally modified at each point by his visual sensations."[37] Here, the organizing principle, the artist's impassioned language of "extremely simple geometrical forms," his design, seems to be altered unsystematically in response to the unaccountable vicissitudes of his vision. Can a fully intelligible rhythm or harmony, subject to the critic's rational exposition, ever take form in such an art? Can Cézanne ever *complete* a painting in which technical and expressive means are subject to such continual modification? Cézanne's synthesis (as Fry conceived it) was *"incapable of realization."*[38] The result of his artistic process was an individual manner, a set of "distortions," over which the painter himself might exercise no conscious control. Fry implies that Cézanne would be no more able to explain his art than is his admiring critic.

Although Fry claims that Cézanne applied an intellectual structure to his vision of nature ("with Cézanne the intellect—or, to be more exact, the intellectual part of his sensual reactions—claimed its full rights"), this discriminating consciousness remained dialectically bound to a "sensibility," an emerging and original self.[39] To be sure, for Fry, as for Denis, Cézanne attains a certain synthesis in his art, a synthesis of making and finding, dependent on both conscious and unconscious processes. Fry once wrote that "synthesis is of course always made by a jump of the unconscious, but the materials out of which the synthesis is made are given by the conscious mind."[40] Finally, despite all the equivocation, it seems that Cézanne is more the original finder than the skilled master maker; as such he remains unassimilated and unassimilable. Perhaps Fry made his most direct statement to this effect in 1917:

> In a world where the individual is squeezed and moulded and polished by the pressure of his fellow-men the artist remains irreclaimably individual—in a world were every one else is being perpetually educated the artist remains ineducable—where others are shaped, he grows. Cézanne realised the type of the artist in its purest, most unmitigated form. . . .[41]

Cézanne's technique, then, cannot be learned; it must be original—indeed it must remain original—and Fry feels no embarrassment in speaking inconclusively about what no one can be expected to understand.

Part Three

Seeing Cézanne

11

Introduction:
"Postimpressionism" and Expression

IN THE PRECEDING DISCUSSION of Roger Fry's critical response to Cézanne, one important document was never cited: the introductory essay to the catalog of the first postimpressionist exhibition at the Grafton Galleries (November 1910–January 1911). Historians have often ignored this statement, perhaps because its authorship is unclear. Desmond MacCarthy, who accompanied Fry on his travels to select works for the show and who served as secretary to the exhibition committee, produced the actual composition of the essay. According to his own testimony, however, he had relied largely on notes supplied by Fry.[1] Certainly the content of the essay invokes Fry's ultimate "authorship," for the argument parallels statements the critic had made just previously, around 1908–10, as he became more and more familiar with the French painters whom he chose finally for his "postimpressionist" show.

In forming a group of "postimpressionists," Fry wanted to establish a clear distinction between this new art and the impressionism that had set the stage for it. Such a distinction had been made by others whose work Fry knew—by Maurice Denis and the French symbolists, and by the German critic Julius Meier-Graefe and his followers, such as Rudolf Meyer-Riefstahl.[2] Just as the new art had seemed especially "expressive" to Meier-Graefe and had suggested a theory of "expression" to Denis, "expressionism" appeared to Fry to define the spirit of the younger generation. Accordingly, at one point he offered this term as a candidate for the name of the new art. But since others had already used this descriptive label in various ways, both approvingly and pejoratively, it was likely to encourage partisanship. Fry felt compelled to abandon his choice, however fitting it seemed. Eventually, he settled on what he thought to be an innocuous term of chronological identification, "postimpressionism." As Desmond MacCarthy recounts, Fry lost patience with the search for an appropriate name and remarked: "Oh, let's just call them post-impressionists; at any rate, they came after the impressionists."[3]

In its final form, the exhibition attempted to reconstruct a historical development and referred to its paternity in its title—"Manet and the Post-Impressionists." Manet's oeuvre was well represented, and there were large numbers of works by Cé-

zanne, Gauguin, and Van Gogh. Seurat and the neoimpressionists were shown as well, along with Matisse, Denis, Picasso, and a sampling of the younger French "avant-garde," most of whom could be identified with symbolism or Matisse's "fauvism." The catalog essay by Fry/MacCarthy bore the simple title, "The Post-Impressionists," masking the complexity of its authors' conception. It deserves more serious attention than it has received because it reveals how easily the strands of impressionism, symbolism, and "expressionism" could be woven into a single synthetic fabric to which none of the names of the component fibers could unequivocally be applied.[4] Postimpressionism was, and is, an awkward invention, a new whole substituted for its disparate parts. Within the discourse of art history and criticism, this category has gradually lost its rough edges; it continues to efface the remaining signs of the various antecedent forms of art that it seeks to assimilate and supplant. In successfully dominating a field of inquiry, the term "postimpressionism" has effectively skewed the interpretation of both Cézanne's painting and the artist's own motivation. The very application of the title indicates rejection of the principles of impressionism; the name itself implies that a theoretical chasm separates impressionist art from whatever followed it, whether neoimpressionist, symbolist, "neoclassical," or "expressionist." In reading the Fry/MacCarthy essay of 1910, one can indeed detect the elements of impressionism, symbolism, and expressionism within the newly created hybrid of postimpressionism, but only with difficulty. Thus the confusion that befell Cézanne's critics during the twentieth century, their often contradictory statements with regard to the artist's intentions and allegiances, is prefigured in the very use of the term applied to him. This classification gives no hint of the extent to which Cézanne continued to appreciate the paintings of Monet, Renoir, and Pissarro throughout his career.

Most of the artists who interested Fry were either self-proclaimed symbolists (Gauguin) or were nurtured in a symbolist environment and theorized in the manner of symbolists (Matisse). The distinction that Fry customarily made between postimpressionism and impressionism closely resembled the one that symbolists had often established between their art and impressionist naturalism. Fry followed Bernard and Denis in seeing Cézanne as contributing structure and design to impressionist spontaneity. Cézanne, the symbolists' reluctant father figure, correspondingly became Fry's seminal postimpressionist. Since Cézanne's own view of impressionism was not in agreement with Fry's, the artist would likely have declined this honor.

Those who discussed the ideological conflict, historical transition, or simple difference—call it what one will—could not avoid equivocation. As I have demonstrated, impressionists held many symbolist values, and the theoretical differences between the two groups of artists were often exaggerated. Furthermore, both impressionism and symbolism were arts of expression. Both employed simplified technical means to express an "idealized" image of their own experience—personal, subjective, but also potentially universal—an experience marked by its originality.[5] One suspects, as a result, that the distinctions that the new term "postimpressionism" tended to institutionalize may never have been designed to function properly in a rig-

idly constructed critical apparatus. Impressionism was never itself so simply defined that it could foster a clearly defined reaction, a sharply delineated "postimpressionism"; in France a number of perceptive critics had recognized this.[6]

Perhaps Fry could have served history better had he allowed himself to opt for the imprecision and contentiousness of the descriptive label "expressionist." When he instead chose "postimpressionist," he inadvertently obscured his own major concern and that of the artists he studied and admired, both impressionists and postimpressionists—the search for emotional expression and expressive communication.[7] In fact, Fry realized that the artists he called the postimpressionists aimed at expression; and more than one of his British contemporaries realized in turn that the critic had made an injudicious choice of title given the nature of the art that interested him. Charles Lewis Hind stated flatly: "Expressionism is a better term than Post Impressionism."[8] A. Clutton-Brock said it with more wit: Cézanne, Van Gogh, and Gauguin might be called "Expressionists, which is an ugly word, but less ugly than Post-Impressionists."[9]

If artistic expression is the issue, whether directly acknowledged or not, how does Fry conceive of it? He and MacCarthy oppose *expression* to *representation*. This dichotomy constitutes the central theme of the 1910 catalog essay as well as of several of Fry's independent publications, including his "Essay in Aesthetics" (1909).[10] Expression is tantamount to discovering, or finding, the originality of truly personal experience. Fry allies the term with the concept of emotion—one experiences and comes to know emotion only through its expression.[11] Thus Fry can speak of the special emotion of the artist, the aesthetic emotion that is conveyed through the formal design of a work. The content of aesthetic emotion often contrasts sharply with the content (either denotative or connotative) of representation; the one is known with immediacy, the other is mediated. "Accurate" representation, characterized by similitude, may mask or diminish feeling; and conversely, "true" expression may deform representation. The postimpressionist catalog essay, for example, states:

> Like the work of the primitive artist, the pictures children draw are often extraordinarily expressive. But what delights them is to find they are acquiring more and more skill in producing a deceptive likeness of the object itself. Give them a year of drawing lessons and they will probably produce results which will give the greatest satisfaction to them and their relations; but to the critical eye the original expressiveness will have vanished completely from their work . . . there comes a point when the accumulations of an increasing skill in mere representation begin to destroy the expressiveness of the design.

In other words, representation and expression often stand in reciprocal relation to one another: as one increases, the other diminishes. Given this formulation, post-impressionism becomes an art of increasingly expressive design, supplanting the representational art of impressionism; the artist "is prepared to subordinate consciously his power of representing the parts of his picture as plausibly as possible, to the expressiveness of his whole design."[12] For the sake of the dichotomy, impressionism

must suffer reduction to a relatively limited art of observational detail; the post-impressionists return to a purer expression.

Fry and MacCarthy begin their essay by stating that the artists in the exhibition have previously been called "synthesists." (This was one of the labels applied to Gauguin and other French symbolists.) They proceed to define the ends of this " synthesist" art in a manner that might also characterize impressionism: "In no school does individual temperament count for more . . . its methods enable the individuality of the artist to find completer self-expression in his work than is possible to those who have committed themselves to representing objects more literally." Despite the fact that this description of purpose might serve impressionists and symbolists equally well, Fry and MacCarthy follow the rhetorical lead of the symbolists who wished to establish their own historical identity. The authors insist on an opposition and a conflict between two schools of thought. They claim that the concern for self-expression "is the first source of [the "synthesists'"] quarrel with the Impressionists: the Post-Impressionists consider the Impressionists too naturalistic."[13]

Throughout the essay, Fry and MacCarthy vacillate as they implicitly recognize and explicitly deny the close identification of impressionism with postimpressionism. They develop the issue of emotional expression quite subtly by distinguishing the two types of expression that Denis would refer to as "subjective" and "objective": the postimpressionists not only express personal temperament, as do the impressionists, but "express emotions which the objects themselves evoked." For the sake of "expressing that emotional significance which lies in things," the postimpressionists simplify and even "distort" the objects they represent. In effect, the catalog essay suggests that an artist faces a difficult choice: either to express, or transmit, an impression (*found* in subjective, but naturalistic vision), or to express an object (*made* in the transformative act of rendering). The point is difficult to grasp since the expressed "object" is not external, but is created in the very act of artistic expression. The authors conclude that the impressionists were too partial to finding and not sufficiently involved with making: "The impressionists were artists and their imitations of appearances were modified, consciously and unconsciously, in the direction of unity and harmony; being artists they were forced to select and arrange. But the receptive, passive attitude towards the appearances of things often hindered them from rendering their real significance."[14]

The basic distinction that Fry and MacCarthy wish to establish is the same one that had concerned Octave Mirbeau with regard to both Van Gogh and Monet in 1890. It is too insecure a footing on which to stand very long. Mirbeau had written that Van Gogh "did not allow himself to become absorbed into nature. He had absorbed nature into himself; he had forced her to bend to his will, to be molded to the forms of his thought. . . . " Similarly, this critic had stressed the active element of expression in Monet's art.[15] But could an artist ever actually escape being self-conscious or deliberate about his own expressiveness? Was earlier impressionism really as passive and naïve as the straightforwardness of its representation might signify? One is

confronted with the possibility that *all* art is actively made; and impressionism's appearance is not the result of receptive innocence, but active deception.

《 》

In part 1, I demonstrated that well before Fry invented postimpressionism and its theoretical position, the symbolists argued their case from two sides: sometimes they claimed that the impressionists and naturalists were too naïve or haphazard in their art; and sometimes they stated the opposite, that their predecessors were too mechanistic and studied in their process of depiction, that they lacked feeling. For the symbolists, the impressionists could be either too subjective or too objective. Van Gogh, Gauguin, and (to a lesser extent) Seurat were symbolists who came to be considered postimpressionists once Fry established the classification. Since these artists, along with Cézanne, have always formed the nucleus of postimpressionism, the more sophisticated studies of this movement have found themselves revolving around symbolist art, theory, and criticism. John Rewald's detailed history of postimpressionism is effectively a fine account of the symbolist era; and Sven Loevgren's *Genesis of Modernism* ably demonstrates the extent to which Van Gogh, Gauguin, and Seurat identified with the ideas of symbolist literary figures.[16] Today, Cézanne remains as the only "major" postimpressionist who resists the symbolist label and the concerns associated with it. He is, of course, older than the other three, but the same age as Redon, who fits into the symbolist mold much more comfortably.

Fry and MacCarthy, in their 1910 essay, indirectly provide one of the many causes of this slippage in the art-historical gears. While they unequivocally describe Van Gogh and Gauguin (and also Matisse) as self-conscious makers, Cézanne appears as a finder.[17] Although anti-impressionist, he yet remains naïve. Moreover, he is something less than a full-fledged postimpressionist. He becomes an artistic creature, an invention that one would not have expected to fly very well, the missing link between artistic passivity and activity (Fry/MacCarthy's distinction) or between being "absorbed into nature" and "absorbing nature" (Mirbeau's distinction). Chronologically a member of the impressionist generation but "discovered" by the symbolists, he seems available to personify the synthesis of all the desirable but incompatible artistic qualities, and thereby to give credence to the most insubstantial yet ideologically potent claims. He becomes Denis's "spontaneous classic" and Fry's "unconscious" formal master. Both critics describe him as a fluid mixture of the finder and the maker in which finding becomes the more basic and viscous of the two mediums, allowing a thin film of making to appear on the artist's pictorial surface as "structure." The question always remained as to how deep this structure of making extended—how much control did the painter actually exercise?

Fry and MacCarthy identify Cézanne as the originary, liberating spirit of postimpressionism: "The artists who felt most the restraints which the impressionist attitude towards nature imposed on them, naturally looked to the mysterious and isolated figure of Cézanne as their deliverer . . . Cézanne did not use consciously his newfound method of expression to convey ideas and emotions."[18] Cézanne, in other

words, becomes a master of an expression that postimpressionism will come to control, but he does so without having control himself. The argument is even more explicit in Fry's own essay on postimpressionism of several months later (May 1911):

> In essentials the principles of [the postimpressionists] are diametrically opposed to those of Impressionism. . . .[19] [The impressionists'] aim was still purely representative . . . exactly how they came to make the transition from an entirely representative to a non-representative and expressive art must always be something of a mystery, and the mystery lies in the strange and unaccountable originality of a man of genius, namely, Cézanne. What he did seems to have been done almost unconsciously.[20]

Cézanne's "unconsciousness" was, of course, a major theme of the praises Fry sang of him (see above, pp. 146–52); it allowed the spontaneous play of "genius" to enter into the master's art.

Fry's earliest accounts of postimpressionism identify the painters Cézanne, Van Gogh, Gauguin, and Matisse as the leading figures. All aim at "expression" rather than "representation." Cézanne is distinguished as the one whose expressive method remains "unconscious." In consequence, one must wonder how clear the difference can be between his "postimpressionism" and what might be regarded as an equally unconscious "impressionist" expression of innate temperament. Denis had dodged the dilemma (and to some extent Fry did, too) by allowing Cézanne to be "classic" *by his very nature*—the painter's immediate expression of temperament led *spontaneously* to an art of abstract order and harmony which exhibited the visual qualities that Fry and others came to view as characteristic of postimpressionism. Such spontaneous expressiveness—communicative, yet innovative—was the essence of artistic "genius" and "originality" for both Denis and Fry.

Had Fry chosen to call the artists from Cézanne to Matisse "expressionists" rather than postimpressionists, perhaps the question of Cézanne's expression would arise today in a more accommodating context; the art historian would not feel obliged to maintain some categorical distinction between impressionist and symbolist, pre-Cézanne and post-Cézanne, or even early Cézanne and late Cézanne. Rather than emphasizing stylistic dichotomies, one might concentrate on a deeper investigation of the concept of artistic expression itself. Cézanne could be claimed by both impressionists (Pissarro, Monet) and symbolists (Gauguin, Denis)—as indeed he was—because, on a more general level of classification, he acted as a master of artistic expression of the "modernist" sort. Matisse, who admired Cézanne beyond all other moderns, wrote of his own art: "What I pursue above all is expression . . . it is in the whole arrangement of my picture."[21]

When Fry created the chasm between the old impressionism and the new French art, and then bridged it with the accommodatingly "unconscious" Cézanne, he was merely following the suggestions of Maurice Denis and other members of the symbolist generation. During the previous two decades, they had invented a "Cézanne

legend" to explain the presence and power of the man few had met and whose works had for a long period remained unseen. The legend continued to grow after Fry's own contributions to it, nurtured by such "witness" accounts as those of the dealer Ambroise Vollard and the "naturist" poet from Aix, Joachim Gasquet. Even more than Bernard and Denis, the later writers tended to exaggerate Cézanne's eccentricities and his alienation from impressionism; and they borrowed anecdotes from each other with the result that the truth of certain curious incidents seemed continually reconfirmed.[22] Despite the eventual degeneration of the Cézanne myth because of this kind of inbreeding, in its original manifestations it bore more directly on the compelling artistic issues of its day. It serves to illuminate not only the secrets of Cézanne's late but spectacular success, but also the values shared by impressionists and symbolists alike.

To investigate the early form of the Cézanne legend, I shall return to the familiar territory of Maurice Denis and others sympathetic to the symbolist cause; I do so now, however, with the aim of reconstituting the specifically symbolist view of an artist who saw himself as an impressionist. Although the descriptive languages differed, retrospectively, at least, the two views begin to appear much the same; the similarities figure more significantly in the historical picture than the differences.

12

The Cézanne Legend

I N 1890, ALBERT AURIER lauded the relatively obscure Vincent van Gogh as an "homme isolé," an artist who had liberated himself from the material concerns of a Western civilization in desperate need of spiritual rejuvenation; Van Gogh's art had attained the intellectual and emotional purity of the Symbol.[1] To be sure, Cézanne also existed in isolation, both in the spiritual sense that Aurier considered so important and in his everyday affairs. As a personality, he was odd and mysteriously incommunicative, the type to whom layers of legend readily adhere and begin to grow as if fed by an ever veiled but undeniably real core of being.[2] The basic facts of the artist's biography have been chronicled by John Rewald and others; bits of new information appear from time to time, but the general impression Cézanne left on the surfaces of art criticism and history has not changed much over the years.[3] The most significant details of this public image appeared to Cézanne's earliest observers; if the image of the man that has remained for posterity seems as incomplete as many of his paintings, it may have been this very lack of final definition that attracted the interest of subsequent generations of imitators and admirers. The facts of Cézanne's case—or the absence of them—have allowed great interpretive flexibility, if not outright inventiveness. Maurice Denis admitted as much in 1920: "Such is Cézanne, complex and diverse, that each one expects of him the confirmation of his own system; certainly his painting and his ideas ask to be interpreted."[4]

Cézanne's isolation had at least three contributory sources in the circumstances of his life and career: first, the public rejected his earlier efforts; second, either as the cause of this or as its result, the artist tended to insult the public and to distrust or resist any kind attention it might pay him;[5] third, he was heir to a fortune and never depended on his art as a commercial venture.[6] This last factor may be especially important in accounting for the unprofessional character of Cézanne's enterprise—as a rule, he neither signed nor dated his paintings, left parts of them in varying states of finish, and often returned to repaint canvases with the result of placing one image over another incompatible one. His lifelong search may have had its inherent principles and order, but the physical record of that work is chaotic.

Not surprisingly, the exhibition record, too, is irregular. Cézanne showed with the impressionists in 1874 and 1877 and then virtually disappeared from the view of Parisian *amateurs* until late 1895.[7] Gustave Geffroy—Monet's friend, critic, and bi-ographer—aptly characterized Cézanne's position in 1894: "a person at once un-known and famous, having only rare contacts with the public and taken up as an in-fluence among dissatisfied investigators into the art of painting, known only to some, living in determined isolation, reappearing, disappearing abruptly before the eyes of his intimates."[8] In March 1895, Cézanne could still be described as "unknown to the public."[9] By November of that year, however, he had hit the newspapers; the aggres-sive dealer Ambroise Vollard had arranged a one-man show that brought forth to the world at large a representative group of about 150 paintings. The combination of Vollard's entrepreneurial effort and the accumulation of glimpses and rumors of the artist over the preceding years resulted in a widespread notoriety.[10] Still personally isolated, Cézanne subsequently figured in major exhibitions such as the Salon des In-dépendents and the Salon d'Automne every year from 1899 to his death in 1906. By 1905, his oeuvre was so generally seen and discussed that Charles Morice could put this simple question, directed at the younger generation, into his *Mercure de France* survey on the subject of contemporary art: "What do you make of Cézanne?"[11]

Before Vollard transformed the artist's curiosities into a topic of journalistic de-bate, they had been known, of course, to the impressionists with whom the painter had often worked. In addition, the symbolist artists could see a few canvases at the small Parisian shop of Julien "Père" Tanguy, with whom Cézanne, as well as Van Gogh and Gauguin, exchanged works of art for paint and other supplies.[12] Gauguin was the only member of the developing symbolist group who actually met Cézanne at an early date. The encounter between these two strong personalities occurred dur-ing the summer of 1881 while Gauguin was "apprenticed" to Pissarro at Pontoise. There he found himself working beside Pissarro's other "pupil" and was duly im-pressed by the eccentric Cézanne and his struggle to realize an expression of self and nature. Around this time, Gauguin probably began to form his small collection of paintings by Cézanne, which he considered an especially valuable investment. He owned five or six, at least two of which were purchased from Tanguy. Motifs from these Cézannes appear in Gauguin's studies; he effectively appropriated aspects of the "isolated" master's technique for his own purposes.[13] By all accounts, this did not sit well with Cézanne, especially as it seems that Gauguin may have teased him about stealing the secrets of his art—Cézanne was, after all, not only suspicious and para-noid, but attempting to be a painter of "originality."[14] Perhaps Cézanne's well-docu-mented distaste for both Gauguin and Van Gogh stemmed from his having been forced to assume the role of a mediating genius pressed into involuntary service to others.[15]

In fact, this image approximates the picture of Cézanne that the symbolists cre-ated. According to Gauguin (in 1885), the painter seemed to embody an Oriental mysticism, as if he were a source from which materialistic Occidentals might derive

some otherwise unattainable insight.[16] Félix Fénéon, André Mellerio, and Émile Bernard followed Gauguin in associating Cézanne's style with mystical revelation; and, as early as 1891, Fénéon spoke of the existence of "la tradition Cézanne"—the legendary presence of the artist had already resulted in a devoted following that included the young Bernard and Denis.[17] Among the symbolist painters and their literary friends, Cézanne rapidly became recognized as the "initiator" of the movement, although perhaps a "neglected" one.[18] Needless to say, all this occurred without the painter's involvement; indeed, there exists hardly any record of his concern for his own reputation, and his few claims to artistic accomplishment were quite modest.[19]

《 》

If Cézanne had a serious rival for the title—disdained, of course—of "initiator" of symbolist painting, it was Pierre Puvis de Chavannes (1824–1898), who was renowned for his clearly structured compositions, often designed for use as mural decorations (fig. 34). Isolation certainly does not characterize Puvis's career, but he did share some of Cézanne's qualities. First, he was an "outsider," known as an independent-minded artist who avoided official academic channels and had suffered some early rejections.[20] Second, his painting seemed an ideal synthesis of nature and art, restricted neither by fidelity to observation nor by academic convention; his images of landscape were said to be "at once stylized and real."[21] In support of such an assessment, critics repeatedly referred to Puvis's stated desire to create an art "parallel" to nature; and Cézanne himself once described the general aim of art in the same way, perhaps because he knew of Puvis's formulation.[22] Third, Puvis's simplified figural forms appeared anatomically unlearned, even naïve and awkward; yet, at the same time, his compositions exhibited the most compelling order.[23] Fourth, in the critical discourse of the turn of the century, Puvis moved in the same circles as did Cé-

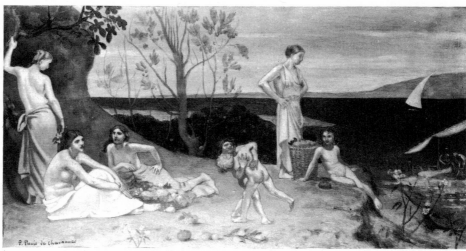

34. PIERRE CÉCILE PUVIS DE CHAVANNES, *Pleasant Land (Doux Pays)*, 1882. Yale University Art Gallery. The Mary Gertrude Abbey Fund.

zanne—among primitives, classical Greeks, and the classical French master, Nicolas Poussin.[24]

The symbolists recognized, however, that although Puvis may have been "classic," his primitivism (and the spontaneity associated with it) did not run deep; Puvis was not "naïf," but decidedly "savant." His grand allegories, complex and sophisticated with regard to their studied associations, had been constructed by means of a laborious process involving numerous acts of measuring, tracing, and refining as the artist reduced his figures to their simplest expressive forms. Gauguin, in comparing himself to Puvis, found it necessary to distinguish this classical simplicity from a simple primitivism: "[Puvis] is Greek while I am a savage, a wolf in the forest without a collar." Gauguin complained that critics usually responded to Puvis because his allegorical symbolism could be readily grasped intellectually; in contrast, Gauguin's own symbolism was emotional.[25] This "savage" claimed direct involvement in the culturally unmediated forms he presented; his art was the more spontaneously expressive.

Maurice Denis, too, found a certain failing in Puvis, who nevertheless exemplified the best of the moderns who had attained general acclaim. Puvis's modern form of the "classical" could never equal Poussin's for reasons related to the distinction Gauguin had belabored. According to Denis, Puvis maintained too clear a division between the external nature he observed and the idealized image he created from it; in other words, he made the "academic error" of opposing "style" to "nature."[26] In effect, he concentrated too exclusively on his making, at the expense of the found element in his art; and his naïveté became calculated, having lost its innocence. For Denis, Poussin's classicism had come into being in a purer state than had Puvis's flawed variety; in it, nature and style merged seamlessly. Still, Poussin's compositions, like Puvis's, were not "naïf" but revealed the knowledgeable manner of a "savant" maker.

As I have indicated, Denis claimed that both the knowledgeable and the naïve artist might have expressive "style," the style of the symbolist, one based on the "correspondence between forms and emotions."[27] In the greatest "classic" art, form and feeling would become one just as style and nature would. With this in mind, Denis found it more natural to create an analogy between Poussin and Cézanne than between Poussin and Puvis. Consequently, in 1905 and 1907, Denis honored Cézanne by titling him a modern Poussin.[28] Significantly, he had already related Gauguin to the standard set by Poussin, and in such a way as to reinforce the image Gauguin had created when he contrasted his own primitive style to Puvis's—Denis praised Gauguin (after his death in 1903) as a "kind of Poussin without classical culture."[29] Denis amplified this identification by stating that Gauguin was a Poussin "for our corrupted age," one who never went to Rome to study the antique, but instead discovered a valid artistic tradition in the primitive forms of Breton and Oceanic sculpture, as well as in the imagery of crude, anonymous woodblock prints.[30] Gauguin's great achievement was to have recovered the naïveté and sincerity of the primitive, not merely some superficial stylistic mannerism. The analogy becomes clear: Gauguin drew

from the "primitive" as Poussin drew from the "classical"; neither was "academic" in his study; both recovered the true essence of their sources. For Denis and others, the dichotomy of primitive and classical (perhaps personified in Gauguin and Poussin) could be made to serve a scheme of classification for nearly all sincerely expressive and original art: "primitivism" could characterize naïve art and "classicism" art that was informed by theory, the best of the tradition that had degenerated in the hands of conventional "academic" masters. Accordingly, the category of primitives was quite broad. It included not only artists of the ancient Orient and of contemporary non-Western societies, but also those belonging to the earlier stages in the development of various Western styles (the archaic Greeks, the pre-Raphaelite Italians) and any provincials or those working before the advent of national schools.[31]

The traditions of the primitive and the classical, however broadly based, did not exhaust all possible origins for a valid artistic style. The "double origin" of nature and self—that immediate experience of nature, which the impressionists had appropriated almost as a "method"—was also available. Cézanne, as the "Poussin of impressionism," the Poussin of the experience of nature, filled out Denis's system of classification in completing a triumvirate of true artists: the *classical* Poussin, the *primitive* Gauguin, and the *natural* Cézanne.

Now if Cézanne was a modern reincarnation of Poussin, something may have been lost in the regenerative process. Like Gauguin, Cézanne seemed to lack Poussin's masterful refinement; Denis called the style of his compositions of bathers "gauchement Poussinesque"—these paintings were awkward.[32] Along with a number of other critics, Denis assigned the notion of *gaucherie* (awkwardness, distortion, naïveté) nearly as much importance as the idea of style. Cézanne may have had style of the purest sort, but only coupled with an awkwardness which indicated his extreme originality and sincerity. Because the artist struggled so directly to express his sensation, refusing to follow any conventional formulations, his painting of nature became as distorted and awkward as that of a primitive.[33] Indeed, the Cézanne legend repeatedly refers to the primitive qualities of his painting.[34] Yet it is apparent that neither the artist's naturalism nor his primitivism prevented him from occupying the rank of the classical—this despite the fact that Denis stated bluntly that the classical style of the ancients was "not at all gauche."[35] Perhaps Denis need not have formed his triumvirate of the classical Poussin, the primitive Gauguin, and the natural Cézanne; the mystery-man from Aix represented all three and everything the history of art required: Cézanne became a Caesar, however unwilling he may have been to assume the role.

<center>« »</center>

Gauguin, Denis, and others of their era created an image of Cézanne as the initiating spirit of symbolism, both a primitive and a classic, albeit an awkward one. What specifically were these early viewers seeing in Cézanne's painting? Where, for example, is the evidence of *gaucherie*? Van Gogh, in a moment of his own naïveté, spoke of

"how clumsy [Cézanne's] touch in certain studies is," and went on to attribute this
awkwardness to working outdoors "when the mistral was blowing."[36] The novelist
and critic Joris Karl Huysmans mentioned the distorted linear contours of the artist's
bathers ("des lignes insanes"); Denis saw the same ("des proportions inimagina-
bles").[37]

Both these elements of Cézanne's style, the pronounced "touch" or brushstroke
(the technical term is *facture*) and the odd linear rendering, are clearly visible in works
such as *Bathers* (fig. 35) and *Trois Baigneuses* (fig. 36), which probably date from the
early 1880s. The "awkwardness" of these studies becomes especially apparent when
they are compared to a more refined work produced about the same time, Bouguer-
eau's *Bathers* (1884; fig. 37). The comparison juxtaposes paintings of very different
nature—studies probably not intended for exhibition (although completed) and the
large-scale project of a member of the Académie des Beaux-Arts who exhibited regu-
larly. In a sense, however, Bouguereau's more "finished" work provided the critical
standard for Cézanne's sketchlike canvases since his contemporaries frequently classi-
fied him as an academic naturalist, a master of the painter's craft and the imitation of
natural effects. In addition, he was regarded as an artist whose subject matter (just as
Cézanne's) often appeared opaque and devoid of poetic content.[38] If Cézanne's art
seemed crude or distorted, it seemed all the more so in comparison with an accepted
standard of naturalistic refinement, such as Bouguereau's painting. According to
both Geffroy and Bernard, Cézanne himself identified public approval with admit-
tance into the company of this academic master.[39]

Clearly marked parallel strokes characterize the *facture* of Cézanne's *Bathers* and
his *Trois Baigneuses*. These strokes may at times seem to denote the planar elements
of a complex volumetric form or even the individual leaves of a tree, but most often
they appear as an abstraction, a loosely structured pattern that articulates the pictori-
al surface by means of color. The strokes seem hastily applied and give the images a
sketchy, unfinished quality. The patterns of color are abrupt; no transitional tones
mediate juxtapositions of (for example) light green and dark green, green and ochre,
or yellow-green and pale blue. In contrast, Bouguereau's brushstrokes and colors are
a study in subtlety. He suppresses the visibility of the individual stroke to a great ex-
tent and employs a traditional system of chiaroscuro modeling—that is, the passage
from light to dark or from one color to another is gradual; transitional tones elimi-
nate any sudden shifts in value or hue.

Cézanne's compositions of bathers present in addition the multiple sketchy con-
tour lines which Denis and others found so problematic.[40] The figures seem crudely
drawn and anatomy is not well defined. In the Detroit *Bathers*, for example, the seat-
ed figure to the left has bizarre proportions: its neck is long and thick, its head is
small, and its legs taper to a crippling degree. Furthermore, the background foliage
appears, in places, to impinge on the physical integrity of the foreground figures as it
overlaps their contours. In contrast, Bouguereau's bathers (although they may be va-

35. PAUL CÉZANNE, *Bathers*, ca. 1881–84. Courtesy of the Detroit Institute of Arts, bequest of Robert H. Tannahill.

pid) have a convincing pictorial character as illusionistic volumetric forms. It is no wonder, then, that Cézanne's art, in comparison, was seen to be awkward, full of *gaucherie*.

The artists and critics who observed this awkward art, those few who in the 1880s and 1890s wrote at length about Cézanne, nevertheless generally praised him. In fact, during this period it was common for the crude, the awkward, or the distorted to be accepted as more sincerely expressive than the refined.[41] Maurice Denis, of course, linked Cézanne's *gaucherie* to his originality and sincerity.[42] Earlier, when Gustave Geffroy reviewed the artist's first one-man exhibition, he justified the "awkwardness, the lack of perspective and balance, and the unfinished aspect" as signs of a "scrupulous observer, like a primitive, deeply concerned with truth."[43] And in 1899 Georges Lecomte wrote that Cézanne's *gaucheries* "demonstrate [his] fine sincerity . . . He has the clumsiness and the imperfections of a true primitive."[44]

36. PAUL CÉZANNE, *Trois Baigneuses*, ca 1881–82. Musée du Petit Palais. Photograph courtesy Giraudon.

Aside from the odd way in which Cézanne rendered figures, there was another reason to characterize his paintings as distorted or awkward: they appeared to lack illusionistic space; they seemed flat. In his essay of 1899, Lecomte emphasized this absence of spatial illusion; he appreciated the harmonies produced by the "very simple, flat tones" but was disturbed by Cézanne's failure to distinguish the various levels of depth in a landscape.[45] Had Lecomte been viewing the *Bathers*, he might have issued just this complaint, for the lower landscape area consists of four horizontal bands of color—pale yellow-orange (or ochre), blue-green, yellow-orange, and green—which represent a stream (blue-green), its sandy banks (yellow-orange) and a meadow beyond (green), and the colors themselves vary little in intensity as they would if in accord with the convention for indicating spatial recession. In addition, the horizontal bands are of nearly equal width and of similar *facture*; this uniformity offers no hint of relative spatial displacement. Having observed features of this sort, Denis (just as

37. WILLIAM ADOLPHE BOUGUEREAU, *Bathers*, 1884. Courtesy of the Art Institute of Chicago.

Lecomte) concluded that the artist's color lacked true value gradation (chiaroscuro) with the result that the "perspective planes disappear." For Denis, the effect seemed comparable to that of the very flat color of symbolists such as Gauguin and Bernard.[46]

Characteristically, Denis saw this deviation from the standards of conventional technique as linked to classicism and, especially, primitivism. The historical concept of the primitive figured in a scheme he created analogous to Bernard's theory of the "naïf" and the "savant": essentially, he interpreted all artistic evolution in terms of a passage from the primitive to the classical.[47] Furthermore, according to Denis, art could, and often did, evolve beyond the classical, but such movement constituted no welcome advance; it represented instead a degeneration from a consciousness of universal knowledge to a reliance on conventional "academic" formulas. In an era of academicism, a time of fallen classicism, a return to the primitive could be rewarding—hence Denis's appreciation of both Gauguin and Cézanne.

For Denis, any primitive distinguishes himself not only by his naïve *gaucherie*, but by his general mode of visualization—his representations are determined by his concepts of individual objects rather than by a coherent system of organizing visual data. In other words, he renders the reality that he *knows*, rather than the appearance that he *sees*. The primitive has no sense of an idealized aesthetic (associated with both personal taste and artistic convention); he understands things only as external to him, including even his own "objects" of art—in painting a surface, he creates a concrete object instead of a sensory illusion. Denis presented his theory of the primitive, the classical, and the academic as follows:

> Every Primitive sees nature as the savage does; he appreciates the common qualities of things more than their beauty. . . . He prefers reality to the appearance of reality [and] makes the image of things conform to the idea he has of them
>
> An equilibrium between the sense of the Beautiful and the love of Reality gives birth to the superiority of the classical
>
> Such perfection does not last long. The academies soon lose the idea of reality, they repeat the formulas of the masters. *Gaucherie* disappears along with the sense of objects. Greek [classical] art ends in academicism and the [conventional] picturesque

In what may be one of his most confusing formulations, Denis offers an explanation of how a primitive regards perspective and spatial illusion: "The Primitive knows objects with his intellect as so many entities distinct from himself; he ranks them always in the same plane, the plane of his conscious knowledge [*connaissance*]." Denis here refers to a (naïve) conceptual knowledge as opposed to the visual data given to the (educated) eye. The primitive's "perspective" will set one thing next to another rather than employ the sophisticated illusionistic devices of overlap, diminution of scale, and gradation of light and color.[48]

Thus, according to Denis, the primitive's world, like the one in Cézanne's paintings, lacks the illusion of depth; it appears flat. Denis repeated his basic argument on

the *gaucherie* of the primitive (1904) in a footnote to his essay on Cézanne (1907) and used this reference to expand on his appreciation of the "sincerity" of the painter's distortions.[49] For Denis, then, Cézanne's flatness and other distortions were linked to the primitive's vision, characterized by a simple mode of conceptualization.

Today, as in the nineteenth century, one generally associates flat, unmodeled color with the primitivistic kind of "symbolism" Denis related to Cézanne; for such color does not seem to belong to nature, but to the intellect and to the systems of signs man creates.[50] Yet, to the nineteenth-century viewer, Cézanne's "flat" pictorial surface indicated something very natural as well: it was "atmospheric"; atmosphere, in painting, could be flat, that is, rendered with a uniform intensity of hue and a lack of value gradation. Since atmosphere (or what Cézanne also called the "envelope," enveloping illumination[51]) was considered as the most general aspect of one's view of nature, it was also regarded as the primordial visual sensation, the most immediate and spontaneous effect to be observed. As such, it was both "original" and expressive of the individual—in short, the atmospheric effect constituted the painter's impression.[52] With regard to its pictorial representation, the atmospheric effect demanded a technique of originality—specifically, in the case of Cézanne, the use of a field of uniformly intense vibrating color, and a concomitant suppression of chiaroscuro values. I have argued that Cézanne avoided conventional hierarchical "composition" for the sake of finding (making?) both a style of his own and the nature he experienced.[53] It follows that the "flatness" that Denis associated with primitive conceptualization may also have been seen (by Cézanne and his contemporaries) as a product of immediate appearance.

When Denis discussed the vision of the primitive, he contrasted it with that of the modern artist who had become academic and who saw nature unoriginally, "according to the conventions established by the Masters, that is . . . with the eyes of others." Denis maintained that even the work of the independent Manet could be characterized as "picturesque," determined more by preconceived aesthetic concerns than by an intense emotional experience.[54] Yet to another viewer of the time, Manet's painting appeared quite differently; in 1892 Georges Lecomte noted its atmospheric flatness and derived from that observation that the artist was "original," painted only what he saw, disdained conventional techniques, and (in direct opposition to what Denis would later claim) had not been at all influenced by the way others envisioned reality. Lecomte began this chain of reasoned evaluation by commenting on a portrait by the artist in which a "uniform light spreads over the entire canvas." He continued:

> [Manet's] originality of interpretation, [his] concern for truth induced [him] to render natural objects and country scenes according to the exact sensation he received of them. In landscape as in all other studies, refusing to subjugate his talent to conventional procedures and his vision to that of others, he was naturally led to express the exterior world *enveloped in its authentic atmosphere.*

To reiterate: this "atmosphere" is described as a "uniform light [which] spreads over the entire canvas"; it results from a suppression of chiaroscuro differentiation, seen in Manet to bring about the near elimination of the usual distinction between foreground figure and background space—"atmosphere" (pictorially) is flat.[55]

In returning to Cézanne's *Bathers*, one notes the same general effect that Lecomte (and many others) observed in Manet and found so significant: the foreground and background elements are rendered with similar color and *facture*. This uniformity produces an apparent unity of the spatial plane (i.e., flatness) and evokes a natural atmosphere immediately perceived.[56] Needless to say, this effect is characteristic of impressionist painting and was recognized as such by critics of the time.[57] In accord with the sense of a pictorial atmospheric effect which makes little distinction between figure and ground, the early viewers of Cézanne's painting often described it as a brilliantly patterned tapestry; they alluded to the uniform vibrating field of color and the resultant surface flatness. Lecomte himself wrote in 1899: "Often [Cézanne's] studies of nature are without depth. They give the impression of a sumptuous tapestry without any background space [*sans lointain*]."[58]

Cézanne's seemingly unrefined technique—his *gaucherie*—thus lent itself to two conflicting interpretations: it was consistent with both the symbolist's conceptual "flatness" and the impressionist's "flatness" of an atmosphere immediately perceived.[59] Cézanne's vision could be "primitive" in two ways since it suggested both a naïve sense of objects and an adherence to primordial impressions. *By either estimation his art was liberated from "art," from academic convention.* In what seems to be the most perceptive comment made on the central position Cézanne occupied, Lecomte recognized this fortunate ambiguity in the artist's style:

> During the heroic era of naturalism, these *gaucheries* were praised the most. In the revolution directed against the conventional, one came to confuse necessary laws of [pictorial] logic with the stupid formulas of the academy. In reaction against correct but tiresome academicism, Cézanne above all was allowed faults committed in ignorance which the [trained] artist would have been well able to avoid. . . .
> [In more recent years, the symbolists] took a fancy especially to [Cézanne's] flatness [*absence de profondeur*]. It became the fashion [*Cela fit école*]. Since it was the vogue to reinstitute systematically the naïve qualities of the Primitives, Cézanne was welcomed as a precursor. He was admired for the imperfections (which, with all his strength, he was trying to avoid) as if they had been arrived at deliberately. As a result, at two successive stages in the [history of] art, Cézanne had the bizarre fortune of being lauded less for his [good] qualities than for his faults.[60]

Lecomte's suggestion of genuine technical weaknesses in Cézanne's art (as opposed to mere idiosyncrasies) does not detract from the importance of the critic's insight. Just as he had observed an essential link between impressionism and symbolism, Le-

comte saw that Cézanne's style rendered him acceptable to both impressionist and symbolist ideologies.[61]

In the years following the artist's death, the "Cézanne legend" fed only the symbolist branch of the dichotomy; cut off from many of its roots by the notion of "post-impressionism," the impressionist branch withered. Despite the record of his own protestations, the "isolated" artist was grafted onto the symbolist generation. In a passage from his monograph of 1927, Roger Fry described the formal character of Cézanne's mature work as primitive and flat; he related these qualities neither to a concern for "atmosphere" nor to impressionism. Instead, just as Maurice Denis had done, Fry invoked Poussin's classicism:

> We find every person and every object presented to the eye in the simplest, most primitive fashion; instead of searching for diagonal perspective vistas, movements which cross and entwine, [Cézanne] accepts planes parallel to the picture-surface, and attains to the depth of his pictorial space by other and quite original methods. In the plenitude of his development Cézanne may be rightly thought of as rediscovering the tradition of Poussin . . . the founder of French landscape.[62]

Among those aspects of Cézanne's mythic stature that have determined his place in the history of modern art, his association with Poussin is one of the most often repeated. What did it mean for Cézanne to be a modern Poussin? Much of the answer has already been indicated, but more needs to be said: Poussin, the "founder of French landscape," was very much alive during the nineteenth century, sustained by a legend of his own.

13

The Poussin Legend

MANY OF THE HIGH POINTS OF THE TERM *classique*, as it was understood during the nineteenth century, are evident in this observation: the great masters of the new "golden age" in France (the seventeenth century) represented "classical" authority just as the ancients did; and, as a charter member of this group or *classe*, Poussin was by definition a model to be followed in the schools, *dans les classes*.[1] In the ancient world, the "classic" was a member of a high-ranking group within his society; hence, by metonymy, any distinguished figure who became a model for others; and, finally, for the moderns, one who could be regarded as a source.[2] Just as it is difficult ultimately to distinguish "distinction" from "identity" (cf. above, pp. 70–78), so it becomes unclear whether "originality" stems from one's being the first (having priority) or from one's being of the first rank, *de la première classe*, that is, singular either in one's birth or in one's accomplishments (and, as a result, granted priority within one's society).

To follow are three quotations that provide some loose ends useful for unraveling the intertwined concepts of "classic," "model," "originality," and "copying." These statements address Poussin's historical importance and reveal the self-image of one of his progeny, Delacroix. More comprehensively, they serve to identify the character and concerns of each modern master (Delacroix, for example, or even his predecessor Poussin) who returned to classic sources (such as the art of the ancients, or of the seventeenth-century Poussin—or even of Delacroix, himself a modern-classic). Indeed, Cézanne—whom Denis, Fry, and others regarded as the most modern "classic" within the sequence of this tradition—did not oppose Poussin to Delacroix (as, say, "classic" to "romantic"), but considered both masters as models to be emulated.[3]

The statements in question share a critical discourse and, apparently, a common historical moment:

> It is necessary to return to the origins, to trace back to the source of the great current that Greek and Latin art made run over the world; and so we see Poussin studying antiquity, copying and measuring the statues. . . .
>
> This vigorous return to antique art constitutes the better part of Poussin's originality. . . .[Paul Mantz, 1858][4]

[Classic works are] those that seem destined to serve as models, as the rule in all their parts. [Eugène Delacroix, 1857][5]

I've become a master, and I'm the one whom people copy; I no longer copy others. [Delacroix's comment (1833 [?]) as reported by Alexandre Dumas, 1867][6]

"I've become a master": Delacroix's proud declaration of his artistic mastery is remarkable in its self-assurance. It may, however, amount to no more than the novelist Dumas's literary invention. But if Dumas had actually been present to hear such words and reported them accurately, the inescapable conclusion is that Delacroix—by his own definition—had not only "become a master," but had also attained the status of the "classic"; as he put it, he had become the model to be imitated, the original master-copy that others would copy, the "rule in all [its] parts."

According to Dumas, Delacroix had made his statement in response to a suggestion from Adolphe Thiers (then minister of the interior) that he accept a commission to copy Michelangelo's *Last Judgment*. Apparently Delacroix thought his own level of artistic achievement already too advanced for him to assume the role of the copyist, and, as Dumas claims to have predicted, firmly rebuffed Thiers's overture to a formal offer. There are few references in the art-historical literature to any exchange of words between Delacroix and Thiers regarding this matter; perhaps the incident occurred as Dumas tells it, perhaps not.[7] What is generally known is that in 1833 Thiers arranged for Delacroix to receive a commission to decorate the Salon du Roi at the Palais Bourbon, and in the same year he awarded Xavier Sigalon the commission to copy the *Last Judgment*.[8] In effect, Delacroix took on the job of inventing new images, while Sigalon set about to reproduce old ones. Dumas himself mentions Sigalon's work as if to point out that the lesser master was better suited to the lengthy and potentially unrewarding occupation of making a large-scale copy.[9] With a certain dark humor and sense of narrative effect, Dumas hints that Sigalon's premature death from cholera in 1837 may have been the result of his physical and artistic exhaustion.[10]

Shortly after the unveiling of Sigalon's *Last Judgment* at the École des Beaux-Arts and shortly before its author's untimely end in Rome, Delacroix wrote an essay in praise of both the copy and Michelangelo's original.[11] He took the opportunity to reiterate some themes quite familiar in his own previous thought and in that of both "romantics" and "classics": modern French art had declined during the decades following the Revolution; an improper imitation of the antique had led to a dry, lifeless style; the young artist should return to the invigorating works of the truly original geniuses. If Delacroix's views at this time departed in any significant manner from the mainstream of criticism and theory, the deviance can be traced back to his selection of a master-source—Michelangelo. The more orthodox choice would have been Raphael. But despite his deep admiration for Raphael and his use of Raphael's art as one of his own "sources," Delacroix claimed that this painter's spirit was influenced

by and subordinated to the more original force of Michelangelo. Delacroix's appreciation of innovation and his tolerance for Michelangelo's eccentricity marked his position as particularly "romantic"; rather than identify the summit of Renaissance achievement with Raphael, he located it in Michelangelo—whom, moreover, he called a modern Homer and the "fecund source from which [all the great painters] drew forth everything."[12]

Michelangelo, however, was not an artist to be imitated literally; in a sense he was not "classic" at all, since his own origins were so internalized. One might even claim that he was "inimitable." In Delacroix's theoretical musings, Michelangelo seems to correspond not only to the southern Homer but also the northern Shakespeare, the source who was too individualistic and irregular to serve as a ready-made model. Delacroix suggests that those who become "classics" do so only when they have been imitated by others as part of an academic process; before such cultural assimilation and canonization has occurred, these "classics" appear otherwise—as "romantics," artists who maintain their own original peculiarities, their rudeness, or, as Maurice Denis would describe it later in the century, their *gaucherie*.[13] Delacroix's distinction between "romantic" and "classic" does not necessarily malign or condemn classical art, but it does evoke the notion of a degenerative evolution from the classical to the academic that Denis and others throughout the century would dwell on. For both Delacroix and Denis, the irregularity of the unschooled primitive (or, alternatively, "romantic") artist can lead an etiolated "academic" classicism back to its vital origins.

Delacroix respected the "classic" Poussin as he did Michelangelo and Raphael, and seems to have conceived of him in his own "romantic" image. He stressed the seventeenth-century painter's individuality and independence: "Poussin is probably the only great artist who has not sacrificed [himself] to the temptation to appropriate some of the values of those imposing figures we are in the habit of considering the luminaries of art; perhaps he is the only one who has not imitated Michelangelo." The more usual issue to decide, one way or the other, was whether Poussin had imitated Raphael. At any rate, Delacroix proceeded to say that Poussin imitated only those whose genius resembled his own—hence, in his imitation, he retained his innate character and remained original. What was his proper source? According to Delacroix, the "vigorous [*mâle*] genius of the ancients."[14]

In these brief citations Delacroix provides the basic elements of the nineteenth-century view of Poussin: he is a master, an original, a classic; his work not only seems to recall that of the ancients, but also serves as a model for those who desire artistic rejuvenation and independence. As Paul Mantz wrote in 1858, Poussin's "vigorous return to antique art constitutes the better part of his originality." Perhaps Poussin thus represents a case of "spontaneous" classicism, a combination of originality and tradition, the amalgam of qualities that Denis perceived in Cézanne. If so, one begins to understand why Poussin, among all the "old masters," seemed the most readily comparable to Cézanne around the turn of the century, a time when the "isolated" artist had himself "become a master."

《 》

38. NICOLAS POUSSIN, *Saint John Baptizing the People*, 1636–37. Musée du Louvre. Cliché des Musées Nationaux.

Nineteenth-century opinion on Poussin approached unanimity. Occasional critical differences on the value of his achievement were linked to specific rhetorical strategies and external causes; genuine interest and appreciation of his painting never faded and, as a result, never really required "revival." Critics recognized him as the greatest French artist, and scholars strove to retrieve documents that might establish the details of his life and work.[15] His reputation was sustained by his being regarded not only as classic, but as the specifically French classic; for the French concern with national identity, commonly manifested in debates over artistic distinction, never waned (and, of course, often waxed in moments of xenophobia and simple political extremism).[16]

In examining Poussin's mythic status during the nineteenth century, I shall refer repeatedly to a particular aspect of his career in Italy, one recounted by his seventeenth-century biographers, Bellori and Félibien, and reassessed by nearly all later writers on the subject.[17] During his early years in Rome (he arrived in 1624) Poussin made many copies after antique statuary, some quite liberal, others very literal. Whether he was seeking to replicate antique figures or merely to grasp their general system of proportion became a matter of some debate.[18] At any rate, the documentary sources specify that Poussin made a measured study of the proportions of the

Roman Antinous (known as the "Belvedere Antinous," at present in the Vatican Museum).[19] Engaged in such activity in Rome, this most French of artists was thus, quite problematically, both an expatriate and a copyist.

According to Théophile Thoré, who argued forcefully for an independent "national" style, Poussin's study in Italy had "deadly" consequences for his native originality.[20] For nearly all other commentators, however, Poussin managed to remain independent and original even as he imitated the antique. Mantz's remark (cited above) is typical in that Poussin's return to the ancients is seen to represent not only an expression of the artist's own temperament, but also his successful avoidance of the "degenerate" art of his day. It was important for Mantz to stress that Poussin had turned first neither to his Italian contemporaries nor even to the great classic Raphael, but had returned "to the origins"; Poussin thus dissociated himself from the academic community into which the course of history had borne him. In Mantz's view, the artist's measuring of the Antinous served to remedy a "sick" modern painting more than to resuscitate a "dead [antique] art."[21] In taking this position, the critic reiterated a line of argument commonly used to justify the maintenance of a classical canon: those (such as Poussin) who do not appear at the earliest stages of a cultural tradition must avoid secondary interpretations and return to the original sources in order to discover their own means of expression. The return to cultural origins does

39. NICOLAS POUSSIN, *The Four Seasons: Spring*, 1660–64. Musée du Louvre. Cliché des Musées Nationaux.

not threaten individual identity, but preserves it. Hence Ingres (who held this view just as his rival Delacroix did) could suggest a certain compatibility of "romantic" eccentricity and "classical" regularity in the continuity of artistic form from one worthy master to another: Ingres wrote that "in the great modern periods, the men of genius remade [*ont refait*] what had been made before them"—they knew enough to use the proper models, the works of antiquity.[22] According to such reasoning, in copying the Antinous, Poussin had merely immersed himself in the current that would carry him back to the proper source of his own vital rejuvenation.

Indeed, throughout the nineteenth century, scholars often emphasized that this "classic" had studied antique art much more than any model in nature itself.[23] Most often, this admission of influence was taken to Poussin's credit; nevertheless, in the hands of many of his stylish followers (Le Brun, for example), Poussin's very healthy return to the antique seemed to have been transformed into an academic industry polluting the waters with effluents: "du classicisme de Poussin sort ainsi l'académisme."[24] The problem of this deadly academicism belonged not only to the historical past of the seventeenth and eighteenth centuries, but to Cézanne's generation as well: "pasticher Poussin, en 1893 . . . c'est le suicide de l'art."[25]

If one were seeking a cure for the academic rigor mortis that (according to impressionists, symbolists, and others) threatened the body of French painting, where might it be found? Although the very strength of Poussin's classic style may have led (againt the artist's own prescription) to a poisonous overdose of academicism, one might still return to Poussin for the necessary purge. Such a "revival" of the artist and his principles would not only constitute the use of a purer "source," but would represent a return to an alternative model, the model in *nature* as opposed to the one in *art* (antique or otherwise). Poussin was much more than the man who measured the ancient statues. Critics and historians knew him also as the master of "classical" landscape, the devoted student of nature who studied the details of stones and moss with the same attention he paid to the Antinous.[26] Even more than Claude, Poussin was considered the father of the "French" landscape tradition.[27] For some commentators, Poussin's landscapes surpassed his figural compositions because they completely escaped the mediation of the antique (however beneficial it could be), and therefore seemed his most original works. It was noted that no ancient landscapes remained for Poussin to study; as a result, he viewed nature only at first-hand and transformed it immediately, according to his own ideal—in other words, he created a landscape art with an originality as pure as that which the ancients had given to their statues.[28]

《 》

The conclusion to be drawn is this: if the originality of the "classic" was the remedy to cure the ills of a modern "academic" art, one might consider Poussin to provide a double dose of it, for he was the recognized master of two true "sources," antique art and nature. This point was well taken in the writings of the symbolists, who seem to have conditioned later critics and historians to compare Cézanne to Poussin as if by reflex. It is apparent that both Émile Bernard and Maurice Denis, the authors of the Cézanne legend whose accounts were the most often repeated, sought to ex-

plain Cézanne's achievement by reference to classicism in general and Poussin in particular. For the symbolist theorists, the essence of Poussin's classicism could be captured in the same observation they brought to bear on Cézanne: he did not oppose style (making) and nature (finding) but instead held these factors in equilibrium.[29]

In November 1905, Denis called Cézanne the "Poussin of still-life and green landscape."[30] He was by no means the first to associate the modern master with the classical one in a published statement. Earlier in the same year, Charles Camoin, a painter who had made a point of meeting Cézanne when he arrived at Aix in November 1901 for military service, had answered the question that Charles Morice posed in the pages of *Mercure de France*—"What do you make of Cézanne?" In his reply, Camoin stressed the master's seminal importance: his role as the "primitive of outdoor painting," his classicism, his concern "to bring Poussin back to life by way of nature." The phrase in French was *vivifier Poussin sur nature*, in which "sur" has the sense of "according to," "after," or "on the model of" (as in *sur mesure*). Whether or not the specific wording that Camoin recalled accurately reflected Cézanne's thought and speech, by this time (1905) the association of Cézanne with Poussin seems to have become a commonplace; many critics were linking the two masters primarily because they believed that Cézanne himself had identified his artistic project with Poussin's classicism.[31] Camoin's formulation—"vivifier Poussin sur nature"—would often be repeated and would appear also as "refaire Poussin sur nature."[32] In his reply to the *Mercure de France* survey, Camoin actually illuminated both versions of this cryptic phrase by quoting excerpts of letters that Cézanne had written him during the preceding three and a half years. The word "vivifier" appeared in a sentence taken from a letter of 1903; Cézanne had stated: "Go to the Louvre, but after [one has] seen the Masters who hang [*reposent*] there, one must hasten to leave and to revive [*vivifier*] in oneself, in contact with nature, the instincts, the sensations of art that live within us."[33] Similarly, Camoin quoted passages from Cézanne's letters that advised making studies after the Baroque masters, as if after nature, but which also warned that the method of another artist should never be allowed to alter one's own sensation.[34] In other words, Cézanne had told Camoin to study the masters for solutions to technical problems, but, above all, to retain his individuality through a personal experience of nature. If Poussin's classical style was to be revived, it was to be brought back to life only in accordance with the expression of the modern artist's personal sensation.

But this was exactly how Poussin himself had revitalized the antique statues: it was said that his study of *their* style and knowledgeable form had made possible the expression of *his* style and personality; their originality had both become his own originality and enabled his originality to manifest itself. Indeed, such a relationship of one original to another defined the essence of classicism as a "living" tradition (in opposition to a lifeless academic order of copying—or imitation—guided by convention).[35] Poussin's legion of modern defenders claimed that, in his own time, he had accomplished a vital "revival." In 1893, for example, Raymond Bouyer wrote that "we forget too often that this *genius* [Poussin] . . . far from tyrannizing art, rehabilitated nature, bringing to life [*vivifiant*] through his heart the icy convention of the

Bolognese [academics]."[36] Poussin, so to speak, had brought the Italian masters and their moribund academic following "back to life" through his own contact with nature.

When the Poussin legend is taken into account, Cézanne is seen to have been attempting to solve an old familiar problem in a manner not very innovative, but with perhaps an unprecedented degree of success. According to Denis, the painter's "classicism" seemed "spontaneous"; ultimately, he had no need of the tradition of the old masters and its academic formulation; he merely relied on his immediate experience of nature. Among theorists, to turn from the academic for the sake of sensation represented no great innovation. Many had called for a return to the original truths known to the ancients, a return that could be facilitated by a general rejection of modern academic models. In the eighteenth century, Diderot had been one who advanced this "classic" argument (and perhaps Bernard's way of thinking about the "naïf" and the "savant" owed something to him). Diderot had spoken of the loss of artistic forms that might express universal truths during an age of high civilization. Ironically, in such an age, secure knowledge leads to the shallow imitation of past masters who are believed to have already achieved ultimate artistic perfection. Only the return to a primitive state might enable the slow, searching discovery of truth once again. Accordingly, the ancients (and their modern equivalents such as Raphael or Poussin) did not copy others, but studied nature directly. In sum, Diderot reasoned in a manner that brings Cézanne to mind: "To remake nature on [the model of] the antique [*réformer la nature sur l'antique*] is to follow the inverse route of the Ancients who had no model at all; it is always to work after a copy."[37] Now if to "remake nature after the antique" is the inverse of what is required, what the classic must do is to "remake the antique after nature." And since Poussin often represented the truth of the antique (as when he measured the Antinous), to "remake Poussin after nature" would serve the cause of original truth just as well. In this context, to "remake Poussin after nature" becomes a formula for originality, for returning art (the antique) to its proper model, a personal vision of nature.

Refaire Poussin sur nature: this, of course, is what Cézanne was said to do, and seems also himself to have claimed as his achievement. He becomes, as Bernard stated, "classic by nature," classic in his personal experience, or in Denis's expression, "spontaneously classic."[38] To his contemporaries his strange and awkward style indicated that he had succeeded in attaining a genuine primitiveness, no mere affectation or imitation of the primitiveness of others, but rather a primordial originality. He seemed to escape convention and imitation to an extent that few, if any, knowledgeable moderns had done: "What others have sought and sometimes found in imitating the ancients, the discipline that [Cézanne] himself in his first works asked of the great artists of his time or of the past, he discovers finally in himself . . . he is . . . so spontaneously classical!"[39]

Cézanne offered the following advice to his young admirers: "go out and study nature . . . let us seek to express ourselves according to our personal temperament . . . you will find through nature the *techniques* [*moyens*] employed by the four or five masters of Venice."[40] Apparently, the modern master was not very discriminatory in

his choice of "old masters"; sometimes he referred to "the Venetians" in general, sometimes more specifically to Veronese or Tintoretto, sometimes also to Rubens, and (on the evidence of Camoin's statement) at least occasionally to Poussin.[41] Nearly any "old master" might do. Although the sources of the technical means of art could be manifold, Cézanne was more particular about the singularity of nature. Artists were not to bring the manner of past masters to their experience of nature, but to bring a very present and personal nature back into the inherited artistic tradition.[42] The artist's ultimate source could only be immediate experience. Thus Cézanne offered what was essentially an *impressionist* view on the proper relation of expressive style to immediate, personal sensation: technical contrivance must be held to a minimum; technique must seem to derive only from present, living experience. Significantly, when Camoin, his "pupil," was asked whether the modern artist should follow nature (like an impressionist) or follow his inner abstract thought (like a symbolist), he replied: "I look for all in the study of nature."[43]

Among the concerns that impressionism and the classicism of the nineteenth century had in common were originality and personal expression. Both impressionism and classicism found their origins in nature and human experience, and both resisted the technical conventions of the "academic." But whenever polemical issues narrowed and critics sacrificed their broader vision for the sake of defining a limited field of controversy, impressionism might be held to ignore classical values, even to deny them. Indeed, the two positions might seem irreconcilable if the negative potential of either were stressed—impressionism's tendency to deteriorate into a materialistic accumulation of natural phenomena, classicism's inclination toward "academic" formulation. Two consequences of the ambivalence of the terms of the late nineteenth-century critical debate are central to the convoluted development of the Cézanne myth. First: Bernard and Cézanne are likely to have misunderstood each other when they discussed the relationship of the natural and the classical in 1904 because their arguments drew from different theoretical contexts.[44] Second: when Denis named Cézanne the "Poussin of impressionism," he may have meant that Cézanne's classicism entailed a radical reformation of impressionism, but such a reading would represent only one of the possible significations of the title.[45] From a broader perspective, to call Cézanne the Poussin of impressionism could simply be to point to the artist's success in achieving an impressionist end that Poussin had attained before him—the antiacademic return to the origin in nature.

《 》

Poussin's "copying and measuring the [antique] statues" had always demanded some elaborate explanation on the part of nineteenth-century historians who wanted to demonstrate the master's independence, originality, and adherence to nature. Similarly, Cézanne's procedure of copying figures from paintings in the Louvre and from various types of prints and reproductions has always seemed problematic to those who discount his own simple justification of the practice, an explanation consistent with the aims of both Poussin's classicism and Cézanne's impressionism: if necessary, consult the old masters on *technical* problems.[46] According to the legend of the modern classic (the classic who must *return* to original sources before becoming a

source or model for others), in copying from the masters, Cézanne would not only be returning to a proper source, he would also be returning *the very figures he copied* to a proper source, to an origin in immediate sensation, his own sensation. Since Cézanne made many drawings after "academic" artists whose mastery might be questionable—and even copied indirectly, after prints and photographs—he seems (despite the often striking resemblance between copy and model) to have revitalized his chosen images more than he submitted to their strengths as exemplary classics; as either impressionist or classicist, he would be more inclined to "submit" himself to nature than to art.[47] Furthermore, as a "modernist," his copies would have to be "original."[48] This is why he could advise his young admirers to copy the masters as if they were copying nature—original sensation should prevail in either case. Even on its surface, the modern (original) copy would differ from the copied original. Both impressionists and symbolists had difficulty in building the theories that supported such technical practices; yet they were certain of one thing: however technically advantageous copying might be, artists should never imitate others with the narrow aim of appropriating some material appearance.

Accordingly, the analogy drawn between Cézanne and Poussin, based on the points of intersection of their legends of artistic independence, was never to any great extent a matter of imitable visual qualities. Around 1900, critics cared little whether Cézanne's figures would resemble Poussin's in the eye of a connoisseur. The relationship between the two classics depended on the presumed similarity of their attitudes toward art and nature and to the historical past and present. If any stylistic resemblance should develop, it would be the result of two independent artists having attained a common means of universal expression, an end consistent with both impressionism and symbolism, and also, more generally, with classicism.[49]

In much of the art history written during the twentieth century, the profound notion of the "classic" undergoes a reduction to something quite naïve and flat—a stylistic classification dependent on the observation of linearity and (in Roger Fry's language) "planes parallel to the picture surface."[50] To add "solidity" to this formal category, to speak of the three-dimensional quality of either a human or a geometric figure, may return the illusion of volume to the picture, but it does not bring back the depth of the intellectual tradition that nineteenth-century scholars associated with the true "classic."[51] By the standards of the nineteenth century, classic art can be either linear or coloristic and either "flat" or "solid," as long as it is neither too illusionistic nor too stylized; one way or another, the "classic" maintains a balance between found nature and made art. Because the classic moment so often occurs at a point of revival or return, the external appearance of the classic work (the style of the painting) can vary in accordance with that to which it is opposed or that which it transforms. At moments of academic technical refinement, for example, the classic may return to the primitive and appear gauche. Many of Cézanne's early critics recognized that the modern classic would seem the simple negation of whatever was acceptable to educated taste. As the American James Huneker wrote when he attempted to assimilate the new French art and present it to the public: "Think of Bouguereau and you have his antithesis in Cézanne."[52]

[The artist] should be wary of the literary mind which so often causes the painter to depart from his true path—the concrete study of nature—to become lost for too long a time in intangible speculations.

CÉZANNE, *letter to Émile Bernard, 12 May 1904*[1]

[Bernard's art is created] not by the emotional experience of nature [*l'émotion de la nature*], but by what he has been able to see in the museums, and even more by a philosophical mind. . . .

CÉZANNE, *letter to his son, 13 September 1906*[2]

Time presses upon me. . . . No more theories! Works. . . . Theories waste men away. One must have an inviolable core, an inexhaustible vital force to resist them.

From JOACHIM GASQUET'S *account of "what [Cézanne] told me"*[3]

14

Did Cézanne Have a Theory?

ÉZANNE'S COMPLAINT ABOUT THEORY was that of a man who had no
time to lose in speculation, even over the activity in which he was so total-
ly engaged. In his later years, he suffered from increasing physical weak-
ness and was chronically insecure about his capacity to reach some proper
end to his artistic quest. Almost desperately, he sought to avoid distraction. His sym-
bolist admirers, in contrast, had an inclination to let painting follow theory's lead;
and, as much younger men, they did not feel wary of time on the scale of their own
lives, but rather grew anxious over pressures that historical time might eventually put
upon their reputations. Unlike Cézanne, the symbolist painters practiced theory and
criticism with a view to establishing the importance of what they had already accom-
plished—including their own discovery and elaboration of Cézanne's style. While
the old "initiator" looked to a narrowing future for the "realization" of his incom-
plete art, his young followers, obsessed with history, engaged in arguments about
their past. In the opinion of their "master," they were wasting time.

Still, artists must have theories, or at least some formulated sense of what they are
doing, both with regard to technical matters and the purpose of art itself. The artist
who does not make theory a major aspect of his enterprise is likely to enunciate cli-
chés in order to dispense with the task quickly and efficiently. Indeed, when visitors
pressed Cézanne into making statements on questions of broad theoretical import,
he usually chose language and concepts in very common use. Furthermore, his phras-
ing was rarely elegant, but elliptical, even stubborn. As a result, his remarks often
seem simultaneously trite and cryptic.[4] Nevertheless, a coherent line of argument
emerges, and it is one associated readily with the ideas of "romantics" and impres-
sionists.

The "theoretical" statements that Bernard, Denis, and later scholars took most se-
riously are to be found among the group of letters Cézanne wrote during his last dec-
ade to those who were demanding some rational account of his painting and of art in
general. Within these statements the word "sensation" appears frequently. It is a dif-
ficult term in both French and English. "Sensation" has a double meaning since it re-
fers to the perception of something external as well as to internal emotion—seeing

and feeling. Considered with regard to its dual reference, the artist's "sensation" becomes analogous to his "impression"; both experiences (sensation and impression) are simultaneously subjective and objective, interactions that imply the presence of both self and nature.[5] Cézanne used the term "sensation" in its full meaning when he wrote of the necessity to revitalize "in contact with nature, the instincts, the sensations of art that live within us."[6]

How does an artist's sensation differ from that of anyone else? Cézanne and others commonly stated that it is "stronger." In 1870 a journalist wrote that Cézanne explained the grotesque character of his figures simply by saying, "I paint as I see, as I feel—and I have very strong sensations."[7] Later in his career, the painter spoke again of a "strong sensation of nature" and also of his "temperament" as a "force" or "power."[8] In associating both sensation and temperament with artistic potential, Cézanne approached what amounts to a full "theoretical" account of artistic activity, one that he expressed relatively completely on at least two occasions: first, in 1904, in a letter to a young admirer Louis Aurenche; and second, in 1905, to the important critic Roger Marx. To Aurenche, Cézanne said: "If the strong sensation of nature—and surely I have it—is the necessary basis of any conception of art . . . the knowledge of the means of expressing our emotion is no less essential, and is not acquired except through a long period of study [*très longue expérience*]."[9] To Roger Marx, the artist wrote: "With the temperament of a painter and an ideal of art, that is to say, a conception of nature, sufficient means of expression would have been necessary [for me] to be intelligible to the general public and occupy a proper rank in the history of art."[10]

The special importance of this latter quotation did not go unnoticed; Rivière and Schnerb received it from Marx and reprinted it in their interpretive study (published in 1907), which was largely dependent on recollections of their visit to the master in 1905. Their version of the statement differs somewhat from that given later by Rewald in the definitive *Correspondance*, but the changes do not affect the meaning—in fact, they seem to enhance it by indicating the full range of reference proper to Cézanne's terms. If the version published by Rivière and Schnerb is not an accurate transcription, the differences seem quite unconscious, the kind of substitutions that occur naturally between closely related concepts.[11] For example, Rivière and Schnerb give *idéal d'artiste* where Rewald has *idéal d'art*; there need not be any contradiction here because nineteenth-century critics regarded the artistic "ideal" both as the individual vision of the painter (associated with his personality or temperament) and as a universal normative style (associated with the tradition of art).[12] In addition, Rivière and Schnerb write *moyens d'exécution* rather than *moyens d'expression*; both phrases, however, refer to the technical means of execution which are indeed the means of artistic expression.[13] Thus several of Cézanne's terms seem to have double meanings: *sensation* (often synonymous with *impression*), since it bonds the artist's temperament with the nature he experiences, refers to an interaction that is at once constitutive of both a self and a world; the *idéal*, similarly, is both subjectively individ-

ual and objectively communal, a part of the "history of art"; and, finally, the artist's technique (*moyens*) represents both spontaneous emotional expression and the deliberative organization of elements of design (color and line) to convey a public message. On these points, Cézanne's theoretical framework should seem quite familiar; it is the same structure of interrelated concepts investigated in part 1 with regard to impressionism and symbolism (see esp. p. 43).

Cézanne held the very common (if not universal) belief in the essential individuality of artists; as those who saw "truth" and who knew or expressed "la vérité en peinture," true artists would never imitate one another.[14] An artist's sensations or impressions of the world were necessarily linked to his personal temperament, to which his expressed "ideal" corresponded.[15] Cézanne's basic formulation belongs not only to the romanticism of Stendhal and Baudelaire, both of whom he admired, but, more immediately, to the naturalism of Émile Zola, the close companion of his youth and early maturity.[16] It resembles Zola's own distillation of art theory: "a work of art is a bit of nature seen through a temperament."[17] As I have argued, Zola's statement served as a theory of impressionist subjectivity, and symbolist critics often cited it to account for the "subjective" distortion visible in naturalistic painting. So when Cézanne first conversed with Émile Bernard in 1904 and (one can assume) used some of the language that appears in his late letters, the symbolist painter heard some familiar words, but in a context he had not quite expected: "Cézanne speaks only of painting nature according to his personality and not according to [the idea of] art itself. . . . He professes the theories of naturalism and impressionism. . . ."[18] Like Zola, Cézanne preferred nature, even his own nature, to any (conventional) art.

《 》

If Cézanne's "theory" was an impressionist one, what are the implications with regard to the analysis of his style? I have indicated (above, pp. 169–73) that although Cézanne's spatial "flatness" could be regarded as a product of "primitive" conceptualization, it could also be viewed as "atmospheric" and consistent with impressionist concerns. What might account for other aspects of the painter's *gaucherie*, his general awkwardness or distortion? Symbolist theorists had a ready answer, and quite an obvious one: the temperament causes distortion. As Albert Aurier wrote, Zola's art of "nature seen through a temperament" must result in "distortion that varies according to personalities"; a naturalistic work reveals the "essential nature of its maker because it shows us the deformations that the object underwent in the process of the artist's perception." In sum, for Aurier, impressionism amounted to the "translation of instantaneous sensation, with all the distortions of a rapid subjective synthesis."[19]

Could some of Cézanne's oddly distorted forms be explained in terms of such impressionist immediacy of vision? Gustave Geffroy seemed to think so. Geffroy had the opportunity to witness Cézanne in action as he painted the critic's portrait in 1895.[20] In essays that he wrote shortly before and shortly after this firsthand observation, Geffroy spoke of Cézanne's deep concern for the study of nature, but expressed some distress at the degree of distortion or *gaucherie* evident in his typically

"unfinished" works.[21] Yet Cézanne became something of a classic despite this lack of professionalism, his isolation, and his consequent failure to reach the broadest public:

> It is regrettable that [Cézanne] did not endow his country and his time with the work of grand scale that he had within him. But his individuality loses nothing from this failing since it is present, and decidedly present, in all those works where, to an extent perhaps never seen before, reflection and spontaneity are combined.[22]

Geffroy recognized those aspects of Cézanne that entered into his "symbolist" legend: personal isolation, artistic independence, *gaucherie*, primitiveness, and a classic equilibrium of conceptual order and immediate sensation. But ultimately he gave the artist's eccentricities an impressionist interpretation:

> They say that Cézanne's canvases are not finished. It doesn't matter, so long as they express the beauty [and] harmony that he has felt so deeply. Who will say at what precise moment a canvas is finished? Art does not proceed without a certain incompleteness, because the life that it reproduces is in perpetual transformation. One must give an idea of the whole and of duration [*la durée*] by the appearance of a moment. This is the truth of art everywhere and always, the truth affirmed with such power and charm by impressionism.
>
> Cézanne is one of the representatives of this fugitive and eternal vision. . . .[23]

Geffroy's criticism integrates the artist's painting with his vision, indeed, his life. In its immediate responsiveness to sensation, Cézanne's painting reproduces not so much an external world, but the life of the artist who inhabits the world and even vitalizes it. Accordingly, artistic distortion, just as the artistic distinction of an "original" classic, arises from two sources: the artist's independence of the concepts and methods of others (his "naïveté") and the degree of his intrinsic individuality (the "strength" of his sensation). Certainly, Cézanne had both these factors in operation and his art revealed clear evidence of them. When Pissarro saw the exhibition at Vollard's gallery in 1895, he remarked on the "savage" and "unfinished" character of Cézanne's paintings, yet found them compelling and even refined: "Why? [Because] the sensation is there!" Pissarro emphasized that his old "pupil" had kept "his own sensation" even as he learned from the examples of others, including Pissarro himself.[24] According to Zola—who, like Geffroy, could see art only as one with life—these same factors of independence and personal sensation had been present in Manet and accounted for both the power and the idiosyncrasy of his painting.[25] Subsequently, Matisse (representing the generation so deeply moved by Cézanne's example) would link his own immediate sensation to artistic distortion by a similar reasoning: "I cannot distinguish between the feeling I have of life and the manner in which I translate it."[26]

For both impressionists and symbolists the general phenomenon of distortion (departure from conventional representation) was quite familiar; yet the varieties of *gaucherie* seen in Cézanne's paintings may have been unusually convincing in the manner

in which they seemed to constitute the image from its inception rather than to deform an image already given or created. It was entirely proper for "distortion"—as a desirable artistic quality signifying naïveté or sincerity—to constitute an artistic representation; but to *impose* distortion on an image was to fabricate naïveté, to *make* a *found* quality rather than to discover it. Denis and many others throughout the nineteenth century had warned against such artistic artificiality, which seemed antithetical to any "original" art, whether classical or primitive.[27] No one understood this common knowledge better than the impressionists, who sought to establish sensational and emotional immediacy with every separate stroke of the brush; indeed, the type of *gaucherie* that Geffroy saw in Cézanne's painting had already become something of a hallmark of naturalistic vision.

An early instance of such "impressionist" distortion is seen in Bazille's *Portrait of Édouard Blau* (1866; fig. 40). Here, as in the case of so many of the familiar objects depicted in Cézanne's paintings, a chair frame appears to lack coherent physical structure because its left and right sides are discontinuous.[28] Furthermore, Bazille seems to have superimposed strokes of brown paint (which form the chair) over the extreme left part of the figure as if he were making an unplanned pictorial correction or simply reexperiencing his vision; as a result, some of the previously rendered mass of hair appears awkwardly truncated. A viewer familiar with conventional standards for setting figures against grounds would know that the chair cannot play figure while the figure plays ground. To be sure, in the genre of portraiture, "figure" (the model) and ground cannot be so readily transposed. Bazille, however, functions as both portraitist and impressionist painter: he indicates that his immediate sensation determines the placement of the elements of his picture, as if they were in correspondence with a living, and ever incomplete, sequence of visions that can never form a stable composition.

In other words, Bazille's sketchlike tentativeness represents an "immediate" or unmediated vision which—in terms of the conventions of picture making—may seem inaccurate, awkward, or distorted. Although Bazille's rendering is problematic with regard to external "objective" appearances (i.e., those that are generally accepted as normative), his manner of painting conveys at least one message with great clarity: that the artist has remained (and *is* remaining) faithful to his direct impression. The same could be said of Cézanne (as indeed Geffroy suggests), regardless of the fact that his works often seem products of long periods of labor, since each successive application of paint is itself, for the impressionist, the reflection of spontaneous sensation.[29] For example, Cézanne's *Bathers* and his *Trois Baigneuses* (see figs. 35, 36, pp. 168–69) exhibit passages of *facture* that deny any rigid distinction between figure and ground; these passages move across contour lines that seem subject to continual adjustment. Similarly, the sketchy record of shifts in contour apparent in Cézanne's portrait of his wife (ca. 1890; fig. 41) indicates, in terms of impressionism, a continuing immediacy rather than any finalizing corrective vision.[30] Another such "spontaneous" process of delineation and coloration is recorded in the artist's *Three Skulls* (ca. 1900; fig. 42), where the apparent "warping" of the surface of the table may be regarded as an ele-

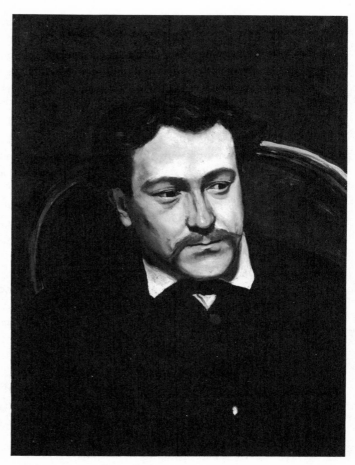

40. FRÉDÉRIC BAZILLE, *Portrait of Édouard Blau*, 1866. National Gallery of Art, Washington, D.C., Chester Dale Collection.

ment of *gaucherie* analogous to the incoherent structure of the chair in Bazille's *Édouard Blau*. Émile Bernard observed Cézanne at work on a still-life of three skulls, perhaps this one, and commented that the painting "changed color and form nearly every day. . . . Truly his manner of study was a meditation, brush in hand."[31]

I have argued that impressionists as well as symbolists sought a "technique of originality"; technique or the *moyens d'expression* was the object of their study, however much they may have preferred to consider their investigation as a search for the double origin, nature and self. According to its own theoretical formulation, impressionist art could "find" the visual image of "nature seen through a temperament" only in perfecting a certain technical means. But the means of expression seemed unattainable—at least to Cézanne. Hence the "incomplete" character of his work, including its *gaucherie*. Geffroy asked how one could determine when a painting was "finished," how one could ever terminate the image, the recording of sensation, if life itself, the life of sensation, continued on without end. Certainly Cézanne could see the point of Geffroy's question, which he himself asked not only in his paintings, but in his later letters. He frequently referred to his lack of completion or "realization":

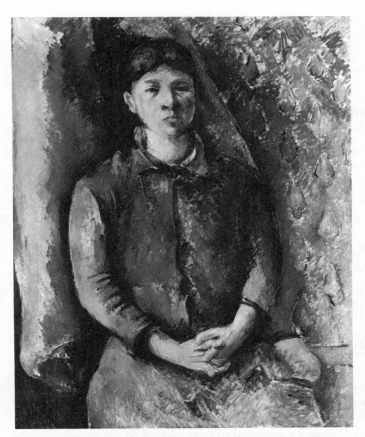

41. PAUL CÉZANNE, *Portrait of Madame Cézanne*, ca. 1890. Courtesy of the Detroit Institute of Arts, bequest of Robert H. Tannahill.

42. PAUL CÉZANNE, *Three Skulls*, ca. 1900. Courtesy of the Detroit Institute of Arts, bequest of Robert H. Tannahill.

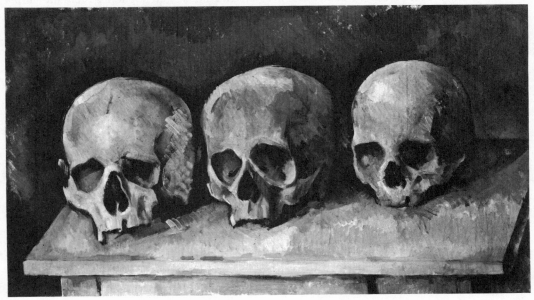

> I think I am reaching [my realization in art] more and more each day, although with some difficulty . . . the knowledge of the means of expressing our emotion . . . is not acquired except through a long period of study.

> As a painter, I am becoming more lucid before nature, but for me, the realization of my sensations is always very difficult. I am not able to arrive at the intensity which unfolds before my senses; I do not have that magnificent richness of color which animates nature.

Cézanne wrote this latter statement, indicating that a great distance had yet to be traversed, only six weeks before his death.[32]

« »

Ironically, Cézanne's failing gave him an advantage with his critics; within an aesthetic of finding and originality, the artist's unending search for a proper (but unattainable) means of expression seemed exemplary. One of the standard arguments against fixed and perfected academic convention had always been that it would halt the growth, indeed the *life*, of art. As Ernest Chesneau remarked in 1862, "imperfection is a providential law without which the world would long ago have ceased."[33] Additionally, it is clear that commentators such as Geffroy, Lecomte, and Denis might see sincerity behind any *gaucherie* and would evaluate an artist's "primitive" style in terms of a scrupulous return to nature.[34] In the same spirit, Rivière and Schnerb wrote that Cézanne excused his awkwardness in drawing by stating, "Je suis un primitif." The painter claimed that he had avoided the training of the École des Beaux-Arts because it led to an automatic "photographic" manner of rendering that fixed all images by means of a standardized technique and negated the immediate force of sensation, the welcome source of distortion. Rivière and Schnerb observed that the artist recognized his own irregularities, but would not adjust them; he simply allowed them to come into being.[35] Consequently, according to Bernard, Cézanne admitted that his imperfect art could serve only as a beginning for others: "I am too old, I have not realized, and now I will not [be able to] realize. I remain the primitive of the way I have discovered."[36]

The "incomplete" and "primitive" quality of Cézanne's painting not only suggested that he was an "initiator," but it appealed to all those who sought rejuvenation and spiritualization in the inexhaustible source of nature. Joachim Gasquet, a poet who lived in Aix, contributed to various journals of the "naturist" movement during the last decade of Cézanne's life and cited his paintings as inspirations.[37] Gasquet's naturist motto read: "We are without doubt the Primitives of a future race."[38] Naturism concerned itself with the evolution and history of art, just as symbolism did. Accordingly, Gasquet, perhaps borrowing from Bernard's writings, quoted a patriarchal Cézanne as saying, "I am the primitive of my own way." Furthermore, Gasquet noted that Cézanne mused still more poetically on his continuing absorption in nature—the artist and the landscape became one in a living sensation: "The landscape reflects itself, humanizes itself, thinks itself in me [*se pense en moi*]."[39] This notion, more than any other associated with the painter, appealed to the phenomenologist

Maurice Merleau-Ponty as he composed his essay "Cézanne's Doubt" (1945). Merleau-Ponty saw the artist's struggle to realize nature as an effort to know his own self, ever emerging in his experience. A painting could be no more complete than a life.[40]

For Roger Fry, too, Cézanne's unending search seemed an ideal for a modern art that sought to experience sensation, the world, life itself—an art that does not plan its effects in advance, but "finds." In 1919, Fry described what he called "creative vision" in this manner:

> the (aesthetically) chaotic and accidental conjunction of forms and colours begins to crystallise into a harmony; and as this harmony becomes clear to the artist, his actual vision becomes distorted by the emphasis of the rhythm which has been set up within him. . . . In such a creative vision the objects as such tend to disappear, to lose their separate unities, and to take their places as so many bits in the whole mosaic of vision.[41]

Fry's image recalls those presented by Cézanne's early critics, who spoke of the painter's characteristic distortion and the uniform texture of his weft of color. Indeed, Fry applied his general description of "creative vision" to Cézanne in 1927:

> Each canvas had to be a new investigation and a new solution . . . in certain works of Cézanne we seem to get a particularly clear vision of the process of [artistic] creations. . . . One suspects that . . . an endless search was needed to discover exactly the significant position of each volume in the space [of a painting of bathers]—a research in which the figures have become ungainly and improbable. *At any moment* the demand of the total construction for some vehement assertion of a rectilinear direction may do violence to anatomy. . . .[42]

According to Fry's reasoning, the tentative, "incomplete" character of Cézanne's painting made it a paradigm for creation, a made thing that incorporated the qualities immediately found and felt in the artist's ever evolving experience. Fry's reference to creative spontaneity ("at any moment") evokes an impressionist ideal of direct vision as much as it does any other modernist sense of the creative process.

Later, Meyer Schapiro followed the line of analysis Fry had employed; he, too, emphasized the artist's vision as process:

> [Cézanne] loosened the perspective system of traditional art and gave to the space of the image the aspect of a world created free-hand and put together piecemeal *from successive perceptions*, rather than offered complete to the eye in one coordinating glance as in the ready-made geometrical perspective of Renaissance art. . . . Cézanne's method was not a foreseen goal which once reached, permitted him to create masterpieces easily. His art is a model of steadfast searching and growth.[43]

Here, in accord with a modernist aesthetic, the artist's value lies not so much in what he can *make*, but in his capacity to seek and to continue to *find*.

《　》

If, by his own estimation, Cézanne never "realized" his artistic end, what indeed was he finding along the way? How did he contribute to the continuing "life" of art,

the history of art? Significantly, his most explicit theoretical statement (discussed above, pp. 188–89) appeared in a letter to Roger Marx, sent in grateful response to the critic's review of the paintings the artist exhibited at the Salon d'Automne of 1904. Four years previously, Marx had organized the retrospective Centennial Exhibition (in which he included works by Cézanne); and he was especially interested in establishing continuity in the development of modern French art.[44] Reflecting his concern for a lineage of masters, Marx spoke of Cézanne as one of the founders of impressionism—but, like Degas, an "isolé" within the group. He noted that the painter had a past: he should be compared with Courbet because of his bold and ample application of pigment, and with Daumier because of his "deliberate" distortion of figural forms. Moreover, the critic suggested that Cézanne had been an important influence on the generations who followed, a necessary "link" in what he called an historical "chain." In sum, Cézanne received quite a complimentary review within a widely circulated journal, the *Gazette des beaux-arts*; his historical importance was recognized; and one of his landscapes was even chosen as an illustration for the text.[45]

In the letter that he wrote soon after Marx's publication appeared, Cézanne humbly acknowledged the honor paid him by using the critic's own metaphor: "In my opinion, one does not substitute oneself for the past, one just adds a new link."[46] Such, then, was Cézanne's contribution, seen more as a continuation than a revolution. He went on to present Marx with his statement of purpose, framed in the language of impressionism: with a "temperament" and a "conception of nature" one need have only the "means of expression" in order to communicate to the public and "occupy a proper rank in the history of art." Cézanne felt certain that he possessed an artistic "temperament" and had "strong" sensation; but he continued to search after the "means of expression," the required artistic technique. And if he ever attained it (as one must assume, perhaps, on the evidence of the remarkable historical status he was awarded), *that* realization apparently escaped him. No wonder. In Cézanne's case, a failure to realize, to come to an end, signified success—incompletion *was* his end.[47]

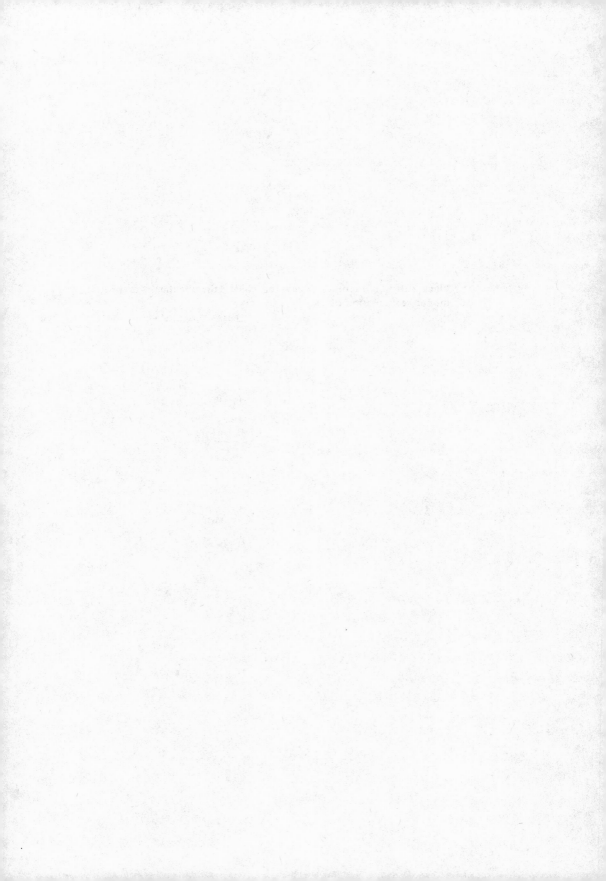

Of all the technical means of painting, color is the one that gives the most immediate sensation of life.

JULES ANTOINE CASTAGNARY, *1863*[1]

15

Cézanne's Practice

MUST THE ARTIST FIND his originality blindly, unconsciously, or can he succeed in seeking after it, come to possess it and to manipulate it as one of a number of "techniques"? Given Cézanne's statements and those of the critics and historians who wrote so enthusiastically about him, it would seem that the modernist artist should follow his own "creative vision" rather than direct it. Yet, as I have maintained, Cézanne's technique (as well as that of so many of his contemporaries) developed in accord with specific intentions, indeed, as a response to "statements" made by the techniques of other painters.

I wish now to investigate Cézanne's technical procedure as a strategy of painting, intended to convey a preconceived content or message; but no exhaustive account of this technique is proposed. As in chapter 8, I focus my analysis on issues that are central within the context of the theories of art Cézanne and his contemporaries inherited. Specifically, I link the artist's practice to the concerns and methods of impressionism. This is a somewhat different context from that in which the symbolists preferred to see Cézanne—but not so different as is usually stated—and it is still further removed from the context of later modernism.

My analyses in chapter 8 emphasized the unconventional structure in the artist's landscapes, and the ways in which he avoided hierarchical organization. Many of his decisions were negative ones: he did one thing as if to escape doing another; he strove to deny all established academic principles. In chapters 12 and 14, I discussed Cézanne's *gaucherie* and "flatness," aspects of his art that might be considered as byproducts of an intense search for the direct representation of sensation. Now I concentrate more exclusively on the decisions Cézanne made with regard to color, which I believe to be the most willful and self-consciously controlled aspect of his art. Problematically, but not paradoxically, this immaterial element of the painter's pictorial language makes the most concrete reference to "originality."

As I have suggested throughout, in his maturity Cézanne used color in a manner consistent with impressionist practice; and if the artist felt any sense of community, his ties were to the impressionist group. On balance, his statements, even the apocryphal ones, indicate that he never lost his initial respect for Monet, Renoir, and Pis-

sarro; nor did they fail to appreciate him.[2] It is generally agreed that Cézanne's manner of painting took on a decidedly impressionist character during the early 1870s when he worked closely with Pissarro. At that time he began to paint with a *facture* of small juxtaposed strokes of relatively brilliant color. This technique did not emerge from a closer observation of nature (as perhaps some supportive friends wished to believe), but from a calculated assessment of what, in relation to the established formal language of painting, could be done to create an original art. Given that Cézanne associated "original" sensation with the direct experience of nature, the basic choices that he made concerning the use of color were relatively obvious ones.

It can be assumed that the "independent" Cézanne—just as his contemporary, the "academic" Henri Regnault—declared conventional chiaroscuro unacceptable for two reasons: first, because it seemed unlike the coloristic effects actually observed in nature; and second, because it was recognized as an academic artifice, a product of doctrine rather than personal experience.[3] The first reason, the appeal to direct observation, is (as I have already implied) suspect in the extreme, for it can always be argued that a painter "sees" in nature only what his acquired technical practice allows him to imagine as a picture.[4] If, instead of chiaroscuro, Cézanne "saw" a pattern of juxtaposed brilliant colors in nature, he possessed a theory to guide this "naïve" vision, a theory of the impression, the visual effect proper to an "innocent," unindoctrinated eye. Thus, one could argue that the colors of the painter's "naïve" vision had their origin in an acquired theoretical discourse. The "field" of vision from which colors might be selected was determined neither by an external nature nor by an internal temperament.

Ultimately, Cézanne chose a technical solution to the problem of representing the impression that was one of several available, perhaps the best one, at least the most emphatic. The possible solutions discussed during the period about 1865 to 1885 were these: (1) the use of strong contrasts of dark and light, a kind of "summary modeling" (*modelé sommaire*) that limited the number of chiaroscuro values in the picture to a few tones (supposedly) immediately perceived and subject to being executed rapidly; (2) the use of only the most attenuated contrasts, that is, the establishment of a relative uniformity of value and also of hue (this manner was often referred to as *la peinture grise* or *la peinture blonde*); and (3) the use of attenuated value contrast along with *strong* contrast of hue, usually in the form of relatively bright, pure, "spectral" colors. The presence of any of the three techniques might lead critics to describe the work as *la peinture claire* or simply to speak of the representation of a "brightness" (*clarté*) associated with natural light. Both Fromentin and Van Gogh referred to an unfortunate vogue for *clarté* that characterized the painting of the 1870s.[5] Most other commentators were more accepting and praised a diversity of artists for exhibiting this quality of "brightness." Castagnary went further, indicating that the presence of *clarté* as a physical characteristic implied its metaphoric content—"clarity" and "truth."[6]

The first method for producing "brightness" and the effect of the immediate impression was the most traditional and hence the most frequently discredited by those

who acknowledged the incompatibility of academic convention and "naïve" representation. Nevertheless, this method was still being advocated as late as 1882 in the writing of Georges Guéroult, who studied the science of vision. Guéroult noted the truism that "the colors available to painting are incomparably less intense than the hues given by sunlight," and stated that "to resolve this difficulty, the artist is obliged to paint [strong] contrasts themselves." But he cautioned the contemporary painter not to employ the bright hues of the "new school of plein air [i.e., impressionism]," insisting that the "true colorists" had always done otherwise: "on the contrary, it is in *chiaroscuro* that the Titians and the Rembrandts sought and found their most beautiful effects."[7]

The systematic use of chiaroscuro was usually seen as an academic device, but simple strong "contrasts" escaped this criticism. Such abrupt contrasts of value characterized Manet's painting, especially his earlier works; and he, more than anyone else, received both positive and negative comment directed at this so-called summary modeling. The simple want or intentional suppression of intermediate transitional tones (see, e.g., fig. 7, p. 31), could indicate either that the artist recorded only "what he saw" immediately *and no more*, or (alternatively) that he lacked the ability or determination to advance his painting any further toward its proper goal. The supporters of impressionism, of course, chose to evaluate Manet's painting by the former criterion: Zola, for example, did not judge Manet's *means* to be limited, but praised the artist for having limited himself to representing only the "truth," only the tones that he actually saw and the effect of the moment he experienced.[8]

Usually, however, Zola did not describe Manet's attenuated modeling in terms of the violent opposition of dark and light; instead he spoke of a brightness produced by a concentration of light tones: "his paintings are blond and luminous . . . the light falls in an expanse of white . . . he sees blond."[9] Thus Zola found a brightness in Manet's painting that resulted from a variant of the second of the three techniques for producing *clarté*, the use of a limited range of chiaroscuro values with a concentration on the lighter end of the scale. Indeed, critics often characterized this manner of painting as *blonde* or *blanche*—and also sometimes as *grise*, as they referred to the general evenness of value, neither black nor white but gray all over. Grayness evoked a uniform (and often intense) illumination, the kind of "brightness" observed in the natural light of an "impression."[10] Zola himself seems to have attributed the production of a blond or gray effect not only to Manet but also to Bastien-Lepage, one of a great number of naturalistic painters who achieved success within the more conventional artistic circles.[11] At the Salon of 1880, Zola viewed works by both Manet and Bastien-Lepage; he took the opportunity to speak of the general tendency toward *la peinture claire*, of which Manet had been an initiator, and noted the irony that many artists had gained public favor by imitating self-consciously the "blond color" that had been the product of Manet's naïve vision. Bastien-Lepage was one who seemed to have adapted Manet's methods to suit the expectations of the public—his was an "impressionism corrected [and] tempered." Thus Zola described Bastien-Lepage's monumental *Joan of Arc* (fig. 43) in terms of its "gray tonality," an attenuated chiar-

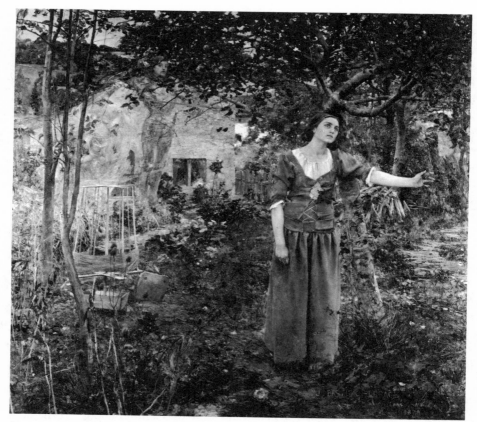

43. JULES BASTIEN-LEPAGE, *Joan of Arc*, 1880. The Metropolitan Museum of Art. Gift of Irwin Davis, 1889. (89.21.1)

oscuro effect that called forth a natural light; he could not help but admire this painting despite a number of misgivings concerning the artist's facile technique and his "literary" subject matter.[12] In general, Bastien-Lepage, like Manet, became known for effects of *clarté* achieved through the suppression of parts of the full range of chiaroscuro.[13]

The third technique for producing brightness, the one most exclusively identified with the impressionist style, was the most radical because it seemed to do more than modify conventional chiaroscuro—it eliminated it. The use of juxtaposed brilliant hues without neutralized transitional tones weakened "academic" chiaroscuro beyond any possible recovery, not only because so many of the hues were of nearly like value, but also because strong hues seemed to distract the eye from any appreciation of value; unruly hue would always subvert value's attempt to instill order. This, at least, is what theorists traditionally claimed.[14] Furthermore, they noted that since the representation of outdoor light often demanded the use of a very limited chiaroscuro, the painter of *plein air* faced the difficult task of creating the illusion of space with severely limited means.[15] Although the association of bright color with natural illu-

mination was obvious to all, many critics and theorists concluded that the painter simply *found* such light "flat" in nature; he needed to *make* it pictorially effective by adding a very subtle chiaroscuro gradation.[16]

Because the third technique seemed so acutely problematic, critics who endorsed naturalism within the other two modes often made a point of dismissing the impressionism of Monet and Pissarro as they simultaneously accepted its more conservative representatives in the Salon. In 1877, for example, Frédéric Chevalier wrote an article entitled "L'Impressionnisme au Salon" in which he defined impressionist technique in terms of three qualities: no more detail in drawing than could be perceived at a glance; simplified, expressive *facture*; brilliant naturalistic color. Chevalier was quite aware of impressionism both inside and outside the Salon; he had just reviewed the independents' exhibition of 1877, where he complained of a "rudimentary execution" and "willful incoherence." But in his discussion of Salon impressionism, he argued that the misuse of excessively bright color by certain "intransigents" should not be regarded as characteristic of the entire school. One of the "impressionist" paintings which met Chevalier's approval was Jean Béraud's *The Church of Saint-Philippe-du-Roule* (fig. 44), not excessive at all in its quality of hue, but rather an example perhaps of *peinture grise*. Béraud's painting did share one very important quality with other "impressionist" works: except for the stagelike emptiness of its foreground, it lacks the more obvious compositional devices and seems instead to capture the life of a moment as if without preconception or arrangement.[17]

44. JEAN BÉRAUD, *The Church of Saint-Philippe-du-Roule*, 1877. The Metropolitan Museum of Art. Gift of Mr. and Mrs. William B. Jaffe, 1955. (55.35)

Perhaps critics who tended to evaluate paintings in terms of subject matter (Chevalier among them) could think of Béraud as representing his "impression" of daily life and dismiss an artist such as Monet as an aberration; but for others who argued first from a technical standpoint, the juxtapositions of brilliant color seen in some impressionist works appeared too remarkable to be anything less than definitive.[18] Such works demanded evaluation, for or against. Thus, long before Denis associated Cézanne's effect of "atmospheric" flatness with primitivism, some critics had categorically rejected the impressionist attempt at rendering natural light because it produced no more than the quality of flatness found among the early Western primitives and the Japanese.[19] On the positive side, however, Edmond Duranty could appreciate impressionist paintings as well as Japanese prints. He wrote approvingly of images having a "luminous tone spread nearly equally everywhere."[20] As I have maintained, such was an effect both of flatness and of the immediate impression, a colorful but undifferentiated light.

Another problematic aspect of the more extreme use of impressionist color must be mentioned: the painters eliminated not only transitional passages from dark to light, but from one hue to another; they generally excluded the "broken" or neutralized tones that would have created variation in intensity (saturation) just as they shunned the chiaroscuro gradations that would have produced variation in value (illumination). Apparently, too great a mixture and manipulation of variations of the basic hues represented the same sort of fabricated "compositional" quality that the impressionists sought to obviate both in their choice of subjects and in their *facture*. Certainly they knew that the use of harmonizing neutral tones in works of unusually brilliant color had been recommended by the same theorists who had advocated an orderly system of chiaroscuro.[21] In the end the impressionists rejected, or at least resisted, both practices.

<div align="center">« »</div>

Cézanne's technique during his early years in Paris (the 1860s) resembles Manet's in its use of strong value contrasts and a *modelé sommaire;* and it often follows Courbet's method of broadly stroking paint on the canvas with a palette knife.[22] In effect, paintings such as *Uncle Dominic* (ca. 1865–67; fig. 45) exhibit the first of the three procedures commonly associated with the aim of rendering the impression of natural light.

As Cézanne began to work beside Pissarro in 1872, he developed a more colorful manner, one that approached the third technique I have discussed, but which retained some of the character of the second. Together Pissarro and Cézanne created a solution to the problem of the impression that seems to reflect a very conscious estimation of the limits toward which a painting devoid of conventional chiaroscuro could safely be directed—as if hedging a bet, they preserved something of the order and "system" of chiaroscuro in their forceful image of *clarté*. Specifically, the two painters gave a unifying harmony to their works by mixing as many hues as possible from a relatively limited palette of the purest "spectral" colors. They proceeded to minimize the presence of black, earth colors, and other neutral pigments regardless of

45. PAUL CÉZANNE, *Uncle Dominic*, ca. 1865–67. The Metropolitan Museum of Art, Wolfe Fund, 1951, from the Museum of Modern Art, Lillie P. Bliss Collection. (53.140.1)

how "neutral" or "gray" the motif to be represented might appear. Their technique embodied a productive duplicity: they could employ bright hues and maintain a relatively limited range of value, while they simultaneously "broke" (neutralized) this strong color in order to avoid excessively harsh juxtapositions. They made a gesture toward *la peinture grise*, even as they restricted themselves to the palette that (in theory) characterized "primitive" natural vision. This was surely "impressionism," but not of the most radical type.

The more experienced Pissarro seems to have taken the lead in this creative venture.[23] His *Kitchen at Piette's, Montfoucault* (1874; fig. 46) represents an early and rather extreme use of the new method. The palette employed here consists almost exclusively of pigments resembling bright spectral colors—ultramarine blue, cadmium yellow, red lead (a strong orange-red), alizarin crimson (a deep red), cobalt green, and lead white.[24] Despite the chromatic brilliance of the palette, the painting appears neutral in color—"gray." Yet it also seems uniformly luminous, for Pissarro has mixed most of his grayish tones from blue, yellow, red, and small amounts of green. It is as if the intensity of the component colors maintains itself even as the individual hues become indistinct; the brilliant luminosity remains while the hue contrasts disappear. The net effect is of a unified and harmonious color that doubly evokes the immediate impression of natural light—both through the absence of (artificial) chiaroscuro and through the presence, however subdued, of a full spectrum of hue. Pissarro used this limited palette and system of pigment mixture many times during the 1870s, frequently allowing his basic colors to appear in a relatively pure, unblended

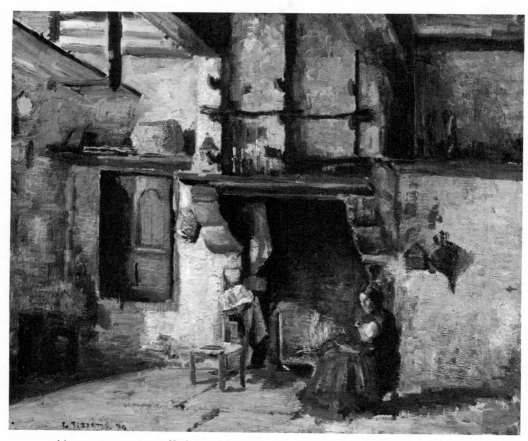

46. CAMILLE PISSARRO, *Kitchen at Piette's, Montfoucault,* 1874. Courtesy of the Detroit Institute of Arts, bequest of Edward E. Rothman.

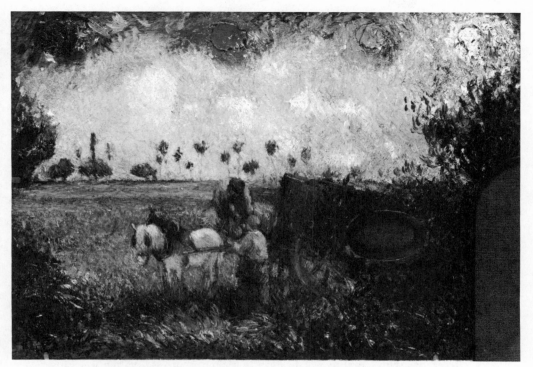

47. CAMILLE PISSARRO, *The Artist's Palette with a Landscape*, ca. 1877–79. Sterling and Francine Clark Art Institute, Williamstown, Massachusetts.

state. He even created a permanent demonstration of his method when he made a small picture on the surface of one of his wooden palettes (fig. 47), allowing the six component pigments to remain visible as distinct masses arranged along the edges; the central area of the palette, normally to be used for mixing colors, became the landscape representation itself.[25] And in another painting of the period, *Maison de Piette, à Montfoucault* (1874), the artist created a surface of grayish tones brushed over a brownish ground, in which the traces of unmixed primary hues remain visible to the naked eye, even though they sometimes are to be seen only as the stroke of a single bristle of the brush that must have been mixing the "grays" from red, yellow, and blue.[26] As if to demonstrate that the "gray" light of his painting originated in the primary colors of the spectrum, Pissarro signed his name in a brilliant pinkish violet and then overlaid it with a more neutralized greenish blue. The bright violet remains visible both in the signature and as traces scattered throughout the landscape; it is a tone that must have appeared on the palette in the process of preparing the more complex combinations of duller harmonizing colors.

Cézanne's palettes of the 1870s and early 1880s seem to have been more varied than Pissarro's, but he followed a similar method, usually mixing several brilliant colors together whenever he wished to make a neutral brown or grayish tone. He would render the trunk of a tree or a bathing figure's hair with mixtures of red, blue,

green, and yellow, just as he would define the leaves of the tree or the flesh of the bather with these same colors in their purer states, often simply juxtaposed one against another.[27] In paintings of the early 1870s, Cézanne seems concerned to use the bright colors he associated with the atmospheric effect while simultaneously avoiding extremes of hue contrast that might interfere with strictly pictorial unification. However, along with Pissarro and the other impressionists, during the later 1870s he gradually turned to a more direct employment of his primary hues. He went so far as to exaggerate the colors he "observed" in nature in order to compensate for the inferior quality of the luminosity captured by pigment. He abandoned the chiaroscuro light of the "studio" and the "schools" (developed for pictorial effects) and, whether working indoors or *en plein air,* used the hues that signified both the "immediate" and the "natural." The association of natural light with bright hues became so strong for him that such color, even in a pattern of harsh contrasts with few if any "broken" passages, *seemed itself to unify a picture.* This was the visual "truth" he "observed" in 1876 at L'Estaque: "the objects are defined in silhouette not only in white or black, but in blue, in red, in brown, in violet . . . it seems to me to be the antithesis of [chiaroscuro] modeling."[28] Does this account of Cézanne's vision, apparently a statement of fact, constitute a theory? Whether vision or theory generated the painter's observation may be impossible to determine; the very question remains equivocal. The term "observation" itself reflects the ambiguity: it signifies the product either of sensation or of thought.

In accord with Cézanne's realization that chiaroscuro is not "natural," his *Plate of Apples* (fig. 48), a typical work of the late 1870s, lacks any pronounced play of dark and light values; it has no modeling of the conventional sort. Instead, it displays a harmonious surface in which the colors of foreground and background form a continuous pattern of interrelated hues. These various colors have been mixed from a relatively limited palette. A grayish blue shadow on the plate, for example, has been made primarily from ultramarine and white with the addition of a near-complementary vermilion to "dim" the intensity of the hue; and a grayish tone in the tablecloth has been mixed largely from white, ultramarine, vermilion, and chrome yellow—the three primary hues form this neutralized color.[29] In a somewhat later work, *Trois Baigneuses* (ca. 1881–82; fig. 49), Cézanne employed his limited palette once again, but in a more obvious manner; his surface of color seems more "immediate" with regard to both the intensity of the hues and the direct application of pigment, the characteristic "primitive" facture.[30] The "flesh" tones of the bathers range from blue at the contours to green shadows to lighter areas of pinkish violet and pale yellow. And within the predominantly yellow, green, and blue foliage, traces of bright red are visible. Because Cézanne tended to employ each of his basic palette pigments in its pure or primitive state, his canvases retained the look of immediacy even when repeatedly reworked—whether thinly sketched or encrusted with layers of thick pigment, they kept the "sensation." Even while he "finished" a work, it became, in his terms, no more removed from experience, no more "refined."

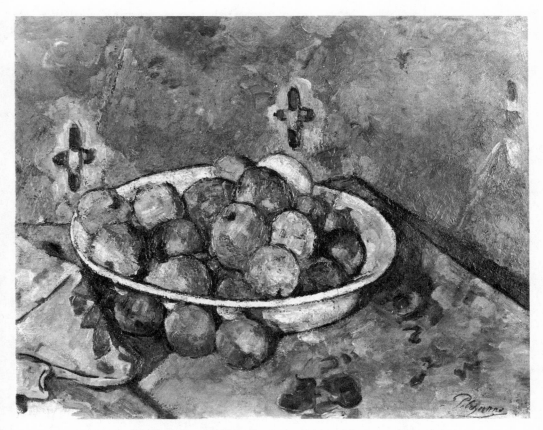

48. PAUL CÉZANNE, *Plate of Apples*, ca. 1877–78. Courtesy of the Art Institute of Chicago.

Houses in Provence (fig. 50)—a painting that exhibits the same general manner as *Trois Baigneuses* and probably dates somewhat earlier, perhaps about 1880—may be one of the most successful of Cézanne's works in meeting the technical goal of producing a harmonious unified pattern of brilliant color (to create the atmospheric effect) without any major reliance on chiaroscuro gradation.[31] In this painting, rocks and vegetation appear as a pattern of blue, blue-green, yellow-green, and ochre with traces of red (both vermilion and alizarin) visible as components in the various mixtures. Surfaces of architecture are primarily blue and ochre, with some red and green added. Despite the fact that the image contains illuminated rock outcroppings rendered with tones of pale yellow and pale blue set against darker colors, there is surprisingly little sense of a general spatial recession. This absence of illusionistic depth results from several factors: a number of "highlighted" areas appear in like manner in the foreground, middle-ground, and background; the strength of the values as well as the intensity of the hues is quite uniform; and this effect is enhanced by the repetitious pattern of brushstroke, which does not distinguish "near" from "far." In conse-

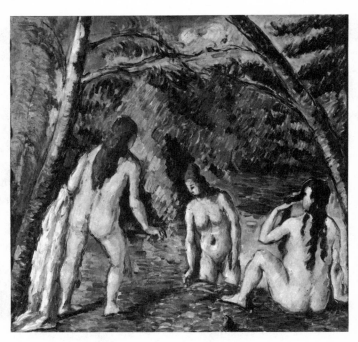

49. PAUL CÉZANNE, *Trois Baigneuses*, ca. 1881–82. Musée du Petit Palais. Photograph courtesy Giraudon.

quence, the viewer "sees" illusionistic depth in this work only because of the persistance of the convention of reading a landscape painting from bottom to top as if from "front" to "back." Although aerial perspective (the gradual diminution of value contrast) may have once been *found* by Renaissance masters to give the illusion of a "real" phenomenon, Cézanne here rejects it as a convention. His "naïve" observation of a uniform light replaces a studied vision of chiaroscuro; and a painting signifying the natural impression, with all the roughness of a spontaneous discovery, develops in implicit opposition to a display of acquired technical expertise. The technical manner of *Houses in Provence* must be viewed as a refinement of Cézanne's earlier painting style, but the artist directed the work itself toward an effect of increasingly naïve simplicity.

As Cézanne came to use his bright palette more and more freely, with less concern for "broken" color, he produced impressionist paintings that displayed the third type of *clarté*. To create a varied but unifying pattern within his works (an alternative to the "compositional" structure of gradated chiaroscuro modeling), he relied on contrasts of warm and cool hues. As noted in chapter 8, the painter's early admirers observed this central aspect of his technique. Subsequently, it has been rediscovered repetitiously by twentieth-century critics and scholars as if it were a "classic" phenomenon: each writer speaks of the "truth" of Cézanne's structure of colors as if he himself sees it (or returns to it) "originally."[32] For most of these critics, the appearance of system in the artist's sequences of contrasting hues has indicated an ordered (made) quality lacking in a more spontaneous (found) impressionism. But Fry's

adversary D. S. MacColl recognized that the artist's method was consistent with familiar naturalistic principles; he wrote in 1912 that Cézanne's substitution of

> contrasts of tint [hue] for contrasts of tone [value] . . . [is] not Post-Impressionism at all, but the Impressionism of Turner and Monet . . . the convention Turner and Monet adopted, to gain a general brilliance, was to omit the lower as well [as the higher values], to leave out not only the real sun, which no one could put in, but also the shadows, the tones, of the lower notes, rendering only their difference of colour or tint, and that in an exaggerated way . . . [Cézanne] is on this ground a pure impressionist.[33]

In other words, MacColl attributed to both impressionism and Cézanne the device of narrowing a painting's tonal range to a group of middle values and simultaneously emphasizing contrasts of hue. Although the impressionists took this method to ends that many considered excessive, through the nineteenth century it had indeed been recommended for effects of *plein air*. The quality of *chaud* and *froid* (hue) could be substituted for that of *lumière* and *ombre* (value) in order to give coherence to pictorial color.[34]

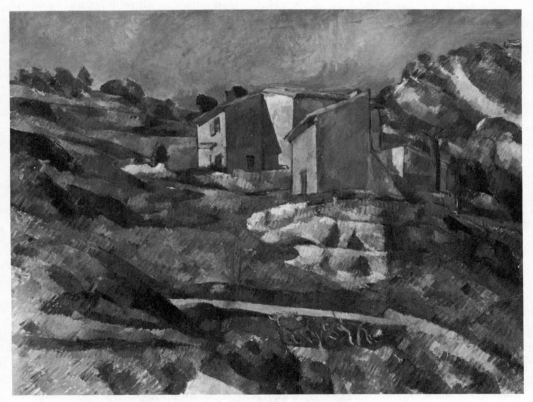

50. PAUL CÉZANNE, *Houses in Provence*, ca. 1880. Collection of Mr. and Mrs. Paul Mellon, National Gallery of Art, Washington, D.C.

The pattern of contrasting warm and cool hues that defines Cézanne's most mature technique is regular only in its ubiquity and uniformity. The artist allows the chromatic range of "local color"[35] to extend to far distant hues—his "green" foliage often moves in the direction of red and violet. Moreover, he accumulates strokes of contrasting colors in the most unlikely locations—within "naturally" monochromatic skies, articles of clothing, and pieces of furniture. As his admirers remarked, he made his background areas as colorful as his foregrounds as if without any specific cause in nature to do so.[36] For example, it is likely that the dress depicted in his *Portrait of Madame Cézanne* (ca. 1890; fig. 51) was a solid blue, but he extended the range of this hue, while he retained a narrow range of value: the dress becomes blue, green, and violet. Similarly, the figure's face and hands are defined with tones of rose, pale orange, and green.

Even in works of relatively dull coloration, such as the late still-life *Three Skulls* (fig. 52), Cézanne evoked the chromatic presence of a brilliant impressionist light: in this simple composition, he rendered the left skull with broad strokes of green, pale blue, dull yellow, pink, and reddish violet, and even its contour outlining is multicolored. Moreover, the plane of the table top is "modeled" with various contrasting but

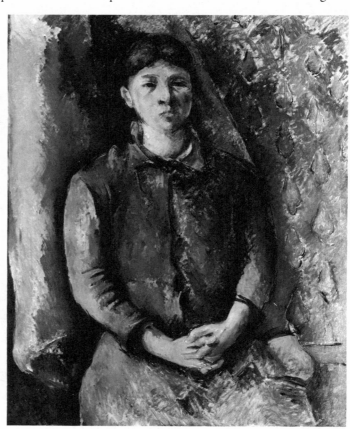

51. PAUL CÉZANNE, *Portrait of Madame Cézanne*, ca. 1890. Courtesy of the Detroit Institute of Arts, bequest of Robert H. Tannahill.

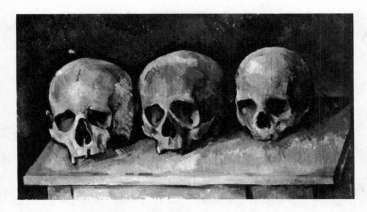

52. PAUL CÉZANNE, *Three Skulls*, ca. 1900. Courtesy of the Detroit Institute of Arts, bequest of Robert H. Tannahill.

close-valued hues. If Cézanne ever intended to use a "system" of color to imitate volume in nature, here he has instead made a flat object "round," or, at the very least, warped. Both his "theory" and his earlier practice support the assumption that such color modulation signifies the unifying atmosphere of an impression rather than specific peculiarities in the appearance of an object. The painter's impression is (conceived as) immediate and found. His impressionist aim inhibits his observing an object as a differentiated part of a whole "sensation" of nature since this would be to study it and make it into a compositional element. Cézanne did not make compositions in the usual sense.[37] He preferred to let his technique of making perform a finding—the impression becomes the end of his art, not merely the beginning.

《 》

To reiterate: Cézanne's *Three Skulls* conveys immediacy not only in its "atmospheric" color but in its apparent lack of "composition." Such a simple and repetitive arrangement of forms implies no deliberative process of organizing either the still-life elements of the model in the studio (the skulls on the table) or the colors and shapes on the canvas. But I have argued that the painter calculated "straightforward" effects of this sort. The degree of an artist's deliberation can never be determined on the basis of visual indications alone. The visual evidence is part of a rhetorical system, not "plain truth." Cézanne's own paintings accentuate the potential for confusion: although many of them evoke the sense of a found simplicity, others do not. A painting from the same period as *Three Skulls*, Cézanne's *Still Life* (ca.1900; fig. 53), presents a much more complex appearance; it displays apples on a plate that tilts forward, several other pieces of fruit, and a milk pitcher, all on a table (seen somewhat from above) in front of a characteristically varied and barely decipherable background of curtain and wall. But this is certainly not the most complicated of Cézanne's later still-lifes; many have greater numbers of items on the table, typically including a dish tilted forward and an irregularly folded patterned cloth in the immediate foreground. These particular details are traditional ones, to be seen in many still-lifes of the seventeenth century, both French and Dutch, and also later in the work of Cézanne's contemporaries such as Antoine Vollon.[38] In general, Cézanne

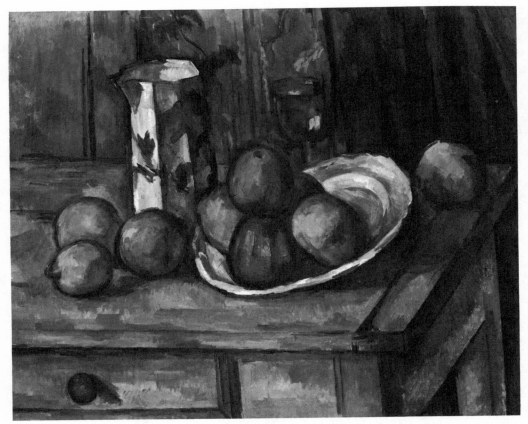

53. PAUL CÉZANNE, *Still Life*, ca. 1900. Gift of the W. Averell Harriman Foundation, National Gallery of Art, Washington, D.C.

did not invent new subjects; on the contrary, he seems to have employed the most conventional ones—still-lifes of bowls of fruit, compositions of nude "bathers" in a landscape, views of a distant mountain—in order to transform conventional art all the more decidedly by way of an unconventional technical procedure designed to appear natural. Cézanne took the inherited stock of representational art, often in the form of images drawn after the "old masters," and brought immediate "sensation" back to it: as his admirers noted, he wished to return Poussin's art to its origin in nature.[39]

Still Life can be regarded as a characteristic work of the painter's last years. As I have stated, it looks (at least superficially) more complex than *Three Skulls* and less elaborate than a number of other works of the period.[40] As is so often the case, its features of organization are largely invisible in black-and-white reproductions since they depend on analogies and contrasts of color. I wish to describe aspects of the "compositional" order of this painting, while yet maintaining (as in chapter 8) that

Cézanne strove to avoid conventional *hierarchical* composition—indeed, he transformed or eliminated nearly all that would be recognized as "composition" in the eyes of his contemporaries. Essentially, in terms of the linking of one articulated part to another, the artist established correspondences to unify the image and reinforce the uniformity of the atmospheric effect. It is largely because of this sort of structural correspondence—a nonhierarchical repetition of motifs of color, shape, or directional line—that so many later viewers called the paintings "flat"; they seemed uniform not only in color and value but in the degree of illusionistic depth established in one part of the painting relative to another. I prefer to describe as "correspondence" or "nonhierarchical composition" the effect of an integration of surface flatness and illusionistic depth that others have observed.[41] When one perceives that Cézanne's technique produces compositional and coloristic uniformity, his practice becomes consistent with his "impressionist" theory. Yet it remains subject to the more usual "symbolist" mode of interpretation, the critical discourse applied by his younger admirers and by nearly all historians who have used symbolist writings to document this "isolated" painter's case.

Examples of typical structural correspondences that Cézanne created in his *Still Life* include: (1) the linear accents of the right vertical edge of the drawer in the table echo the rendering of the right side of the pitcher and also the directional strokes in the lower left part of the dish; (2) the central part of the background corresponds coloristically to the foreground table plane; (3) the pattern of brushstrokes in the pitcher corresponds to that in the adjacent part of the background (to the right of the pitcher), and patches of ochre, the dominant color of the adjacent background, are added to the pitcher; (4) the brushstrokes that define the wineglass extend beyond the representational limits of the object and correspond to the strokes of the adjacent background; (5) the background drapery at the top right seems arranged to form diagonal folds defining an angle reciprocally related to that of the receding right edge of the foreground table; (6) horizontal "shadows" next to the oranges and the lemon at left echo the edges of the table and drawer. Such analogies reinforce the sense of an articulated but repetitious variation in the entire surface that is given also by the artist's insistent use of contrasts of warm and cool colors: the dish is a pattern of blue, pink, and green; the red, orange, yellow, and green fruit are edged by linear strokes of blue and red-violet; the linear edges of the table consist of segments of blue, red-violet, green, and reddish brown with the strokes of brilliant cool blue often flanked by contrasting warm orange-browns; the plane of the table ranges from various warm and cool browns to pale red-violets, violets, blues, and greens.

Cézanne's *Still Life* must be judged an "impression" because its parts, although varied and unified, fail to form a hierarchical composition; this effect is the product of both the use of a type of color that supercedes a more conventional chiaroscuro, and the use of an arrangement of contrasting shapes, colors, and lines designed not to appear in strict rank or sequence, but rather as forming a set of equivalent spontaneous "sensations." Some of the artist's early critics recognized his intentions and re-

marked on the final simplicity of his order. For example, Théodore Duret wrote in 1906:

> Cézanne is devoted to painting still-lifes, landscapes, portraits and, as a sort of crowning achievement, compositions—of however, a simple order—where figures [i.e., "bathers"] are placed side by side, without being given clearly defined actions, and above all [simply] to be painted. His pictures offer a range of color of very great intensity.[42]

To art historians today, this may appear to be an insensitive "formalist" reading of a psychologically rich subject matter; on the contrary, I would suggest that Duret, although by no means an exceptionally perceptive critic, focused on what Cézanne actually wished him to see—the essential wholeness, integrity, and *identity* of a vision "true" to nature and self, whatever its object of scrutiny. That object could be found anywhere: in the imagination, in art, in nature. And all the painter's subjects held equal interest. Duret himself noted that in Cézanne's works apples assumed the same "grandeur" as a human figure or a landscape by the sea.

Indeed, to reverse the order of Duret's comparison, Cézanne's great composition of female bathers, left unfinished at his death in 1906 (fig. 54), can be considered as "simple" as his less ambitious works (apples, landscapes by the sea), especially with regard to the apparent unification of its linear motifs and its continuous interweaving of warm and cool colors. The artist "distorted" the figures so that they form a central triangular motif in combination with the trees; he also extended sequences of contrasting hues across "natural" barriers—from figure to figure and from figure to ground. According to Roger Fry, however, this distortion for the sake of unification (which Maurice Denis called "gauchement Poussinesque") had been taken too far and pursued too deliberately. As a result, the *Grandes Baigneuses* lacked the quality of immediacy associated with earlier impressionism; and, in this case, even the structured rhythm of postimpressionism failed to invigorate what could only appear a lifeless invention. Fry wrote in complaint:

> [Cézanne's] point of departure is the pyramid given by the inclined tree trunks on either side. The poses of the figures are clearly dictated by this—too clearly, too obtrusively indeed do they adapt themselves to this elementary schema. In spite of the marvels of his handling and the richness of delicacy of the colour transitions he has not escaped the effect of dryness and wilfulness which so deliberate a formula arouses.[43]

The issue here is one discussed at the end of part 2: must a critic's awareness of a "modern" artist's deliberation and manner of artifice lead to a negative assessment of the efficacy of his art? If the specific procedure of making becomes apparent, does the painting consequently lose its quality of a found originality?

Cézanne's *Mont Sainte-Victoire* (ca.1885; fig. 55) presents the dilemma clearly. It is a painting with a fully developed pattern of contrasting warm and cool hues extended across the canvas surface to give the effect of the "impression," a unifying and uniform atmospheric light. But this painting also displays a "compositional" motif as

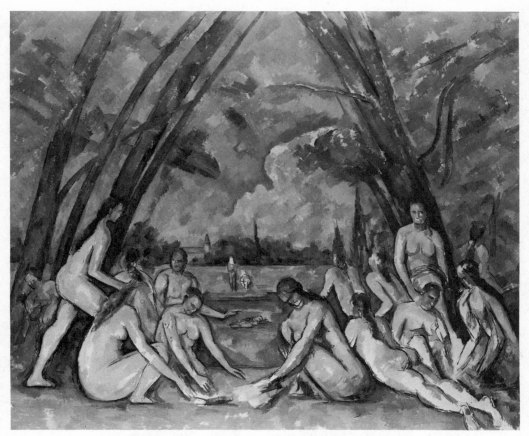

54. PAUL CÉZANNE, *Large Bathers (Grandes Baigneuses)*, 1906. The Philadelphia Museum of Art, W. P. Wilstach Collection.

obvious and "simple" as the arch of trees and figures in the *Grandes Baigneuses*—the intersection at right angles of a central, nearly vertical tree with the accented horizontal of a railroad viaduct. Is the viewer to regard this conflation of the organic and the geometrical as a willful construction or merely a relatively passive observation? Does the simplicity of the relationship of the two elements suggest directness and naïve vision, or rather a sophisticated distillation of form for the sake of the most logical representation? *Mont Sainte-Victoire* may represent a case of either a fabricated order or a "natural" (or even "unconscious") one. My evidence has indicated that Cézanne used a "technique of originality" just as his fellow impressionists did. In other words, he self-consciously created the sense of a found order by employing a field of color made uniform in the repetitiveness of patterns of warm and cool hues; and he simplified his compositions to the point where spatial distinctions of the usual sort became unintelligible—one sees the geometric bonding of tree and viaduct in *Mont Sainte-Victoire* as linking foreground to background and as reinforcing the perception of atmospheric "flatness." Yet the question of the fabricated and the natural must remain

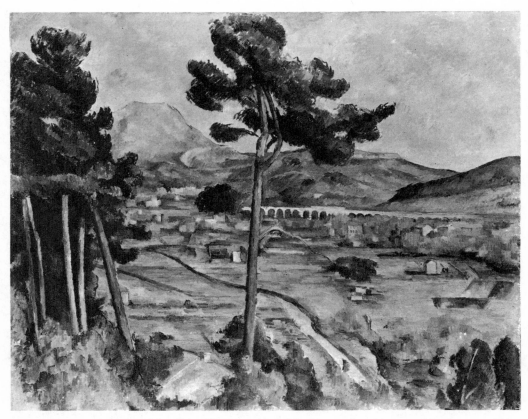

55. PAUL CÉZANNE, *Mont Sainte-Victoire*, ca. 1885. The Metropolitan Museum of Art, bequest of Mrs. H. O. Havemeyer, 1929. The H. O. Havemeyer Collection. (29.100.64)

open for any modernist critic who regards originality as the greatest achievement; for if Cézanne possessed the originality inherent in the discovery or experience of nature and self, this modernist end would not be seen as a mere product of the manipulation of technical means. The modernist critic or art historian is inclined to discount the artifice of impressionist originality and to judge Cézanne—who seemed to have introduced a new kind of structure into painting—as Roger Fry judged him: he may not have known what he was doing; his originality ran ahead of his technique.

It is something of a cliché to say that "few if any artists are entirely conscious of their enterprise, and therefore of the manner in which the changing directions in their art may transcend the frames of reference imposed by their moment in time."[44] Like all clichés, this one has repeatedly been put to productive use: it has allowed the art historian to attribute a complex level of system and signification to a given work and to explain it in a sophisticated fashion, while viewing its creator as a relatively naïve finder, someone unaware of his own accomplishments. Not only does the art historian thereby establish his own professional territory of "original" interpretation, he also maintains the modern myth of an originality that must be found and never made. This dichotomy of the found and the made is unnecessary because both the

art historian's interpretation and the artist's creation are made things. The fact that they may differ does not imply that interpretation must supercede creation as a conscious act following unconscious or passive discovery.

The interpretive act manipulates a raw material of art, but so does art itself; both have technique (much, if not all of it, inherited) and both require skill in expression. The modern artist often demonstrates his craft by successfully disguising it, so that his created representation, a magnificent fiction, appears independent of the technique that made it. With a complementary agility, the historian or critic unveils the relationship between the artist and his inherited artistic tradition; yet in the next breath, he denies that the artistic product is constituted of that past—he values the "modernist" work to the extent that it breaks with the past and originates in a living present. But just at this point in the critical discourse comes a recognition: the "living present" must include those *classics* who never die; Cézanne's modernism can be at one and the same moment a classicism—and this without sacrificing modernism's claim to vital, (re)generative originality.

At such a moment, the modernist conflict between present and past abates. Hence the great attraction of Clement Greenberg's later "modernism," which stresses not only individual achievement, but also the necessity of acknowledging standards set by the past: "Nothing could be further from the authentic art of our time than the idea of a rupture of continuity. Art is, among other things, continuity. Without the past of art, and without the need and compulsion to maintain past standards of excellence, such a thing as Modernist art would be impossible."[45] Perhaps Greenberg's position (just as Cézanne's) represents a classicism within modernism or a classical modernism—or simply classic modernism. It resembles all modernism and all classicism.[46] The critic's favored artists live up to the standards set by the art of the past, but simultaneously re-view that art and create their own standards. It seems that such artists are engaged in a familiar activity, "remaking Poussin by way of nature."

If modernist artists reevaluate the past, they must make progress—or do they find it? Surely artists cannot predict the full form that their works will take any more than competent speakers can control all the implications and meanings of their words; any process of representation will hold surprises. But to glorify the degree of surprise and unconsciousness within an act of signification, at the expense of the element of control and deliberation, seems somewhat perverse. Is there any compelling reason why the artist who finds more than he can make (an innovator in spite of himself) should be greater than some rival who can make exactly what others would wish to find? Perhaps so: the finder creates new desires; the maker seems (merely?) to satisfy old ones. Yet I find it salutary to recognize the strong possibility that Cézanne discovered nothing beyond impressionism but instead used impressionist technique to *represent* the "original" vision impressionism had been designed to find. That is surely mastery. Cézanne was remarkably successful despite his doubts and his inability, or lack of concern, to control the course of his own interpretive fortune. He received post-impressionist credit that he neither needed nor desired. He was wealthy enough in his impressionist sensation.

Part Four

Conclusion: Making a Find

I seek in painting. [Je cherche en peignant.]

CÉZANNE'S WORDS *as reported by Maurice Denis, 1906*[1]

Let us learn from *those who find*, and not from these *eternal seekers*, for whom the search only leads them deeper into the morass; let us seek, but by paths that are sure.

ÉMILE BERNARD, *1910*[2]

We are almost invited to articulate the weft of movements [in Cézanne's paintings] for ourselves.

ROGER FRY, *1927*[3]

In my opinion to search means nothing in painting. To find, is the thing. . . . When I paint my object is to show what I have found and not what I am looking for. . . . The artist must know the manner whereby to convince others of the truthfulness of his lies. . . .

PABLO PICASSO, *1923*[4]

Making a Find

CÉZANNE SAW HIMSELF AS A FINDER, but not of the accomplished kind that Picasso sought to be. In his distrust of theory and in his pursuit of a "sensation" that entailed the simultaneous discovery of a nature and a self, Cézanne exemplified the most typical of "modern" artists, one who would become expressive by minimizing the referential (or mediated) character of his own technical means. If fate condemned this artist to a lifelong "search in painting," and if he reached no "realization," his own resistance to familiar methods of representation contributed to the problem: Cézanne's technique was ever "original" and hence evolving, incomplete. Ultimately, Bernard, as well as some other symbolist admirers, judged the painter's "primitive" imperfection to be an obstacle to his full artistic expression. In addition, Bernard, like Fry, decided that the works came into being not by controlled design, but as a result of the vicissitudes of unconscious processes. In the eyes of his critics, Cézanne's findings, for better or worse, were products of chance, not final creations that he had intended to make.[5] They signified an exemplary process of discovery, rather than an artistic end: "in certain works of Cézanne we seem to get a particularly clear vision of the process of [artistic] creations"; "his art is a model of steadfast searching and growth."[6]

I have attempted to reverse what I take to be the usual order of interpreting Cézanne's art. I have not sought to conclude that his painting is a demonstration of an open-ended creative process, one that strives to maintain its own change, growth, and originality. Instead, I began by viewing this art as a reference to such originality and then sought to determine *how* the artist made his expression of finding—what technique did he employ? The question does not lend itself to a direct answer. From within the ideology of originality shared by the artist and his critics, matters of technique seem inconsistent with the essentials of art. The "original" artist conceals his mediating technique while he exposes its references to the immediacy of artistic process. He displays marks that (like "impressions") are meant to be seen as direct manifestations of the experience that constitutes consciousness; concomitantly, he suppresses any hint of representation, of his mark imitating another's mark or some preconceived object. Whether such artistic creativity is a conscious or an uncon-

223

scious act, it must perform its expression as a pure discovery, as if without the aid of any artificial devices: as R. G. Collingwood wrote, "expression is an activity of which there can be no technique."[7]

Collingwood's theory is detailed in his *Principles of Art*, and represents a cogent argument in support of a number of fundamental notions implicit in Cézanne's practice and that of his critical interpreters. It was published in 1938, when one could take stock of the phenomenon of a "modern" art of expression from a certain historical distance. It is useful to recall some of the questions that the academic philosopher entertained: How is the work of art generated? How is it different from God's creation? In what sense is it original? Just as Fry did, Collingwood set about to distill an essence of pure artistic activity from its attendant technical procedure. Simply put, he wished to separate "creative" art from craft: "to create something means to make it non-technically, but yet consciously and voluntarily." Although he assigned full consciousness to artistic creation and conceived it even as a paradigmatic act of consciousness, still, within his theory, the mystery associated with the discovery of the unknown remained. Collingwood used an explicating figure of comparison mysterious in itself—supernatural "divine" creation. Neither artistic nor divine creation transforms matter according to fixed principles:

> Works of art . . . are not made as means to an end; they are not made according to any preconceived plan; and they are not made by imposing a new form ·upon a given matter. Yet they are made deliberately and responsibly, by people who know what they are doing, even though they do not know in advance what is going to come of it.
>
> The creation which theologians ascribe to God is peculiar in one way and only one . . . in the case of his act there lacks not only a prerequisite in the shape of a matter to be transformed, but any prerequisite of any kind whatsoever. [In contrast,] in order that a work of art should be created, the prospective artist . . . must have in him certain unexpressed emotions, and must also have the wherewithal to express them. . . .
>
> The artistic experience is not generated out of nothing.[8]

Nevertheless, works of human art may appear "original"—similar to God's creations—despite their contingency and the need for an artistic medium or language. Collingwood stated this clearly: "Every genuine [artistic] expression must be an original one. . . . The artistic activity does not 'use' a 'ready-made language,' it 'creates' language as it goes along."[9] The theorist undertook to argue that artistic expression is not restricted by preexisting expressive patterns. In effect, Collingwood (with great justification) sought to deny any fully determining role to the world of discourse and technical procedure into which the artist is cast, although this situation is surely a major aspect of what he called the "circumstances" that facilitate creation, circumstances to which God is not held. But Collingwood paid the medium its due. Certainly he was cognizant of its importance when he wrote that "there is no way of expressing the same feeling in two different media" and that a conscious or imaginative "idea is had as an idea only in so far as it is expressed [in a medium]." Yet the de-

fining force of the medium itself seems to dissipate as the theorist approaches the logical extreme of his own position: "every word [i.e., every objectified artistic expression] as it actually occurs in discourse, occurs once and once only."[10] Artistic language does not await its use in repetition; man "creates" language as he "goes along." Every expression is original; every making is a finding.

Consequently, for Collingwood, an achievement of strict, reiterative representation, if possible, could not count as an act of *human* expression. All attempts at such representation would fail because of the inherent "originality" of all technical procedures—when put into practice. Even artists' copies, in necessarily differing from their originals (as one act of sincere expression must differ from another), would be unique and original to some degree, however accidental or purposeless this originality might seem.[11] As a result, it becomes difficult to distinguish the artist from the madman because any "strong" artistic expression—the products of Cézanne's self-proclaimed "strong sensation" are appropriate examples—must bring forth an artistic language of an unusually pronounced deviance. According to theorists such as Collingwood or critics such as Fry, the viewer always has an attractive option: to regard the unforeseen or "unconscious" distortions of Cézanne's paintings as evidence of the artist's *conscious* and heroic struggle to gain knowledge of his own experience; the paintings became the acts of a sane and meditative man. But in any specific case, such an affirmative critical conclusion would not necessarily be the obvious one. What prevents Cézanne from being judged an incompetent technician who simply fails to use his communicative medium according to its rules? Why is his deviant expression interpreted as both original and creative, both found and meaningfully made? The answer, I believe, is that this finding has been made or crafted with *skill*: the artist has employed a technique to communicate originality according to some principle, and his manner even becomes subject to knowing repetition. His technique does more than merely exemplify the original by means of some singularity. It both follows an old standard and becomes originality's new emblem.

Despite the secondary role that technical skill has usually been accorded in discussions of modern art, one's awareness of the nature of this mediating factor, whether acknowledged or not, enters into critical judgments. Here it is useful to consider an example of "creative" activity generally *not* regarded as art, the magician's performance. When a magician waves his arm and a rabbit appears, the critical observers in his audience assume that some special technique, a "trick," has been employed, since no man can create a rabbit immediately and out of nothing. Momentarily, however, it does seem that the rabbit arises on the spot; and this effect can be enhanced by the magician's own feigned surprise. He can act out the role of the astonished witness to his own apparently uncontrolled creative powers, substituting himself for his audience and evoking the response he desires. On reflection, of course, the rabbit must be viewed as having been generated by a process simply designed to escape all notice. Despite the theatrical pretenses, the experienced viewer assumes that the magician knows full well that the rabbit will appear. Because the magician has therefore preconceived the end of his "art," his activity cannot be art (in Collingwood's terms)—it is craft. And if the undetectable technical factor were not presumed, the viewer

would have to admit to having witnessed some transcendent "art" as opposed to the performance of a mere material skill. Under these circumstances of blinded observation, the magic act can become a magical art, art of an invisible technique, perhaps of an ideal "technique of originality" in which process and product converge. The rabbit can become an "original" expression and, despite its surprise appearance, can seem to be the product of a most powerful being who brings forth not only a living art, but life itself. Here, a human art approaches divine creation *ex nihilo*.

《 》

In the great majority of cultural exchanges, one assumes the presence of technique much more readily than "magic," even if magic is all that is to be observed. Similarly, one can be aware of an artistic presence even when it leaves no visible mark on the object of its creation; and unauthored objects are often attributed to artistic makers. Some seemingly spontaneous products of finding have leaped forth like rabbits from artistically unarticulated environments, to be accorded the relatively high status of creative art: Duchamp's "readymades," the surrealists' found objects, and, more recently, certain "happenings" and "performances." (One can add the earlier and less obvious example of nineteenth-century painters' "unconscious distortions.") Each of these examples of found art, however unintended its features may appear, seems identified with a specific artistic enterprise, usually with a particular artist or group of artists. Conversely, not every act of finding can find "art," for not everyone has been publicly sanctioned to perform this act, despite the common claim that everyone has the potential to be an artist. I suspect, for example, that Duchamp was able to "make" or convert readymades (a urinal, a bottle rack) into works publicly accepted as art, not because his objects were inherently aesthetically distinguished nor even because the "found" objects were so well chosen for his purposes;[12] rather, Duchamp could display these mundane objects as art primarily because Duchamp was an artist; he was *already* regarded as an artist—a painter, sculptor, and printmaker. In other words, Duchamp had already mastered technique; consequently, one could assume him to be creative even in the absence of any visible evidence of such activity, and even in his passive finding. In the case of the magician, the unseen technique seems to diminish the power or significance of the act; for the recognized artist, the invisible can only work to increase a power already accorded by consensus.

If creations are "made," they must have origins. As an institutionally recognized artist, Duchamp was the obvious origin, or author, of his own art. Regardless of the fact that his readymades appeared as "found" objects, he presented them to the public as if they were sculptures; they seemed to issue from Duchamp the artist and could be seen as a coherent expression of an artistic self (no matter how insignificant that expression and that self might be). Without appearing importunate, artists can impose even trivial forms of their self-expression on the public's attention; in the modern mass-market especially, such public exposure seems to further professional careers.

《 》

Generally, three kinds of making are regarded as creative actions. One of these is the *making of something out of something*, that is, fabrication or the purposeful manipulation of materials. Collingwood and others would argue that this type of creativity is but an element of art, never its essence.[13] Fabrication is often dismissed as mere craft, skill, or technical facility, lacking a "higher" and more decidedly human or "spiritual" component; boorish artisans, naïve children, and even some animals seem to have this capability. Of all creative types, the fabricator (but not necessarily the inventor) seems most limited by his own education and the most bound to tradition; conceivably, a machine might perform his functions.

The other two types of making are readily associated with "original" creativity, that is, a degree of creative power beyond the means of the fabricator or craftsman, a creativity extending beyond prediction to the unforeseen. The first of these "higher" forms of making is the *making of something out of nothing*. Independent of the manipulation of material, this type of creativity evokes neither the human nor the subhuman, but the superhuman; it is an activity appropriate to the divine and perhaps to certain pretenders to divine insight or power—religious mystics, miracle workers, and various demonic figures who inhabit myths. Supposedly, artists perform a different kind of making, *making something greater than the sum of its parts*. Here, material technique remains a factor, although some surplus, some radically original creation appears: in the case of the artist, it is as if one and one made three rather than two.[14]

What are the sources (origins) of the three types of creativity—where are they to be found? Simple fabrication depends on techniques that a cultural tradition offers to its members. The desire to discover the ultimate source of an object of fabrication calls forth an attempt at reconstructing the historical development of the particular craft involved. One might be satisfied simply to discover a semiotic system at work (or at play), but one might also be tempted to invoke either of the two higher forms of creativity to account for the state of the lower craft. In like manner, by invoking a hierarchy, one could always refer any "classic" art back to the truth of an absolute origin (divinity, Homer, perhaps Phidias), even in its degenerate "academic" form— the "academicism" of which nineteenth-century critics so often complained represented an art that had fallen into a state of craft. Academicism entailed the transmission of skills from master to pupil; it provided the means to depict or to copy a preconceived reality, but, supposedly, failed to engender the "discovery" of any new reality. No matter how academic, the craft of painting could have much of its artistic authority restored through reflection on its origins. One might claim that the first painter, the one who initiated the tradition—as a creator of a magic likeness—must be a god, a divinity. Alternatively, the painter's act of representation could originate in the creativity of a most unusually inventive man. Nevertheless, it seems that any human artistic act would always be subject to collapse back into a divine source, because this type of creativity, making something more than the sum of its parts, appears as a combination of the other two. The human artistic act seems the simple sum of skilled fabrication plus divine "inspiration."

A quick perusal of the comments of modern artists and their critics reveals that, in this relatively antitheocratic age, a different source is usually found—the individual. An artist need not serve as medium of the divine, but merely of himself: he expresses himself; he is the source of his own creativity; he is original. What may distinguish the "artist" from the "craftsman" is the incorporation in his making, of an originality which he can only *find*. His originality is not made as the fabrications of his culture are; it is found only within himself, in his self-expression.

《 》

These summary statements should seem quite familiar; they resemble a number of highlighted quotations and concluding remarks made at various stages of my analysis of Cézanne and his "modernism." I have not been advocating the elements of this modern argument for artistic validity, but have merely presented this position for study. The efficacy of modernism is tested in every artistic action that makes in order to find—tested largely by the response of its critical observers.

Modern critics commonly claim discontinuity or disjunction in artistic practice, as if to reinforce its achievement of fortunate discovery, a creation for which interpreters can establish logical links and dependencies in the direction of antecedent sources only with some misgiving. The artist himself "leaps" forward.[15] But does he? Cézanne denied doing any more than adding another "link" to history; and because of this, as a major figure of modern art, he appears inappropriately modest or unaware of his own expressive gains.[16] Was he indicating that the "leap" or discontinuity of modern art, as well as its "originality," amounted to a mere artistic effect, even an affectation? (Such an assessment would be in some agreement with the painter's "classicism.") Cézanne was probably not quite "isolated" enough or cynical enough to view modern art as a kind of magic act demanding that its audience either accept the appearance of divine creation or assume the unseen existence of a brilliantly masked technical procedure.[17] Nevertheless, a master of a technique of originality could indeed represent a "leap" never taken—or a discovery never found, but actually made. It is the public viewer who takes the leap, whenever he becomes convinced of the "truth" and "sincerity" of the artist's own vision. At that moment of conviction, the viewer ceases to observe *critically*. And so the proud Picasso (much more the public figure than Cézanne, but having achieved a greater ironic distance) stated in 1923: "the artist must know the manner whereby to convince others of the truthfulness of his lies."[18]

If the viewer is "convinced," he is yet wary. He realizes that his own imagination cannot comprehend a technique or craft that would enable artists to achieve repeatedly and with deliberation images that he himself can only be led passively to find. He does indeed attribute a transcendent "leap" to the artist's imagination, but only when he recognizes that his own falls short of generating a comparable craft. If the viewer cannot conceive how the necessary degree of skill could be attained, he denies it even to the artist. This may be a face-saving gesture, a defense against an admission

of impotence or creative inferiority. The viewer's own self-estimation cannot suffer the artist to possess a touch of divine power: he is allowed a found inspiration, but not an unbounded creative will or ability to make. One admits that the divine creator is a maker, not a finder; but the human artist's conscious craft must remain secondary to his capacity and need to discover. The pattern of modern culture maintains distinctions between divine creation, artistic creation, and simple craft even if they cannot always be observed.

Whenever a modern artist repeats his own performance, this phenomenon is usually regarded as a sign of authenticity—the same original self revealing itself with the consistency that marks an expressive style. Repetition, however, can also be seen as a technical achievement, a demonstration of the ability to fake a find at will. Those concerned primarily with originality (including both impressionists and symbolists, as well as others who followed) opt for the former explanation, but the latter, too, is sufficient. It focuses attention on the artist as maker, as creator, but a creator liberated from the burden of originality, a creator who may voluntarily control the findings of his own artistic actions. The origin of such an artist's oeuvre lies no longer in a mystery, an unpredictable eruptive self, but becomes of his own making. In effect, the modern artist learns how to *make a find*, how to represent a find or an origin. He need not actually discover an origin or final truth, for he knows how to give the appearance of doing so; he knows how to represent the original without ever comprehending or attaining it.

Modern culture has depended on this creative skill. Like the "classicism" of Poussin and Cézanne, such creativity affords both change and a stable reference; it offers an original truth that is both new and perpetually repeated. As a result, one is free to conceive the world as created entirely in artistic acts—acts of making, not finding—and one can yet characterize this world as agreeably stable, punctuated by "discovered" points of origin, expressions to which one can refer again and again. One can make the world and yet live in it, find oneself in it.

《 》

The modern artist's practice of making a find remains problematic because some are much more the "artist" than others; some exhibit unusual creative "talent" or (to shift from a term of finding to one of making) creative technique or craft. Those such as Cézanne, who appear to others as inexplicably adept at finding, have a "technique of originality" that seems unrelated to any craft others might possess. Since this technique is out of one's control, one assumes it to be equally out of the artist's own control. It ceases to appear as a manipulative practice. Hence, one tends to regard the products of highly unusual artistic skills as if they were found fully formed and morally neutral, neither good nor bad, set by no intent and to no specific purpose. But what thus seems true in its originality, true because it is found as an origin, may have been made by the "artist" for the purpose of manipulating his audience. A great "artist," just as a great magician, has a superior control of will. As a master of the means

of expression, he may immobilize and convince his audience without their exercising either a judgment in which observation plays a major part or one based exclusively on theory.

The historian or critic—or whoever performs critical evaluation—must resist yielding to the artist's truth of originality; he cannot assume that the expressive truth of a work of art is self-evident in the referential signs it presents (such as the "distortion," "primitiveness," and "flatness" seen in Cézanne's paintings). The critical observer challenges originality whenever he regards it as a product of creativity, of making. If the artist demonstrates his control of culture in his ability to make a find, the interpreter can profit from the self-knowledge that comes from an understanding of how the artist reached this end. To conclude by asserting the originality of Cézanne's or any other modern artist's act would merely reaffirm the myth that sanctioned his performance. The myth of the artist, either modern or classic, accommodates and encourages an endless repetition of originality. It is possible to acknowledge the mechanisms of the myth while neither disclaiming its importance nor denying its power.

Notes

Preface

1. John House, "The Legacy of Impressionism in France," *Post-Impressionism: Cross-currents in European Painting*, ed. Alan Bowness (New York, 1979), p. 15 (emphasis added).

2. John Rewald, *The History of Impressionism* (New York, 1961, 1973); *Post-Impressionism: From Van Gogh to Gauguin* (New York, 1962, 1978); *Paul Cézanne, a Biography* (New York, 1968). I also consulted Rewald's unpublished notes on the dating of individual paintings; in most cases, my dates are in close agreement with his. Several other scholarly works were essential to my progress in formulating and investigating the problem of Cézanne and the end of impressionism. During the initial stages of my research (ca. 1968–69), Sven Loevgren's *Genesis of Modernism* (Stockholm, 1959; Bloomington, Ind., 1971) and Theodore Reff's "Cézanne and Poussin" (*Journal of the Warburg and Courtauld Institutes* 23 [1960]:150–74) were especially helpful. In addition, two far-reaching studies offered very profitable alternatives to the "mainstream" of the art historical method of the 1960s: E. H. Gombrich's *Art and Illusion* (Princeton, 1960, 1969) and Michael Fried's "Manet's Sources" (*Artforum* 7 [March 1969]:28–82). At a later stage, I received much needed information on Roger Fry and British criticism from Jacqueline Falkenheim's dissertation, "Roger Fry and the Beginnings of Formalist Art Criticism" (Yale, 1972; now published as a book [Ann Arbor, 1980]), and from an unpublished essay on the British response to French impressionism by Barbara Esbin.

3. Parts of *Cézanne and the End of Impressionism* draw from or elaborate on themes that I have explored previously. Part 1 (chapters 1–5) represents an expanded version of my essay "The End of Impressionism: A Study in Theories of Artistic Expression," *Art Quarterly*, n.s., 1 (Autumn 1978): 338–78. Part 3 (chapters 11–15) closely follows a line of reasoning I first presented in "Seeing Cézanne," *Critical Inquiry* 4 (Summer 1978):769–808; that argument, more amply documented, stands now in its proper context, preceded by general discussions of impressionism, symbolism, and nineteenth-century painting theory and practice. Chapter 15 ("Cézanne's Practice") conveys many of the conclusions I reached concerning the artist's use of color and other aspects of his technique in my unpublished dissertation, "Impressionist Criticism, Impressionist Color, and Cézanne" (Yale, 1973). Chapters 6 and 14 and my concluding statement (part 4) draw on the content of several earlier essays: "Art and Life: A Metaphoric Relationship," *Critical Inquiry* 5 (Autumn 1978):107–22; "The Art of Excellence

and the Art of the Unattainable," *Georgia Review* 32 (Winter 1978):829–41; "Miscreation," *Studies in Visual Communication* 7 (Spring 1981):57–71; "Making a Find: An Argument for Creativity, Not Originality," *Structuralist Review* (forthcoming).

Chapter 1

1. Jules Antoine Castagnary, "L'Exposition du boulevard des Capucines: Les Impressionnistes," *Le Siècle*, 29 April 1874, reprinted in Hélène Adhémar, "L'Exposition de 1874 chez Nadar (rétrospective documentaire)," *Centenaire de l'impressionnisme* (Paris, 1974), p. 265.

2. Castagnary included among the naturalist school painters such as Daubigny (noted for his "vérité d'impression") and Courbet (noted for representing "ce qu'il voit"). Among the contributors to the Salon des Refusés, he admired the landscapists Chintreuil and Jongkind. He later stated that he had been wrong to call naturalism a "school," for it did not constitute "une manière conventionnelle et arbitraire de voir." See Jules Antoine Castagnary, "Salon de 1863," "Salon des Refusés" (1863), "Salon de 1868," *Salons*, 2 vols. (Paris, 1892), 1:104–5, 145, 149, 163, 170, 291.

3. Louis Leroy had published a satirical review of the exhibition four days previously in the journal *Le Charivari*. He is generally credited with having introduced the term "impressionist" in print. Cf. Monet's statement on this matter as recorded in T. Taboureux, "Claude Monet," *La Vie moderne*, 12 June 1880, reprinted in Lionello Venturi, *Les Archives de l'impressionnisme*, 2 vols. (Paris, 1939), 2:340. Cf. also Paul Durand-Ruel's memoirs, ibid., 2:200.

4. John Rewald, *The History of Impressionism* (New York, 1961), p. 330.

5. Rewald, *Impressionism*, p. 338.

6. Lionello Venturi, "The Aesthetic Idea of Impressionism," *Journal of Aesthetics and Art Criticism* 1 (Spring 1941):34–45.

7. Rewald, *Impressionism*, p. 338.

8. Castagnary, "Les Impressionnistes," p. 265. Rewald (*Impressionism*, p. 330) quotes this passage, but without extended commentary.

9. See Hippolyte Taine, *De l'intelligence*, 2 vols. (Paris, 1880; orig. ed., 1870), 2:13. Taine's psychological study was widely read.

10. According to Castagnary, art should allow a society to become consciously aware of its own nature, aims, and accomplishments. Romantic art could not aid in this project; often it was "somnambulistic." Naturalist art, however, was "truth in balance with science [*la vérité s'équilibriant avec la science*]." See Castagnary, "Salon de 1863," *Salons*, 1:102–4. On Castagnary's theory of politics, art, and society, cf. Joseph C. Sloane, *French Painting between the Past and the Present* (Princeton, 1951), pp. 68–71; and James Henry Rubin, *Realism and Social Vision in Courbet and Proudhon* (Princeton, 1980), pp. 93–94, 161–64.

11. Jean Moréas, "Les Décadents," *XIXᵉ Siècle*, 11 August 1885. See Noël Richard, *Profiles symbolistes* (Paris, 1978), pp. 219–20.

12. Jean Moréas, "Un Manifeste littéraire: Le Symbolisme," *Le Figaro*, 18 September 1886. Later, in 1891, Moréas suggested that "Symbolisme" should be supplanted by an "École romane" dedicated to revitalizing the French language by means of the poetic art of medieval and Renaissance troubadours, through which there were linguistic links to the ancient Mediterranean world. On the development of the symbolist school, see the detailed account given by Moréas's associate Gustave Kahn, "Les Origines du symbolisme," *Symbolistes et décadents* (Paris, 1902), pp. 7–71. Among the most informative secondary studies of the

movement (frequently cited by English and American scholars) are A. G. Lehmann, *The Symbolist Aesthetic in France 1885–1895* (Oxford, 1968; orig. ed. 1950); and Kenneth Cornell, *The Symbolist Movement* (New Haven, 1951). See also Guy Michaud, *Message poétique du symbolisme*, 3 vols. (Paris, 1947). Henri Peyre (*What Is Symbolism?*, trans. Emmet Parker [University, Ala., 1980; orig. French ed., 1974], p. 6) defines the symbol as that which unites "in an immediate fusion the concrete or external sign and the thing it signifies." The very possibility of such "direct" symbolism (sometimes opposed to allegory) is a matter of continuing debate. Cf. below, pp. 47–52.

13. Many of the more recent studies of French symbolism reveal the continuity and commonality within the movement and its major theoretical statements; in contrast, the older studies, many of them written by those associated with symbolism itself, tend to enlarge the factional differences. For an example of the former, see Peyre; for examples of the latter, see André Barre, *Le Symbolisme* (Paris, 1911) and (primarily for the outgrowth from and "reaction" to symbolism) Eugène Montfort, ed., *Vingt-cinq ans de littérature française*, 2 vols. (Paris, n.d.). (Montfort himself was aligned with the movement known as "naturisme.") Although Barre describes numerous splinter groups developing out from the original symbolist circles, he warns against the assumption that there are significant theoretical distinctions to be found between the various symbolist factions who argued against each other, and he notes with some frustration that "il y a autant de définitions du symbolisme que de symbolistes" (pp. 99–100).

14. See, e.g., Félix Fénéon, "Le Néo-Impressionnisme," *L'Art moderne* (Brussels) 7 (1 May 1887):139. On Fénéon's criticism in relation to other symbolist writings, see Joan Halperin, *Félix Fénéon and the Language of Art Criticism* (Ann Arbor, 1980); and Sven Loevgren, *The Genesis of Modernism* (Bloomington, 1971), chap. 2.

15. Aurier noted that as an idealist and mystical reaction had evidently set in against literary naturalism, it would be surprising if there were not a parallel development within the visual arts; Albert Aurier, "Le Symbolisme en peinture: Paul Gauguin" (1891), *Œuvres posthumes*, (Paris, 1893), p. 209. Aurier's brilliant career as a critic of the arts was cut short by his sudden death in 1892 at the age of 27; his most important writings appear in *Œuvres posthumes*, published by his colleagues at the *Mercure de France*, with a critical introduction by Rémy de Gourmont.

16. On the details of the personal relationships between Aurier, Bernard, and Gauguin, see John Rewald, *Post-Impressionism from Van Gogh to Gauguin* (New York, 1962), chaps. 4, 6, and 9. On Gauguin's and Bernard's dispute, see, e.g., Émile Bernard, "Lettre ouverte à M. Camille Mauclair," *Mercure de France*, n.s., 14 (June 1895):333–34; and Gauguin's letter to Maurice Denis, June 1899, in Maurice Malingue, ed., *Lettres de Gauguin à sa femme et à ses amis* (Paris, 1946), p. 291. As early as 1892 Denis (under the pseudonym Pierre Louis) had written that Bernard "vulgarized the rare talent of M. Gauguin"; "Sur l'Exposition des indépendants," *La Revue blanche*, n.s., 2 (25 April 1892):234.

17. Cf. Loevgren, pp. 127–28.

18. For a negative appraisal of Gauguin's style—characterized by "un contour abrégé, peu ou point de modelé, des tonalités étendues sans dégradations . . . l'exclusion de la perspective et la suppression des reliefs"—see Alphonse Germain, "Théorie des déformateurs," *La Plume* 3 (1 September 1891):289–90. Along with Gauguin, Germain associated Cézanne and Van Gogh with this constellation of stylistic characteristics, and named as Gauguin's followers the "néo-traditionnistes"—Denis, Sérusier, Bernard, Bonnard, and Vuillard.

19. Rewald, *Post-Impressionism*, pp. 281–83. Jules Antoine reviewed the Volpini exhibition and argued that only Bernard and Anquetin were true "synthétistes"; Bernard was said to copy Gauguin. See Jules Antoine, "Impressionnistes et synthétistes," *Art et critique* 1 (9 November 1889):369–70.

20. See, e.g., Gauguin's letter to Bernard, November 1889, Malingue, p. 172. Denis referred to "l'impressionnisme de Paul Gauguin" in 1895; Maurice Denis, "A propos de l'Exposition d'A. Séguin" (1895), *Théories, 1890–1910: Du symbolisme et de Gauguin vers un nouvel ordre classique* (Paris, 1920; orig. ed., 1912), p. 22.

21. Denis, "L'Influence de Paul Gauguin" (1903), *Théories*, p. 168. Cf. also Denis, "A propos de l'Exposition d'A. Séguin," "Paul Sérusier" (1908), *Théories*, pp. 20–21, 147; and "L'Époque du symbolisme," *Gazette des beaux-arts*, 6 per., 11 (March 1934):172. Here Denis indicates that his own term "néo-traditionnisme" (first used in 1890) was also equivalent to the "symbolisme" of the literary figures. Denis's various formulations often seem to derive from Aurier; he wrote in 1896, for example, that "all great painters, unconsciously or not, declared themselves symbolists: they did not make a double of the thing seen, [but] substituted for nature an aspect of their imagination, that is to say, the sign of an idea; they are not moved by the subject, but rather by the work of art itself, as they have painted it." See Denis, "Notes sur la peinture religieuse" (1896), *Théories*, pp. 41–42; and Aurier, "Le Symbolisme en peinture: Paul Gauguin," *Œuvres*, pp. 213, 216. On the comparison of Aurier and Denis, see also Mathew Herban III, "Maurice Denis' 'Nouvel Ordre Classique' as contained in his *Théories* (1890–1910)," unpublished dissertation, University of Pennsylvania, 1972, pp. 99–118. Secondary accounts of symbolist painting rely heavily on the formulations of both Aurier and Denis: see, in addition to Rewald's *Post-Impressionism* and Loevgren's *Genesis of Modernism*, H. R. Rookmaaker, *Gauguin and Nineteenth Century Art Theory* (Amsterdam, 1972); and Robert Goldwater, *Symbolism* (New York, 1979). Goldwater (p. 200) argues (with some internal contradiction) that "synthetism" is a technical program, whereas "symbolism" is a thematic concern; but such a distinction is not in accord with Aurier's and Denis's statements.

22. Concerning Gauguin's personal contacts with Moréas, Morice, and others during the winter of 1890–91, see Rewald, *Post-Impressionism*, pp. 451–58.

23. Aurier, "Les Isolés: Vincent van Gogh" (1890–92), *Œuvres*, p. 262.

24. Aurier, "Le Symbolisme en peinture: Paul Gauguin," *Œuvres*, pp. 211–13. Like Aurier, Maurice Denis contrasted *both* naturalism and idealism with symbolism; see his "Notes sur la peinture religieuse," *Théories*, pp. 36–37, 39.

25. Aurier, "Le Symbolisme en peinture: Paul Gauguin," *Œuvres*, pp. 215–16. Aurier used the term "décorative" to refer both to the relatively abstract images found in architectural settings in ancient and primitive societies, and to the design (or "sign") character of a painted image.

26. Aurier, "Le Symbolisme en peinture: Paul Gauguin," "Les Peintres symbolistes" (1892), *Œuvres*, pp. 208, 215, 297–98.

27. Aurier, "Les Peintres symbolistes," *Œuvres*, pp. 306, 297. Cf. Bernard, who in 1893 related Van Gogh's artistic development to a mode of expression found also among the impressionists, namely, "Renoir, Cézanne, Degas, Monet, Sisley"; Émile Bernard, "Vincent van Gogh," *Mercure de France*, n.s., 7 (April 1893):330. Rémy de Gourmont indicated the close association of impressionism with symbolism when he referred (in 1893) to Aurier's prominence within the "world in which impressionist-symbolist painting is appreciated and understood"; see Rémy de Gourmont, "Notice," in Aurier, *Œuvres*, p. xxii.

28. Aurier, "Meissonier et Georges Ohnet," *Œuvres*, p. 322. Cf. Denis, "Définition du néo-traditionnisme" (1890), *Théories*, pp. 4–5. Denis associated Bouguereau and Meissonier with naturalism. Rémy de Gourmont called Meissonier a "photographic" naturalist and opposed his art to both impressionism and symbolism; he linked the two modern movements by noting that "il faut au symboliste un fond d'impressionnisme." See R[émy de] G[ourmont], "Les Premiers Salons," *Mercure de France*, n.s., 5 (May 1892):60–61. Bastien-Lepage also represented for the symbolists a naturalism that had become too literal and had failed for lack of emotion. On the opposition of Manet and Monet to Bastien-Lepage, cf. Henry Houssaye, "Salon de 1882," *Revue des deux mondes*, 3 per., 51 (1 June 1882):561–62; Armand Dayot, *Un Siècle d'art* (Paris, 1890), pp. 79–81; and Signac's remarks in his journal, 23 August 1894, published in John Rewald, "Extrait du journal inédit de Paul Signac—I, 1894–1895," *Gazette des beaux-arts*, 6 per., 36 (July–September 1949):101. Signac argues that Monet paints things as he feels them, not as he sees them. On the degeneration of impressionism in "academic" hands, see Denis, "La Réaction nationaliste" (1905), *Théories*, p. 196.

29. E.g, Charles Morice, in reviewing the 1893 exhibition of "Impressionnistes et Symbolistes" at Le Barc de Boutteville, wrote that "l'Impressionnisme pur, *sans mélange de symbolisme* à nul degré . . . est défendu, ici, [seulement] par Guillaumin et Luce"; Morice, "Salons et Salonnets," *Mercure de France*, n.s., (10 January 1894):69 (emphasis added). (Luce was usually considered a "neoimpressionist.") On the nature of the series of exhibitions of "Impressionnistes et Symbolistes" held at Le Barc de Boutteville, see G.-A[lbert] A[urier], "Choses d'art," *Mercure de France*, n.s., 4 (February 1892):185–86. On the continuity of impressionism and symbolism, cf. also the review by Georges Roussel of the exhibition of Denis's circle of artists in 1891; "Les Impressionnistes symbolistes à l'exposition de Saint-Germain," *La Plume* 3 (1 October 1891):341.

30. Denis, "Le Salon du Champ-de-Mars; L'Exposition de Renoir" (1892), *Théories*, p. 19.

31. Georges Lecomte, "M. Camille Pissarro," *La Plume* 3 (1 September 1891):302; Roger Marx, "Les Salons de 1895," *Gazette des Beaux-arts*, 3 per., 13 (May 1895):357.

32. See Steven Z. Levine, *Monet and His Critics* (New York, 1976) and Grace Seiberling, *Monet's Series* (New York, 1980). Levine's discussion of W. G. C. Byvanck's remarks on Monet (pp. 129–36) is especially pertinent to the argument I am developing here. See also Levine's "The 'Instant' of Criticism and Monet's Critical Instant," *Arts* 55 (March 1981):114–21. Camille Mauclair, in a review in which he attacked both the impressionists and many of the symbolists, spoke of a general lack of "composition" in impressionist works, but maintained that Monet (and also Degas) often attained "la synthétisation absolue des paysages"; this was one of the qualities in Monet that might set him within the framework of symbolist art. See Mauclair, "Expositions récentes: Exposition Armand Guillaumin," *Mercure de France*, n.s, 10 (March 1894):266.

33. Pierre Francastel, *L'Impressionnisme: Les Origines de la peinture moderne de Monet à Gauguin* (Paris, 1937), pp. 58–59, 182–220, esp. p. 191; Gustave Geffroy, *La Vie artistique*, 8 vols. (Paris, 1892–1903), and *Claude Monet, sa vie, son œuvre*, 2 vols. (Paris, 1924). Cf. also Goldwater (*Symbolism*, p. 179), who notes that Geffroy and others saw symbolist qualities in Monet.

34. André Mellerio, *Le Mouvement idéaliste en peinture* (Paris, 1896), p. 13.

35. Ibid., p. 26

36. Letter to his son Lucien, 21 November 1895, in Camille Pissarro, *Lettres à son fils Lu-*

cien, ed. John Rewald (Paris, 1950), p. 390. During the same year, Pissarro praised one of Lucien's engravings by calling it both "naïf" and "savant"; see his letter to Lucien, 28 April 1895, quoted in Richard Brettell and Christopher Lloyd, *A Catalog of the Drawings by Camille Pissarro in the Ashmolean Museum, Oxford* (Oxford, 1980), p. 77. Perhaps Pissarro borrowed his terms from a contemporaneous essay by Émile Bernard that referred to an ideal combination of the naïve and the refined; cf. Bernard, "De l'art naïf et de l'art savant," *Mercure de France*, n.s., 14 (April 1895):86–91.

37. Mellerio, pp. 65, 67.

38. Geffroy, "Les Meules de Claude Monet" (1 May 1891), *La Vie artistique*, 1:26–29.

39. Georges Lecomte, "Des tendances de la peinture moderne," *L'Art moderne* (Brussels) 12 (21 February 1892):58; *L'Art impressionniste, d'après la collection privée de M. Durand-Ruel* (Paris, 1892), pp. 260–61. Lecomte and Geffroy were both associated with the journal *Art et critique* (1889–92) which published, among other essays of a symbolist orientation, Maurice Denis's "Définition du néo-traditionnisme" (1890). Lecomte also served as editor of *La Cravache* (1888–89), to which Geffroy, Fénéon, and many symbolist writers contributed. He and Fénéon (as well as Octave Mirbeau) shared a commitment to the anarchist movement. Lecomte's interpretation of the historical development of impressionist painting may represent his critical formulation of some of Pissarro's views. Lecomte recounts his close association with the painter in his *Camille Pissarro* (Paris, 1922); see esp. pp. 9–10, 38.

40. See, e.g., the papers delivered at the session of the Twentieth International Congress of the History of Art, entitled "The Reaction Against Impressionism in the 1880s: Its Nature and Causes" (chaired by Meyer Schapiro), published in *Problems of the 19th and 20th Centuries: Acts of the XX International Congress of the History of Art*, vol. 4 (Princeton, 1963), pp. 91–133. Of the four participants in the session, only Robert Goldwater seems to acknowledge the possibility that impressionist concerns might lead eventually to a symbolist style. Goldwater's subsequent posthumous publication, *Symbolism* (New York, 1979), does not represent a significant addition to what had already been established. He does, however, note with regard to Monet's series of *Haystacks* (1891) that "fragmenting the object (conceived as a duration) into a succession of observed moments increased the accuracy of the record, but because this accuracy, in fact, depends upon an acute sensibility in the artist which he wants the spectator to share, subjectivity is also increased"; and Goldwater adds that "in the eighties [the symbolists] wrote of the impressionists' 'subjectivity of perception' and their desire for 'expressive synthesis' . . . " (p.2). Among the other participants in the session on the "crisis" of impressionism, Pierre Francastel had previously drawn some analogies between impressionism and symbolism, had noted the subjective nature of impressionism, and had located the so-called crisis around 1900 instead of 1885 (*L'Impressionnisme*, pp. 92–94). But in his paper of 1963, he restricted himself to arguing that impressionism is a general epistemological "structure" and not a mere "mode" ("La Fin de l'impressionnisme: esthétique et causalité," *Acts*, vol. 4, pp. 122–33). Among later studies, Mark Roskill's *Van Gogh, Gauguin and the Impressionist Circle* (Greenwich, Conn., 1970) follows from Goldwater's essay of 1963, but, for the most part, the author limits himself to a consideration of superficial (and often ephemeral) stylistic affinities, without probing for intentions or meanings that may lie behind them. For example, he asserts that "by a natural process of continuity and inheritance, the impressionists' way of making the section of wall behind the sitter or still-life implicitly go on beyond the framing edges passed on to Van Gogh and Gauguin" (p. 48). The most recent detailed discus-

sion of a "crisis" of impressionism is Joel Isaacson, *The Crisis of Impressionism, 1878–1882* (Ann Arbor, 1980).

41. Lecomte, "Des tendances de la peinture moderne," p. 58; *L'Art impressionniste*, p. 261. In an extended version of his "Tendances" essay, Lecomte contended that much symbolist art had a falsely religious character and had lost its proper origin in the experience of the natural and social environment; see Georges Lecomte, "L'Art contemporain," *La Revue indépendante* 23, no. 66 (April 1892):1–29. In taking stock of his career, Lecomte later described himself as having fought "pour un art d'observation directe ou de transposition décorative— j'ai horreur des catégories et des classements!" See Georges Lecomte, "La Crise de la peinture française," *L'Art et les artistes*, October 1910, p. 29. Like Lecomte, Geffroy seems to have been predisposed to describe events in terms of a continuing human evolution and to see in successful works of art evidence of an individual's penetrating experience of reality, a step toward mankind's comprehension of itself and its world. See, e.g., Geffroy, preface (May 1895), *La Vie artistique*, 4:xv–xvi.

42. See Loevgren, chap. 1.

43. Pierre Francastel is an exception; see his *L'Impressionnisme*, pp. 93–94. Francastel's awareness of the subjectivity and emotional content of impressionist painting may stem from his careful reading of Geffroy and Denis.

Chapter 2

1. Théodore Véron, *Salon de 1875: De l'art et des artistes de mon temps* (Paris, 1875), p. 35.

2. Frédéric Chevalier, "L'Impressionnisme au Salon," *L'Artiste*, 1 July 1877, pp. 32–39. Similarly, Jules Claretie spoke in 1872 of a group of young landscapists at the Salon who were "un peu trop contentés d'une *impression* pour faire un tableau"; "L'Art français en 1872; Revue du Salon," *Peintres et sculpteurs contemporains* (Paris, 1874), p. 287.

3. Henry Houssaye, "Le Salon de 1882," *Revue des deux mondes*, 3 per., 51 (1 June 1882):563.

4. Paul Mantz, "Salon de 1872," *Gazette des beaux-arts*, 2 per., 6 (July 1872):45.

5. Théodore Duret, *Histoire des peintres impressionnistes* (Paris, 1906), pp. 42–43.

6. Charles Bigot, "La Peinture française en 1875," *Revue politique et littéraire*, 2 ser., 8 (7, 15 May 1875):1062–68, 1088–93; Houssaye, pp. 561–86.

7. See, e.g., in addition to Bigot and Houssaye, Félix Fénéon, "L'Impressionnisme, 1887," *L'Émancipation sociale* (Narbonne), 3 April 1887, reprinted in Félix Fénéon, *Au-delà de l'impressionnisme*, ed. Françoise Cachin (Paris, 1966), p. 83; Félix Fénéon, "Le Néo-Impressionnisme," *L'Art moderne* (Brussels) 7 (1 May 1887):138; W. C. Brownell, *French Art* (New York, 1892), p. 133; and Duret, *Histoire*, pp. 41–42. Duret argues that Degas's color resembles that of the impressionists, but he is essentially a draftsman, not a plein air painter. Most recently, Joel Isaacson notes that Degas was indeed frequently distinguished from "pure" impressionists; Isaacson, *The Crisis of Impressionism, 1878–1882* (Ann Arbor, 1980), p. 25. Isaacson's view is derived from Pierre Francastel, *L'Impressionnisme: Les Origines de la peinture moderne de Monet à Gauguin* (Paris, 1937), pp. 124, 133–34.

8. Jules Antoine Castagnary, "L'Exposition du boulevard des Capucines: Les Impressionnistes," *Le Siècle*, 29 April 1874, reprinted in Hélène Adhémar, "L'Exposition de 1874 chez Nadar (rétrospective documentaire)," *Centenaire de l'impressionnisme* (Paris, 1974), p. 265.

9. See Théodore Duret, "Les Peintres impressionnistes" (1878), *Critique d'avant-garde* (Paris, 1885), pp. 64–69; and Georges Rivière, *L'Impressionniste, Journal d' art*, 6 April 1877, reprinted in Lionello Venturi, *Les Archives de l'impressionnisme*, 2 vols. (Paris, 1939), 2:312.

10. Paul Signac, for example, wrote in 1899 that the "aim" of both impressionism and neoimpressionism was "to give to color the greatest possible force [*éclat*]"; see Signac, *D'Eugène Delacroix au néo-impressionnisme*, ed. Françoise Cachin (Paris. 1964), p. 113.

11. Émile Zola, "Mon Salon" (1868), *Mon Salon, Manet, Écrits sur l'art*, ed. Antoinette Ehrard (Paris, 1970), p. 160. Cf. Duret, "Les Peintres impressionnistes," pp. 65–66.

12. See, e.g., François-Xavier de Burtin, *Traité théorique et pratique des connaissances qui sont nécessaires à tout amateur de tableaux* (Valenciennes, 1846; orig. ed., Brussels, 1808), p. 45. The related technical definitions of the word "impression" from the fields of printing, dyeing, and photography also refer to primacy. On some aspects of the relationship between the visual "impression" and the printer's "impression," cf. Michel Melot, "La Pratique d'un artiste: Pissarro graveur en 1880," *Histoire et critique des arts*, June 1977, p. 16.

13. Émile Deschanel, *Physiologie des écrivains et des artistes, ou essai de critique naturelle* (Paris, 1864), p. 9. For an alternative approach to the derivation of the term "style" (but *not* the derivation considered by French theorists who related "style" to "impression"), see George Kubler, "Towards a Reductive Theory of Visual Style," *The Concept of Style*, ed. Barel Lang (Philadelphia, 1979), pp. 119–28.

14. Thus "impressionism" as a mode of critical writing was defined as the most subjective, relativistic manner of analysis, an appreciation that could never reach any objective conclusions; the "impressionist" critic would consider each work as the product of a unique personal view. See Ferdinand Brunetière, "La Critique impressionniste" (1891), *Essais sur la littérature contemporaine* (Paris, 1900), pp. 1–30.

15. Théophile Thoré (Thoré-Bürger), "Salon de 1844," *Les Salons*, 3 vols. (Brussels, 1893), 1:20. Curiously, what Thoré here calls "poetry" and insists is the opposite of "imitation" is very close to what others had indeed considered imitation. See below, part 2, pp. 92–95. On photographic "imitation," cf. below, chap. 3, note 8.

16. Albert Boime, *The Academy and French Painting in the Nineteenth Century* (New York, 1971), p. 170. Cf. Félix Bracquemond, *Du dessin et de la couleur* (Paris, 1885), p. 139: "L'effet est le but unique de l'art. Ce mot signifie d'abord sensation, impression perçue."

17. Boime, *Academy*, p. 172.

18. Impressionism has only rarely been studied in relation to nineteenth-century psychology. Teddy Brunius provides a brief but thoughtful discussion of the impression in relation to Théodule Ribot and Hippolyte Taine in his *Mutual Aid in the Arts from the Second Empire to Fin de Siècle, Figura*, no. 9 (Uppsala, 1972), p. 102. More recently, Marianne Marcussen and Hilde Olrik have signaled the importance of Taine's *De l'intelligence* in their article "Le Réel chez Zola et les peintres impressionnistes: perception et représentation," *Revue d'histoire littéraire de la France* 80 (November–December 1980):965–77.

19. See, e.g., the account given in Jules Lachelier, "Psychologie et métaphysique" (1885), *Du fondement de l'induction, Psychologie et métaphysique, Notes sur le pari de Pascal* (Paris, 1916), pp. 104–7. In summarizing the position of the new psychologists, Lachelier (p. 123) presented the view that "les véritables lois de la psychologie ne peuvent être, en définitive, que des lois physiologiques." Lachelier himself attempted to reintroduce a metaphysical element into a psychology dominated by physiological study.

20. Pierre Larousse, *Grand Dictionnaire universel du XIXᵉ siècle,* vol. 9 (Paris, 1873), p. 604; Émile Littré, *Dictionnaire de la langue française,* vol. 3 (Paris, 1866), p. 38. On Hume's use of the term "impression," cf. Ian Watt, *Conrad in the Nineteenth Century* (Berkeley, 1979), p. 171.

21. Émile Littré, "De quelques points de physiologie psychique" (1860), *La Science au point de vue philosophique* (Paris, 1876), pp.312, 314. Cf. Auguste Laugel, *L'Optique et les arts* (Paris, 1869), pp. xiii, 1.

22. This reasoning is reflected in Émile Blémont's commentary on the second impressionist exhibition. He wrote that the impressionists "ne voient pas la nécessité de modifier suivant telle ou telle convention leur sensation personnelle et directe." In other words, one view of the world may be as true as any other. See Émile Blémont, "Les Impressionnistes," *Le Rappel,* 9 April 1876.

23. Littré, "Quelques points," p. 315. The notion of the sensory impression as primary is evidenced by the frequency of the phrase "première impression" in the critical literature.

24. Théodule Ribot, *La Psychologie anglaise contemporaine* (Paris, 1896; orig. ed., 1870), p. 59; Hippolyte Taine, *De l'intelligence,* 2 vols. (Paris, 1888; orig. ed., 1870), 1:166–69. Cf. also Armand Sully-Prudhomme, *L'Expression dans les beaux-arts* (1883), *Œuvres de Sully-Prudhomme,* vol. 5, *Prose* (Paris, 1898), p. 408.

25. Larousse, vol. 9, pp. 604–5; Georges Guéroult, "Du rôle du mouvement des yeux dans les émotions esthétiques," *Gazette des beaux-arts,* 2 per., 23 (June 1881):537. Cf. Taine himself on this distinction: *De l'intelligence,* 2:4.

26. Fernand Caussy, "Psychologie de l'impressionnisme," *Mercure de France,* n.s., 52 (December 1904):628–31. Caussy considered the entire oeuvres of Monet and Renoir, not just the later works.

27. Castagnary, "Les Impressionnistes," p. 265. Cf. statements by Charles Bigot and Ernest Chesneau. Bigot: "Ce n'est pas toujours la nature elle-même que représente Corot, c'est l'impression que la nature a faite en lui"; "Corot" (1875), *Peintres français contemporains* (Paris, 1888), p. 67. Chesneau: the impressionists wish to "traduire . . . non plus la nature comme elle est . . . mais la nature comme elle nous apparaît"; "Les Peintres impressionnistes," *Paris-Journal,* 7 March 1882.

Chapter 3

1. Baudelaire spoke also of a third type of artist, neither "réaliste" nor "imaginatif," who simply conforms to established conventions and produces a false art. Charles Baudelaire, "Salon de 1859," *Écrits sur l'art,* ed. Yves Florenne, 2 vols. (Paris, 1971), 2:36–37. Cf. the related discussion of photography, realism, and the imagination in notes by Delacroix, dated 1 September 1859; see Achille Piron, *Eugène Delacroix, sa vie et ses œuvres* (Paris, 1865), pp. 406–7. On this issue, cf. also the later statement of Jean-François Rafaëlli, *Catalog illustré des œuvres de Jean-François Raffaëlli . . . suivi d'une étude des mouvements de l'art moderne et du beau caractériste* (Paris, 1884), pp. 36–37, 46–47.

2. Eugène Fromentin, *Les Maîtres d'autrefois* (Paris, 1876), pp. 284–85.

3. Georges Lafenestre, "Le Salon de 1887," *Revue des deux mondes,* 3 per., 81 (1 June 1887):604–6, 638–39.

4. Roger Marx, "Les Salons de 1895," *Gazette des beaux-arts,* 3 per., 13 (May 1895):354–55.

5. Baudelaire, "Le Peintre de la vie moderne" (1863), *Écrits,* 2:155.

6. Baudelaire, "Salon de 1859," *Écrits,* 2:25.

7. Armand Silvestre, preface to *Galerie Durand-Ruel, Recueil d'estampes gravées à l'eau-forte* (Paris, 1873), p. 23; Théodore Duret, "Salon de 1870," *Critique d'avant-garde* (Paris, 1885), p. 8. Silvestre's essay was never actually distributed publicly. Cf. also Edmond Duranty, *La Nouvelle peinture: A propos du groupe d'artistes qui expose dans les Galeries Durand-Ruel,* ed. Marcel Guérin (Paris, 1946; orig. ed., 1876), pp. 39–40.

8. Furthermore, any general "impression" (whether or not "impressionist" in some narrow sense) could be opposed to any fixed and detailed "reality." As many of the citations in chapters 2 and 3 indicate, critics often contrasted the photographic image to the painter's "impression" as one might contrast a mechanical tracing of a material object to an individualized response to immaterial sensation. For example, with regard to landscape painting, René Ménard wrote: "Ce n'est pas la réalité photographique qu'il s'agit de rendre; c'est l'impression que nous avons sentie devant la nature"; Ménard, "Salon de 1870," *Gazette des beaux-arts,* 2 per., 4 (July 1870):60. Theorists differed as to the final status of the photograph in terms of its manipulation in the hands of an artist-photographer, but to nineteenth-century viewers it seemed at least relatively "mechanical" by comparison with painting. Its presumed objectivity became part of its mythology; and, as a result, the photograph could manipulate (or represent) "objectivity" itself. On this point, cf. Roland Barthes, "The Photographic Message" (1961), *Image—Music—Text,* ed. and trans. Stephen Heath (New York, 1977), pp. 15–31. On some problems in the "mechanical" model of photography, see Joel Snyder and Neil Walsh Allen, "Photography, Vision, and Representation," *Critical Inquiry* 2 (Autumn 1975):143–69, esp. 157–65.

9. Duret, "Salon de 1870," *Critique,* p. 41.

10. Jules Laforgue, "L'Impressionnisme" (1883), *Mélanges posthumes, Œuvres complètes,* vol. 3 (Paris, 1919), pp. 136–37, 140–41.

11. Émile Zola, "Édouard Manet" (1867), *Mon Salon, Manet, Écrits sur l'art,* ed. Antoinette Ehrard (Paris, 1970), pp. 101–2. Cf. Émile Deschanel, *Physiologie des écrivains et des artistes, ou essai de critique naturelle* (Paris, 1864), pp. 249–50: "Il y a un fait physiologique incontestable, c'est que chaque homme voit à sa manière, à plus forte raison, chaque peintre. Les objets apparaissent à chacun d'une certaine façon, sous un certain jour: ses yeux teignent les choses de telle couleur. Quiconque niera ce fait n'a jamais observé. Tel peintre voit tout en rouge, tel autre voit tout en bleu; tel autre en vert; tel autre, en or. Ce n'est ni un parti-pris de l'intelligence, ni une affaire d'imagination; c'est un fait réel, physiologique."

12. Zola, "Manet," *Écrits,* p. 99. Zola's position seems to have been inspired, at least in part, by Taine; see Émile Zola, "M. H. Taine, artiste" (1866), *Mes Haines* (Paris, 1879), pp. 212–13.

13. Jules Antoine Castagnary, "Salon de 1874," *Salons,* 2 vols. (Paris, 1892), 2:179–80.

14. For Littré's attitude toward Comte, see his introduction (written in 1864) to Auguste Comte, *Principes de philosophie positive* (Paris, 1868).

15. D. G. Charlton, *Positivist Thought in France during the Second Empire, 1852–70* (Oxford, 1959), pp. 4–5. Charlton's general definition serves much better than W. M. Simon's strictly Comtean one, especially since, as Charlton explains, Littré's views were better known than Comte's (W. M. Simon, *European Positivism in the Nineteenth Century* [Ithaca, 1963]).

16. Auguste Comte, *Discours sur l'ensemble du positivisme* (Paris, 1848), pp. 276ff. See also Émile Littré, "Culture morale, scientifique, esthétique et industrielle" (1849), *Conservation, révolution, et positivisme* (Paris, 1852), pp. 138–39; Hippolyte Taine, *Philosophie de l'art,* 2 vols. (Paris, 1893; orig. ed., 1865–69), 2:258 and passim.

17. Pierre Petroz, *L'Art et la critique en France depuis 1822* (Paris, 1875), pp. 335–39.

18. See, e.g., Zola's arguments against Taine on this issue: "M. H. Taine, artiste," *Mes Haines,* pp. 224–25.

19. (Eugène Véron), editorial statement, *L'Art* 1 (1875):1–2.

20. Pierre Petroz, "Du classement des œuvres d'art dans les musées," *L'Art* 1 (1875):102–4.

21. One Comtean notion that may indeed have appealed to the impressionists is the relativity of all knowledge derived from observation.

22. Linda Nochlin, *Realism* (Harmondsworth and Baltimore, 1971), pp. 43, 28. A second level of confusion in Nochlin's analysis results from the choice of the term "instantaneity," since it normally refers to a temporality external to the perceiver, the kind of time or moment, however brief, that is subject to measurement. With specific intent, the early critics of impressionism usually spoke instead of "spontaneity." Spontaneity escapes time altogether (as in "spontaneous generation"). The first term, "instantaneity," is directly associated with stop-action photography, which isolates a detailed view of "contemporary" life—the French word for the snapshot is *instantané*. In view of this term's "external" reference, to consider impressionism as an art of instantaneity is to focus on subject matter and to ignore formal distinctions other than iconic ones (as I believe Nochlin does). The second term, "spontaneity," suggests an actualization of an internal potential and describes the experience of emotion; in the criticism of painting, it highlights the artist as much or more than the object of his vision. Nevertheless, the concept of instantaneity, as it was employed during the later years of impressionism—in the writings of those familiar with symbolism—came to signify the apprehension of both subjective and objective truth; on this matter, cf. Steven Z. Levine, "The 'Instant' of Criticism and Monet's Critical Instant," *Arts* 55 (March 1981):114–21. On the pictorial fabrication of the effect of instantaneity (but not, as I have defined it, spontaneity), cf. also Kirk Varnedoe, "The Artifice of Candor: Impressionism and Photography Reconsidered," *Art in America* 68 (January 1980):72–75.

23. Théophile Thoré (Thoré-Bürger), "Salon de 1844," *Les Salons,* 3 vols. (Brussels, 1893), 1:35.

24. Thus Degas and Morisot were often treated more gently by reviewers of the impressionist exhibitions than were Monet and Pissarro; see, e.g., Roger Ballu, "L'Exposition des peintres impressionnistes," *Chronique des arts et de la curiosité,* 14 April 1877, p. 147.

25. H. R. Rookmaaker, *Gauguin and Nineteenth Century Art Theory* (Amsterdam, 1972), p. 86. (This position is qualified somewhat on p. 110.) Cf. George Heard Hamilton, who also misrepresents the relationship between positivism and impressionism and underestimates the painters' concern for the subjective sense of the "impression"; "The Philosophical Implications of Impressionist Landscape Painting," *Houston Museum of Fine Arts Bulletin* 5 (Spring 1975):2–17.

26. Letter of Monet to Durand-Ruel, 12 January 1884, reprinted in Daniel Wildenstein, *Claude Monet, Biographie et catalogue raisonné,* 3 vols. (Lausanne, 1974–79), 2:232; cf. also the letter of Monet to Bazille, December 1868, Wildenstein, 1:425–26. Letter of Pissarro to his son Lucien, 22 November 1895, in Camille Pissarro, *Lettres à son fils Lucien,* ed. John Rewald

(Paris, 1950), p. 391; cf. also the letter of 21 November 1895, p. 388. In addition, see Louis Le Bail's notes (1896–97) on Pissarro's opinions, quoted in John Rewald, *The History of Impressionism* (New York, 1961), p. 458. Le Bail recorded Pissarro as advising the following: "Don't proceed according to rules and principles, but paint what you observe and feel. Paint generously and unhesitatingly, for it is best not to lose the first impression." Here, the artist's "impression" (or "sensation") would entail both "observation" and "feeling" (emotion).

27. Émile Littré, "De quelques points de physiologie psychique" (1860), *La Science au point de vue philosophique* (Paris, 1876), pp. 312ff.

Chapter 4

1. Hippolyte Taine, *De l'intelligence*, 2 vols. (Paris, 1880; orig. ed., 1870), 1:7; 2:4–5. Cf. Léon Dumont: "Le mouvement matériel et la conscience sont les deux faces de la force [ressentie], la face objective et la face subjective"; Dumont, "Conscience et inconscience," *La Revue scientifique*, 2 per., 26 (28 December 1872):602.

2. José Argüelles, *Charles Henry and the Formation of a Psychophysical Aesthetic* (Chicago, 1972), pp. 15–17.

3. The distinction between subject and object, observer and observed, is still not lost, however, since such an "indeterminacy" principle reestablishes a subject who manipulates the mathematical description of the observer/observed relationship.

4. Charles Lévêque, "L'Esthétique de Schopenhauer," *Journal des savants*, December 1874, pp. 785–87.

5. Jules Laforgue, "L'Impressionnisme" (1883), *Mélanges posthumes, Œuvres complètes*, vol. 3 (Paris, 1919), pp. 140–41.

6. Cf. also the remarks on Schopenhauer by Rémy de Gourmont, symbolist critic and admirer of Laforgue: "Par rapport à l'homme, tout ce qui est extérieur au moi, n'existe que selon l'idée qu'il s'en fait. Nous ne connaissons que des phénomènes, nous ne raisonnons que sur des apparences; toute vérité en soi nous échappe; l'essence est inattaquable. C'est ce que Schopenhauer a vulgarisé sous cette formule si simple et si claire. Le monde est ma représentation. Je ne vois pas ce qui est; ce qui est, c'est ce que je vois. Autant d'hommes pensants, autant de mondes divers et peut-être différents." See Rémy de Gourmont, *Le Livre des masques, portraits symbolistes* (Paris, 1921; orig. ed., 1896–98), pp. 11–12.

7. Maurice Denis, "Préface de la IXᵉ Exposition des peintres impressionnistes et symbolistes" (1895), *Théories, 1890–1910: Du symbolisme et de Gauguin vers un nouvel ordre classique* (Paris, 1920; orig. ed., 1912), p. 29. The painters who are today regarded as the major impressionists did not participate in the exhibition to which Denis refers. Cf. above, chap. 1, pp. 7–10 and n. 29.

8. Maurice Denis, "Cézanne," *L'Occident* 12 (September 1907): 120. When Denis republished this essay in 1920, he revised the quoted passage to read thus: "an agreement between the object and the subject" (*Théories*, p. 247). This is one of several minor changes that serve to integrate the language of the essay on Cézanne with the language of the general theory of classicism that Denis had been developing. Some of the changes are found in the 1912 edition of *Théories*, but not the particular change to which I refer here. On the character of Denis's various revisions of his theoretical statements, see below, part 2, pp. 138–39.

9. Eugène Véron, *L'Esthétique* (Paris, 1878), pp. xiv, xxiii–xxv. For a related statement by Véron, see above, pp. 24–25.

10. Ibid., p. xii. On this issue, cf. Albert Boime, *The Academy and French Painting in the Nineteenth Century* (New York, 1971), pp. 173–84.

11. On this subject I have profited from conversations with Eustathia Costopoulos, who is preparing a doctoral dissertation on the concept of temperament for the University of Chicago. The four basic temperaments traditionally discussed were the "sanguin," "phlegmatique," "cholérique," and "mélancolique"; see Johann Caspar Lavater, *Essai sur la physiognomonie*. 4 vols. (The Hague, 1781), 1:262; 3:85–117. In the nineteenth century the nervous and athletic temperaments were sometimes added to the group; see Stendhal (Henri Beyle), *Histoire de la peinture en Italie*, 2 vols. (Paris, 1929; orig. ed., 1817), 2:55; and Émile Deschanel, *Physiologie des écrivains et des artistes, ou essai de critique naturelle* (Paris, 1864), p. 82.

12. Deschanel, p. 81; cf. also pp. 10–11.

13. Stendhal, 2:31. Cf. Deschanel, p. 242.

14. Alfred Johannot, "Du point de vue dans la critique," *L'Artiste* 1 (1831):109–10. Cf. Charles Baudelaire, "Exposition universelle, 1855: Beaux-arts," *Écrits sur l'art*, ed. Yves Florenne, 2 vols. (Paris, 1971), 1:373–84.

15. Champfleury (Jules Husson), "L'Aventurier Challes," *La Revue de Paris* 21 (15 May 1854):574.

16. From Delacroix's notes; see Achille Piron, *Eugène Delacroix, sa vie et ses œuvres* (Paris, 1865), p. 421.

17. Eugène Delacroix, "Questions sur le beau," *Revue des deux mondes*, 2 ser., 7 (1854):306–15, esp. 313.

18. Émile Zola, "Mon Salon" (1866), *Mon Salon, Manet, Écrits sur l'art*, ed. Antoinette Ehrard (Paris, 1970), p. 60. For Zola's definition of art in terms of nature and temperament, see his "Proudhon et Courbet" (1866) and "M. H. Taine, artiste" (1866), *Mes Haines* (Paris, 1879), pp. 25, 229. See also Zola's letter to Valabrègue (1864), reprinted in *Correspondance 1858–71*, ed. M. Le Blond (Paris, 1927), p. 248. For an example of the discussion of the influence of temperament on art from one of Zola's fictional works, see his description of Laurent as a painter in his *Thérèse Raquin* (Paris, 1910; orig. ed., 1867), pp. 228–29. On seeking the "man" in a work of art, cf. Zola, "M. H. Taine, artiste," *Mes Haines*, p. 225; and Deschanel, p. 196. See also Joseph C. Sloane, *French Painting between the Past and the Present* (Princeton, 1951), p. 75, for a discussion of Zola's distinction between nature and temperament in relation to the problem of defining realist art; and see James Henry Rubin, *Realism and Social Vision in Courbet and Proudhon* (Princeton, 1980), p. 98, for a discussion of Zola's definition of art as a "direct reaction to Proudhon's proposals."

19. Zola, "Édouard Manet" (1867), *Écrits*, p. 99.

20. Zola, "Mon Salon" (1866), *Écrits*, p. 60.

21. Zola, "Édouard Manet," "Mon Salon" (1868), *Écrits*, pp. 100–3, 109, 142.

22. This is the subject of part 2. Zola's reference to the "law of values" is reconsidered in part 2, pp. 77–78.

23. Jules Antoine Castagnary, "Salon de 1863," "Salon des Refusés" (1863), "Salon de 1874," *Salons*, 2 vols. (Paris, 1892), 1:149, 173–74; 2:179. On the possible connection between judgments of technique and sincerity, cf. also "Salon de 1868," 1:292.

24. On the general importance of self-expression and artistic sincerity, cf. Henri Peyre, *Literature and Sincerity* (New Haven, 1963), p. 138: "The ablest critics of the last century, even those who endeavored most determinedly to deprive literary judgment of its changeable subjectivity, like Taine, preserved in their hearts and ultimately resorted to sincerity as the

hallmark of greatness." Zola had recognized in Taine the quality of which Peyre speaks; cf. his "M. H. Taine, artiste," *Mes Haines,* p. 229, and also his "M. Hippolyte Taine" (written under the pseudonym Simplice), *L'Événement,* 19 August 1866, reprinted in Émile Zola, *Œuvres complètes,* ed. Henri Mitterand, 15 vols. (Paris, 1968), 10:200.

25. Zola, "Le Naturalisme au Salon" (1880), *Écrits,* pp. 340, 342ff.

26. Aurier also thus suggests the essence of the distinction between finding (sincerity, originality) and making (technical procedure) which I develop in part 2. The unrevised version of Aurier's statement on Van Gogh is found in his "Vincent van Gogh," *Mercure de France,* n.s., 1 (January 1890):26. For the revised version, see "Les Isolés: Vincent van Gogh," *Œuvres posthumes* (Paris, 1893), p. 260 (emphasis added); and for the remarks on an active sincerity, see "J.-F. Henner" (1889), *Œuvres,* p. 286. Rémy de Gourmont, in his introduction to Aurier's writings, noted the importance of the critic's comments on the question of sincerity; see his "Notice," *Œuvres,* p. xix. On the problem of the possibility of inauthentic sincerity, cf. the excellent study by Lionel Trilling, *Sincerity and Authenticity* (Cambridge, 1971). Cf. also Jean Starobinski, "The Style of Autobiography," in Seymour Chatman, ed. and trans., *Literary Style: A Symposium* (London, 1971), pp. 286–87; and Richard Shiff, "Miscreation," *Studies in Visual Communication* 7 (Spring 1981):65–66.

27. Zola, "Mon Salon" (1868), "Jongkind" (1872), *Écrits,* pp. 160, 192. Like most members of the generation of the impressionists, Zola held Jongkind in great admiration; he paid the artist a personal visit in December, 1871, shortly before composing the second critical account. See Victorine Hefting, *Jongkind, sa vie, son œuvre, son époque* (Paris, 1975), p. 47.

28. Zola, "Le Naturalisme au Salon" (1880), *Écrits,* pp. 335–41.

29. Baudelaire, "L'Œuvre et la vie d' Eugène Delacroix" (1863), *Écrits,* 2:291.

30. Charles Blanc, "Eugène Delacroix" (1864), *Les Artistes de mon temps* (Paris, 1876), pp. 61ff.

31. Antonin Proust, "Édouard Manet," *Revue blanche* 12 (June 1897):427.

32. Stéphane Mallarmé, "The Impressionists and Édouard Manet," *Art Monthly Review* (London), September 1876, reprinted in *Documents Mallarmé,* vol. 1, ed. Carl Paul Barbier (Paris, 1968), pp. 75–77.

33. Gustave Geffroy, "Histoire de l'impressionnisme" (1894), *La Vie artistique,* 8 vols. (Paris, 1892–1903), 3:21.

34. Charles Bigot, "Jules Bastien-Lepage" (1885), *Peintres français contemporains* (Paris, 1888), pp. 160–61, 176.

35. Armand Sully-Prudhomme, *L'Expression dans les beaux-arts* (1883), *Œuvres de Sully-Prudhomme,* vol. 5, *Prose* (Paris, 1898), p. 22; Maurice Denis, *Journal,* 3 vols. (Paris, 1957), 1:197 (entry for 15 April 1903). Cf. also Denis, "De la gaucherie des primitifs" (1904), *Théories,* pp. 174–75; and Charles Baudelaire writing on Guys in "Peintre de la vie moderne" (1863), *Écrits,* 2:154.

36. Denis, "Aristide Maillol" (1905), *Théories,* p. 242.

37. Denis, "Cézanne" (1907), *Théories,* pp. 254–55. Cf. below, part 2, pp. 137–40.

38. Denis, "A propos de l' Exposition d'A. Séguin" (1895), *Théories,* p. 23. Denis here repeats what Aurier had written in 1890–92; see Aurier, "Les Isolés: Vincent van Gogh," *Œuvres,* p. 260.

39. Denis, "A propos de l'Exposition d'A. Séguin," *Théories,* p. 23. Cf. also Denis, "De Gauguin et de Van Gogh au classicisme" (1909), *Théories,* pp. 267–68; and Maurice Denis, "L'Époque du symbolisme," *Gazette des beaux-arts,* 6 per., 11 (March 1934):175–76.

40. Cf. above, chap. 1, pp. 6–7 and n. 21.

41. Aurier, "Le Symbolisme en peinture: Paul Gauguin" (1891), "Les Isolés: Vincent van Gogh" (1890–92), "Les Peintres symbolistes" (1892), *Œuvres*, pp. 208, 211, 215, 260 [on Aurier's revision of this passage, see above, n. 26], 297–98, 302. On symbolism and calculated "rational distortion," cf. Roger Marx, "Le Salon d'Automne," *Gazette des beaux-arts*, 3 per., 32 (December 1904):465. On the importance of the concept of temperament for the symbolists, cf. Bernard's analysis of Van Gogh; Émile Bernard, "Vincent van Gogh," *Mercure de France*, n.s., 7 (April 1893):324–30, esp. 325. Both Aurier ("Les Isolés: Vincent van Gogh," *Œuvres*, p. 261) and Bernard attribute the peculiar qualities of Van Gogh's style to his unusual (if not abnormal) physical constitution and temperament. On Gauguin's "temperament," cf. Charles Morice, "Salons et Salonnets," *Mercure de France*, n.s., 10 (January 1894):67.

42. Maurice Denis wrote in his journal (15 April 1903) that he studied antique art (which he associated with abstraction) in order to discover the "formula by which I may reconcile my natural expression (my awkwardness) with a more general beauty"; Denis, *Journal*, 1:195.

43. Gustave Kahn, "Réponse des symbolistes," *L'Événement*, 28 September 1886, quoted in Sven Loevgren, *The Genesis of Modernism* (Bloomington, 1971), pp. 83–84. Cf. Roger Marx, "Les Salons de 1895," *Gazette des beaux-arts*, 3 per., 13 (May 1895):359. For Aurier's reflections on Kahn's formulation, see his essay (written under the pseudonym Albert d'Escorailles), "Sensationnisme," *Le Décadent littéraire* 1 (13 November 1886):1. Aurier notes the close connection between the new "symbolist" theory and the old "realism" and "naturalism."

44. This term is explained fully below, pp. 39–42.

Chapter 5

1. Jules Antoine Castagnary, "L'Exposition du boulevard des Capucines: Les Impressionnistes," *Le Siècle*, 29 April 1874, reprinted in Hélène Adhémar, "L'Exposition de 1874 chez Nadar (rétrospective documentaire)," *Centenaire de l'impressionnisme* (Paris, 1974), p. 265. Castagnary's sense of the "ideal" is in part in accord with traditional theory and in part in opposition to it. Quatremère de Quincy, for example, had noted that the word "idéal" was merely the adjectival form of "idée," or, as Quatremère wrote, "la notion gravée dans l'esprit"; for Quatremère, idealized artistic creation was the imitation of mental images. See Antoine Chrysostome Quatremère de Quincy, *Essai sur la nature, le but et les moyens de l'imitation dans les beaux-arts* (Paris, 1823), pp. 186, 189. However, unlike Castagnary, Quatremère and others also stressed that the ideal must be the product of a "generalized" or "abstract [abstrait]" vision, not a "particularized" or "individual" one; see Antoine Chrysostome Quatremère de Quincy, *Essai sur l'idéal dans ses applications pratiques aux œuvres de l'imitation propre des arts du dessin* (Paris, 1837), pp. 31, 42–43. In essential agreement with both Quatremère and Castagnary, Delacroix linked "idéal" to "idée"; according to Théophile Silvestre, he remarked: "N'est-il pas vrai de dire que ce que l'on appelle l'idéal est tout ce qui va à notre idée, imité fidèlement ou purement inventé?" See Théophile Silvestre, *Histoire des artistes vivants* (Paris, 1856), p. 73.

2. Jules Antoine Castagnary, "Salon de 1863," *Salons*, 2 vols. (Paris, 1892), 1:102.

3. Zola admired the fact that Taine had no absolute standard of beauty, whereas Aurier

ridiculed his aesthetic theory for just this reason. Zola appreciated the lack of dogma; Aurier wrote with acidic sarcasm that "on sait que M. Taine aime mieux être absurde que de dogmatiser." See Émile Zola, "M. H. Taine, artiste" (1866), *Mes Haines* (Paris, 1879), pp. 214–15, 228–29; Albert Aurier, "Essai sur une nouvelle méthode de critique" (1892), *Œuvres posthumes* (Paris, 1893), p. 190. Zola's use of the term "naturalism" may be derived from Taine (as opposed to Castagnary or other contemporaries); see F. W. J. Hemmings, "The Origin of the Terms *Naturalisme, Naturaliste,*" *French Studies* (Oxford) 8 (April 1954):111.

4. Hippolyte Taine, "De l'idéal dans l'art" (1867), *Philosophie de l'art*, 2 vols. (Paris, 1893; orig. ed., 1865–69), 2:258. Aurier quotes this passage and discusses its (unsatisfactory) implications; he concludes that a work of art constitutes a marriage of man's ideal and nature's ideal; "Essai sur une nouvelle méthode de critique," *Œuvres*, pp. 190–95, 201.

5. On the multiplicity of real "worlds" (i.e., "right versions" of the "world"), cf. Nelson Goodman, *Ways of Worldmaking* (Indianapolis, 1978), pp. 2–5. The complex of ambiguities in the use of the term "idéal" was widely discussed at the end of the nineteenth century; see, e.g., Charles Recolin, "Définition de l'idéal," *L'Art et la vie* 4 (January 1895):11. On the relationship between the real and the ideal, cf. also Richard Shiff, "Representation, Copying, and the Technique of Originality," *New Literary History* 15 (Winter 1984):333–63.

6. Concerning the potentially confusing use of the term "subject" to refer to the artist's model in nature, Nelson Goodman notes simply that a "quirk of language makes a represented object a subject"; see Nelson Goodman, *Languages of Art* (Indianapolis, 1976), p. 5.

7. Charles Baudelaire, "Salon de 1846," *Écrits sur l'art*, ed. Yves Florenne, 2 vols. (Paris, 1971), 1:199. Cf. Delacroix's journal entry, 31 August 1855: "Rubens est emporté par son génie et se livre à des exagérations qui sont le sens de son idée et fondées toujours sur la nature"; Eugène Delacroix, *Journal*, ed. André Joubin, 3 vols. (Paris, 1950), 2:371. When Baudelaire made his statement associating the ideal with individuality, he was confronting the traditional view expressed (for example) by Quatremère de Quincy, who argued that the result of such a personalized art would depend "ou du hasard d'un modèle, ou de la chance d'une inspiration plus ou moins heureuse"; *Essai sur l'idéal*, p. 44.

8. Cf. Hippolyte Taine, preface to second edition (1866), *Essais de critique et d'histoire* (Paris, 1892), pp. vii–xxxii. Cf. also the discussion of Taine's concept of the "master faculty" in Sholom J. Kahn, *Science and Aesthetic Judgment* (Westport, Conn., 1970), pp. 119–21. Aurier took as a point of departure Taine's remark that artists "ne sont pas des hommes isolés" and referred (with some irony) to his own favored painters as "Les Isolés" (Van Gogh, Henry de Groux, Eugène Carrière, J.-F. Henner). The force of the great artist's universal expression would develop in *opposition* to the social environment, and artistic distinction would arise not out of a fortunate harmony existing between an individual temperament and its surroundings, but rather from heroic resistance: "L'œuvre d'art est, en valeur, inversement proportionnelle à l'influence des milieux qu'elle a subie." See Aurier, "Essai sur une nouvelle méthode de critique," *Œuvres*, pp. 179–80, 187–88.

9. Armand Sully-Prudhomme, *L'Expression dans les beaux-arts* (1883), *Œuvres de Sully-Prudhomme*, vol. 5, *Prose* (Paris, 1898), pp. 29, 31, 410–11.

10. Rémy de Gourmont, "Le Symbolisme," *La Revue blanche*, n.s., 2 (25 June 1892):323–25.

11. Maurice Denis, "A propos de l'Exposition d'A. Séguin" (1895), *Théories, 1890–1910: Du symbolisme et de Gauguin vers un nouvel ordre classique* (Paris, 1920; orig. ed., 1912), p. 23. Cf. Denis, "De la gaucherie des primitifs" (1904), "Le Soleil" (1906), *Théories*, pp. 176–77, 223.

12. Denis, "A propos de l'Exposition d'A. Séguin," *Théories*, pp. 20–21; letter of Gauguin to Denis, ca. early March 1895, Maurice Malingue, ed., *Lettres de Gauguin à sa femme et à ses amis* (Paris, 1946), p. 267.

13. Paul Gauguin, "Armand Séguin," catalog preface reprinted in *Mercure de France*, n.s., 13 (February 1895):222–23.

14. Denis, "Notes sur la peinture religieuse," *Théories*, pp. 33–34. On the interrelationship of a particularized ideal, universal symbolization, and the psychophysical laws of line and color, cf. the earlier remarks of Auguste Laugel, *L'Optique et les arts* (Paris, 1869), pp. 142–44. On Denis's definition of symbolism, see also "A propos de l'Exposition d'A. Séguin," *Théories*, p. 23: "Symbolisme . . . affirme l'expression possible des émotions et des pensées humaines par des correspondances esthétiques, par des équivalents en Beauté."

15. On this point, cf. Sully-Prudhomme, p. 31; and, in the twentieth century, R. G. Collingwood, *The Principles of Art* (Oxford, 1938), p. 162.

16. Aurier recognized this double meaning and accordingly coined the word *sensationnisme* as a term of mediation between an art of the material and an art of the spiritual. See his essay (written under the pseudonym Albert d'Escorailles), "Sensationnisme," *Le Décadent littéraire* 1 (13 November 1886):1. On "sensation," cf. below, chap. 14, esp. note 6.

17. The choice between the three terms is problematic. Cf. part 2.

18. The impression is conceived as "external" in relation to its attendant emotion. It is also readily conceived as external if specifically distinguished from a felt or "perceived" impression. Cf. the discussion above, chap. 2.

19. See, for example, Paul Sérusier's comments in Charles Morice, "Enquête sur les tendances actuelles des arts plastiques," *Mercure de France*, n.s., 56 (15 August 1905):543–44. See also remarks by Raymond Bouyer, who contrasted the "impressionniste" (e.g., Monet) to the "réaliste" in terms of an opposition of an idealized, internal feeling to a purely external vision; "Le Paysage dans l'art," *L'Artiste*, n.s., 6 (July 1893):31.

20. Charles Morice, *La Littérature de tout à l'heure* (Paris, 1889), pp. 165–67.

21. Jean Moréas, "Un Manifeste littéraire: Le Symbolisme," *Le Figaro*, 18 September 1886.

22. Gauguin, "Armand Séguin," p. 223.

23. Gustave Kahn, "Réponse des symbolistes," *L'Événement*, 28 September 1886, quoted in Sven Loevgren, *The Genesis of Modernism* (Bloomington, 1971), pp. 83–84. Cf. René Ghil, "Notre École," *La Décadence artistique et littéraire* 1 (1 October 1886):1–2.

24. Aurier, "Le Symbolisme en peinture: Paul Gauguin" (1891), *Œuvres*, pp. 208–9. Cf. Émile Bernard who defined the "symbolism" of Puvis de Chavannes in terms of an "interior" creation; see his "Puvis de Chavannes," *L'Occident* 4 (December 1903):278. Cf. also Fénéon's distinction of Seurat's work from that of "mechanical copiers of the external"; Félix Fénéon, "Le Néo-Impressionnisme," *L'Art moderne* (Brussels), 7 (1 May 1887):139.

25. From an interview with Albert Aurier (1891), as quoted in Jules Huret, *Enquête sur l'évolution littéraire* (Paris, 1891), p. 132. Among the "physiologists," Aurier would include Émile Hennequin along with Taine and Sully-Prudhomme. Aurier was familiar with Hennequin's work, including his major study *La Critique scientifique* (Paris, 1888).

26. Hippolyte Taine, *De l'intelligence*, 2 vols. (Paris, 1880; orig. ed., 1870), 2:7–13. Cf. the reference to the possibility of the existence of an internal sensation with no external impression in the entry for "impression" in Pierre Larousse, *Grand Dictionnaire universel du XIX*ᵉ *siècle*, vol. 9 (Paris, 1873), p. 604.

27. Kahn's associate Paul Adam also held that "le rêve est indistinct de la vie"; see Paul

Adam, "La Presse et le symbolisme," *Le Symboliste*, no. 1 (7 October 1886), p. 2. Adam went on to oppose the dream to hallucination, as if recognizing Taine's use of the term and implying that the normal waking state is hallucinatory.

28. See Huysmans's discussions of Holland and England and his analysis of the Parisian bar girl in *A rebours* (Paris: Fasquelle, 1968; orig. ed., 1884), pp. 176–79, 217–19. Cf. Taine, *Philosophie de l'art*, 1:38–41.

29. For Aurier's criticism of Taine, see his "Essai sur une nouvelle méthode de critique," *Œuvres*, pp. 176–95.

30. Aurier, "Le Symbolisme en peinture: Paul Gauguin," *Œuvres*, pp. 205, 208–11. Gauguin himself refers to Swedenborg in his commentary on the work of Séguin; "Armand Séguin," p. 222. On the iconography of Gauguin's *Lutte de Jacob*, see Mathew Herban III, "The Origin of Paul Gauguin's 'Vision after the Sermon: Jacob Wrestling with the Angel,'" *Art Bulletin* 59 (September 1977):415–19.

31. Charles Henry, *Cercle chromatique* (Paris, 1888), quoted in José Argüelles, *Charles Henry and the Formation of a Psychophysical Aesthetic* (Chicago, 1972), pp. 162–63. Cf. Alphonse Germain, "Théorie chromo-luminariste," *La Plume* 3 (1 September 1891):285–87.

32. See Huysmans, *A rebours*, chap. 5; and Maurice Denis, "L'Époque du symbolisme," *Gazette des beaux-arts*, 6 per., 11 (March 1934):174. Denis writes that "Moreau était, à certains égards, à l'antipode de nos idées." On the symbolist distinction between symbol (as form) and allegory (as subject), cf. Denis, "Définition du néo-traditionnisme" (1890), *Théories*, pp. 9–10: "Un Christ byzantin est symbol: le Jésus des peintres modernes . . . n'est que littéraire [i.e., representational in terms either of naturalism or allegory]. Dans l'un c'est la forme qui est expressive, dans l'autre c'est la nature imitée qui veut l'être." Cf. also Denis, "Le Salon du Champ-de-Mars; L'Exposition de Renoir" (1892), *Théories*, p. 17: some critics confuse "les tendances mystiques et *allégoriques*, c'est-à-dire la recherche de l'expression par le sujet, et les tendances *symbolistes*, c'est-à-dire la recherche de l'expression par l'œuvre d'art." And see Aurier, "Les Peintres symbolistes" (1892), *Œuvres*, p. 296; here, Moreau is included among those who were "symboliste" in the sense of departing from immediate appearances, but who yet did so without the self-reflective theorizing characteristic of true symbolist art. Gustave Kahn, primarily a critic of literature rather than the visual arts, is more willing to admit Moreau as a symbolist; see his "L'Art à l'Exposition: La Centennale," *La Plume* 12 (15 July 1900):447. Roger Marx takes a middle course in remarking that Moreau is the "lien entre l'école romantique et le symbolisme nouveau"; Roger Marx, "Les Salons de 1895," *Gazette des beaux-arts*, 3 per., 14 (July 1895):17. On Moreau, cf. also Gustave Larroumet, "Le Symbolisme de Gustave Moreau," *La Revue de Paris* 5 (15 September 1895):408–39, esp. 436.

33. Angus Fletcher is one who considers the allegory/symbol conflict unfortunate; he traces the modern distinction to Goethe and Coleridge in his *Allegory: The Theory of a Symbolic Mode* (Ithaca, 1964), pp. 13–19. For an account that is more relevant to the French symbolists' conception of the conflict, see Hans-Georg Gadamer, *Truth and Method* (New York, 1982), pp. 65–73. See also A. G. Lehmann, *The Symbolist Aesthetic in France 1885–1895* (Oxford, 1950), pp. 248–318; and Henri Peyre, *What Is Symbolism?*, trans. Emmett Parker (University, Ala., 1980; orig. Fr. ed., 1974), esp. pp. 18, 92. Robert Goldwater gives a brief account of the symbol/allegory issue; *Symbolism* (New York, 1979), pp. 5–8.

34. See, e.g., Roger Fry, "An Essay in Aesthetics" (1909), *Vision and Design* (New York, 1956; orig. ed., 1920), pp. 16–38.

35. Maurice Denis made this point; see his "A propos de l'Exposition d'A. Séguin," *Théories*, p. 23.

36. Sérusier in Morice, "Enquête," p. 544.

37. Letter from Gauguin to August Strindberg, 5 February 1895, published in *L'Ermitage* 15 (January 1904), pp. 79–80. Gauguin's concern for the exotic, mysterious, or primitive sometimes seems to suggest that his art was intended to be esoteric and open only to his close associates; but his search for universal primordial truths led in principle to an art that was open to all those initiated into the realm of such truth, and any viewer had the potential to leave his materialistic culture and enter this world. Paul Adam ("La Presse et le symbolisme," p. 2) expressed this defense of the difficulty of symbolist prose and also (like Gauguin) referred to the study of primordial language: "Nous demandons aux écrivains qui adopteront nos théories une science complète de la langue et des langues mères, la recherche du mot exact qui, sous sa forme unique, réunira la matière de trois ou quatre phrases actuelles."

38. Aurier, "Les Peintres symbolistes," *Œuvres*, p. 298.

39. V. W. van Gogh, ed., *The Complete Letters of Vincent van Gogh*, trans. J. van Gogh-Bonger and C. de Dood, 3 vols. (Greenwich, Conn., 1959), 3:6–7. Van Gogh's choice of the verb "sentir" (feel) rather than "voir" (see) is significant here. For Van Gogh's letter in the original French, see Georges Philippart, ed., *Lettres de Vincent van Gogh à son frère Théo* (Paris, 1937), pp. 216–17.

40. Octave Mirbeau, "Vincent van Gogh," *L'Écho de Paris*, 31 March 1891, p. 1. Cf. Aurier, "J.-F. Henner" (1889), *Œuvres*, p. 286.

41. Octave Mirbeau, "Claude Monet," *L'Art dans les deux mondes* (March 1891), quoted in Steven Z. Levine, *Monet and His Critics* (New York, 1976), p. 118. Cf. Geffroy's similar commentary; Gustave Geffroy, "Les Meules de Claude Monet" (1891), *La Vie artistique*, 8 vols. (Paris, 1892–1903), 3:22–29. During the same period, Mirbeau discussed Pissarro, too, in terms of a transformation of nature into "great decorative poetry"; see Octave Mirbeau, "Camille Pissarro" (1892), *Des artistes*, 2 vols. (Paris, 1922–24), 1:152–53. Camille Mauclair called both Mirbeau and Geffroy advocates of "une vague philosophie panthéiste"; see his "Lettre sur la peinture à Monsieur Raymond Bouyer, critique d'art à l'*Ermitage*," *Mercure de France*, n.s., 11 (July 1894):271.

42. Georges Rivière, *L'Impressionniste, Journal d'art*, 6 April 1877, reprinted in Lionello Venturi, *Les Archives de l'impressionnisme*, 2 vols. (Paris, 1939), 2:312.

43. Aurier, "Les Isolés: Vincent van Gogh" (1890–92), *Œuvres*, p. 260.

44. Cf. Quatremère de Quincy, *Essai sur . . . l'imitation*, pp. 11–13: "Imiter dans les beaux-arts, c'est produire la resemblance d'une chose, mais dans une autre chose qui en devient l'image . . . [whereas mechanical reproduction] n'est pas l'image de son modèle, il n'en est que la répétition." Quatremère (p. 17) stresses the fact that the "image" is always "fictive" and differs from its source in nature; the greatest error is "à confondre la *ressemblance par image* . . . avec la *similitude par identité*. . . ." On the distinction between imitating and copying, see below, part 2, pp. 92–95.

45. Gustave Kahn, "Difficulté de vivre," *Le Symboliste*, no. 2 (15 October 1886), p. 1.

46. For an alternative presentation of this issue, see E. H. Gombrich, *Art and Illusion* (Princeton, 1969), p. 324.

47. To borrow some terms from hermeneutics, one may say that the creative self appropriates "language" or "textuality" that is already "in play." In other words, the self is both found and made in the play of artistic discourse (creation) in which the artist-player engages.

The artist does not create the rules of the game, but may distinguish himself in that he "plays" better than others; hence, it becomes appropriate to consider artistic expression as an accomplishment, a made (poetic) thing. On "discourse," "textuality," "appropriation," and "play," see Paul Ricoeur, "The Hermeneutical Function of Distanciation," "Appropriation," *Hermeneutics and the Human Sciences,* ed. and trans. John B. Thompson (Cambridge, 1981), pp. 131–44, 182–93. Ricoeur's analysis draws upon Hans-Georg Gadamer's concept of play, detailed in *Truth and Method,* esp. pp. 91–99.

Chapter 6

1. Charles Morice, "Enquête sur les tendances actuelles des arts plastiques," *Mercure de France,* n.s., 56 (1 August 1905):349.

2. Remark made to Pierre Matisse, 9 September 1950, quoted in Alfred H. Barr, Jr., *Matisse, His Art and His Public* (New York, 1951), p. 38. Matisse's conversation with Pissarro occurred in Paris, about 1897. The exchange, as recalled by Matisse, is reported also in Georges Duthuit, *Les Fauves* (Geneva, 1949), pp. 169–70. Pissarro had stated that Cézanne "a peint toute sa vie le même tableau," whether of bathers or of Mont Sainte-Victoire. He added that Cézanne always painted the effect of a uniform gray light ("il a fait du temps gris") rather than of sunlight and shadow. Duthuit reports Matisse's gloss on this reference to Cézanne's use of a natural effect: "c'est-à-dire, ajoute Matisse qui se rappelle ce dialogue à cinquante ans de distance, que les sensations de Cézanne sont celles du temps gris." Thus, Matisse stresses that the effect belongs to the artist and not to nature.

3. Although he tends to be known today as a figure of the 1890s, during his elder years Denis received many commissions and did not lack official honors; he was elected to the Académie des Beaux-Arts in 1932.

4. On the connection between symbolism and Matisse's "fauvism," cf. Ellen C. Oppler, *Fauvism Reexamined* (New York, 1976), pp. 256–59. Oppler's study is thorough and intelligent; she may err, however, in assuming that to make a close association between symbolism and classicism is to present a "paradox" (Oppler, p. 239). Scholars have often given too much credence to claims by French literary figures that they rejected their immediate predecessors. One must recognize that each generation (and even much smaller groupings) felt it necessary, often for political as well as professional reasons, to define its own distinct position, even when its own views were largely in harmony with the views of those to whom it responded; "classicists" were not necessarily opposed to "symbolists," or to "primitives," or to "fauves." (On the meaning of classicism for those of the symbolist era, cf. below, pp. 125–40.) In general, art historians have exaggerated the differences between critics and even between the earlier and later statements of a single critic. For example, Theodore Reff, in a comprehensive study of "Cézanne and Poussin" (*Journal of the Warburg and Courtauld Institutes* 23 [1960]:150–74), argues that, during the years around 1900, there occurred a "shift from symbolism to neoclassicism" (p. 164). According to Reff, this is indicated even by Maurice Denis's title for his collected criticism, *Théories, 1890–1910: Du symbolisme et de Gauguin vers un nouvel ordre classique.* But there is little of substance in Denis's "neoclassicism" that is not to be found in his "symbolism," and "classical" masters of the past had always been admired by symbolist painters. In a short essay which he claimed to have written around 1889, Émile Bernard, very much a symbolist, praised Cézanne by remarking that one of his paintings appeared "comme une des plus grandes tentatives de l'art moderne vers le beau classique" (Émile Bernard, "Paul

Cézanne," *Les Hommes d'aujourd'hui* 8, no. 387 [February–March 1891], n.p.). The desire to redefine one's critical position frequently and to distinguish oneself from others if only rhetorically—indeed, this phenomenon is especially apparent among the symbolists—seems to affirm the importance of Harold Bloom's notion of the "anxiety of influence" (*The Anxiety of Influence* [New York, 1973]) and a related "anxiety of anticipation." The latter notion is Sima Godfrey's; see her "The Anxiety of Anticipation: Ulterior Motives in French Poetry," *Yale French Studies*, no. 66 (1984), pp. 1–26. Modern critics and artists wish neither to follow another nor to be subject to the translative power of another's critical evaluation.

5. For Matisse's comments on Sisley, see Henri Matisse, *Écrits et propos sur l'art*, ed. Dominique Fourcade (Paris, 1972), pp. 44–45.

6. "Ma seule force, ç'a été ma sincérité." Statement made to Père Couturier, 1951; cited in *Écrits et propos*, p. 56.

7. Maurice Denis, "De Gauguin, de Whistler et de l'excès des théories" (1905), "Cézanne" (1907), *Théories, 1890–1910: Du symbolisme et de Gauguin vers un nouvel ordre classique* (Paris, 1920; orig. ed., 1912), pp. 204, 261, 255. On the standardization of seemingly innovative technical devices and the great number of painters who were imitating Cézanne's "originality," cf. Georges Lecomte, "La Crise de la peinture française," *L'Art et les artistes*, October 1910, pp. 25–26, 28.

8. Ironically, with regard to dates of birth (but not development of careers), Matisse and Denis belong to the same generation; Denis, " De Gauguin et de Van Gogh au classicisme" (1909), *Théories*, pp. 271–72. For Matisse's concern with instinct, cf., e.g., the painter's remarks to Apollinaire, "Matisse interrogé par Apollinaire" (1907), *Écrits et propos*, pp. 54–58. On Denis's shifting attitude toward Matisse, cf. below, chap. 9, note 85.

9. The younger Marcel Duchamp, however, carried the notion of artistic "finding" to extreme and often ironic ends around 1914; he appears as a pioneer in questioning and reassessing originality, authorship, aesthetic distinction, and like concepts. Cf. below, part 4, p. 226.

10. Notes by Matisse in the margins of a text of 1942 by Louis Aragon; cited in *Écrits et propos*, p. 161.

11. George Desvallières, "Présentation de *Notes d'un peintre*," *Écrits et propos*, pp. 39–40. Desvallières was a painter who, like Matisse, had been a pupil of Gustave Moreau. He had answered Morice's questionnaire of 1905 as one would imagine Matisse might have done, given his views on Sisley and Cézanne: "La nature n'a jamais été qu'un moyen de réaliser une pensée; j'entends par pensée un mouvement de l'âme." See Morice, p. 352.

12. On this issue, cf. Richard Shiff, "Miscreation," *Studies in Visual Communication* 7 (Spring 1981):57–71.

13. Roger Fry, "Retrospect" (1920), *Vision and Design* (New York, 1956), p. 302. On the importance of "intuition" and the direct apprehension of "truth" for Fry and other British intellectuals, cf. John Paul Russo, "A Study of Influence: The Moore-Richards Paradigm," *Critical Inquiry* 5 (Summer 1979):683–712. For a discussion of the broader theoretical background of the view that Fry articulated—including the distinction between "expression" and "manipulation," and the "application of the doctrine of the unconscious creation of genius"—see Hans-Georg Gadamer, *Truth and Method* (New York, 1982), esp. pp. 63–64, 458–59.

14. See Giovanni Morelli, *Italian Painters*, trans. Constance Jocelyn Ffoulkes, 2 vols. (London, 1892–93; orig. German ed., 1889),1:1–63. On Morelli's methods, see Richard

Wollheim, "Giovanni Morelli and the Origins of Scientific Connoisseurship," *On Art and the Mind* (Cambridge, Mass., 1974), pp. 177–201; and Henri Zerner, "Giovanni Morelli et la science de l'art," *Revue de l'art* 40–41 (1978):209–15.

15. Morelli, 1:69; and Charles Blanc, "Une Peinture de Léonard de Vinci," *Gazette des beaux-arts*, 1 per., 9 (January 1861):67.

16. Denis's concept of a "classic" originality approaches such anonymity; cf. below, chaps. 9, 12, and 13.

17. Cf. Richard Shiff, "The Art of Excellence and the Art of the Unattainable," *Georgia Review* 32 (Winter 1978):829–41.

18. Henri Matisse, "Notes d'un peintre" (1908), *Écrits et propos*, p. 51.

19. Ibid., p. 46. "Copying" may be either an act of finding or of making; see below, pp. 87–98.

20. Remark to J. and H. Dauberville in 1942; cited in *Écrits et propos*, p. 47.

21. Matisse uses various forms of the verb "trouver."

22. "Notes d'un peintre," *Écrits et propos*, p. 52.

23. The most frequently cited English translation of "Notes d'un peintre," by Margaret Scolari in Barr, pp. 119–23, fails to convey some of the nuances of Matisse's argument and, in general, presents his position as more extreme than it is. The significance of the distinction between reasoning and acting is lost. One sentence in particular should be retranslated: "Un artiste doit se rendre compte, quand il raisonne, que son tableau est factice, mais quand il peint, il doit avoir ce sentiment qu'il a copié la nature." Scolari (in Barr, p. 122) gives this sentence as: "An artist must recognize that when he uses his reason, his picture is an artifice and that when he paints, he must feel that he is copying nature." This should instead be given as: "An artist must realize, when he reflects [upon it], that his picture is artificial, but when he paints, he must have the feeling that he has copied nature [faithfully]." Matisse goes on to say that "even when [the artist] has deviated from nature, he must retain the conviction that this has been done to render it all the more completely." The Scolari translation implies that any self-conscious reflection on one's own painting will have a negative effect, but Matisse is not so explicit on this point. He argues that when a painting is studied rationally, its relation to "nature" may seem much less clear than it would to the artist himself in the immediate emotional experience of artistic creation. (The more recent translation by Flam is essentially correct; see Jack D. Flam, *Matisse on Art* [London, 1973], p. 39.) For one of many relevant passages from Henri Bergson, see his *Essai sur les données immédiates de la conscience* (Paris, 1906; orig. ed., 1889), pp. 134–40. The distinction between acting and passing judgment on one's actions becomes a cornerstone of the theory and criticism of many later modernist arts, including surrealism and abstract expressionism. For example, Allan Kaprow finds it especially significant that Jackson Pollock, "interrupting his work, would judge his 'acts' very shrewdly and with care for long periods of time before going into another 'act.'" See Allan Kaprow, "The Legacy of Jackson Pollock," *Art News* 57 (October 1958):26.

24. "Notes d'un peintre," *Écrits et propos*, pp. 51–52. Matisse's source for the Cézanne "quotation" is probably Charles Camoin's reply to Morice's survey; see Morice, p. 353.

25. Ibid., p. 51.

26. Cf. Matisse's statement of 1929: "Mon but est de rendre mon émotion. . . . L'unité réalisée dans mon tableau . . . me vient naturellement. Je ne pense qu'à rendre mon émotion. Très souvent, ce qui fait la difficulté, pour un artiste, c'est qu'il ne se rend pas compte de la qualité de son émotion et que sa raison égare cette émotion" *Écrits et propos*, p. 100.

27. Cf. Matisse's statement of 1929: "[L'artiste] ne devrait se servir de sa raison que pour

le contrôle." *Écrits et propos*, p. 100. Here, "contrôle" refers to a subsequent act of inspection or verification, a rational judgment of the act already performed.

28. "Notes d'un peintre," *Écrits et propos*, pp. 41–42.

29. Ibid., p. 42.

30. See P. H. Valenciennes, *Élémens de perspective pratique à l'usage des artistes suivis de réflexions et conseils à un élève sur la peinture, et particulièrement sur le genre du paysage* (Paris, 1800), p. 419. On the relationship of imitation and idealization, cf. also Claude Henri Watelet and Pierre Charles Levesque, *Dictionnaire des arts de peinture, sculpture et gravure*, 5 vols. (Paris, 1792), 3:130–32.

31. With regard to the details of a painting, the unsigned encyclopedia entry for "Composition, en peinture" (1753), states: "Choisissez avec jugement celle qui vous convient, et rendez la avec scrupule"; Diderot and d'Alembert, *Encyclopédie ou dictionnaire raisonné des sciences, des arts et des métiers, par un société de gens de lettres*, 17 vols. (Paris, 1751–72), 3:285. Cf. also the Abbé Batteux, *Les Beaux-Arts réduits à un même principe* (Paris, 1746), p. 26: "Si les Arts sont imitateurs de la Nature, ce doit être une imitation sage et éclairée, qui ne la copie pas servilement, mais qui, en choisissant les objets et les traits, les présente avec toute la perfection dont ils sont susceptibles."

32. Cf. the account of the use of the concepts of invention and originality from the sixteenth through the nineteenth century given in Grahame Castor, *Pléiade Poetics* (Cambridge, 1964), pp. 86–94. The definition of *invention* offered by Watelet and Levesque clearly distinguishes its senses of finding and making; within the arts, invention is associated with the acts of choice (making) that bring an original work of art into being: "Ce mot [invention], dans la langue des arts, ne signifie pas une *découverte*, comme dans la langue ordinaire; mais il exprime le *choix* que fait l'artiste des objets qui conviennent au sujet qu'il se propose de traiter" (Watelet and Levesque, *Dictionnaire*, 3:183).

33. "Notes d'un peintre," *Écrits et propos*, pp. 42, 46–47, and passim.

34. Letter from Monet to Bazille, December 1868, reprinted in Daniel Wildenstein, *Claude Monet, Biographie et catalogue raisonné*, 3 vols. (Lausanne, 1974–79), 1:425.

35. Letter from Gauguin to Vollard, January 1900, in John Rewald, *Paul Gauguin, Letters to Ambroise Vollard and André Fontainas* (San Francisco, 1943), p. 33 (Rewald's translation).

36. Ian Watt (among others) calls attention to the characteristically modern association of originality with the individuality of artistic style—"underived, independent, first-hand"—and opposes this to an earlier sense of originality—"having existed from the first"; Ian Watt, *The Rise of the Novel* (Berkeley, 1957), p. 14. On "immediate experience," see above, chaps. 2, 3.

37. See, e.g., Matisse's comments on past masters and styles in his interview with Apollinaire (1907), reprinted in *Écrits et propos*, pp. 54–58. Cf. also Cézanne's comments on the "old masters," discussed below, part 3, pp. 180–83.

38. For the challenge, see, e.g., Roland Barthes, "From Work to Text" (1971), *Image—Music—Text*, ed. and trans. Stephen Heath (New York, 1977), pp. 155–64.

39. It was common, in contrast, for "academics" of the earlier nineteenth century to argue that once a true vision of nature had been created by an artistic genius, this (ideal) representation should be imitated by others as a means of attaining once again the truth of nature. See, e.g., É. J. Delécluze, "Salon de 1827," *Journal des débats*, 2 January 1828, p. 2. Cf. also Ingres's views of ca. 1813–27, as reported in Henri Delaborde, *Ingres, sa vie, ses travaux, sa doctrine* (Paris, 1870), p. 139; and Boyer d'Agen, ed., *Ingres d'après une correspondance inédite* (Paris, 1909), pp. 91–92.

40. Eugène Delacroix, "Raphaël" (1830), *Œuvres littéraires*, ed. Élie Faure, 2 vols. (Paris,

1923), 2:12; Ingres, as in Delaborde, p. 140; H. W. Janson, *History of Art* (Englewood Cliffs, 1977), pp. 15–16.

41. Janson, p. 15. For a similar view on imitation and the copy, see Clive Bell, *Art* (New York, 1958; orig. ed., 1913), pp. 49–50. The familiar argument that Janson presents has not been restricted to those opposed to traditional academic doctrine; Paillot de Montabert, in a text completed in 1843, had made much the same case in defense of the Greeks who had produced imitations, but had done so freely: "de telles copies devenaient ainsi des originaux." Paillot also asserted that (the copyist's) craft must not dominate original artistic creation: "Homme de métier, dans aucune production des beaux-arts, tu ne dois chercher à dominer l'artiste." Paillot's sense of "originality," unlike Janson's, is bound primarily to the notion of divine origin, not the human origin of self-expression. See Jacques-Nicolas Paillot de Montabert, *L'Artistaire, livre des principales initiations aux beaux-arts* (Paris, 1855), pp. 181, 246. Traditional academic theorists, such as Paillot de Montabert or Quatremère de Quincy, would, however, recognize the validity of a submissive copying of another master (under certain circumstances) much more readily than would "modernists" such as Delacroix, Bell, or Janson. Quatremère de Quincy, for example, stated that when Raphael repeated a figural grouping he had found in Masaccio, he had acted properly: "Quand une belle pensée s'est une fois trouvée frappé au coin du génie, il y a aussi de génie à ne pas vouloir lui donner une nouvelle empreinte, et il y a plus de mérite à se proclamer ainsi débiteur, qu'à dissimuler la dette sous de trompeuses variantes." See Antoine Chrysostome Quatremère de Quincy, *Histoire de la vie et des ouvrages de Raphaël* (Paris, 1835; orig. ed. 1824), pp. 241–42.

42. There is a tendency now to label as "postmodernist" those artists who acknowledge past conventions only to comment ironically upon them. In this study I am, in effect, interpreting artists of the modernist tradition as if they were actually postmodernist in their artistic practice (although perhaps not in their theory). Such an interpretation calls the distinction between modernism and postmodernism into question. On this general issue, cf. Stanley Cavell, "Music Discomposed," *Must We Mean What We Say?* (Cambridge, 1969), pp. 180–212; and Paul De Man, "Literary History and Literary Modernity," *Blindness and Insight* (New York, 1971), pp. 142–65. Self-consciousness and self-criticism assume a central importance in the later "modernism" of Clement Greenberg, who stresses adherence to basic artistic norms and standards of excellence along with a history of individual achievements; see Clement Greenberg, "Modernist Painting" (1965), in Gregory Battcock, ed., *The New Art* (New York, 1966), pp. 100–110. Cf. my remarks below, part 3, pp. 218–19. On modernism and postmodernism, see also Richard Shiff, "Mastercopy," *Iris* 1 (September 1983):113–27.

43. See, e.g., Greenberg, "Modernist Painting." Cf. also Harold Rosenberg, "Art and Words," *The De-definition of Art* (New York, 1972), pp. 60–61, for further discussion on this issue.

44. On this shift in orientation, cf. Clement Greenberg, "Abstract, Representational, and So Forth" (1954), *Art and Culture* (Boston, 1961), pp. 136–38.

45. Greenberg, "Cézanne" (1951), *Art and Culture*, pp. 57–58. On Greenberg's "modernism," see also below, chap. 13, note 51; chap. 15, pp. 218–19.

46. Théodore Duret, "Salon de 1870," "Les Peintres impressionnistes" (1878), *Critique d'avant-garde* (Paris, 1885), pp. 39, 70. On the reaction of the "public" to innovative art, cf. Émile Zola, "Édouard Manet" (1867), *Mon Salon, Manet, Écrits sur l'art*, ed. Antoinette Ehrard (Paris, 1970), pp. 112–17.

47. See Duret's letter to Pissarro, 15 February 1874, as quoted in Ludovic Rodo Pissarro and Lionello Venturi, *Camille Pissarro, son art, son œuvre*, 2 vols. (Paris, 1939), 1:34.

48. Théodore Duret, "Édouard Manet" (1884), *Critique d'avant-garde*, p. 121.

49. See below, pp. 87–88.

50. Cf. above, chap. 4, pp. 29–35. Duret's task is to establish a public (or objective) technical standard by which to judge the validity of private unconventional acts. Northrop Frye, in a review (1953) of Susanne K. Langer's *Feeling and Form*, makes a relevant statement: "The difference between neurosis and art is the difference between a private and a public world"; *Northrop Frye on Culture and Literature*, ed. Robert D. Denham (Chicago, 1978), p. 116. Émile Deschanel, publishing around the same time as Duret, distinguished the originality of artistic genius from the originality of madness by noting that the one is consciously controlled while the other is uncontrolled; see his *Physiologie des écrivains et des artistes, ou Essai de critique naturelle* (Paris, 1864), pp. 142–53.

51. See, e.g., Duret, "Salon de 1870," "Claude Monet" (1880), "Renoir" (1882), *Critique d'avant-garde*, pp. 11–12, 41, 100, 113–14.

52. Additionally, French writers often play on the assonance and semantic opposition of *travail* and *trouvaille*.

53. The making/finding distinction articulates the discrepancy between two conceivable "arts" of originality and sincerity: the one would find and embody the original in its immediate presence; the other would fabricate it, artificially. At the present time, critics of the visual arts tend to associate the former art with modernism and the latter with postmodernism. Although the postmodernist artist does not claim to find an original self, he often seems to perceive himself as "finding" in the act of appropriating the representations of others. I prefer to consider such activity as making. Cf. Shiff, "Mastercopy."

Chapter 7

1. See Albert Boime, *The Academy and French Painting in the Nineteenth Century* (New York, 1971); and "The Teaching Reforms of 1863 and the Origins of Modernism in France," *Art Quarterly*, n.s., 1 (Autumn 1977):1–39.

2. Boime, *Academy*, pp. 174–84; Ludovic Vitet, "De l'enseignement des arts du dessin," *Revue des deux mondes*, 2 per., 54 (1 November 1864):80–82. The descriptive categories "mark of identity" and "mark of distinction" are Boime's.

3. É. J. Delécluze, *Traité élémentaire de peinture* (Paris, 1842; orig. ed., 1828), pp. 229, 250.

4. See, e.g., É. J. Delécluze, "Salon de 1827," *Journal des débats*, 2 January 1828, pp. 1–3; É. J. Delécluze, *Les Beaux-arts dans les deux mondes en 1855* (Paris, 1856), pp. 303–5; and Jacques Nicolas Paillot de Montabert, *Traité complet de la peinture*, 9 vols. (Paris, 1829–51), 4:272. Cf. David's views as reported in É.J. Delécluze, *Louis David, son école et son temps* (Paris, 1863; orig. ed., 1855), pp. 61–62.

5. From notes of ca. 1813–27, reprinted in Henri Delaborde, *Ingres, sa vie, ses travaux, sa doctrine* (Paris, 1870), p. 140.

6. Boime, *Academy*, p. 185 (emphasis added).

7. Antoine Chrysostome Quatremère de Quincy, *Essai sur la nature, le but et les moyens de l'imitation dans les beaux-arts* (Paris, 1823), p. 181.

8. See Pissarro's letter to Lucien, 4 June 1883, in Camille Pissarro, *Lettres à son fils Lucien*, ed. John Rewald (Paris, 1950), p. 48.

9. *Dictionnaire de l'Académie des Beaux-Arts*, vol. 4 (Paris, 1884), pp. 264–65. Publication of the *Dictionnaire* began in 1858. Cf. the basic point established by E. H. Gombrich, *Art and Illusion* (Princeton, 1969), p. 87: "There is no neutral naturalism. The artist, no less than the

writer needs a vocabulary before he can embark on a 'copy' of reality." For a brief but suggestive account of other matters of contention associated with the academic copying of masterworks and the establishment of an artistic canon, see Albert Boime, "Le Musée des Copies," *Gazette des beaux-arts*, 6 per., 64 (October 1964):237–47.

10. *Dictionnaire de l'Académie des Beaux-Arts*, vol. 4, p. 262.

11. Boime, *Academy*, pp. 43–44, 138.

12. Cf. Quatremère de Quincy, who defines the *croquis* or *esquisse* as "l'image la plus sommaire, de celle que [l'artiste] porte toute formée dans son imagination, avant d'en produire le développement"; Antoine Chrysostome Quatremère de Quincy, *Essai sur l'idéal dans ses applications pratiques aux œuvres de l'imitation propre des arts du dessin* (Paris, 1837), p. 120.

13. See, e.g., the writing of Paillot de Montabert and Charles Blanc discussed below, pp. 82–83 and n. 44. Theorists usually stated that brushwork revealed the individual personality of the artist; this factor was far more important to the "independents" than to the "academics." On this issue, cf. Henri Delaborde, "La Photographie et la gravure," *Revue des deux mondes*, 2 per., 2 (1 April 1856):631; Félix Bracquemond, *Du dessin et de la couleur* (Paris, 1885), p. 151.

14. Boime, *Academy*, p. 104.

15. Charles Rosen and Henri Zerner have similarly disputed Boime's claim that the "unfinished" academic sketch can be compared to the finished works of avant-garde naturalists; see their review of Boime's *Academy*, "The Revival of Official Art," *New York Review of Books*, 18 March 1976.

16. For a discussion of this concept, see above, part 1, p. 18.

17. "Ce n'est que l'indication d'un tableau à faire et non un tableau fait"; Ernest Chesneau, *L'Art et les artistes modernes en France et en Angleterre* (Paris, 1864), p. 195.

18. Boime, *Academy*, p. 172.

19. Ibid., p. 169.

20. Ibid., p. 152. On this issue, cf. John Rewald, *History of Impressionism* (New York, 1969), p. 330; and above, part 1, pp. 3–5.

21. Émile Zola, "Édouard Manet" (1867), *Mon Salon, Manet, Écrits sur l'art*, ed. Antoinette Ehrard (Paris, 1970), p. 100.

22. Albert Boime, "Thomas Couture and the Evolution of Painting in Nineteenth-Century France," *Art Bulletin* 51 (March 1969):56. On Couture as a teacher, see Albert Boime, *Thomas Couture and the Eclectic Vision* (New Haven, 1980), pp. 441ff. Anne Coffin Hanson has also discussed Couture's painting technique; see her *Manet and the Modern Tradition* (New Haven, 1977), pp. 145–54.

23. There are at least two other nearly identical studies of the same figure. See Jane Van Nimmen, *Thomas Couture: Paintings and Drawings in American Collections* (University of Maryland, 1970), p. 61. Couture often made several studies of a figural composition in order to understand in advance how the pictorial relationships would be resolved in the final painting; in this way he could maintain speed of execution in a "finished" work. Cf. Boime's discussion of Couture's characteristic technique in *Couture*, pp. 450–56. Boime notes (p. 456) that "we always sense beneath [Couture's] bravura strokes and informal contours a carefully controlled design."

24. This is the conventional contrast (in terms of value) of background and foreground that Henri Regnault emphatically denied; see below, pp. 84–85.

25. *Portrait of Alice Ozy*, ca. 1855, Toledo Museum of Art.

26. On nature as origin, see the remarks on Poussin in Thomas Couture, *Méthode et entretiens d'atelier* (Paris, 1867), pp. 246–47; on the self as origin, see pp. 299–304; on God as origin, see pp. 345–60.

27. Thomas Couture, *Paysage, Entretiens d'atelier* (Paris, 1869), pp. 51–54.

28. From a letter to an American patron, reprinted in G. Bertauts-Couture, *Thomas Couture, sa vie, son œuvre, son caractère, ses idées, sa méthode par lui-même et par son petit-fils* (Paris, 1932), p. 89.

29. Couture, *Méthode*, p. 4.

30. Ibid., p. 247. Cf. also Couture, *Paysage*, pp. 37–41. Couture uses the notion of copying as Matisse would later use it; cf. above, chap. 6, pp. 62–64.

31. Couture, *Paysage*, pp. 55–67; Bertauts-Couture, p. 111.

32. Couture, *Méthode*, pp. 285–87.

33. Bertauts-Couture, p. 106.

34. Ibid., p. 105.

35. Ibid., p. 106. This association of technique and universal law appealed later to the symbolists.

36. Ibid., pp. 108–9.

37. Ibid., p. 110. Couture's interpretation of Leonardo imposes on him a nineteenth-century sense of "science"; it is in conflict with the familiar account of Leonardo's search for new images within indistinctly modeled masses seen in nature and even within his own densely reworked compositional sketches. For an account of Leonardo as "finder" (as opposed to Couture's "maker"), cf. E H. Gombrich, "Leonardo's Method of Working out Compositions," *Norm and Form: Studies in the Art of the Renaissance* (London, 1971), p. 61.

38. Théophile Thoré (Thoré-Bürger), "Salon de 1847," *Les Salons*, 3 vols. (Brussels, 1893), 1:446, 538.

39. On this point, see Pontus Grate, *Deux Critiques d'art de l'époque romantique: Gustave Planche et Théophile Thoré, Figura*, no. 12 (Stockholm, 1959), p. 223; and the discussion of Baudelaire and Thoré in Richard Shiff, "Miscreation," *Studies in Visual Communication* 7 (Spring 1981):66–69.

40. Cf., e.g., the painter Girodet-Trioson, who (as part of a proposed entry on "ordonnance" for a dictionary to be published by the Académie des Beaux-Arts) argued that artistic invention necessarily entailed intellectual organization and compositional choice; P. A. Coupin, ed., *Œuvres posthumes de Girodet-Trioson, peintre d'histoire*, 2 vols. (Paris, 1829), 2:208. See also Kineret S. Jaffe, "The Concept of Genius in Eighteenth-Century French Aesthetics," *Journal of the History of Ideas* 41 (1980):587.

41. Charles Blanc, *Grammaire des arts du dessin* (Paris, 1880; orig. ed., 1867), pp. 502, 531. Most of the *Grammaire* had previously appeared in installments in the *Gazette des beaux-arts* during the years 1860–66. Philippe de Chennevières, who succeeded Blanc in the post of director of fine arts at the end of 1873, strongly disapproved of his predecessor's intellectual activities. He claimed retrospectively that Blanc had spent too much of his time and energy with aesthetic theory and never developed expertise as a connoisseur. Referring to Blanc's *Grammaire*, he wrote: "I can hardly imagine an artist receiving any profitable information concerning the execution of one of his works from this erudite and ingenious verbiage." See Philippe de Chennevières, "Charles Blanc" (1883), *Souvenirs d'un Directeur des Beaux-Arts*, 5

vols. (Paris, 1979; orig. ed., 1883–89), 1:90–91. Nevertheless, Blanc's efforts in aesthetics were generally appreciated; see Albert Soubies, *Les Membres de l'Académie des Beaux-Arts depuis la fondation de l'Institut*, 5 vols. (Paris, 1904–15), 3:236–37.

42. Charles Blanc, "Du style et de M. Ingres," *Gazette des beaux-arts* 14 (1 January 1863):15. Cf. Baudelaire and others: see above, part 1, pp. 39–40.

43. Blanc, *Grammaire*, pp. 21–22, 559.

44. Cf. Paillot de Montabert's *Traité complet de la peinture*, the major antecedent to Blanc's *Grammaire*. Paillot wrote that "la peinture est constituée de cinq grandes conditions: 1re, la composition; 2e, le dessin; 3e, le clair-obscur; 4e, le coloris; et 5e, la touche"; this order is "celui selon lequel procède l'artiste pour exécuter son tableau." See Jacques Nicolas Paillot de Montabert, *L'Artistaire, livre des principales initiations aux beaux-arts* (Paris, 1855), pp. 119–20; and *Traité complet de la peinture*, 1:xxvi–xxvii.

45. Blanc, *Grammaire*, p. 500. Blanc (p. 502) cited Paillot on this issue. For Paillot, unity was the basic artistic principle as well as a theological principle; to achieve unity in art was to gain knowledge of the unity of God. See Paillot de Montabert, *L'Artistaire*, pp. 8, 62–63; and *Traité*, 4:219.

46. Blanc, *Grammaire*, p. 546.

47. See Blanc, *Grammaire*, pp. 20–21; and Charles Blanc, *Les Beaux-arts à l'exposition universelle de 1878* (Paris, 1878), p. 272. The sense of the photograph as "found" is evident in the locution "to take a photograph" (in French, *prendre une photographie*). On the photographic image as found, cf. Champfleury, "L'Aventurier Challes," *La Revue de Paris* 21 (15 May 1854):573–74; Delaborde, "La Photographie et la gravure," p. 635.

48. Blanc, *Grammaire*, p. 555. What Blanc calls uniformity would produce what Paillot de Montabert calls "l'équivoque," an undesirable ambiguity and lack of clarity; Paillot de Montabert, *L'Artistaire*, pp. 69, 185–88. In contrast to Blanc, Lecoq de Boisbaudran, whose prime concern was originality, argued that there could be no true "rule" of composition, only a number of conventions that need not be followed; see his "Lettres à un jeune professeur" (1877), reprinted in Horace Lecoq de Boisbaudran, *L'Éducation de la mémoire pittoresque et la formation de l'artiste* (Paris, 1913), pp. 143–44.

49. Charles Alphonse Du Fresnoy, *The Art of Painting* (London, 1716; orig. French ed., 1668), p. 43; Eugène Véron, *L'Esthétique* (Paris, 1878), p. 262.

50. Blanc, *Grammaire*, p. 573.

51. Charles Blanc, "Eugène Delacroix" (1864), *Les Artistes de mon temps* (Paris, 1876), p. 62. Cf. also the entry "Coloris" in the *Dictionnaire de l'Académie des Beaux-Arts*, vol. 4, p. 183; here color is discussed as a technical quality that can be perfected only through learning.

52. Blanc, *Grammaire*, p. 560. Cf. also Blanc, "Delacroix," pp. 62, 66.

53. See, e.g., Ernest Chesneau, *Les Nations rivales dans l'art*; *L'Art japonais* (Paris, 1868), pp. 453–54; Walther Fol, "Fortuny," *Gazette des beaux-arts*, 2 per., 11 (April 1875):362, 364; Ernest Chesneau, "Exposition universelle; le Japon à Paris," *Gazette des beaux-arts*, 2 per., 18 (September, November 1878):392, 396, 843–44; Edmond Duranty, "L'Extrême-Orient: Revue d'ensemble des arts asiatiques à l'Exposition universelle," *Gazette des beaux-arts*, 2 per., 18 (December 1878):1048.

54. Eugène Fromentin, *Les Maîtres d'autrefois* (Paris, 1876), p. 241.

55. Fromentin, p. 287. Cf. Bigot's description of the works of Bastien-Lepage; these paintings are said to lack chiaroscuro modeling, and the artist's vision is compared to that of the Chinese and Japanese who, supposedly, do not see spatial distinctions, but rather juxta-

posed objects on a flat plane. Charles Bigot, "Jules Bastien-Lepage" (1885), *Peintres français contemporains* (Paris, 1888), pp. 178–79.

56. Letter to Pissarro, 2 July 1876, John Rewald, ed., *Paul Cézanne, correspondance* (Paris, 1937), p. 127. The image of the playing-card that Cézanne invokes appeared often in nineteenth-century discussions of effects of color. It brought to mind not only striking, harsh juxtapositions of brilliant hues and a lack of refined chiaroscuro values, but also, more generally, the naïveté and sincerity associated with the "imagerie populaire" of the cards. Cf., e.g., J.-F.-L. Mérimée, *De la peinture à l'huile* (Paris, 1830), p. 293.

57. Concerning Monet's motivation, see his letter to Durand-Ruel, Bordighera, 11 March 1884: "ceux qui n'ont pas vu ce pays ou qui l'ont mal vu crieront, j'en suis sûr, à l'invraisemblance [between Monet's painting and natural appearances], quoique je sois bien audessous du ton: tout est gorge-de-pigeon et flamme-de-punch. . . ." Reprinted in Daniel Wildenstein, *Claude Monet, Biographie et catalogue raisonné*, 3 vols. (Lausanne, 1974–79), 2:243.

58. Letter to Monfort, Tangier, 15 July 1870; Arthur Duparc, ed., *Correspondance de Henri Regnault* (Paris, 1873; orig. ed., 1872), pp. 382–83. The opposition of conventional studio light to a novel outdoor light was a common theme in Regnault's day; see, e.g., Bigot, "Corot" (1875), *Peintres français comtemporains*, pp. 53–54.

59. André Michel, "A propos d'une collection particulière exposée dans la galerie de M. Georges Petit," *Gazette des beaux-arts*, 2 per., 30 (1 December 1884):500.

60. René Ménard, "Salon de 1870," *Gazette des beaux-arts*, 2 per., 3 (1 June 1870):505.

61. Victor Fournel, *Les Artistes français contemporains* (Tours, 1885), pp. 489, 492, 7.

62. Théodore Duret, "Les Peintres impressionnistes" (1878), "Claude Monet" (1880), "Renoir" (1882), *Critique d'avant-garde* (Paris, 1885), pp. 65–66, 95–96, 113–14. Armand Silvestre, who, like Duret, was a personal friend of the impressionists, also maintained that the technique of juxtaposing brilliant hues was derived from the Japanese; see his preface to *Galerie Durand-Ruel, Recueil d'estampes gravées à l'eau-forte* (Paris, 1873), p. 23.

63. Duret, "Les Peintres impressionnistes," *Critique*, p. 66.

64. Duret, "Claude Monet," *Critique*, pp. 98–99. Similarly, Duranty, when describing aspects of impressionist color that *could* easily be related to analytical scientific investigation, chooses to argue that the impressionists instead derived these techniques from intuition; see Edmond Duranty, *La Nouvelle Peinture, à propos du groupe d'artistes qui expose dans les galeries Durand-Ruel*, ed. Marcel Guérin (Paris, 1946; orig. ed., 1876), p. 39.

65. Maurice Denis, "De Gauguin et de Van Gogh au classicisme" (1909), *Théories, 1890–1910: Du symbolisme et de Gauguin vers un nouvel ordre classique* (Paris, 1920; orig. ed., 1912), p. 264.

66. Théodore Duret, *Les Peintres français en 1867* (Paris, 1867), pp. 23–24.

67. Duret, *Peintres français*, p. 24.

68. Duret, "Les Peintres impressionnistes," *Critique*, pp. 67–68.

69. Ibid., p. 65.

70. Duret, "Claude Monet," *Critique*, p. 100. Cf. Duret's remarks on Manet and Renoir: "Salon de 1870," "Renoir," *Critique*, pp. 41, 114. The essence of the impressionist approach could appeal to a sculptor. Rodin, who was Monet's friend and who came to be discussed in both impressionist and symbolist terms (just as Monet did), said: "Je me suis simplement appliqué à copier la nature. Je l'interprète comme je la vois, selon mon tempérament, ma sensibilité, d'après les sentiments qu'elle évoque en moi." See Edmond Claris, "L'Impressionnisme en sculpture," *La Nouvelle Revue*, n.s., 10 (1 June 1901):327.

71. See below, pp. 92–95.

72. I offer a more complete explanation as to why, in theory, such impressionist natural-ism could not be appropriated by any artists other than those who discovered (or found) it in their own immediate experience; see Richard Shiff, "The Original, the Imitation, the Copy, and the Spontaneous Classic," *Yale French Studies*, no. 66 (1984), pp. 27–54. The essence of the argument is that appropriation can be accomplished only when a style is subject to analy-sis into component (technical) parts. Whenever a style seems completely independent of pre-cedents or transcends its own sources, it escapes any such analysis because it appears as an original whole which can be imitated only in its entirety. The wholesale "copying" that a radi-cally original style demands reduces the copyist to a dependency that an academic would find intolerable—academics guarded their own originality just as jealously as independents did. (Cf. below, pp. 92–95; and see also Rodin's specific use of the term "copier" in the quota-tion above, n. 70.)

73. Émile Zola, "Proudhon et Courbet" (1866), "M. H. Taine, artiste" (1866), *Mes Haines, Mon Salon, Édouard Manet* (Paris, 1879), pp. 25, 229. Cf. also, Zola, "Mon Salon" (1866), *Écrits*, pp. 59–60; and Zola's letter to Valabrègue of 1864, reprinted in *Correspondance 1858–71*, ed. Maurice Le Blond (Paris, 1927), p. 248.

74. Blanc, *Grammaire*, pp. 19–20, 532.

75. Just as other theorists of his time, Blanc recognized that photographs often bore indi-cations of the photographer's manipulation of figural poses and illumination, but he associat-ed such effects with aspects of successful photographic technique rather than expressive artis-tic "style"; Blanc, *Grammaire*, pp. 20–21.

76. Ibid., p. 19 (emphasis added). It may be significant that Blanc here refers to "person-nalité" rather than "tempérament." The difference, if noted, is this: personality is the public, *made* character, whereas temperament is the innate, *found* character, the product largely of physiology and material environmental conditions.

77. With regard to the importance of forethought and choice, cf. Paillot de Montabert, who, like Blanc, stresses that finding (both "trouver" and "inventer") can be only the initial stage of the artistic process, which must also involve choice and composition ("trouver, choi-sir, et composer"); Paillot de Montabert, *L'Artistaire*, pp. 175–77; *Traité*, 4:243. Cf. also Quatremère de Quincy, *Essai sur l'idéal*, pp. 60–70.

78. Lecoq de Boisbaudran, "Lettres à un jeune professeur," p. 142. On Lecoq's reputa-tion as a champion of originality, cf. Duranty, *La Nouvelle Peinture*, p. 33.

79. Cf. Charles Blanc, *Histoire des peintres de toutes les écoles*, 3 vols. (Paris, 1865), 1:46. Fé-lix Bracquemond expressed the same view in his *Du dessin et de la couleur*, pp. 217–18.

80. Blanc, *Grammaire*, p. 21. Cf. the views of Gustave Planche, who stated that great art must involve both (found) "imitation" and (made) "invention," and that contemporary French sculptors had injudiciously opposed the real (and its *vérité*) to the ideal. See Gustave Planche, "L'Art grec et la sculpture réaliste," *Revue des deux mondes*, 2 per., 5 (1 October 1856):545, 552–54.

81. Originally published in *Courrier du dimanche*, 25 December 1861; cited in Jules Cas-tagnary, "Courbet, son atelier, ses théories," *Les Libres Propos* (Paris, 1864), p. 182.

82. Blanc, *Grammaire*, p. 21.

83. Ibid., p. 539; Blanc, "Du style et de M. Ingres," pp. 7–8, 13, 23; Charles Blanc, "In-gres, sa vie et ses ouvrages," *Gazette des beaux-arts* 25 (1 September 1868):243.

84. Ménard, "Salon de 1870," p. 508. On the distinction between "finished" and "sum-mary" modeling, cf. also Philippe Burty, "L'Exposition de Lyon," *Gazette des beaux-arts*, 2 per.,

3 (March 1870):285; Georges Lafenestre, "Salon de 1873," *Gazette des beaux-arts*, 2 per., 8 (July 1873):58.

85. Gabriel Séailles, "L'Impressionnisme," *Almanach du bibliophile*, April 1898, pp. 43–45, 50–51.

86. Camille Mauclair, "Destinées de la peinture française depuis 1865," *La Nouvelle Revue* 93 (March 1895):363–66, 370.

87. See above, part 1, pp. 37–38, 46–47.

88. Mauclair, pp. 363–66, 376. Thirty years previously, Castagnary had advocated an art that might synthesize the "realist" and "idealist" movements; see the commentary on Millet and Courbet in Jules Antoine Castagnary, "Salon de 1864," "Salon de 1866," *Salons*, 2 vols. (Paris, 1892), 1:189–92, 240.

89. Raymond Bouyer, "Le Paysage dans l'art," *L'Artiste*, n.s., 6 (July, August, September 1893):31–33, 114, 213.

90. Blanc, *Grammaire*, p. 17.

91. Ibid., p. 531; cf. also p. 19. For Blanc's fellow academic, Henri Delaborde, active choice distinguished the art of the engraved reproduction from the mere craft of photographic reproduction; Henri Delaborde, "La Photographie et la gravure," p. 635.

92. Blanc, *Grammaire*, p. 531 (emphasis added).

93. Ibid., p. 20. On Claude's use of artificial pictorial devices, see also pp. 558, 602–4. Cf. Gustave Planche, "Le Paysage et les paysagistes: Ruysdael, Claude Lorrain, Nicolas Poussin," *Revue des deux mondes*, 2 per., 9 (15 June 1857):786.

94. Couture, *Méthode*, p. 247; Couture, *Paysage*, pp. 37–38, 67.

95. Entry for *imiter*, Émile Littré, *Dictionnaire de la langue française*, 4 vols. (Paris, 1863–69), 3:19. Cf. the distinction marked in this statement by Delaborde, "La Photographie et la gravure," p. 621: "l'imitation sera insuffisante, si elle garde seulement le caractère d'une copie littérale." As I have indicated, the distinction was very often not maintained. Just as Blanc did, Zola frequently employed *imiter* and *copier* interchangeably, masking their differing etymological identities. In his discussion of Taine's concept of imitation, he used *imiter* where *copier* would be more appropriate, and vice versa: "on ne peut *imiter* l'objet dans sa réalité; il suffit de le *copier*, en maintenant un certain rapport entre ses diverses proportions, rapport que l'on modifie pour faire prédominer le caractère essentiel." See Émile Zola, "M. H. Taine, artiste" (1866), *Mes Haines* (Paris, 1879), p 228 (emphasis added). Taine himself had distinguished between "l'imitation matérielle" (copying) and "l'imitation intelligente" (imitation proper); Hippolyte Taine, *Philosophie de l'art*, 2 vols. (Paris, 1893; orig. ed., 1865–69), 1:46.

96. Quatremère de Quincy, *Essai sur. . . l'imitation*, pp. 8–9, 11–12, 23–25, 189, 238, 272. Cf. also Antoine Chrysostome Quatremère de Quincy, *Considérations sur les arts du dessin en France* (Paris, 1791), pp. x–xi; Paillot de Montabert, *Traité*, 4:273. For a later and very pithy example of the distinction, cf. J. D. Régnier, *De la lumière et de la couleur chez les grands maîtres anciens* (Paris, 1865), p. 74: "La peinture est l'imitation et non la copie de la nature." On the distinction between "imitation" and "copy" in the eighteenth century and in the Renaissance, see, respectively, Jaffe, "The Concept of Genius," p. 582, and David Summers, *Michelangelo and the Language of Art* (Princeton, 1981), pp. 279–80. On the classification of the various types of "copies" (as opposed to "imitations") made by academic artists, see Pierre Malitourne, "Les Copies de Raphaël, par les frères Balze," *L'Artiste*, 4 ser., 11 (7 November 1847):7; and the entry for "Copie," *Dictionnaire de l'Académie des Beaux-Arts*, vol. 4, p. 262. Delécluze noted that to copy a masterpiece was a most difficult and commendable achievement; *Traité élémentaire de peinture*, p. 230.

97. Cf., e.g., Thoré, "Salon de 1844," *Les Salons*, 1:20. On the shift in the use of the concepts of imitation and copy, see Shiff, "The Original, the Imitation, the Copy, and the Spontaneous Classic."

98. This question nags persistently at Western culture. Recently, it has been both raised and circumscribed by Jacques Derrida, who draws it out from his reading of the *Phaedrus* and other "classic" Platonic texts. See Jacques Derrida, "Plato's Pharmacy," *Dissemination*, trans. Barbara Johnson (Chicago, 1981), p. 149.

99. Many of Quatremère's arguments were directed against T. B. Émeric-David, *Recherches sur l'art statuaire* (Paris, 1805); cf. Émeric-David, esp. pp. 221–36, 283–85. On Quatremère's defense of the "classical" academic position, see R. Schneider, *L'Esthétique classique chez Quatremère de Quincy (1805–1823)* (Paris, 1910), esp. pp. 3–12, 25–29. Quatremère's *Essai sur l'idéal* (1837) republished many of the statements he had made around 1805 in response to Émeric-David. On the debate over the merits of the model in art as opposed to the model in nature, cf. Planche, "L'Art grec et la sculpture réaliste," pp. 533, 552. The same issue appears in the theories of Émile Bernard and Maurice Denis, and Cézanne, too, pondered the problem; see below, chaps. 9, 13, 14.

100. Zola, "Édouard Manet" (1867), *Écrits*, pp. 102, 101 (emphasis added). Cf. Zola, "Édouard Manet" (1884), *Écrits*, p. 363. See also Zola's remarks on Pissarro, who is "ni poète ni philosophe, mais simplement naturaliste"; "Mon Salon" (1868), *Écrits*, p. 147.

101. See, e.g., George Mauner, *Manet, peintre-philosophe* (University Park, Penn., 1975), pp. 1–6; and Theodore Reff, "Manet's Portrait of Zola," *Burlington Magazine* 117 (January 1975):41.

102. For this common formulation, see, e.g., P. H. Valenciennes, *Élémens de perspective pratique à l'usage des artistes suivis de réflexions et conseils à un élève sur la peinture, et particulièrement sur le genre du paysage* (Paris, 1800), pp. 630–31: "Quelque sujet que vous ayiez à traiter, souvenez-vous bien que les trois parties essentielles de la Peinture, sont l'Invention, la Composition et l'Exécution. . . . La première tient au génie, la seconde dépend des connoissances acquises, et la troisième est le fruit de l'habitude et de l'expérience." The three areas of artistic expertise correspond to three major divisions of classical rhetoric: invention (*inventio*), arrangement (*dispositio*), and style (*elocutio*).

103. Zola, "Mon Salon," *Écrits*, p. 141. Cf. Zola on Pissarro, "Mon Salon," p. 159. Zola speaks of Manet's "copying" as a result of his having observed the artist painting his portrait: "il me copiait comme il aurait copié une bête humaine quelconque." (Cf. also Zola's similar comments in "Édouard Manet" [1884], *Écrits*, p. 363.) The portrait genre itself had traditionally been associated with copying (as opposed to imitation); see Johann Joachim Winckelmann, "Gedanken über die Nachahmung der griechischen Werke in der Malerei und Bildhauerkunst" (1755), *Winckelmanns Werke*, ed. Helmut Holtzhauer (Berlin, 1969), p. 11; and Quatremère de Quincy, *Essai sur l'idéal*, p. 50. Quatremère remarked that portraits involve no ideas: "Qu'y a-t-il à idéer ou à imaginer dans ce qui fait l'essence d'un portrait?"

104. And such recording or "copying" is, of course (as Littré's definition indicates), "accurate," and hence expressive of objective as well as subjective "vérité"; on this issue, see above, part 1, pp. 21–23.

105. Zola, "Mon Salon," *Écrits*, p. 142. Cf. Castagnary, who contrasts copying to invention and composition; he argues that even when the artist's work involves invention, if it yet appears as a copy, it will seem sincere: "prenant [l']ouvrage pour une copie de la nature, [chacun] s'écrie: Quelle sincérité!" See Castagnary, "Salon de 1868," *Salons*, 1:292. The view ex-

pressed by Zola/Manet differs radically not only from Blanc's, but from that of all true "academics." For example, Paillot de Montabert remarked that "si, donc, malgré les règles, l'ouvrage est froid, c'est faute de chaleur ou de génie chez l'artiste, ce n'est pas la faute des règles"; Paillot de Montabert, *L'Artistaire*, p. 261. Cf. also Quatremère de Quincy, *Essai sur l'idéal*, pp. 99–103.

106. Joséphin Péladan, "Le Procédé de Manet d'après l'exposition de l'École des Beaux-Arts," *L'Artiste*, February 1884, p. 103. Many of the terms of the critical debate over Manet seem to have been set by Zola's early statements. In 1880, Ernest Chesneau praised the artist for having liberated his technique from all convention and studio practice; Manet's works should be noted "pour leur sincérité d'aspect et pour la justesse et la très-rare finesse du ton obtenu sans convention, vu, surpris et fixé par un regard du peintre." Chesneau concluded, however, that Manet failed to mobilize his imagination: "Je dirai donc à M. Manet: Consultez le modèle, *ne le copiez pas*." See Ernest Chesneau, *L'Éducation de l'artiste* (Paris, 1880), pp. 338–39 (emphasis added). For a more sympathetic explanation of Manet's situation, yet one skeptical of his professed naïveté, cf. the subsequent remarks by Georges Lecomte: "Cette apparente naïveté [of Manet's works], en admettant qu'on pût la concevoir en des œuvres si réfléchies, proviendrait d'une compréhension profonde des aspects de la nature et des gestes de l'homme, d'une vision et d'un faire inédits, ne correspondant en rien à la grammaire des formes que l'art des siècles nous à léguée." Georges Lecomte, *L'Art impressionniste d'après la collection privée de M. Durand-Ruel* (Paris, 1892), p. 42. Cf. also Jules de Marthold, "Édouard Manet," *La Revue critique* 1 (29 January 1882):12; here, Manet's manner is said to be "l'opposé de toute manière, c'est-à-dire la simple volonté de ne faire que copier les choses."

107. Zola, "Édouard Manet" (1867), *Écrits*, p. 97. Cf. the introduction to the catalog of Manet's 1867 exhibition, "Motifs d'une exposition particulière," generally believed to have been coauthored by Manet and Zola; this statement stresses Manet's "sincerity" and his attempt to "be himself." See Alan Krell, "Manet, Zola and the 'Motifs d'une Exposition particulière,' 1867," *Gazette des beaux-arts*, 6 per., 99 (March 1982):109–15.

108. Zola, "Édouard Manet" (1884), *Écrits*, p. 362.

109. Blanc, "Henri Regnault," *Les Artistes de mon temps*, p. 348. Cf. the similar comments by Ménard, "Salon de 1870," p. 505.

110. Blanc, "Henri Regnault," p. 362. Cf. Fournel, *Les Artistes français contemporains*, p. 489: "Regnault n'était pas de la race des penseurs, mais de la famille des peintres. . . ."

111. Blanc, "Henri Regnault," p. 351.

112. Ibid., p. 360. Contrast Blanc's favorable assessment of Delacroix, who, although a colorist, has "qualities of another order"; "Eugène Delacroix," *Les Artistes de mon temps*, p. 61.

113. Blanc, "Henri Regnault," p. 363.

114. Blanc, *Grammaire*, p. 18.

115. Zola, "Mon Salon" (1866), *Écrits*, p. 60.

116. Antonin Proust, "Édouard Manet," *Revue blanche* 12 (15 April 1897):427.

117. Castagnary, "Salon des Refusés" (1863), *Salons*, 1:170.

118. Zola, "Édouard Manet" (1867), *Écrits*, p. 102. Cf. Zola's later statement in "Édouard Manet" (1884), *Écrits*, p. 363: "La composition a disparu." Other critics who were sympathetic to naturalism made the same observations as Zola and set them into a similar interpretive framework: Castagnary noted the violent contrasts and associated them with Manet's "temperament"; Thoré remarked upon the painter's failure to discriminate among figures

and furnishings, but praised the sense of a unifying light. See Castagnary, "Salon de 1868," *Salons*, 1:314; Thoré, "Salon de 1868," *Les Salons*, 3:532. For the contemporaneous negative reaction to Manet, see, e.g., J. Grangedor, "Le Salon de 1868," *Gazette des beaux-arts* 24 (1 June 1868):520; Marc de Montifaud, "Salon de 1868," *L'Artiste*, June 1868, p. 412.

119. Zola, "Mon Salon" (1868), *Écrits*, p. 160. Concerning Zola's interpretation of Jongkind's technique, cf. above, part 1, pp. 33–34.

Chapter 8

1. Eugène Fromentin, *Les Maîtres d'autrefois* (Paris, 1876), p. 285.

2. Ibid., p. 271.

3. Thomas Couture, *Paysage, Entretiens d'atelier* (Paris, 1869), p. 63.

4. Charles Blanc, *Grammaire des arts du dessin* (Paris, 1880; orig. ed., 1867), p. 555. Blanc admired Claude's compositional artifice; Ruskin, notoriously, did not. In 1844 he implied that Claude would have been a far greater artist if he had been able to make his works appear as if there were *no* composition within them. Couture, of course, thought that Claude had succeeded in doing just this. See John Ruskin, "Preface to the Second Edition" (1844), *Modern Painters*, 5 vols. (London, 1906), 1:xxxiv.

5. For an account of the history of this painting, see Charles Sterling, *A Catalogue of French Paintings, XV–XVIII Centuries, The Metropolitan Museum of Art* (Cambridge, 1955), p. 82.

6. Cf. the advice of Valenciennes to the effect that a landscape composition should not have a "monotonous regularity" nor a lack of "contrast on its different planes"; the artist should seek a "site that presents him continually with inequality, that is, correspondences and contrasts." Valenciennes suggests as a suitable landscape element a tree bearing both dead and healthy, foliated branches; P. H. Valenciennes, *Elémens de perspective pratique à l'usage des artistes suivis de réflexions et conseils à un élève sur la peinture, et particulièrement sur le genre du paysage* (Paris, 1800), p. 425.

7. Fromentin, pp. 238–39.

8. Charles Blanc, "Corot," *Les Artistes de mon temps* (Paris, 1876), p. 377.

9. Théophile Thoré (Thoré-Bürger), "Salon de 1844," *Les Salons*, 3 vols. (Brussels, 1893), 1:20. Thoré makes these remarks in his general introduction to the Salon; for his references to Corot's own "poetry," see p. 35.

10. See Pierre Courthion, ed., *Corot raconté par lui-même et par ses amis*, 2 vols. (Geneva, 1946), 1:82–83, 89; 2:94–96. Cf. also Étienne Moreau-Nélaton, *Corot raconté par lui-même*, 2 vols. (Paris, 1924), 1:125: "La couleur et l'exécution sont, pour Corot, des qualités secondaires et tout à fait subjectives."

11. Moreau-Nélaton, 1:126.

12. See, e.g., Charles Bigot, "Corot" (1875), *Peintres français contemporains* (Paris, 1888), pp. 65–67; Anatole de Montaiglon, "Salon de 1875," *Gazette des beaux-arts*, 2 per., 12 (1 July 1875):22; and Émile Zola, "Mon Salon" (1868), *Mon Salon, Manet, Écrits sur l'art*, Antoinette Ehrard, ed. (Paris, 1970), p. 161.

13. Statement made to Alfred Robaut, 19 November 1872, reprinted in Courthion, 1:84.

14. Conversation reported by Alfred Robaut, 2 January 1874, reprinted in Courthion, 1:88.

15. See Corot's undated notes on this matter and also the report of Mme. Aviat, who painted with him in 1871; Courthion, 1:89, 95.

16. Jacques Nicolas Paillot de Montabert, *L'Artistaire, livre des principales initiations aux beaux-arts* (Paris, 1855), pp. 182–83. On Paillot's belief that art must involve the thoughtful combination of elements and the technical elaboration of a compositional "idea," cf. also pp. 9, 120–21, 246.

17. See, e.g., the comments of Duret, who was on the whole in sympathy with the artist: "[Pissarro] never composes a picture and, in a landscape, never arranges nature . . . but often he comes to paint insignificant sites, where nature itself makes so little of a composition that he paints a landscape without making a [meaningful] picture." Théodore Duret, "Salon de 1870," *Critique d'avant-garde* (Paris, 1885), pp. 8–9. Cf. also the more conservative critic Jules Claretie, who complained of a lack of composition in the works of younger landscapists exhibiting at the Salon of 1872; "L'Art français en 1872; Revue du Salon," *Peintres et sculpteurs contemporains* (Paris, 1874), p. 287.

18. Although he had a different sense of artistic originality than Corot, Paillot de Montabert, among many others, made this common argument with regard to following nature, not art; see Paillot de Montabert, *L'Artistaire*, pp. 178–79.

19. Théodore Duret, *Les Peintres français en 1867* (Paris, 1867), pp. 21–28.

20. Raymond Bouyer, "Le Paysage dans l'art," *L'Artiste*, n.s., 5 (January 1893):22; and 6 (August 1893):125.

21. Letter from Monet to Bazille, December 1868, reprinted in Daniel Wildenstein, *Claude Monet, Biographie et catalogue raisonné*, 3 vols. (Lausanne, 1974–79), 1:425–26.

22. Letter from Monet to Geffroy, 7 October 1890, reprinted in Wildenstein, 3:258. Monet here refers to his difficulty in developing the proper speed and precision of execution while painting the haystacks. He discovers that he needs to labor carefully to create the sense of spontaneity. On Monet's "instantaneity," see Steven Z. Levine, "The 'Instant' of Criticism and Monet's Critical Instant," *Arts* 55 (March 1981):114–21. Cf. above, chap. 3, note 22.

23. This is the reasoning Baudelaire applied in his defense of Manet's *Incident in the Bull Ring* in 1864. It was generally recognized that this painting was "original," that is, that its technique appeared so unconventional that it might be judged naïve or even incompetent. Baudelaire could turn this observation to his advantage. But to assert Manet's original genius he had to deny a further observation, namely, that Manet's imagery seemed to be derived from other artists, Velasquez and Goya. See Baudelaire's letter to Théophile Thoré, ca. 20 June 1864, reprinted in Charles Baudelaire, *Œuvres complètes, Correspondance générale*, Jacques Crépet, ed., 18 vols. (Paris, 1948), 4:275–77; and Richard Shiff, "Miscreation," *Studies in Visual Communication* 7 (Spring 1981):65–68. Although he analyzes Monet's Sainte-Adresse paintings in a manner different from mine, Kermit Champa similarly notes that in these works "Monet's view is . . . relatively submissive. He does not force his viewpoint, nor does he appear to construct the scene arbitrarily." See Kermit Champa, *Studies in Early Impressionism* (New Haven, 1973), p. 19.

24. Zola, "Édouard Manet" (1867), *Écrits*, p. 102.

25. Monet seems to display color, too, "as he sees it" in nature—and furthermore, as he finds it in his painter's tubes. He inserts the three primaries into his composition in an unattenuated state: one of the central rowboats is a pure blue; a rowboat at left has trim of brilliant yellow; the figure at extreme left wears blue and red; and a stroke of red is located beneath the female figure at center. These colors call attention to the natural, or immediate, state of Mon-

et's art. The same device of exhibiting the three primary colors is seen in another painting of 1867, Monet's *The Cradle—Camille with the Artist's Son Jean*, in the collection of Mr. and Mrs. Paul Mellon, Upperville, Va.

26. Robert Herbert, "Method and Meaning in Monet," *Art in America* 67 (September 1979):90–108, esp. p. 97.

27. Letter to Zola, ca. 19 October 1866; John Rewald, ed., *Paul Cézanne, correspondance* (Paris, 1937), pp. 98–99.

28. Many of Cézanne's works of the 1870s—many still-lifes, for example—appear more dependent on a linear framework than does *Auvers*; this, however, is primarily a factor of the nature of the motif itself and not an indication that the artist considered one manner more successful than another. Coloristically and compositionally, both types of painting, with strong outlining and without, reveal the "technique of originality."

29. The colors are set against a gray ground; Cézanne painted upon gray grounds very often, especially during the 1870s and 1880s. The use of the middle-value gray ground, a unifying device, was common among the impressionists and others. Cf. below, chap. 15, note 30.

30. See, e.g., *Uncle Dominic* (ca. 1865–67; fig. 45), discussed below, part 3, p. 204.

31. Letter to Bernard, 23 October 1905; *Correspondance*, pp. 276–77.

32. Letters to Paul Cézanne *fils*, 13 September 1906, 22 September 1906, 26 September 1906; *Correspondance*, pp. 289, 292, 293.

33. Émile Blémont, "Les Impressionnistes," *Le Rappel*, 9 April 1876; partially reprinted in Lionello Venturi, *Les Archives de l'impressionnisme*, 2 vols. (Paris, 1939), 2:297–98; and in Gustave Geffroy, *Claude Monet, sa vie, son temps, son œuvre*, 2 vols. (Paris, 1924), 1:81–83 (emphasis added). Cézanne's comment on Blémont is found in his letter to Pissarro, April 1876; *Correspondance*, p. 125. Cézanne also mentions the review by Jean-Lubin ("La Galerie Durand-Ruel," *L'Esprit moderne*, 2 March 1876); this critic identified the style of impressionism with a uniform lighting effect.

34. On Cézanne's concern for the "moyens d'expression," see below, part 3, pp. 188–89, 192–94.

35. Letter to Bernard, 26 May 1904; *Correspondance*, p. 262.

36. "Awkward," hence naïve or original. Awkwardness was commonly associated with artistic sincerity by both impressionists and symbolists. See, e.g., R. P. Rivière and J. F. Schnerb, "L'Atelier de Cézanne," *La Grande Revue* 46 (25 December 1907):813. See also below, part 3, pp. 166–74, 189–94.

37. Another example is *Bathers at Rest* (Barnes Foundation, Merion, Penn., ca. 1875–76). Here, in addition to the use of the brilliant yellow-green, anomalous touches of strong red and green are added to a cloud.

38. In the painting of the late nineteenth century, there are many similar cases of a disjunction of subject matter and style. Writers of the early twentieth century often discussed such difficult interpretive situations in terms of a conflict between "romantic" impulse and "classical" restraint, hinting at an analysis to be informed by psychobiography. With regard to Cézanne, Roger Fry stated that this painter was indeed a "classic artist, but perhaps all great Classics are made by the repression of a Romantic"; Roger Fry, *Cézanne, a Study of His Development* (New York, 1958; orig. ed., 1927), p. 87. Meyer Schapiro drew on Fry's formulation and added that Cézanne's "exceptional pictures [of scenes of violent passion] permit us to see more clearly how [his] new art [of 'classically' structured impressionism] rests on a deliberate repression of a part of himself which breaks through from time to time"; Meyer Schapiro,

Paul Cézanne (New York, 1962; orig. ed., 1952), p. 28. In a study of the development of Cézanne's "impressionist" structure of parallel brushstrokes, Theodore Reff initially disagreed with Schapiro's emphasis on psychological repression, but eventually returned to it. Reff argued that the technique of the divided brushstroke arose *naturally* as a means of rendering imagined subjects or "invented, somewhat schematic forms rather than the more variable sensations of nature." Cézanne, however, "by systematizing even the size and direction of the brushstroke . . . [was striving] to master within himself the turbulent impulses that had led him to choose such themes of struggle, temptation and ironic adoration [e.g., *L'Éternel féminin*] in the first place. It is as if he strove to incorporate these hidden feelings into the domain of constructive professional activity, submitting them to strict esthetic requirements through which he might ultimately neutralize them"; Theodore Reff, "Cézanne's Constructive Stroke," *Art Quarterly* 25 (Autumn 1962):223–24. For the purposes of my own argument, it is unnecessary to distinguish between Cézanne's more "romantic" subjects such as *L'Éternel féminin* (which Reff describes as a sexual fantasy) and his seemingly less provocative images such as *The Pond* (which nevertheless reveals certain traces of erotic tension in the odd placement of a poplar tree into a cleft hillside). I do not wish to engage in a reading of the artist's psychic biography, but rather (in the manner of a nineteenth-century "academic") to interpret his stylistic qualities as if they were consciously chosen—or, at least, to interpret them to whatever extent they may be conceived as products of conscious selection. In this chapter, I am concerned with a reading of Cézanne's technical procedure in respect to standards set for him by others, and in relation to the public image that the artist wished to give to his own activity (as that image might be conveyed by association with the artist's own intelligible stylistic manner). Below, in chapter 13, I return to the issue of the romantic/classic distinction that features so prominently in the writings of Fry, Schapiro, Reff, and others—and I claim, in effect, that in the opinion of nineteenth-century artists, to be a classic was to repress nothing at all.

39. Letter to Bernard, summer (?) 1905; *Correspondance*, p. 276.

40. "Sensation" can refer to both nature and self as origins; see below, part 3, pp. 187–89.

41. Rivière and Schnerb, pp. 813–16. Cf. the views of Matisse and Couture as discussed above, pp. 62–64, 78–79.

42. The early critics of Cézanne's painting commonly described it as "incomplete"; see, e.g., Thadée Natanson, "Paul Cézanne," *Revue blanche* 9 (1 December 1895):497; Gustave Geffroy, "Paul Cézanne" (1894), "Paul Cézanne" (1895), *La Vie artistique*, 8 vols. (Paris, 1892–1903), 3:257, 6:218; Charles Morice, "Paul Cézanne," *Mercure de France*, n.s., 65 (15 February 1907):588. Émile Bernard observed this quality in Cézanne's painting when he first visited the artist; he wrote to his mother (5 February 1904) that "Cézanne's canvases are made of pieces. He leaves white [spaces] in them everywhere. In sum, he works as Ingres did, proceeding by the detail and finishing the parts before bringing the whole together." See "Un Extraordinaire Document sur Paul Cézanne," *Art-Documents* (Geneva), no. 50 (November 1954), p. 4. For further discussion of the "incomplete" character of Cézanne's art (related to the very nature of impressionist "sensation"), cf. below, part 3, pp. 189–96.

43. Rewald has identified the motif of *Winter Landscape* as Giverny, and has therefore dated it to autumn 1894, when Cézanne visited Monet (communication from John Rewald, 31 March 1983). See also Joseph J. Rishel, *Cézanne in Philadelphia Collections* (Philadelphia, 1983), pp. 38–39.

44. Although the surface of *Domaine St.-Joseph* is only thinly covered with paint, the work is signed, indicating that the artist regarded it either as complete or at least as existing in its own final form. Robert Ratcliffe has demonstrated the likelihood that Cézanne signed works only as they left his studio, having been purchased or requested by admirers; see Robert William Ratcliffe, "Cézanne's Working Methods and Their Theoretical Background," unpublished dissertation, Courtauld Institute of Art, University of London, 1961, pp. 216–65.

45. Émile Bernard, "Paul Cézanne," *L'Occident* 6 (July 1904):23–24. See also, Émile Bernard, "Souvenirs sur Paul Cézanne et lettres inédites," *Mercure de France*, n.s., 69 (1 October and 16 October 1907):400. Cf. Rivière and Schnerb, p. 814: "[Cézanne] modelait plus par la couleur que par la valeur . . . c'est par l'opposition des tons chauds et froids que les couleurs . . . arrivent à représenter la lumière et l'ombre."

46. Maurice Denis, "Cézanne" (1907), *Théories, 1890–1910: Du symbolisme et de Gauguin vers un nouvel ordre classique* (Paris, 1920; orig. ed., 1912), pp. 257–59. (This passage was expanded for the sake of clarity as Denis reworked it for *Théories*; on this matter, see below, p. 139.) Cf. also the entry for 26 January 1906, Maurice Denis, *Journal*, 3 vols. (Paris, 1957–59), 2:29. Cézanne's rejection of the device of aerial perspective has been noted by Liliane Brion-Guerry, *Cézanne et l'expression de l'espace* (Paris, 1966; orig. ed. 1950), p. 107.

47. Denis, "Le Renoncement de carrière, la superstition du talent" (1906), *Théories*, p. 214. Among later accounts, the recognition that Cézanne employed little or no "composition in the usual sense" is clearest in Fritz Novotny, *Cézanne und das Ende der wissenschaftlichen Perspektive* (Vienna, 1938), pp. 96–97.

Chapter 9

1. Émile Bernard, "Paul Cézanne," *L'Occident* 6 (July 1904):24. Bernard repeated the quotation in his later article on the artist; Émile Bernard, "Souvenirs sur Paul Cézanne et lettres inédites," *Mercure de France*, n.s., 69 (1 October and 16 October 1907):401.

2. For example, Bernard, speaking both for himself and for Cézanne as his artistic ideal, wrote that the only valid artistic doctrine was this: "Sens la Nature, organise tes perceptions, exprime-toi profondément et avec ordre, c'est-à-dire classiquement"; Bernard, "Cézanne," *L'Occident*, p. 29.

3. On consulting the "old masters," see the discussion of Cézanne's letters to Camoin and Bernard, below, part 3, pp. 180–83. See also Bernard's own allusions to this advice; Bernard, "Cézanne," *L'Occident*, pp. 20, 28. Cf. Couture's remarks in G. Bertauts-Couture, *Thomas Couture, sa vie, son œuvre, son caractère, ses idées, sa méthode par lui-même et par son petit-fils* (Paris, 1932), p. 106.

4. Robert Rey makes a very similar point: "[Cézanne] invoquait la nature, créatrice et nourricière du sentiment classique, contre un idéalisme plus philosophique et plus abstrait vers lequel, croyait-il, son disciple Émile Bernard voulait l'attirer." See Robert Rey, *La Renaissance du sentiment classique dans la peinture française à la fin du XIX^e siècle* (Paris, 1931), p. 89. However, Rey does not acknowledge that the interests of the "impressionist" and the "classicist" are one; this conclusion—to be drawn indirectly from the involvement of Bernard and Denis with Cézanne, and directly from the convergence of the "legends" of Cézanne and Poussin—is central to my own argument (see below, chaps. 13, 14).

5. Bernard, "Cézanne," *L'Occident*, pp. 26–27. Cf. also Louis Lormel, "L'Individualisme et l'école traditionaliste," *La Rénovation esthétique* 5 (August 1907):174; Lormel refers to "le symbolisme déformateur de Paul Cézanne." (Lormel may be a pseudonym for Louis Libaude, Bernard's associate at *La Rénovation esthétique*; on this, see Marcel Giry, "Le Salon des Indépendants de 1905," *L'Information d'histoire de l'art*, May–June 1970, p. 113, n. 10.) Much later, when Bernard fully acknowledged Cézanne's concern for following nature, he became accordingly severely critical; see Émile Bernard, "L'Erreur de Cézanne," *Mercure de France*, n.s., 187 (1 May 1926):513–28. In general, Bernard argued that artists should follow a universal tradition to direct them beyond the individualized experience of nature; see Émile Bernard, *L'Esthétique fondamentale et traditionnelle d'après les maîtres de tous les temps* (Paris, 1910), pp. xi, 11–13.

6. Letter of 5 February 1904; Émile Bernard, "Un Extraordinaire Document sur Paul Cézanne," *Art-Documents* (Geneva), no. 50 (November 1954), p. 4.

7. Bernard, "Cézanne," *L'Occident*, p. 25.

8. In his account of symbolist painting, Aurier called Bernard one of the first to react against "la technique compliquée des impressionnistes"; Albert Aurier, "Les Peintres symbolistes" (1892), *Œuvres posthumes* (Paris, 1893), p. 307. On Bernard's importance for the development of symbolist painting, cf. above, part 1, pp. 5–6.

9. Émile Bernard, "Ce que c'est que l'Art mystique," *Mercure de France*, n.s., 13 (January 1895):38–39; "Les Ateliers," *Mercure de France*, n.s., 13 (February 1895):205.

10. Émile Bernard, "Paul Cézanne," *Les Hommes d'aujourd'hui* 8, no. 387 (February–March 1891); Bernard, "Les Ateliers," p. 196. Cf. Bernard's statement in his letter to André Bonger (September 1891), reprinted in Henri Dorra, "Extraits de la correspondance d'Émile Bernard des débuts à la Rose-Croix (1876–1892)," *Gazette des beaux-arts*, 6 per., 96 (December 1980):239. Bernard declares that "chacun a son maître décidément, et s'y conforme au possible, moi j'ai Cézanne."

11. See Émile Bernard, "Puvis de Chavannes," *L'Occident* 4 (December 1903):273–80, esp. 278; and "Odilon Redon," *L'Occident* 5 (May 1904):223–34.

12. This has been noted also by P.M. Doran in his excellent edition of Cézanne documents, *Conversations avec Cézanne* (Paris, 1978), p. 30. In addition to the May correspondance, Bernard might be relying on Cézanne's letter of 15 April 1904 for some of his information; see John Rewald, ed., *Paul Cézanne, correspondance* (Paris, 1937), pp. 259–60.

13. Letter to Bernard, 26 May 1904; Rewald, *Correspondance*, p. 262.

14. Cézanne's response to Bernard's publication is found in his letter of 25 July 1904; Rewald, *Correspondance*, pp. 264–65. Bernard's reference to Cézanne's desire to "forget everything" (Bernard, "Cézanne," *L'Occident*, p. 20) is confirmed by the artist's letter to Bernard, 23 October 1905; Rewald, *Correspondance*, pp. 276–77. Scholars have usually stated that Cézanne endorsed Bernard's account; see, e.g., Theodore Reff, "Cézanne and Poussin," *Journal of the Warburg and Courtauld Institutes* 23 (1961):153; and Lionello Venturi, *Cézanne* (New York, 1978), p. 41. In the revised edition of the artist's correspondence, however, Rewald correctly cautions that Cézanne has indicated only a general approval of Bernard's project; John Rewald, ed., *Paul Cézanne, correspondance* (Paris, 1978), p. 302, n. 7.

15. Bernard, "Cézanne," *L'Occident*, p. 25.

16. Ibid., pp. 19–20, 22.

17. Ibid., p. 25.

18. Ibid., pp. 21–22. For Bernard, the laws expressed in successful art are both natural and divine; see Émile Bernard, "Définitions," *La Rénovation esthétique* 1 (May 1905):28, 33–35.

19. Émile Bernard, "De l'art naïf et de l'art savant," *Mercure de France*, n.s., 14 (April 1895):86–91.

20. In a related article Bernard wrote that the "true mystics are logical men," that is, they are aware of the necessary relationship between intuited "mystical" truths and the ordered forms of their expression; Émile Bernard, "Les Ateliers," *Mercure de France*, pp. 203, 205.

21. Bernard, "De l'art naïf et de l'art savant," p. 89.

22. Cf. Bernard, "Définitions," p. 27: "[tradition is] the invisible thread which, from the origin of man onward to ourselves, links, fastens together each of the parts of the human spirit [*génie*] under the symbol of harmony." Cf. also the editorial introduction to the first issue of Bernard's journal *La Rénovation esthétique*, where aesthetic tradition is defined as the "synthesis of principles which have guided art toward its supreme realization and which have been consecrated by the tacit agreement of all creators of the beautiful"; "Notre But," *La Rénovation esthétique* 1 (May 1905):4. Bernard makes his basic argument once again in *L'Esthétique fondamentale et traditionnelle*, esp. pp. vi–vii, 111.

23. Bernard, "De l'art naïf et de l'art savant," p. 90 (emphasis added). Cf. also Bernard, "Définitions," pp. 28–31: here Bernard associates mathematics with tradition, style, and beauty, and at one point refers to style as "géométrie instinctive."

24. Théophile Thoré (Thoré-Bürger), "Salon de 1864," *Les Salons*, 3 vols. (Brussels, 1893), 3:93–94.

25. Bernard, "Cézanne," *L'Occident*, p. 23. Maurice Denis's sense of tradition is similar to Bernard's; see Denis, "De Gauguin et de Van Gogh au classicisme" (1909), *Théories, 1890–1910: Du symbolisme et de Gauguin vers un nouvel ordre classique* (Paris, 1920; orig. ed., 1912), p. 275. During the period under consideration, critics often called simultaneously for a knowledge of the past and for originality. Armand Dayot, for example, suggested that the great painter of the end of the century would exhibit "une exécution savante et originale" (in other terms, one both made and found); Armand Dayot, *Un Siècle d'art* (Paris, 1890), p. 81. Similarly, Lecomte praised Puvis de Chavannes for his technical knowledge derived from past art and concluded that he was yet "l'artiste original et créateur"; see Georges Lecomte, *L'Art impressionniste d'après la collection privée de M. Durand-Ruel* (Paris, 1892), pp. 188–89.

26. Bernard, "Cézanne," *L'Occident*, p. 24. On the conventional nature of Cézanne's advice here, see Christopher Gray, "Cézanne's Use of Perspective," *College Art Journal* 19 (Fall 1959):55; E. H. Gombrich, *Art and Illusion* (Princeton, 1969), p. 306; Reff, "Cézanne and Poussin," pp. 169–70; and Theodore Reff, "Cézanne on Solids and Spaces," *Artforum* 16 (October 1977):34–37.

27. Bernard, "Cézanne," *L'Occident*, p. 24 (emphasis added).

28. Ibid., p. 26. Cf. Bernard, "De l'art naïf et de l'art savant," p. 89. Bernard holds that the ultimate origin is God; to experience nature artistically is to come to know God. For example, he writes that "L'Art, c'est l'homme, créature de Dieu, incrusté dans la Nature, et, ainsi, la remontant à la primitive et éternelle Beauté"; Bernard, "Définitions," p. 36. Cézanne might agree with Bernard in theory, but his everyday concerns were more practical and confined to the study of nature as a means of personal expression.

29. Cf. Louis de Mouguerre (writing for the journal Bernard founded and edited), "L'Art

désintéressé et l'exposition des orientalistes," *La Rénovation esthétique* 1 (May 1905):41; de Mouguerre claims that "une personnalité très forte . . . créera nécessairement des œuvres *spontanément* originales qui se réclameront—malgré l'imprévu de leur créateur—des principes de l'Art vrai."

30. Auguste Laugel, *L'Optique et les arts* (Paris, 1869), p. vi.

31. Blanc, of course, also stresses the artist's capacity to manipulate an acquired style and technical principles for specific expressive purposes. Charles Blanc, "Eugène Delacroix" (1864), *Les Artistes de mon temps* (Paris, 1876), pp. 62, 64, 68, 78; Charles Blanc, *Grammaire des arts du dessin* (Paris, 1880; orig. ed., 1867), pp. 20, 564.

32. Bernard approaches doing this (with some misgiving) in his "Essai d'une correspondance entre la couleur et la musique," *L'Esthétique fondamentale et traditionnelle*, pp. 154–64.

33. Bernard, "Cézanne," *L'Occident*, p. 29.

34. See, e.g., Bernard, "Cézanne," *L'Occident*, p. 24. Cf. Bernard, "Souvenirs," *Mercure de France*, pp. 396, 399–400, 613–14.

35. Bernard, "Cézanne," *L'Occident*, p. 28. In his discussion of Redon's art, too, Bernard noted the quality of the unpredictable or unforeseen; see Bernard, "Odilon Redon," p. 226. The essence of Bernard's account of the artist's aims—to organize sensation, to combine logic and expression—also flows through the collection of aphorisms (purported to be Cézanne's) published by Léo Larguier, a young poet who visited the painter in 1902 (*Le Dimanche avec Paul Cézanne* [Paris, 1925], pp. 131–38). Larguier's quotations from the master include several references to a need to "compose" (pp. 133, 138). P. M. Doran has reprinted these remarks along with an explanation of their relationship to Bernard's writings. He concludes that Larguier's account of Cézanne is of questionable (or perhaps undeterminable) value; see Doran, *Conversations avec Cézanne*, pp. 9–10, 14–17.

36. See above, chap. 5.

37. See, e.g., Cézanne's letter to his son, 8 September 1906, Rewald, *Correspondance*, p. 288; and Émile Bernard, "Réfutation de l'impressionnisme," *L'Esthétique fondamentale et traditionnelle*, p. 138.

38. Letters of 13 September and 26 September 1906, Rewald, *Correspondance*, pp. 289, 293.

39. Bernard, "Souvenirs," *Mercure de France*, pp. 394–95; and cf. the similar statement in Bernard's "Julien Tanguy dit le 'Père Tanguy,' " *Mercure de France*, n.s., 76 (16 December 1908):607. Here Bernard contradicts Pissarro's opinion of Cézanne; see Pissarro's letter to Lucien, 21 November 1895, in Camille Pissarro, *Lettres à son fils Lucien*, ed. John Rewald (Paris, 1950), p. 388. Ironically, Bernard is attributing to Cézanne the same problem that the older man had attributed to him; see above, note 38.

40. Bernard, "Souvenirs," *Mercure de France*, p. 397. See also similar remarks by Bernard written in 1904; Bernard, "Un Extraordinaire Document sur Paul Cézanne," p. 4.

41. This is Bernard's version of Cézanne's involvement with Poussin. For the interpretation of Cézanne's meaning, see below, part 3, pp. 180–83.

42. Bernard, "Souvenirs," *Mercure de France*, p. 627. Cf. Bernard, "Cézanne," *L'Occident*, p. 19: "Au contact de la Création [les Maîtres] sont devenus créateurs." Cf. also Émile Bernard, "La Méthode traditionnelle," *La Rénovation esthétique* 8 (April 1909):295; "l'art est seulement classique lorsqu'à travers ses lois *propres* il recherche et trouve la Beauté" (emphasis added). It was very common to distinguish an academic classicism from one discovered

through nature; cf., e.g., Pissarro's letter to Lucien, 26 November 1896, Pissarro, *Lettres à son fils Lucien*, p. 427: "Nous ne demandons pas mieux que d'être classiques, mais en le trouvant par notre propre sensation."

43. Bernard, "Réfutation de l'impressionnisme," *L'Esthétique fondamentale et traditionnelle*, pp. 138–39. Cézanne had his own reasons not to be followed. According to Monet, he had remarked of the younger admirers of the impressionist generation: "Les jeunes gens d'aujourd'hui, en étudiant de trop près nos formules, perdent à jamais tout espoir d'être euxmêmes." See Gérome-Maësse, "Cézanne: L'Opinion de Claude Monet," *Les Tendances nouvelles*, no. 26 (December 1906), p. 433. Aurier had previously used the opposition of "chercheurs" and "trouveurs" in a manner similar to Bernard's; Albert Aurier, "Boniment initial," *Le Moderniste illustré* 1 (April 1889):2 (information supplied by Patricia Mathews).

44. Bernard's *Le Pouldu* (fig. 31) is traditionally dated ca. 1886, although it might date later. Its pattern of parallel brushstrokes is typical of many of Bernard's paintings and was usually associated with Cézanne's technique. For the most part, Bernard was willing to let history record him as a follower of Cézanne. He insisted, however, that he was Gauguin's "initiator" rather than his disciple. Along with his supporters, Bernard campaigned (in the early 1890s in the pages of *Mercure de France* and later, around 1902–07, in *L'Occident* and *La Rénovation esthétique*) to establish himself as the guiding spirit of the symbolist movement in painting. See, e.g., Lormel, pp. 171–75; and above, chap. 1, n. 16.

45. Denis, "Cézanne," (1907), *Théories*, pp. 251, 246.

46. Denis uses Bernard's terms at the end of his essay and refers to the artistic aim Bernard had emphasized, to "organize one's sensations"; Denis, "Cézanne," *Théories*, p. 261. Denis had also given Bernard's argument when he wrote that the naïve vision of primitives may be succeeded by a "classical" art that coordinates (found) vision and (made) technique, and may also eventually be followed by an art of convention and imitation; see Denis, "De la gaucherie des primitifs" (1904), *Théories*, pp. 176–77. Cf. also Denis's reference to the fact that "la barbarie" is followed by "la sagesse" in symbolist art; Denis, "De Gauguin et de Van Gogh au classicisme" (1909), *Théories*, p. 265.

47. Denis, Cézanne," *Théories*, p. 254. Denis had written that the "classical artist synthesizes . . . Beauty not only when he sculpts or paints but when he [merely] looks around himself"; "De la gaucherie des primitifs," *Théories*, p. 176.

48. Denis, "Cézanne," *Théories*, p. 260. See also, Maurice Denis, *Journal*, 3 vols. (Paris, 1957–59), 1:197.

49. Denis, "A propos de l'exposition de Charles Guérin" (1905), *Théories*, p. 144. Maillol, too, is "instinctively" classical; see Denis, "De Gauguin, de Whistler et de l'excès des théories" (1905), *Théories*, p. 210.

50. Cf. the standard complaint concerning the "froideur" of the "École de David," painters who supposedly imitated antique style to the point of ignoring nature entirely; see, e.g., Delacroix's journal entry for 13 January 1857, in André Joubin, ed., *Journal d'Eugène Delacroix*, 3 vols. (Paris, 1950), 3:23.

51. Denis, "De Gauguin et de Van Gogh au classicisme," *Théories*, p. 275.

52. Ibid., pp. 267–68.

53. Denis, "A propos de l'exposition d'A. Séguin" (1895), *Théories*, p. 23.

54. Denis, "Préface de la IX^e exposition des peintres impressionnistes et symbolistes" (1895), *Théories*, p. 29.

55. See above, part 1, p. 38.

56. In the opposition of nature and style, nature is "subjective" if one regards it as known only in personal impressions; and style, as a technique of social mediation, becomes "objective." If, instead, "style" is regarded as the human "deformation" of nature, it becomes "subjective"; and nature, as the given permanent reality, becomes "objective."

57. Denis, "Cézanne," "De Gauguin et de Van Gogh au classicisme," *Théories*, pp. 250, 268.

58. Rivière and Schnerb saw in Cézanne's painting neither traditional composition nor any premeditated arrangement of a subject in terms of forms and colors. Instead they located the artist's procedural decisions in the application of color itself, which might result in a "composition" of unexpected deviation from natural color or normal proportion—Cézanne's technique followed its own direction and evolution. See R. P. Rivière and J. F. Schnerb, "L'Atelier de Cézanne," *La Grande Revue* 46 (25 December 1907):815–16. On this issue, cf. also Bernard, "Souvenirs," *Mercure de France*, p. 395: "This picture of skulls . . . changed color and form almost each day. . . . Truly, his manner of study was a meditation, brush in hand." For Fry's general application of the theory of emotional expression (associated here with Denis), see Roger Fry, "An Essay in Aesthetics" (1909), *Vision and Design* (New York, 1956), pp. 16–38. For Fry's formal analysis of Cézanne's paintings, see his *Cézanne, a Study of His Development* (New York, 1958; orig. ed., 1927). Both works are discussed below, chap. 10.

59. Denis, "De Gauguin et de Van Gogh au classicisme," *Théories*, pp. 276, 278. The latter part of this quotation is a revised and expanded version of the concluding statement in the original essay of 1909. The revised version is found in both the 1912 and 1920 editions of *Théories*. On Denis's revisions, see below, pp. 138–39.

60. Denis, "Le Soleil" (1906), *Théories*, p. 223. Cf. Denis, *Journal*, 2:29.

61. Denis, "De Gauguin, de Whistler et de l'excès des théories," *Théories*, p. 204.

62. Ibid., p. 209.

63. Denis, "Cézanne," *Théories*, pp. 260, 250; and "Cézanne," *L'Occident* 12 (September 1907):123. On Denis's revision in wording with regard to the nature of Cézanne's classicism, see below, pp. 138–39.

64. Denis, "Cézanne," *Théories*, p. 251. Cf. the similar remarks in Maurice Denis, "L'Impressionnisme et la France" (1917) and "L'Influence de Cézanne" (1920), *Nouvelles Théories, sur l'art moderne, sur l'art sacré, 1914–1921* (Paris, 1922), pp. 67, 127–28. Whereas Denis would fault Puvis for imposing a deliberate style upon his art, Georges Lecomte, touching on the same issues, had earlier praised this artist for avoiding an artificial, primitivistic "gaucherie." In his discussion of Puvis, Lecomte seems to conceive of a necessary passage from a "naïf" state to a "savant" state, just as Bernard would; and he warns that spontaneity should not be faked: "[Puvis] sait bien qu'on n'a pas le droit d'annuler la science acquise, l'enseignement des siècles et que le pastiche d'un art gauche, d'une naïveté si spontanée serait une duperie sans intérêt s'il était accompli délibérément par des peintres modernes, animés d'un esprit tout différent." See Lecomte, *L'Art impressionniste*, p. 188.

65. Denis, "Cézanne," *Théories*, p. 255. Of course, Denis's argument had been made by many others during the eighteenth and nineteenth centuries. In its call for reform of the academic system, Denis's (neo)classicism resembles David's.

66. Denis, "Cézanne," "La Réaction nationaliste" (1905), "De Gauguin, de Whistler et de l'excès des théories," "De Gauguin et de Van Gogh au classicisme," *Théories*, pp. 261, 255,

189, 204, 207, 265. Cf. also Denis's remarks on "apparent originality"; "Les Arts à Rome ou la méthode classique" (1898), *Théories*, p. 49.

67. Cf., e.g., Gérome-Maësse, "A propos du Salon d'Automne: Manet, Ingres, Renoir, Carrière," *Les Tendances nouvelles*, no. 13 (30 October 1905), pp. 190–91.

68. Denis, *Journal*, 1:197.

69. Denis, "Cézanne," "De Gauguin et de Van Gogh au classicisme," "Artistide Maillol" (1905), "La Réaction nationaliste," *Théories*, pp. 247, 260, 276, 236, 190.

70. Zola had previously reached this conclusion in his early formulation of a theory of artistic genius and artistic law, expressed in a letter to Antony Valabrègue, 18 August 1864. See Émile Zola, *Le Bon Combat, de Courbet aux impressionnistes*, ed. Jean-Paul Bouillon (Paris, 1974), p. 300.

71. Denis, "De Gauguin, de Whistler et de l'excès des théories," "Aristide Maillol," *Théories*, pp. 210, 235–36, 244.

72. Denis, "Cézanne," *Théories*, pp. 254, 247. Denis's suggestion that Maillol and Cézanne shared similar artistic aims was endorsed by Fry; see Roger Fry, "The Sculpture of Maillol," *Burlington Magazine* 17 (April 1910):31.

73. Denis, *Journal*, 1:195.

74. Denis, "Cézanne," *Théories*, p. 251.

75. Denis, *Journal*, 1:195.

76. Denis, "De Gauguin et de Van Gogh au classicisme," *Théories*, p. 272.

77. Denis, "De Gauguin et de Van Gogh au classicisme," "La Réaction nationaliste," *Théories*, pp. 274, 189–91.

78. Denis, "Cézanne," *Théories*, p. 260 (emphasis added).

79. Ibid., p. 254.

80. See Denis, "La Réaction nationaliste," "De Gauguin et de Van Gogh au classicisme," *Théories*, pp. 197–98, 266–67.

81. See Maurice Denis, "Cézanne," *L'Occident* 12 (September 1907):123; and "Cézanne," *Théories*, p. 242 (1912 ed.) and p. 250 (1920 ed.).

82. On Homer, see, e.g., Charles-Augustin Sainte-Beuve, "Qu'est-ce qu'un classique?" (1850), *Causeries de lundi*, 15 vols. (Paris, n.d.), 3:46. For an account of an eighteenth-century version of the argument about Homer, cf. Philippe Van Tieghem, *Les Grandes Doctrines littéraires en France de la Pléiade au surréalisme* (Paris, 1974), pp. 79–80.

83. Denis, "Les Arts à Rome ou la méthode classique," *Théories*, p. 52. Cf. Denis's letter to Vuillard (22 February 1898), *Journal*, 1:140.

84. Denis, "De Gauguin et de Van Gogh au classicisme," *Théories*, pp. 266–68, 275. Cf. also Denis, "Notes sur la peinture religieuse" (1896), "Les Arts à Rome ou la méthode classique," "Le Soleil," "Cézanne," *Théories*, pp. 34, 51, 223, 253.

85. Curiously, Matisse serves Denis as an example of both cases. In 1905 and 1906 he is described as too theoretical, and in 1908 as too instinctive. Denis recommends tradition as the antidote; see Denis, "De Gauguin, de Whistler et de l'excès des théories," "Le Renoncement de carrière, la superstition du talent" (1906), "Le Soleil," "De Gauguin et de Van Gogh au classicisme," *Théories*, pp. 208, 216, 220, 271–72. On Matisse's use of "theory," cf. the remarks of Denis's friend André Gide, "Promenade au Salon d'Automne," *Gazette des beaux-arts*, 3 per., 34 (1 December 1905):483–84. Alfred Barr (*Matisse, His Art and His Public* [New York, 1951], pp. 63–64, 81) discusses Denis's views on Matisse and argues that Denis's own "traditionism" was antithetical to any genuine artistic innovation. Barr fails to recognize that for Denis the return to tradition entailed a revolutionizing of modern art.

Chapter 10

1. Roger Fry, "The French Post-Impressionists" (1912), *Vision and Design* (New York, 1956), p. 242.

2. Roger Fry, "La Peinture moderne en France," trans. Victor Llona, *L'Amour de l'art 5* (May 1924):152.

3. Roger Fry, *Cézanne, a Study of His Development* (New York, 1958; orig. ed., 1927), p. 87. Cf. also Roger Fry, "The Post-Impressionists—II," *The Nation* 8 (3 December 1910):403; "Cézanne is the great classic of our time."

4. Maurice Denis, "De Gauguin, de Whistler et de l'excès des théories" (1905), *Théories, 1890–1910: Du symbolisme et de Gauguin vers un nouvel ordre classique* (Paris, 1920; orig. ed., 1912), p. 208.

5. Fry, "The Post-Impressionists—II," *The Nation*, p. 402 (emphasis added). The contradictions did not go unnoticed. Fry, like Denis, had also claimed that Cézanne's apparent primitivism and distortion arose unself-consciously as a result of his naïve and sincere expression; Roger Fry, "The Grafton Gallery—I," *The Nation* 8 (19 November 1910):331–32. To this, a respondent replied that there was no such honest discovery in operation, for the "Post-Impressionists purposely paint with an assumed ineptitude." See Michael Sadler, "Post-Impressionism," *The Nation* 8 (3 December 1910):405.

6. Maurice Denis, "Cézanne," trans. Roger E. Fry, *Burlington Magazine* 16 (January, February 1910):207–19, 275–80. Since Fry's major writings on Cézanne and modern art follow the appearance of Denis's, one often has the impression that Fry was the younger man; but he was in fact slightly older, having been born in 1866. Matisse, Bernard, Denis, and Fry all belong to the same historical generation.

7. Fry, "Retrospect" (1920), *Vision and Design*, pp. 287, 290.

8. Denis, "Cézanne," *L'Occident* 12 (September 1907):126; trans. Fry, p. 275. In Denis's revised version of the essay for *Théories* (p. 254), the word "beau" is substituted for "esthétique."

9. Denis's comment here must apply to both Cézanne and Redon; one art is naturalistic, the other dreamlike. Hence, the "sensibility" involved may be stimulated by either external nature or internalized imaginative forces. On Denis's notion of the opposition of classical harmony and individual expression, and the resolution of this tension in Cézanne and others, see above, p. 137.

10. Denis, "Cézanne," *Théories*, p. 256; trans. Fry, p. 276 (emphasis added).

11. Fry, "An Essay in Aesthetics" (1909), "Retrospect," *Vision and Design*, pp. 22, 285, 302. See also Fry, *Cézanne*, p. 88: "analysis halts before the ultimate concrete reality of the work of art."

12. Fry, "An Essay in Aesthetics," *Vision and Design*, p. 31. Fry finds powerful artistic expression derived from such "orderly connections" in the Avignon *Pietà*: "It is the four parallel diagonal lines to the right cut at right angles by the wilfully rigid line of the dead torso and balanced on the left by the prominent mass of the donor that convey to us, quite apart from their meaning as representation, so deep a sense of pity and awe. . . ." See Roger Fry, "The Exhibition of French Primitives—Part II," *Burlington Magazine* 5 (July 1904):379. Roger Marx, at the same time, noted that visitors to the exhibition of "Primitifs français" related Cézanne's style to that of the Avignon *Pietà*; Roger Marx, "Le Salon d'Automne," *Gazette des beaux-arts*, 3 per., 32 (December 1904):462–63.

13. Denman W. Ross, *A Theory of Pure Design* (New York, 1933; orig. ed., 1907), p. vi.

14. Fry, "An Essay in Aesthetics," *Vision and Design*, pp. 37–38 (emphasis added).

15. See Herbert Read, "Farewell to Formalism," *Art News*, Summer 1952, p. 37.

16. Roger Fry, "Post Impressionism," *Fortnightly Review* 95 (December 1911):857–58. On Sickert and distortion, cf. also Roger Fry, "Line as a Means of Expression in Modern Art," *Burlington Magazine* 33 (December 1918):206; and 34 (February 1919):69.

17. Fry, "Post Impressionism," *Fortnightly Review*, pp. 863–64, 867 (emphasis added). In 1924, Fry would claim that when artists of the nineteenth century produced paintings of solid construction, this was arrived at "by some unconscious and instinctive process"; the more contemporary painters, however, worked at their construction deliberately. See Fry, "La Peinture moderne en France," *L'Amour de l'art*, pp. 143–44.

18. Roger Fry, "Observations on a Keeper," *Burlington Magazine* 60 (February 1932):99 (emphasis added). On the criticism of Fry and MacColl, cf. Jacqueline V. Falkenheim, *Roger Fry and the Beginnings of Formalist Art Criticism* (Ann Arbor, 1980), chap. 3.

19. D. S. MacColl, "Cézanne's Sketch, *Landscape and Bacchanales*," *Burlington Magazine* 40 (January 1922):42.

20. Fry, "Observations on a Keeper," p. 99 (emphasis added).

21. D. S. MacColl, "Cézanne as Deity" (1928), *What Is Art?* (Harmondsworth, 1940), pp. 65–75.

22. MacColl, "A Year of 'Post-Impressionism'" (1912), *What Is Art?*, p. 21.

23. MacColl, "Cézanne as Deity," *What Is Art?*, p. 65. Cf. Fry, *Cézanne*, p. 10.

24. Fry, *Cézanne*, p. 88. When Fry first studied the Pellerin collection, around which his essay on Cézanne was constructed, he indicated that he would have especially great difficulty in assessing Cézanne's style; see his letters to Helen Anrep, 1 and 8 May 1925, reprinted in Denys Sutton, ed., *Letters of Roger Fry*, 2 vols. (New York, 1972), 2:568, 571. Fry found that his rational descriptive language could not capture the full force of Cézanne's art; yet he refused to move toward a more evocative, poetic prose. He was not in sympathy with Meier-Graefe, who had done so: "Professor Meier-Graefe considers the critic's task to be itself a kind of artistic creation. His aim has been to use language not so much for analysis, for precise discrimination of values, and for exposition as for the evocation by means of words of a feeling as nearly possible corresponding to that provided by the artist's work. . . . I confess I find it difficult to get precise and definite ideas from such writing as this." See Roger Fry, "In Praise of Cézanne" (rev. of *Cézanne* by Julius Meier-Graefe), *Burlington Magazine* 52 (February 1928):98–99.

25. One must recall here that Fry was an active painter as well as critic. On the general issue of translating "higher" experience into language, cf. the multitude of observations made by Allan Janik and Stephen Toulmin in their *Wittgenstein's Vienna* (New York, 1973). John Ruskin set an example for Fry in writing that the "feelings are but feebly touched, if they permit us to reason on the methods of their excitement." John Ruskin, "Preface to the Second Edition" (1844), *Modern Painters*, 5 vols. (London, 1906), 1:xxxiv.

26. Fry, *Cézanne*, p. 35.

27. Ibid., p. 3.

28. Roger Fry, "The Last Phase of Impressionism," *Burlington Magazine* 12 (March 1908):375. Still earlier, in an unsigned review, Fry described Cézanne as using a "wilful opposition of local colours," and as seeking decorative pattern at the expense of fidelity to appearances; see "The New Gallery," *The Atheneum*, 13 January 1906, p. 57.

29. Fry, *Cézanne*, pp. 48–49, 53–54, 59, 66, 77, 79. Fry faced the same issues of finding and making when he wrote about Claude in 1907. He associated Claude's "originality" with a relatively passive acceptance of natural effects; this receptiveness was tempered by the artist's concern for the "laws of design" and for the use of a "logical and mathematical formula." As in the case of Cézanne, Fry admitted to critical indecision: "we must be careful not to count as failings qualities which are essential to the particular kind of beauty that Claude envisages, though, to be quite frank, it is sometimes hard to make up one's mind whether a particular characteristic is a lucky defect or a calculated negation." See Fry, "Claude" (1907), *Vision and Design*, pp. 229–30, 221. Kenneth Clark, writing on Claude in 1949, also remained indecisive: "Claude nearly always conformed to an underlying scheme of composition. . . . In spite of his extreme formality, nothing in Claude is a formula." See Kenneth Clark, *Landscape into Art* (Boston, 1961; orig. ed., 1949), p. 64.

30. Fry, *Cézanne*, pp. 81–82.

31. Ibid., pp. 83–86.

32. Ibid., p. 53. Cf. Fry in 1910: "[in his still-life objects Cézanne] has found...the statement of their material qualities, a language that passes altogether beyond their actual associations with common use and wont." See Fry, "The Post-Impressionists—II," *The Nation*, p. 402. Cf. also Fry's lecture of 1933, "The Double Nature of Painting," translated from the French by Pamela Diamand, abridged and published posthumously in *Apollo* 89 (1969):362–71, esp. 365–66. Here Fry reiterates his claim that Cézanne's art is "pure" and "architectural," that it bears no associated ideas; but he goes on to give some support to "pictures which make their appeal by the associated ideas and emotions called up by the representation of objects in a manner corresponding to literature."

33. Fry, "An Essay in Aesthetics," *Vision and Design*, p. 29; Fry, "Line as a Means of Expression in Modern Art," p. 69. Cf. Fry's appreciation that in Kandinsky's abstractions the "form has to stand the test without any adventitious aids," i.e., without any reference to natural appearances; see Roger Fry, "The Allied Artists," *The Nation* 13 (2 August 1913):677.

34. Fry, "The Artist's Vision" (1919), *Vision and Design*, pp. 51–52.

35. Elsewhere Fry had labeled such vision "formalist"; see Roger Fry, "Children's Drawings," *Burlington Magazine* 30 (June 1917):226.

36. Roger Fry, "Mr. MacColl and Drawing," *Burlington Magazine* 35 (August 1919):84. Concerning the general theoretical issues that Fry raises, see above, chap. 6, note 13.

37. Fry, *Cézanne*, p. 53.

38. Ibid., p. 3.

39. Ibid., pp. 40, 70.

40. Fry, "Line as a Means of Expression in Modern Art," p. 206.

41. Fry, "Paul Cézanne" (1917; rev. of *Paul Cézanne* by Ambroise Vollard), *Vision and Design*, pp. 256–57.

Chapter 11

1. See Desmond MacCarthy, "The Art-Quake of 1910," *The Listener*, 1 February 1945, p. 124.

2. On Denis, see above, part 2, pp. 133–40. Meier-Graefe's major publication was *Die Entwicklungsgeschichte der modernen Kunst: Ein Beitrag zur modernen Ästhetik*, 3 vols. (Stutt-

gart, 1904; English edition: *Modern Art: Being a Contribution to a New System of Aesthetics*, trans. Florence Simmonds and George W. Chrystal, 2 vols. [London, 1908]). Meyer-Riefstahl's work, like that of Meier-Graefe, appeared in English translation; "Vincent van Gogh," trans. H. C. Ferraby, *Burlington Magazine* 18 (November, December 1910):91–99, 155–62. Meyer-Riefstahl cites Meier-Graefe as an authority (p. 97); he identifies Cézanne, Seurat, Van Gogh, and Gauguin (the four who are eventually sanctioned as the major "postimpressionists") as representatives of the new art that succeeds impressionism, and associates them with primitivism, naïveté, classicism, and a union of nature and self (pp. 91–92).

In Meier-Graefe's *Entwicklungsgeschichte*, many themes also to be found in Denis or Fry are developed, as well as other points concerning impressionism and symbolism discussed above (parts 1 and 2). With regard to the expressive intentions of the artists, Meier-Graefe does not make as firm a distinction between impressionism and later styles as does Fry. He refers to the double origin of art in nature and temperament: the fundamental artistic law is "der Natur, zumal der eigenen Natur zu folgen" (1:130). Like Zola, he implies that impressionist art conveys no "ideas" but is nevertheless subjective; it depends on temperament more than on nature (1:151, 154). He speaks of the expressive quality of the art of both Manet and Cézanne (1:154, 166). And, in reference to Maillol, he raises the issues of "instinctive" classicism and the opposition of "naïf" and "savant" art (1:395, 399).

Among British critics, R. A. M. Stevenson resembles Meier-Graefe in his emphasis on the subjectivity of "impressionist" styles. He argues that a proper technique must always allow the expression of personalized experience. Ideally, the "decorative pattern" of a painting should correspond to the mood felt by the impressionist artist. See R. A. M. Stevenson, *Velasquez* (London, 1899), pp. 40–41, 95.

3. MacCarthy, "The Art-Quake of 1910," p. 124. Cf. Roger Fry, "Retrospect" (1920), *Vision and Design* (New York, 1956), p. 290.

4. A recent essay by Alan Bowness misses the opportunity to reinvestigate the critical moment when Fry's choice of term obscured its origins. Bowness repeats the information given by Desmond MacCarthy and quotes several passages from the Fry/MacCarthy essay, but sees little more in this statement than evidence of the "reaction against (or crisis within) Impressionism that occurred in the 1880s." Bowness himself dismisses the proposed label "expressionism" as a poor alternative to "postimpressionism" and, with regard to the former term, notes only its use by Meier-Graefe. See Alan Bowness, introduction, *Post-Impressionism: Cross-Currents in European Painting* (New York, 1979), pp. 9–10. On the so-called crisis of impressionism, cf. above, part 1, pp. 11–12 and n. 40. On the use of the term "expressionism," see Donald E. Gordon, "On the Origin of the Word 'Expressionism,'" *Journal of the Warburg and Courtauld Institutes* 29 (1966):368–85. Gordon's conclusions about the import of the term should be modified in view of the arguments I have presented in part 1.

5. On the "ideal," see above, part 1, pp. 39–42. Fry associated "idealization" with the "distortion" that seemed to characterize postimpressionist art; Roger Fry, "Post Impressionism," *Fortnightly Review* 95 (May 1911):857–58.

6. For example, Gustave Geffroy and Georges Lecomte; see part 1, pp. 10–12, 44.

7. See Fry, "Retrospect," *Vision and Design*, p. 293: "What remained of immense importance [in Tolstoy's theory of art] was the idea that a work of art was . . . the expression of an emotion felt by the artist and conveyed to the spectator."

8. Charles Lewis Hind, *The Post Impressionists* (London, 1911), p. 3. Hind names Cézanne, Van Gogh, and Gauguin as the initiating postimpressionists and considers Matisse

(who "paints . . . his temperament") as their major younger follower (pp. 3, 11–12, 46). He cites the English edition of Meier-Graefe's *Entwicklungsgeschichte* as an authoritative text (p. 31).

9. A. Clutton-Brock, "The Post-Impressionists," *Burlington Magazine* 18 (January 1911):216.

10. See Roger Fry, "An Essay in Aesthetics" (1909), *Vision and Design*, pp. 16–38; "The Grafton Gallery—I," *The Nation* 8 (19 November 1910):331–32; "Line as a Means of Expression in Modern Art," *Burlington Magazine* 33 (December 1918):201–8 and 34 (February 1919):62–69.

11. This theory of expression, rather crudely sketched by Fry, is presented in a much more refined and complete form in R. G. Collingwood, *The Principles of Art* (Oxford, 1938).

12. (Roger Fry and Desmond MacCarthy), "The Post-Impressionists," *Manet and the Post-Impressionists* (London, Grafton Galleries, 1910), p. 12.

13. Fry/MacCarthy, "The Post-Impressionists," p. 7. The authors nearly contradict their introductory statement two paragraphs below when they write that the "two groups had one characteristic in common: the resolve of each artist to express his own temperament" (p. 8).

14. Fry/MacCarthy, "The Post-Impressionists," pp. 8–9. Cf. Fry, "The Grafton Gallery—I," p. 332. Cf. also Hind (p. 19), who, while probably referring to Fry's argument, seems to give impressionism a character more like postimpressionism and less like traditional representation: "Orthodox art is painting the imitation of things[,] Impressionism is painting the effect of things [and] Post Impressionism is painting the psychological feeling or sensation of things. Or, more briefly, the old way was representation; the new way is—expression. Yet the new is not new, and the old is not old." In general, Hind does not attempt to mark any definitive division between impressionism and postimpressionism.

Fry later associated the distinction between passive representation and active expression with that between rendering particulars and rendering universals; Roger Fry, "Mr. MacColl and Drawing," *Burlington Magazine* 35 (August 1919):85. Fry's basic arguments concerning impressionism have been repeated to the present day, to the detriment of a fair assessment of the artists' purposes; for a recent example of this type of reasoning, see Bowness, p. 11: "in the later 1880s...experience rather than appearance became the reason for art." Cf. the similar statements in Richard Cork, "A Postmortem on Post-Impressionism," *Art in America* 68 (October 1980):91.

15. Octave Mirbeau, "Vincent van Gogh," *L'Echo de Paris*, 31 March 1891, p. 1; Octave Mirbeau, "Claude Monet," *L'Art dans les deux mondes* (March 1891), quoted in Steven Z. Levine, *Monet and His Critics* (New York, 1976), p. 118. Cf. above, part 1, pp. 49–50.

16. John Rewald, *Post-Impressionism from Van Gogh to Gauguin* (New York, 1962). A second volume covering the later years of the movement ("from Gauguin to Matisse") is projected. Rewald notes that the "word *post-impressionism* is not a very precise term, though it is certainly a very convenient one" (p. 9). Sven Loevgren, *The Genesis of Modernism* (Bloomington, 1971).

17. Fry and MacCarthy write that "before every scene and every object [Van Gogh] searches first for the quality which originally made it appeal so strongly to him: *that* he is determined to record at any sacrifice." Of Gauguin, they note that "he deliberately chose . . . to become a decorative painter, believing that this was the most direct way of impressing upon the imagination the emotion he wished to perpetuate"; "The Post-Impressionists," p. 11.

18. Fry/MacCarthy, "The Post-Impressionists," pp. 9–10.

19. A year earlier, before "Post-Impressionism," Fry had noted that the new painting in France, with which Cézanne was associated, implied the "direct contrary of the Impressionist conception of art." See Fry's introduction to Maurice Denis, "Cézanne," *Burlington Magazine* 16 (January 1910):207.

20. Fry, "Post Impressionism," *Fortnightly Review*, pp. 866–67.

21. Henri Matisse, "Notes d'un peintre" (1908), *Écrits et propos sur l'art*, ed. Dominique Fourcade (Paris, 1972), p. 42.

22. Vollard, for example, is the source of an often repeated remark that Cézanne supposedly made concerning Monet, which could be interpreted either as high praise of this artist or as a cynical slight: "Monet is only an eye; but good God what an eye!" In a clearly fictive dialogue published later by Gasquet, Cézanne presents a very similar statement on Monet. See Ambroise Vollard, *Paul Cézanne* (Paris, 1914), p. 88; Joachim Gasquet, *Cézanne* (Paris, 1921), p. 90. Rewald and Reff have seriously challenged the reliability of these later accounts of Cézanne's activities and statements. See John Rewald, *Cézanne, Geffroy et Gasquet suivi de souvenirs sur Cézanne de Louis Aurenche et de lettres inédites* (Paris, 1959), pp. 51–55; Theodore Reff, "Cézanne and Poussin," *Journal of the Warburg and Courtauld Institutes* 23 (1960):150–74. Following Vollard and Gasquet, Fry repeated the remark about Monet in his *Cézanne, a Study of His Development* (New York, 1958; orig. ed., 1927), p. 57.

Chapter 12

1. See Albert Aurier, "Les Isolés: Vincent van Gogh" (1890–92), "Le Symbolisme en peinture: Paul Gauguin" (1891), "Essai sur une nouvelle méthode de critique" (1892), *Œuvres posthumes* (Paris, 1893), pp. 262–63, 216, 202. On the common theme of the degeneration of modern Western society, cf., e.g., Victor de Laprade, *Le Sentiment de la nature chez les modernes* (Paris, 1868), pp. 483–88.

2. In a note to Geffroy (23 November 1894), Monet described Cézanne as "si singulier, si craintif de voir de nouveaux visages"; for this and the summary details of Cézanne's encounter with Rodin, Clemenceau, and others during his visit with Monet, see Daniel Wildenstein, *Claude Monet, Biographie et catalogue raisonné*, 3 vols. (Lausanne, 1974–79), 3:60, 278. During his later years at Aix, Cézanne was sought out by many younger admirers; nearly all noted the quirks of his personality. Jean Royère found him nervous and fidgety; to Léo Larguier, he seemed a bit paranoid. See Jean Royère, "Sur Paul Cézanne," *La Phalange* 1 (15 November 1906):378; Léo Larguier, "Journal des revues," *Antée* (Bruges) 2 (1 January 1907):870. Earlier in his career, Cézanne may have inspired the odd characters Marsabiel and Maillobert in Edmond Duranty's stories "Le Peintre Marsabiel" (1867) and "Le Peintre Louis Martin" (1872); see Marcel Crouzet, *Un Méconnu du réalisme: Duranty* (Paris, 1964), pp. 245–47. Perhaps Cézanne also inspired the character "Paul Seguin" (*sic*); see Mario Petrone, " 'La Double Vue de Louis Séguin' de Duranty," *Gazette des beaux-arts*, 6 per., 88 (December 1976):235–39.

3. The standard sources of information on Cézanne are John Rewald, *Paul Cézanne: A Biography* (New York, 1968; expanded version of the work first published as *Cézanne et Zola* [Paris, 1936]); and Lionello Venturi, *Cézanne, son art, son œuvre*, 2 vols. (Paris, 1936). Essential documentation is given in John Rewald, ed., *Paul Cézanne, correspondance* (Paris, 1937; enlarged ed.: Paris, 1978).

4. Maurice Denis, "L'Influence de Cézanne" (1920), *Nouvelles Théories, sur l'art moderne, sur l'art sacré, 1914–1921* (Paris, 1922), p. 118.

5. On this point, see John Rewald's many interesting observations in his *Cézanne, Geffroy et Gasquet suivi de souvenirs sur Cézanne de Louis Aurenche et de lettres inédites* (Paris, 1959), pp. 9–55.

6. Until his father's death in 1886, Cézanne was kept on a limited allowance and often had serious difficulties; yet he never seems to have considered his art as a means to financial security.

7. Cézanne's few public appearances during the period 1877–95 were not of great consequence. Through the intercession of Antoine Guillemet, he showed a portrait in the Salon of 1882 (Rewald, *Paul Cézanne*, p. 133). There was almost no critical comment, but one comprehensive reviewer briefly noted that his painting indicated "un coloriste dans l'avenir"; Théodore Véron, *Dictionnaire Véron, Salon de 1882* (Paris, 1882), p. 113. Again, in 1889, an influential friend interceded on Cézanne's behalf, and a work was shown at the Paris Exposition universelle. Cézanne also exhibited three paintings by invitation with the group "Les XX" in Brussels in 1890.

8. Gustave Geffroy, "Paul Cézanne" (1894), *La Vie artistique*, 8 vols. (Paris, 1892–1903), 3:249.

9. Camille Mauclair, "Destinées de la peinture française," *La Nouvelle Revue* 93 (March 1895):372.

10. In his memoirs, Camille Mauclair attempted to debunk the Cézanne myth and claimed that the artist's success was almost entirely due to scheming dealers; Camille Mauclair, *Servitude et grandeur littéraires* (Paris, 1922), pp. 186–89.

11. Charles Morice, "Enquête sur les tendances actuelles des arts plastiques," *Mercure de France*, n.s., 56 (1 August 1905):349. On Cézanne's continuing isolation after his fame, see Émile Bernard, "Paul Cézanne," *L'Occident* 6 (July 1904):20; Charles Morice, "Paul Cézanne," *Mercure de France*, n.s., 65 (15 February 1907):577–79.

12. For the symbolist appreciation of Tanguy's activities, see Émile Bernard, "Julien Tanguy dit le 'Père Tanguy,' " *Mercure de France*, n.s., 76 (16 December 1908):600–616. For an account of Tanguy's business affairs with Cézanne, see Wayne V. Andersen, "Cézanne, Tanguy, Chocquet," *Art Bulletin* 49 (June 1967):137; and Merete Bodelsen, "Early Impressionist Sales 1874–94 in the Light of Some Unpublished 'Procès-verbaux,' " *Burlington Magazine* 110 (June 1968):334–35, 346–47. Some Cézanne paintings may also have been available through the dealer Portier.

13. See Merete Bodelsen, "Gauguin's Cézannes," *Burlington Magazine* 104 (May 1962):204–11; and "Gauguin, the Collector," *Burlington Magazine* 112 (September 1970):594.

14. On Gauguin's contemplation of artistic "theft," see his letter to Pissarro (summer 1881), as quoted in John Rewald, *The History of Impressionism* (New York, 1961), p. 458. On Cézanne's complaints about "plagiarism," see Gustave Geffroy (reporting a conversation with Cézanne of 1896), *Claude Monet, sa vie, son œuvre*, 2 vols. (Paris, 1924), 2:68; and Émile Bernard (reporting a conversation with Cézanne of 1904), "Souvenirs sur Paul Cézanne et lettres inédites," *Mercure de France*, n.s., 69 (1 October 1907):400. Cf. also Maurice Denis, "Cézanne" (1907), *Théories, 1890–1910: Du symbolisme et de Gauguin vers un nouvel ordre classique* (Paris, 1920; orig. ed., 1912), p. 261; Ambroise Vollard, *Paul Cézanne* (Paris, 1919; orig. ed., 1914), p. 102.

15. For Cézanne's disapproval of the art of Gauguin and Van Gogh, see his letter to Émile Bernard, 15 April 1904, Rewald, *Correspondance*, p. 260. Bernard later reported that Cézanne had once encountered Van Gogh in Tanguy's shop and said: "Sincèrement, vous faites une peinture de fou!" See Bernard, "Julien Tanguy," p. 607.

16. See Gauguin's letter to Émile Schuffenecker, 14 January 1885, in Maurice Malingue, ed., *Lettres de Gauguin à sa femme et à ses amis* (Paris, 1946), pp. 45–46.

17. Félix Fénéon, "Rose-Croix," *Le Chat noir*, 19 March 1892, and "M. Gauguin," *Le Chat noir*, 23 May 1891, reprinted in Félix Fénéon, *Œuvres plus que complètes*, ed. Joan U. Halperin, 2 vols. (Geneva, 1970), 1:211, 192; André Mellerio, *Le Mouvement idéaliste en peinture* (Paris, 1896), p. 26; Bernard, "Paul Cézanne," *L'Occident*, pp. 26–27.

18. See, e.g., Joris Karl Huysmans, "Cézanne," *Certains* (Paris, 1889), p. 43; Alphonse Germain, "Théorie des déformateurs," *La Plume* 3 (1 September 1891):290; Geffroy "Camille Pissarro" (1893), "Paul Cézanne" (1894), *La Vie artistique*, 3:109, 251; Camille Mauclair, "Choses d'art," *Mercure de France*, n.s., 17 (January 1896):130; Denis, "A propos de l'Exposition d'A. Séguin" (1895), "Notes sur la peinture religieuse" (1896), *Théories*, pp. 22, 33; Georges Lecomte, "Les Expositions," *La Société nouvelle* 22 (December 1895):813; Georges Lecomte, "Paul Cézanne," *Revue d'art* 1 (9 December 1899):81. Cf. also, Denis, "Le Salon de la Société Nationale des Beaux-Arts" (1901), "Cézanne," *Théories*, pp. 63, 245; "L'Impressionisme et la France" (1917), *Nouvelles Théories*, p. 67; "L'Époque du symbolisme," *Gazette des beaux-arts*, 6 per., 11 (March 1934):168. Denis exhibited his *Hommage à Cézanne* (1900) at the Salon of 1901 (Société Nationale); this painting depicted a group of artists and critics associated with the symbolist movement—including Redon, Mellerio, and Denis himself—gathered around a still-life by Cézanne, one of the paintings that formed Gauguin's collection.

19. See below, pp. 195–96.

20. Like Cézanne, Puvis not only disclaimed academic allegiances, but also distanced himself from his symbolist admirers. In 1895, Gustave Larroumet compared Puvis to Gustave Moreau with regard to their inherent symbolism and their artistic isolation; Larroumet added, however, that Puvis had always "maintained contact with the public." See Larroumet, "Le Symbolisme de Gustave Moreau," *La Revue de Paris* 5 (15 September 1895):436–38. On Puvis's ideological independence, see also Richard J. Wattenmaker, *Puvis de Chavannes and the Modern Tradition* (Toronto, 1975), pp. 1–25; and the comprehensive assessment in Robert Goldwater, "Puvis de Chavannes: Some Reasons for a Reputation," *Art Bulletin* 28 (March 1946):33–43. Goldwater's description of the critics' image of Puvis closely resembles the image I have presented of Cézanne (drawn primarily from Bernard and Denis [see above, chap. 9]): "Puvis gradually came to embody . . . the new popular psychological image of the artist: the man of great skill and knowledge who is somehow at the same time of the utmost simplicity and childlike naïveté, these two conflicting qualities resolved by the suggestion of spontaneous creation..." (p. 42).

21. Camille Mauclair, "Puvis de Chavannes," *La Nouvelle Revue* 118 (15 June 1899):671. See also, Roger Marx, "Puvis de Chavannes," *Revue encyclopédique* 9 (23 December 1899):1079; Geffroy, "Puvis de Chavannes" (1894), *La Vie artistique*, 6:272.

22. See Marx, "Puvis de Chavannes," p. 1079; Émile Bernard, "Puvis de Chavannes," *L'Occident* 4 (December 1903):277; and Cézanne's letter to J. Gasquet, 26 September 1897, reprinted in Rewald, *Cézanne, Geffroy et Gasquet*, p. 33. Roger Fry used Cézanne's remark about art being a "harmony parallel to nature" as the epigraph for his *Cézanne, a Study of His Development*.

23. See, e.g., Georges Lafenestre, "Le Salon de 1887," *Revue des deux mondes*, 3 per., 81 (1 June 1887):608–9; Georges Lecomte, *L'Art impressionniste d'après la collection privée de M. Durand-Ruel* (Paris, 1892), pp. 186–89.

24. See, e.g., Philippe de Chennevières, "Les Décorations du Panthéon," *L'Artiste*, October 1884, p. 267; Gauguin's letter to Bernard, November 1888, Malingue, p. 151; Mauclair, "Puvis de Chavannes," pp. 668–69; Marx, "Puvis de Chavannes," pp. 1078–79.

25. See Gauguin's letter to Charles Morice, July 1901, Malingue, pp. 300–301; cf. also his letter to André Fontainas, August 1899, Malingue, p. 293. The figure of the "wolf without a collar" refers to La Fontaine's fable, "Le Loup et le chien"; see Gauguin's letter to Fontainas, March 1899, Malingue, p. 289.

26. Denis, "De Gauguin, de Whistler et de l'excès des théories" (1905), *Théories*, p. 209. See above, part 2, pp. 134–36.

27. Denis, "Les Arts à Rome ou la méthode classique" (1898), *Théories*, p. 51. See above, part 2, pp. 133–40.

28. Denis, "De Gauguin, de Whistler et de l'excès des théories," "Cézanne," *Théories*, pp. 204, 260.

29. Denis, "L'Influence de Paul Gauguin" (1903), *Théories*, p. 171. In 1894 Julien Leclercq had similarly related Gauguin to Poussin, and Camille Mauclair had responded by saying that he could not understand such a comparison. See Julien Leclercq, "Sur la peinture (de Bruxelles à Paris)," *Mercure de France*, n.s., 11 (May 1894):77; Camille Mauclair, "Lettre sur la peinture à Monsieur Raymond Bouyer, critique d'art à l'*Ermitage*," *Mercure de France*, n.s., 11 (July 1894):273. Nevertheless, the comparison seemed natural to those who regarded Gauguin as an exemplary modern artist; see, e.g., Jacques Rivière, "Poussin et la peinture contemporaine," *L'Art décoratif* 27 (1912):144–48. Rivière discusses the ways in which both Cézanne and Gauguin bring Poussin to mind, and he then speaks of how Maurice Denis's own painting recalls Poussin.

30. Denis, "L'Influence de Paul Gauguin," *Théories*, p. 171. Denis's reference to woodblock prints (*images d'Épinal*) as one of Gauguin's sources is especially significant since the champion of such "images populaires" had been Champfleury, one of a number of critics who preceded Denis in insisting that artists should take care not to formularize or academicize naïveté; see Champfleury, *Histoire de l'imagerie populaire* (Paris, 1886; orig. ed., 1869), pp. xii, xlvi. Georges Lecomte had also warned against the adaptation of a superficial primitivism ("gaucheries simulées"); see Georges Lecomte, "L'Art contemporain," *La Revue indépendante* 23 (April 1892):27.

31. See, e.g., Aurier, "Les Peintres symbolistes" (1892), *Œuvres posthumes*, p. 304; Émile Bernard, "De l'art naïf et de l'art savant," *Mercure de France*, n.s., 14 (April 1895):86–91; Denis, "De la gaucherie des primitifs" (1904), *Théories*, pp. 172–78. Denis followed common nationalistic interests in seeking to define the character of a "primitive" French school of painting devoid of Italianate influences; his essay "De la gaucherie des primitifs" was written in response to the major exhibition of "Primitifs français" organized in 1904. He noted that "each nation [or] ethnic group wants to have its own [primitives]" (p. 172). On these points, cf. Henri Bouchot, *Les Primitifs français, 1292–1500* (Paris, 1904), pp. 7–8, 28.

32. Denis, "De Gauguin et de Van Gogh au classicisme" (1909), *Théories*, p. 263.

33. Denis, "Cézanne," *Théories*, pp. 251, 254–55.

34. See, e.g., Émile Bernard, "Paul Cézanne," *Les Hommes d'aujourd'hui* 8, no. 387 (February–March 1891); Geffroy, "Paul Cézanne" (1894), "Paul Cézanne" (1895), *La Vie artistique*, 3:257 and 6:220; Lecomte, "Paul Cézanne," *Revue d'art*, p. 85; Camille Mauclair,

L'Impressionnisme (Paris, 1904), p. 152; Georges Lanoë, *L'École française de paysage depuis Chintreuil jusqu'à 1900* (Nantes, 1905), pp. 266, 271–72; Morice, "Paul Cézanne," *Mercure de France*, p. 591.

35. Denis, "De la gaucherie des primitifs," *Théories*, p. 176.

36. Letter to Émile Bernard, June 1888, V. W. van Gogh, ed., *The Complete Letters of Vincent van Gogh*, trans. J. van Gogh-Bonger and C. de Dood, 3 vols. (Greenwich, Conn., 1959), 3:499.

37. Huysmans, "Cézanne," *Certains*, p. 42; Denis, "Cézanne," *Théories*, p. 256. Huysmans was referring to works of the 1870s or 1880s; Denis to the *Grandes Baigneuses* now in Philadelphia.

38. See, e.g., F. Grindelle, "Une Visite au Salon," *La Critique philosophique*, 24 June 1882, p. 330; Joséphin Péladan, "Le Salon de 1882," *L'Art ochlocratique* (Paris, 1888), p. 28; Denis, "Définition du néo-traditionnisme" (1890), *Théories*, p. 4.

39. Geffroy, *Claude Monet*, 2:67; Bernard, "Souvenirs sur Paul Cézanne," *Mercure de France*, p. 394. Van Gogh also used Bouguereau as a norm with which to evaluate his own accomplishments; see his letter to Theo, 30 January 1889, *Complete Letters*, 3:133. On classifying Bouguereau and others as naturalists, cf. above, part 1, pp. 7–8.

40. Denis, "Cézanne," *Théories*, pp. 256–57.

41. See, e.g., Émile Bernard, "Notes à propos de Flandrin," *Mercure de France*, n.s., 12 (November 1894):231; and above, part 1, pp. 37–38. George Heard Hamilton has reinvestigated the mass of early commentary on Cézanne first compiled by Venturi and has concentrated on key descriptive words and phrases; he notes the relationship between notions of the "primitive" and the "awkward" and recognizes that the relevant context is symbolist art and theory. See his essay, "Cézanne and His Critics," in William Rubin, ed., *Cézanne: The Late Work* (New York, 1977), pp. 139–49.

42. Denis, "Cézanne," *Théories*, pp. 251, 254–55. Cf. above, part 2, p. 134.

43. Geffroy, "Paul Cézanne" (1895), *La Vie artistique*, 6:219–20. Geffroy argued that many of Cézanne's paintings were, on the contrary, "admirably balanced and finished"; the artist appeared as both "traditional" and "primitive."

44. Lecomte, "Paul Cézanne," *Revue d'art*, p. 86. Cf. Lecomte, *L'Art impressionniste*, p. 31. Like Geffroy, Lecomte distinguished between Cézanne's works of a "bizarrerie fortuite" and his "œuvres normales." For Lecomte's view that Cézanne's paintings of bathers were particularly odd, see his "Les Expositions," *La Société nouvelle*, p. 814.

45. Lecomte, "Paul Cézanne," *Revue d'art*, p. 86. Cf. Geffroy, "Paul Cézanne" (1894), *La Vie artistique*, 3:257. Earlier, Lecomte had stressed the fact that Cézanne's landscapes maintained their spatial dimension despite a lack of value gradation; see Georges Lecomte, "Des tendances de la peinture moderne," *L'Art moderne* (Brussels) 12 (14, 21, 28 February 1892):67; and "Les Expositions," *La Société nouvelle*, pp. 814–15.

46. Denis, "Cézanne," *Théories*, pp. 258–60. Denis is ambivalent as to whether Cézanne finally creates any volumetric form. Lecomte had previously noted the link between a symbolist flatness and Cézanne's technique; Lecomte, "Des tendances de la peinture moderne," *L'Art moderne*, pp. 66–67.

47. Concerning Bernard's theory, see above, part 2, pp. 127–28.

48. Denis, "De la gaucherie des primitifs," *Théories*, pp. 174–77. A less complete formulation of this argument is found in Denis's journal entry for 15 April 1903; see Maurice Denis, *Journal*, 3 vols. (Paris, 1957–59), 1:196–97. Cf. also Émile Bernard, "De l'art moderne," *La Rénovation esthétique* 4 (December 1906):104.

49. Denis, "Cézanne," *Théories*, pp. 254–55. Previously, a reviewer for *L'Occident* who was familiar with Denis's writings had related Cézanne's simple two-dimensional forms to a primitive vision that made "chaque objet reste dans le plan du tableau"; Solrac, "Réflexions sur le Salon d'Automne," *L'Occident* 6 (December 1904):306.

50. On this association, cf., e.g., Charles Blanc, *Voyage de la haute Égypte* (Paris, 1876), p. 99.

51. See Cézanne's letter to Bernard, summer (?) 1905, Rewald, *Correspondance*, p. 276. Cf. Monet's letter to Geffroy, 7 October 1890, reprinted in Wildenstein, *Claude Monet*, 3:258. Monet described the "envelope" as "la même lumière répandue partout."

52. See above, part 1, pp. 17–26.

53. On the theoretical issues, cf. above, part 2, pp. 83–88; on Cézanne's practice, cf. above, part 2, pp. 111–23.

54. Denis, "De la gaucherie des primitifs," *Théories*, pp. 174–75.

55. Lecomte, *L'Art impressionniste*, p. 51 (emphasis added).

56. See, e.g., Mme. Marie-Élisabeth Cavé, *La Couleur* (Paris, 1863; orig. ed., 1851), p. 118. The term "atmosphere" could also be used to indicate the presence (as opposed to the absence) of a conventional chiaroscuro effect, as in the technique known as "atmospheric perspective"; and the references to the presence or absence of "atmosphere" in the early commentary on Cézanne can be confusing unless this factor is taken into account. For statements with regard to the lack of *conventional* atmosphere in Cézanne's painting, see, e.g., Geffroy, "Paul Cézanne" (1894), *La Vie artistique*, 3:257; Denis, "Cézanne," *Théories*, p. 259.

57. See, e.g., Charles Ephrussi, "Exposition des artistes indépendants," *Gazette des beaux-arts*, 2 per., 21 (1 May 1880):486.

58. Lecomte, "Paul Cézanne," *Revue d'art*, p. 86. On the "tapestry" effect, cf. also Geffroy, "Paul Cézanne" (1894), *La Vie artistique*, 3:259; Félicien Fagus, "Au Salon d'Automne," *L'Occident* 8 (November 1905):253; Denis, "Cézanne," *Théories*, pp. 258–59. Julius Meier-Graefe also discussed Cézanne's style in terms of "atmosphere" and the uniform surface of a tapestry; see his *Die Entwicklungsgeschichte der modernen Kunst: Ein Beitrag zur modernen Ästhetik*, 3 vols. (Stuttgart, 1904), 1:166, 169.

59. I have not yet fully investigated the significance of *gaucherie* for the impressionist artist; I return to this subject below, chap. 14. On the general opposition of conceptual ideas and immediate vision, cf. above, part 2, pp. 93–95.

60. Lecomte, "Paul Cézanne," *Revue d'art*, p. 86.

61. See Lecomte, "Des tendances de la peinture moderne," *L'Art moderne*, pp. 58, 66–67; *L'Art impressionniste*, pp. 260–61. Cf. above, part 1, pp. 11–12.

62. Roger Fry, *Cézanne, a Study of His Development* (New York, 1958; orig. ed., 1927), p. 26. Fry is here demonstrating (among other things) that Cézanne's deepest natural inclination is toward a "classical" style rather than a "baroque" one; in passing, he indicates one of the ways in which the "classic" and the "primitive" may be formally related.

Chapter 13

1. Cf. entries for *classe* and *classique*, Émile Littré, *Dictionnaire de la langue française*, 4 vols. (Paris, 1863–69), 1:638–39. On the equivalence of various "classic" sources, cf. Gautier, who writes that Ingres "remonte directement aux sources primitives, à la nature, à l'antiquité grecque, à l'art du seizième siècle [Raphael]"; Théophile Gautier, "Ingres," *L'Artiste*, n.s., 1 (5 April 1857):5.

2. Cf. entry for *classique*, Littré. See also, É. J. Delécluze, *Traité élémentaire de peinture* (Paris, 1842; orig. ed., 1828), p. 229. Curtius traces to Aulus Gellius (ca. 123–ca. 165) the use of "classic" to signify an author of the first class, whose style becomes the model; Ernst Robert Curtius, *European Literature and the Latin Middle Ages* (London, 1953), pp. 249–51.

3. On Cézanne's admiration of Delacroix, cf., e.g., his letters to Ambroise Vollard, 23 January 1902 (referring to Delacroix as the "grand Maître"), and to Émile Bernard, 12 May 1904 (referring to a projected painting of an apotheosis of Delacroix), John Rewald, ed., *Paul Cézanne, correspondance* (Paris, 1937), pp. 244, 260. For an account of the available evidence with regard to Cézanne's involvement with Delacroix, see Sara Lichtenstein, "Cézanne and Delacroix," *Art Bulletin* 46 (March 1964):55–67. The extent of Cézanne's involvement with Poussin is discussed below, pp. 180–83. For a study of the interrelationship of the three masters, cf. also Kurt Badt, *The Art of Cézanne*, trans. Sheila Ann Ogilvie (Berkeley, 1965; orig. German ed., 1956), pp. 278–323. I find Badt's analysis of Delacroix's views and significance for Cézanne (esp. pp. 284–86, 293) more perceptive than his remarks on Poussin.

4. Paul Mantz, "Un Nouveau Livre sur le Poussin," *L'Artiste*, n.s., 4 (23, 30 May 1858):41.

5. Entry for 13 January 1857, André Joubin, ed., *Journal d'Eugène Delacroix*, 3 vols. (Paris, 1950), 3:22.

6. Alexandre Dumas, "L'École des Beaux-Arts," *Paris Guide*, 2 vols. (Brussels, 1867), 1:858.

7. Dumas did not relate the incident when he spoke briefly of Thiers and the *Last Judgment* commission in an earlier publication. See Alexandre Dumas, "Eugène Delacroix" (1853), *Mes Mémoires*, ed. Pierre Josserand, 5 vols. (Paris, 1954–68), 5:32. However, Delacroix's refusal of Thiers's commission is mentioned prior to this by G. K. Nagler, *Neues allgemeines Künstler-Lexikon*, 25 vols. (Linz, 1911; orig. ed., 1835–52), 18:406.

8. On Delacroix's commission, see, e.g., Maurice Serullaz, *Les Peintures murales de Delacroix* (Paris, 1963), p. 27; on Sigalon's commission, see Ernest Bosc, "Xavier Sigalon," *Nouvelles Archives de l'art français* 4 (1876):425–26.

9. The copy, for display at the École des Beaux-Arts, was to be nearly the size of the original. Dumas stated that Delacroix was not a man who could afford to lose ten years in such "sterile copying of another's work" ("L'École des Beaux-Arts," p. 858). Thiers seems always to have admired Sigalon, but to have considered him second to Delacroix; see Adolphe Thiers, *Salon de mil huit cent vingt-quatre* (Paris [1903]), p. 19. On the laboriousness and lack of spontaneity in any copying process, cf. Théophile Gautier, "Des originaux et des copies," *Le Cabinet de l'amateur et de l'antiquaire* 1 (1842):16–17.

10. Dumas, "L'École des Beaux-Arts," p. 858.

11. Eugène Delacroix, "Sur le *Jugement dernier*" (1837), *Œuvres littéraires*, ed. Élie Faure, 2 vols. (Paris, 1923), 2:217–24.

12. Delacroix, "Le Poussin" (1853), "Sur le *Jugement dernier*," *Œuvres littéraires*, 2:94, 224. Despite the qualification placed on Raphael's ultimate standing, Delacroix considered him a most original artist; "Raphaël" (1830), *Œuvres littéraires*, 2:12, 15. Delacroix applied the title of "Homer" to Rubens as well as to Michelangelo; see his journal entry for 20 October 1853, *Journal*, 2:95.

13. See Delacroix's journal entry for 13 January 1857, *Journal*, 3:23.

14. Delacroix, "Le Poussin," *Œuvres littéraires*, 2:94–95. Delacroix remarked in a journal entry for 28 April 1853 that Poussin was independent of all convention; *Journal*, 2:31.

15. See, e.g., Philippe de Chennevières, "Nicolas Poussin," *Archives de l'art français* 1 (15 January 1851):1–11; Victor Advielle, *Recherches sur Nicolas Poussin et sa famille* (Paris, 1902).

16. On Poussin's "Frenchness," see, e.g., Philippe de Chennevières-Pointel, *Essais sur l'histoire de la peinture française* (Paris, 1894), p. 113; Maurice Denis, "La Réaction nationaliste" (1905), *Théories, 1890–1910: Du symbolisme et de Gauguin vers un nouvel ordre classique* (Paris, 1920; orig. ed., 1912), pp. 189–91.

17. I will be concerned only with the nineteenth-century interpretations and will attempt neither to justify nor refute these views on the basis of either Poussin's own works and writings, or a critical reading of the relevant documentary sources.

18. The various arguments usually made reference to Félibien's account of Poussin's activities in Rome; see, e.g., Jacques Nicolas Paillot de Montabert, *Traité de la peinture*, 9 vols. (Paris, 1829–51), 3:194; Hervé Bouchitté, *Le Poussin, sa vie et son œuvre* (Paris, 1858), pp. 38–39; Paul Desjardins, *Poussin* (Paris, 1903), p. 48; André Fontaine, *Les Doctrines d'art en France* (Paris, 1909), p. 9. In 1792, Watelet and Levesque, without mentioning Félibien, had argued that Poussin made only summary sketches after aspects of antique art; their brief account is especially interesting within the context of the present study since they conclude, not surprisingly, that if Poussin "a peu copié, il a beaucoup imité." Here, *copy* and *imitate* appear in unproblematic opposition, the one term signifying servility, the other indicating free and original creation: "cette *imitation* libre, originale, créatrice, prenne le titre d'émulation." See Claude Henri Watelet and Pierre Charles Levesque, *Dictionnaire des arts de peinture, sculpture et gravure*, 5 vols. (Paris, 1792), 3:138–39.

19. For the primary (and somewhat conflicting) accounts of this act of "copying and measuring," see Giovan Pietro Bellori, *Le Vite de' pittori, scultori e architetti moderni*, ed. Evelina Borea (Turin, 1976; orig. ed., 1672), pp. 426, 472–73; and André Félibien, *Entretiens sur les vies et sur les ouvrages des plus excellens peintres anciens et modernes*, 6 vols. (Trévoux, 1725; orig. ed., 1666–68), 4:12. On Poussin's study of the Antinous, see Georg Kauffmann, *Poussin-Studien* (Berlin, 1960), pp. 19–20. For a brief history of the Antinous, see Francis Haskell and Nicholas Penny, *Taste and the Antique* (New Haven, 1981), pp. 141–43. I am grateful to Elizabeth Cropper, Charles Dempsey and Frances Huemer for bibliographical advice on the subject of Poussin.

20. Théophile Thoré, "De l'École française à Rome," *L'Artiste*, 4 ser., 11 (6 Feb. 1848):216. Cf. Théophile Thoré, "Salon de 1846," *Les Salons*, 3 vols. (Brussels, 1893), 1:248.

21. Mantz, "Un Nouveau Livre sur le Poussin," p. 41. On Poussin's independence, despite his study of others, cf., e.g., "De l'originalité dans les arts du dessin" (1817), P. A. Coupin, ed., *Œuvres posthumes de Girodet-Trioson, peintre d'histoire*, 2 vols. (Paris, 1829), 2:190; Philippe Busoni, "Poussin," *L'Artiste* 7 (1834):51.

22. From notes of ca. 1813–27, reprinted in Henri Delaborde, *Ingres, sa vie, ses travaux, sa doctrine* (Paris, 1870), p. 147. Cf. Étienne Delécluze, "Salon de 1827," *Journal des débats*, 2 January 1828, p. 2; Charles Blanc, "Nicolas Poussin," *Histoire des peintres de toutes les écoles: École française*, 3 vols. (Paris, 1865), 1:5. Ingres's comments on ancient art, Raphael and Poussin, and on the "classic" in general were very well known, especially after Delaborde's publication appeared in 1870. They have been employed repeatedly as a means of articulating the (French) doctrine of classicism. In the course of establishing a definition of "classic" art for the modern period, Robert Rey, the self-proclaimed inheritor of Denis's theories, quotes some of Ingres's statements related to the one I have cited (for the documentary source [not identified

by Rey], see Delaborde, p. 139—Rey actually misquotes Delaborde/Ingres in a very mislead-ing manner); Robert Rey, *La Renaissance du sentiment classique dans la peinture française à la fin du XIX^e siècle* (Paris, 1931), p. 23. Rey names Poussin, Ingres, and Delacroix as the great French classics (pp. 3–4); gives Denis's definition of the classic as one who expresses emotion by way of formal elements (pp. 4–5); speaks of primitives as classics (p. 6); and notes that Poussin had the "sensibilité en presence de la nature dont l'observation pieuse est *la source ori-ginelle* de toute œuvre grande" (p. 11, emphasis added). Rey devotes a chapter to Cézanne's "classical" art (pp. 81–94).

23. See, e.g., Philippe de Chennevières-Pointel, "Jacques Restout, premiers essais de la théorie de l'art en France" (1854), *Recherches sur la vie et les ouvrages de quelques peintres provin-ciaux de l'ancienne France*, 4 vols. (Paris, 1847–62), 3:194; Ernest Chesneau, "Le Réalisme et l'esprit français dans l'art: Les Frères Le Nain," *Revue des deux mondes* 46 (1 July 1863):227; Théophile Gautier, "Le Musée du Louvre," *Paris Guide*, 2 vols. (Brussels, 1867), 1:399; Hen-ry Lemonnier, *L'Art français au temps de Richelieu et de Mazarin* (Paris, 1893), pp. 327–28, 332.

24. Lemonnier, *L'Art français*, pp. 333–34. Cf. also Chennevières-Pointel, "Jacques Res-tout," pp. 195, 204.

25. Raymond Bouyer, "Le Paysage dans l'art," *L'Artiste*, n.s., 6 (August 1893):124.

26. See, e.g., P. M. Gault de Saint-Germain, *Vie de Nicolas Poussin, considéré comme chef de l'école françoise* (Paris, 1806), pp. 14–17; Charles Clément, "Nicolas Poussin," *Revue des deux mondes*, n.p., 5 (February 1850):720. Cf. also Thomas Couture, *Méthode et entretiens d'atelier* (Paris, 1867), p. 247. Maurice Denis stressed Poussin's intellectual "digestion" of his observa-tions of nature rather than their literal exactitude; Denis, "Les Arts à Rome ou la méthode classique" (1898), *Théories*, pp. 50–51. On this point, cf. Gustave Planche, "Le Paysage et les paysagistes: Ruysdael, Claude Lorrain, Nicolas Poussin," *Revue des deux mondes*, 2 per., 9 (June 1857):786.

27. See, e.g., Élie Roy, "Du sentiment de la nature dans l'art français: Les Paysagistes con-temporains et disciples de Poussin," *L'Artiste*, June 1868, pp. 353–54.

28. Raymond Bouyer, "Nicolas Poussin" (1905–6), *Histoire du paysage en France*, ed. Henry Marcel (Paris, 1908), pp. 109–10.

29. Denis, "De la gaucherie des primitifs" (1904), "De Gauguin, de Whistler et de l'excès des théories" (1905), "Cézanne" (1907), *Théories*, pp. 176–77, 209, 260; Émile Bernard, "Souvenirs sur Paul Cézanne et lettres inédites," *Mercure de France*, n.s., 69 (1, 16 October 1907):627. On Poussin's classical equilibrium, cf. Bouyer, "Nicolas Poussin," pp. 109–10. Bouyer states that Poussin's stylization of nature is "not unconscious"; for Bernard, Denis, and Fry, however, the degree to which Cézanne (the modern "Poussin") controlled his own creations always remained a matter for speculation. Cf. above, chaps. 9, 10.

30. Denis, "De Gauguin, de Whistler et de l'excès des théories," *Théories*, p. 204.

31. See Camoin's statement in Charles Morice, "Enquête sur les tendances actuelles des arts plastiques," *Mercure de France*, n.s., 56 (1 August 1905):353–54. (Denis labeled Cézanne a "classic" artist in his reply to Morice's "Enquête" [p. 356], but did not mention Poussin.) Still earlier, Roger Marx had linked Cézanne to Poussin; Roger Marx, "Le Salon d'Au-tomne," *Gazette des beaux-arts*, 3 per., 32 (December 1904):463. The most detailed study of the origins of the several forms of the Cézanne-Poussin association is Theodore Reff, "Cé-zanne and Poussin," *Journal of the Warburg and Courtauld Institutes* 23 (1960):150–74. Reff argued that Denis's statement of November 1905 was the first to relate Cézanne to Poussin.

The published statements of Camoin and Marx are, of course, earlier; yet the connection could still have been suggested first by Denis. In a remark published even earlier a certain François-Charles referred to Cézanne as "grave et classique, comme Poussin, auquel, dit-on, il pense continuellement"; François-Charles, "L'Exposition des artistes indépendants," *L'Ermitage* 13 (May 1902):398. If, as François-Charles implied in 1902, it was generally "said" that Cézanne thought of himself in relation to Poussin, this bit of artworld gossip may have originated either in early accounts of the master offered by Camoin (or others) or in the continuous flow of theory issuing from Denis, whether published or not. In 1899 Denis had in fact heard through Vollard that Cézanne admired Poussin, but only as one among several "anciens maîtres"; see Denis's journal entry for 21 October 1899, Maurice Denis, *Journal*, 3 vols. (Paris, 1957–59), 1:157.

32. See, e.g., Bernard, "Souvenirs sur Paul Cézanne," *Mercure de France*, p. 627. Because Reff (in 1960) was not aware of the published Camoin statement, he maintained that still another formulation of the Cézanne-Poussin relationship, Léo Larguier's, represented a poetic transformation of Bernard's formulation: according to Reff, Larguier willfully changed "refaire" to "vivifier" ("Cézanne and Poussin," p. 156; Léo Larguier, *Le Dimanche avec Paul Cézanne* [Paris, 1925], p. 40). Although Larguier's account seems both fanciful and dependent on Bernard, in view of the Camoin statement, it is likely that Larguier, Camoin's friend, either borrowed the statement from him, or, if Cézanne actually did make the remark himself, may have heard it spoken around the same time Camoin did. In 1962, Reff noted his omission of the Camoin statement, but did not alter the argument he had previously made; Theodore Reff, "Cézanne et Poussin," *Art de France* 3 (1962):302.

33. Morice, "Enquête," p. 354. The quotation is from Cézanne's letter to Camoin, 13 September 1903, Rewald, *Correspondance*, p. 255 (emphasis eliminated). Cézanne was referring to advice that he associated with the teachings of Thomas Couture; cf. Couture, *Méthode*, p. 253. Here and elsewhere, I translate *vivifier* as "bring back to life (revive)" rather than giving it its most literal sense of "bring to life (vivify)." I am led along this semantic drift by the critical discourse within which *vivifier* moves. The nineteenth-century emphasis is most often on revival, resuscitation, or the recovery of artistic truths once living, more recently lost or dead. Since both Poussin and Poussin's art had previously been "alive" (literally and figuratively), critics spoke of their "revival" at a time when one needed to "bring to life" any vital sensation. The standard English edition of Cézanne's letters also translates *vivifier* as "revive"; see John Rewald, ed., *Paul Cézanne: Letters*, trans. Marguerite Kay (London, 1941), p. 230.

34. Morice, "Enquête," p. 354. The quotations are from Cézanne's letters to Camoin, 3 February and 22 February 1903, Rewald, *Correspondance*, pp. 246, 253.

35. Cf. above, part 2, pp. 71–72, 92–95.

36. Bouyer, "Le Paysage dans l'art," p. 123.

37. Denis Diderot, "Salon de 1767," *Salons*, ed. Jean Seznec and Jean Adhémar, 4 vols. (Oxford, 1957–67), 3:61–62. Cf. Ingres, who wrote that the ancient works "are themselves nature"; notes of ca. 1813–27, Delaborde, p. 139.

38. Émile Bernard, "Paul Cézanne," *L'Occident* 6 (July 1904):28; Denis, "Cézanne," *Théories*, p. 251.

39. Denis, "Cézanne," *Théories*, p. 251.

40. Cézanne's letters to Bernard, 23 December 1904 and (undated) 1905, Rewald, *Correspondance*, pp. 269, 275. Cézanne later complained that Bernard did not take his advice and

studied too much museum art instead of experiencing nature; letters to his son, 13 September and 26 September 1906, pp. 289, 293.

41. Francis Jourdain, who visited Cézanne with Camoin, probably in 1904, confirmed that Cézanne spoke of having "toujours essayé de vivifier le Poussin devant la nature." See Jourdain's reminiscences, published in 1946–50, reprinted in P. M. Doran, ed., *Conversations avec Cézanne* (Paris, 1978), p. 84.

42. According to Jules Borély, who visited the artist in 1902, Cézanne had complained that the abundance of past images overwhelmed the contemporary painter: "Nous ne voyons plus la nature; nous revoyons les tableaux." See Borély's reminiscences, published in 1926, reprinted in Doran, p. 22. Cézanne's remark is a nineteenth-century cliché, the sort of observation made by artists as they sought a "technique of originality." Cf. above, part 2, p. 125.

43. Morice, "Enquête," pp. 349, 354. In a letter of 2 December 1904, however, Camoin reports to Matisse that Cézanne has said the following: "il faut faire des *tableaux*, composer des tableaux comme l'ont fait les maîtres, non pas comme l'ont fait les Impressionnistes qui découpent un morceau de nature au hasard. . . ." See Danièle Giraudy, "Correspondance Henri Matisse-Charles Camoin," *Revue de l'art* 12 (1971):10. Despite his apparent criticism of impressionism (as Camoin restated it), Cézanne, according to the whole of Camoin's account, maintains the priority of the study of nature and advocates the use of the masters merely as guides, not as models to be strictly imitated. Cézanne's letter to Camoin of 9 December 1904, written shortly after the visit Camoin reports to Matisse, confirms this attitude: "les conseils, la méthode d'un autre ne doivent pas vous faire changer votre manière de sentir" (Rewald, *Correspondance*, p. 267).

44. See above, part 2, pp. 125–26.

45. Denis, "Cézanne," *Théories*, pp. 250, 260.

46. A great amount of research has been conducted on the subject of Cézanne's "sources" in other works of art. Most of the figures in his compositions of bathers seem to be derived from paintings and sculptures rather than from live models. In addition, Cézanne often worked from photographs and reproductions. In doing so, he generally followed the given linear motifs and often also details of composition; however, as he transformed his "borrowed" subject into an image seen through impressionist "atmosphere," he applied his characteristic pattern of juxtaposed strokes of brilliant color, obliterating much of the given spatial configuration. On Cézanne's "sources," see esp., Gertrude Berthold, *Cézanne und die alten Meister* (Stuttgart, 1958), and its review by Theodore Reff, *Art Bulletin* 42 (June 1960):145–49; Theodore Reff, "Reproductions and Books in Cézanne's Studio," *Gazette des beaux-arts*, 6 per., 56 (November 1960):303–9; Reff, "Cézanne et Poussin," *Art de France*, pp. 302–10; Lichtenstein, "Cézanne and Delacroix," *Art Bulletin*, pp. 55–67; Theodore Reff, "Copyists in the Louvre, 1850–1870," *Art Bulletin* 46 (December 1964):555; Adrien Chappuis, "Cézanne dessinateur: copies et illustrations," *Gazette des beaux-arts*, 6 per., 66 (November 1965):293–308; Guila Ballas, "Daumier, Papety et Delacroix, inspirateurs de Cézanne," *Bulletin de la Société de l'Histoire de l'Art français*, 1974, pp. 193–99; Sara Lichtenstein, "Cézanne's Copies and Variants after Delacroix," *Apollo* 101 (February 1975):116–27; Guila Ballas, "Paul Cézanne et la revue 'l'Artiste,'" *Gazette des beaux-arts*, 6 per., 98 (December 1981):223–32.

47. For a relatively early example of Cézanne's complex transformation of a "borrowed" image (from Gérome), see Chappuis, "Cézanne dessinateur," pp. 298–99. Concerning Cézanne's "submission" to nature, see his letter to Bernard, 26 May 1904, Rewald, *Correspon-*

dance, p. 262. For other references to Cézanne's emphasis on following nature rather than art, see his letters to Camoin, 3 February 1902, 13 September 1903; and to Bernard, 12 May and 23 December 1904 (undated), and 23 October 1905; *Correspondance*, pp. 246, 255, 261, 268–69, 275, 276–77. On the "classicist" submission to nature, cf. Ingres's comments (ca. 1813–27) with regard to Raphael (quoted in Delaborde, p. 117): "Raphaël et cela (le modèle vivant), c'est synonyme. Et quel chemin Raphaël a-t-il pris? Lui-même a été modeste, lui-même, tout Raphaël qu'il était, a été soumis. Soyons donc humbles devant la nature."

48. Cf. above, part 2, pp. 65–66.

49. During the twentieth century, art historians have often denied the "spirituality" of the Cézanne-Poussin relationship, and have sought to establish proof of some base physical union. For a recent example, see Katia Tsiakma, "Cézanne's and Poussin's Nudes," *Art Journal* 37 (Winter 1977/78):120–32.

50. Stylistically, "classic" linearity or planarity is often opposed to "baroque" colorism. An observation of this type usually leads to statements concerning personal development or historical periodization: the classic becomes baroque, or the baroque becomes classic. In addition, the presentation of a subject is sometimes characterized in terms of a "classic" simplicity and order, to be contrasted with excessive "realistic" detail and even disorder (the "ideal" or "essential" distinguished from the "real"). Art historians and critics tend to associate subject and style, preferring to see classic (or baroque) style wherever classic (or baroque) subject matter can be identified, and vice versa. Where the correspondence is not easily established, the resultant pictorial "tension" becomes psychological (cf. above, chap. 8, n. 38). For examples of interpretation focused on Cézanne's so-called baroque and classic manners, see Roger Fry, *Cézanne, a Study of His Development* (New York, 1958; orig. ed., 1927), pp. 25–26; and the similar remarks in Meyer Schapiro, *Paul Cézanne* (New York, 1962; orig. ed., 1952), pp. 27–28. Following Fry (and Denis), Schapiro states that the "old historical alternatives" of color and line or of nature and style could be reconciled in Cézanne's art: "The polarity of styles [was] no longer an artistic problem." This is to articulate a standard feature of the *theory* of the classical: classic art transcends the distinction between classic and baroque *style*, a distinction that many late nineteenth-century critics regarded as superficial and "academic." Yet Schapiro's specific visual observations seem inconsistent with such theoretical breadth and depth, as if predetermined by the knowledge that a painter must be classic in a more limited, formal sense. In other words, his formal analysis of Cézanne's style is not adequate to a comprehensive theory of the "classic." Classicism becomes a matter of pictorial resolution on the level of "planes parallel to the picture surface"; and the late Cézanne is described as sometimes classic, sometimes baroque. But for his contemporary viewers, Cézanne's "classic" simplicity of form and spatial "flatness" were not primarily the products of planar compositional organization (or its lack); rather these classic features resulted from the painter's uniform pattern of color (cf. above, pp. 166–74). Color could signify a "natural" classicism. In contrast, for Schapiro, brilliant color initially evokes the baroque. Accordingly, in order to become a classic, Cézanne must struggle to "discipline" and master color; Schapiro and others regard it as inherently less appropriate to classicism than line.

51. On Cézanne's "solidity," see, e.g., Schapiro, p. 19: "[Cézanne's] constructed form . . . possesses in a remarkable way the object-traits of the thing represented: its local color, weight, solidity, and extension." Clement Greenberg is perhaps the most acute in seeing that the "solidity" ascribed to Cézanne need *not* refer to volume, but rather to coherence of two-dimensional ("decorative") design. In making this observation, Greenberg returns, in effect,

to the distinction between nature and style that had been central to the symbolist theories of Bernard and Denis; these earlier critics had discussed Cézanne as providing a synthesis of a *vision* of nature, complete in its illusion of the third dimension, and an *idea* of style, or abstract pictorial structure (cf. above, chap. 9; and chap. 12, pp. 171–72). The relevant passage from Greenberg is particularly rich: "Cézanne's effort to turn Impressionism toward the sculptural was shifted, in its fulfillment, from the structure of the pictorial illusion to the configuration of the picture itself as an object, as a flat surface. Cézanne got 'solidity,' all right; but it is as much a two-dimensional, literal solidity as a representational one.

"The real problem would seem to have been, not how to do Poussin over according to nature, but how to relate—more carefully and explicitly than Poussin had—every part of the illusion in depth to a surface pattern endowed with even superior pictorial rights. The firmer binding of the three-dimensional illusion to a decorative surface effect, the integration of plasticity and decoration—this was Cézanne's true object, whether he said so or not. And here critics like Roger Fry read him correctly. But here, too, his expressed theory contradicted his practice most." See Clement Greenberg, "Cézanne" (1951), *Art and Culture* (Boston, 1961), p. 54. Greenberg's view of Cézanne's having made the two-dimensional surface effect dominant, the artist's having made his picture visible in its very flatness and not as a representational illusion, agrees with the critic's later generalized account of modernism: "One is made aware of the flatness of [modernist] pictures before, instead of after, being made aware of what the flatness contains"; Clement Greenberg, "Modernist Painting" (1965), reprinted in Gregory Battcock, ed., *The New Art* (New York, 1966), p. 103. For the purposes of my own argument, Greenberg's remark with regard to the apparent disjunction between Cézanne's theory and practice is quite telling; one wonders whether further investigation might lead to some kind of reconciliation. In my opinion, Cézanne had somewhat simpler theoretical aims than Greenberg ascribes to him, and a correspondingly simpler practice as well; see below, chap. 14.

52. James Huneker, "Paul Cézanne," *Promenades of an Impressionist* (New York, 1910), p. 4. Huneker found Cézanne's art crude and primitive, but suggested that he might become a "classic" because he seemed moderate by comparison with Van Gogh and Gauguin (p. 11). In other words, according to Huneker, general assimilation will make a style "classic"; this is one of the senses of the classic that Delacroix had given—one becomes "classic" in serving as a model accessible enough to be imitated (cf. above, pp. 176–77).

Chapter 14

1. John Rewald, ed., *Paul Cézanne, correspondance* (Paris, 1937), p. 261.

2. Rewald, *Correspondance*, p. 289.

3. Joachim Gasquet, *Cézanne* (Paris, 1921), p. 81.

4. When Maurice Denis recorded his visit to Cézanne in his journal (entry for 26 January 1906), he paraphrased a number of the painter's remarks, many of which may have been responses to questions prompted by the statements that Bernard had published in 1904. Cézanne is reported to admit the need for theory, but clearly emphasizes his sensation of nature: "Je cherche en peignant. Je n'ai pas de doctrine comme Bernard, mais il faut des théories, la sensation et des théories. La nature, j'ai voulu la copier, je n'arrivais pas." See Maurice Denis, *Journal*, 3 vols. (Paris, 1957–59), 2:29. The fact that Cézanne's statements were so eagerly recorded and so often quoted is testimony to the stature his art had attained.

5. See above, part 1, pp. 17–26, 39–43.

6. Letter to Charles Camoin, 13 September 1903, Rewald, *Correspondance*, p. 255. Lawrence Gowing has made some perceptive remarks on the "double meaning" of "sensation"; see his "The Logic of Organized Sensations," in William Rubin, ed., *Cézanne: The Late Work* (New York, 1977), p. 62. Gowing implies that Cézanne's double sense of sensation is unusual; I believe, on the contrary, that Cézanne's understanding of the concept of sensation was quite ordinary and that his usage of the term amounts to something of a cliché related to an equally common (yet profound) notion of artistic temperament. In his recollections of Cézanne's "theory," Camoin himself associated the concepts of artistic sensation and temperament with the antiacademic return to nature; see Charles Camoin, "Souvenirs sur Paul Cézanne," *L'Amour de l'art* 2 (January 1921):25–26. The double meaning of "sensation" is clear even in texts in which impressionists are criticized for rendering *only* sensation; see, e.g., Albert Aurier, "Le Symbolisme en peinture: Paul Gauguin" (1891), *Œuvres posthumes* (Paris, 1893), p. 208. Indeed, after reading Aurier's essay on Gauguin, Lucien Pissarro noted that the "émotivité" that the symbolist critic advocated seemed identical to "ce que nous appelons *sensation*"; letter to Camille Pissarro, May 1891, reprinted in Camille Pissarro, *Lettres à son fils Lucien*, ed. John Rewald (Paris, 1950), p. 245. Although Aurier would not agree with Lucien's observation, the ambiguity in the use of "sensation" allowed Lucien to make this connection. Cf. also above, part 1, pp. 3–5.

7. See John Rewald, "Un Article inédit sur Paul Cézanne en 1870," *Arts* (Paris), no. 473 (21–27 July 1954), p. 8; and John Rewald, *The History of Impressionism* (New York, 1961), p. 246.

8. Letters to Louis Aurenche (25 January 1904), Charles Camoin (22 February 1903), and Émile Bernard (23 October 1905), Rewald, *Correspondance*, pp. 257, 254, 276. Gasquet later presents Cézanne as arguing that "temperament" is the source of all artistic sensation; Gasquet, *Cézanne*, p. 82. Additional indirect references to Cézanne's concern for temperament and personalized vision are provided by Edmond Duranty's fictional characters Marsabiel (1867) and Maillobert (1872) who are supposedly modeled after Cézanne and who use the term "temperament" repeatedly; see Marcel Crouzet, *Un Méconnu du réalisme: Duranty* (Paris, 1964), pp. 245–47. See also Mary Cassatt's account of her meeting with Cézanne in 1894; A. D. Breeskin, *The Graphic Work of Mary Cassatt* (New York, 1948), p. 33. On the notion of "strong" artistic sensation, cf. Gustave Courbet, letter published in *Courrier du Dimanche*, 25 December 1861, reprinted in Jules Antoine Castagnary, *Les Libres Propos* (Paris, 1864), p. 182; Hippolyte Taine, *Philosophie de l'art*, 2 vols. (Paris, 1893; orig. ed., 1865–69), 1:44; Thomas Couture, *Méthode et entretiens d'atelier* (Paris, 1867), p. 304; Armand Sully-Prudhomme, *L'Expression dans les beaux-arts* (1883), *Œuvres de Sully-Prudhomme*, vol. 5, *Prose* (Paris, 1898), p. 408.

9. Letter to Aurenche, 25 January 1904, Rewald, *Correspondance*, p. 257.

10. Letter to Marx, 23 January 1905, Rewald, *Correspondance*, pp. 273–74.

11. R. P. Rivière and J. F. Schnerb, "L'Atelier de Cézanne," *La Grande Revue* 46 (25 December 1907):816. P. M. Doran also notes that Rivière/Schnerb's quotation differs from Rewald's; P. M. Doran, ed., *Conversations avec Cézanne* (Paris, 1978), p. 203.

12. Cf. above, part 1, pp. 39–42.

13. Lastly, Rivière and Schnerb have *une place convenable* instead of *un rang convenable*.

14. The phrase, "la vérité en peinture," appears in Cézanne's letter to Bernard, 23 October 1905, Rewald, *Correspondance*, p. 277.

15. For a refined statement of this theory by an exact contemporary of Cézanne, cf. Sully-Prudhomme, pp. 29, 227–28, 408–10.

16. Cézanne praised Stendhal's *Histoire de la peinture en Italie* in 1878 and noted also that he had read it previously in 1869; letter to Zola, 20 November 1878, Rewald, *Correspondance*, p. 153. (Robert Ratcliffe has recorded numerous correspondences between the statements of Cézanne and Stendhal; see Robert William Ratcliffe, "Cézanne's Working Methods and Their Theoretical Background," unpublished dissertation, Courtauld Institute of Art, University of London, 1961, pp. 312–30.) Cézanne also praised Baudelaire's collection of art criticism, *L'Art romantique*, especially the essay on Delacroix; letters to his son, 13 and 28 September 1906, Rewald, *Correspondance*, pp. 290, 294. (Cf. Ratcliffe, pp. 364–71.) On Cézanne's long association with Zola, see John Rewald, *Paul Cézanne: A Biography* (New York, 1968), which emphasizes the importance of this personal relationship. Zola's ideas may initially have owed much to his conversations with Cézanne.

17. See Émile Zola, "Proudhon et Courbet" (1866), "M. H. Taine, artiste" (1866), *Mes Haines* (Paris, 1879), pp. 25, 229.

18. Letter to his mother, 5 February 1904, Émile Bernard, "Un Extraordinaire Document sur Paul Cézanne," *Art-Documents* (Geneva), no. 50 (November 1954), p. 4. Others who saw symbolism or classicism in Cézanne's painting, but could not reconcile it with his "impressionist" theory, experienced the same sense of disappointment as Bernard; see, e.g., Robert Rey, *La Renaissance du sentiment classique dans la peinture française à la fin du XIXe siècle* (Paris, 1931), p. 93.

19. Albert Aurier, "Les Isolés: Vincent van Gogh" (1890–92), "Le Symbolisme en peinture: Paul Gauguin," *Œuvres posthumes*, pp. 260, 211, 208. On distortion (*déformation*), cf. above, part 1, pp. 37–38.

20. On the relationship between the two men, see Gustave Geffroy, *Claude Monet, sa vie, son œuvre*, 2 vols. (Paris, 1924), 2:65–73; John Rewald, *Cézanne, Geffroy et Gasquet suivi de souvenirs sur Cézanne de Louis Aurenche et de lettres inédites* (Paris, 1959), pp. 9–19; and Rewald's catalog entry for Cézanne's *Portrait of Gustave Geffroy*, Rubin, *Cézanne: The Late Work*, pp. 385–86.

21. Gustave Geffroy, "Paul Cézanne" (1894), "Paul Cézanne" (1895), *La Vie artistique*, 8 vols. (Paris, 1892–1903), 3:253–55, 257; 6:219–20.

22. Geffroy, "Paul Cézanne" (1895), *La Vie artistique*, 6:218.

23. Geffroy, "Salon de 1901," *La Vie artistique*, 8:376. Geffroy's comments on Cézanne appear in the context of his review of Maurice Denis's painting *Hommage à Cézanne*. His line of argument may reflect a reading of Henri Bergson as well as his familiarity with Monet's series paintings of the 1890s (cf. above, part 1, pp. 10–11). George Heard Hamilton has argued for a Bergsonian interpretation of Cézanne's "distortions"; see his "Cézanne, Bergson and the Image of Time," *College Art Journal* 16 (Fall 1956):2–12.

24. See Pissarro's letters to Esther, 13 November 1895, and to Lucien, 21 and 22 November 1895, Pissarro, *Lettres à son fils Lucien*, pp. 386, 388, 390–91.

25. Émile Zola, "Édouard Manet" (1867), *Mon Salon, Manet, Écrits sur l'art*, ed. Antoinette Ehrard (Paris, 1970), pp. 93–103. Cf. above, part 2, pp. 93–97.

26. Henri Matisse, "Notes d'un peintre" (1908), *Écrits et propos sur l'art*, ed. Dominique Fourcade (Paris, 1972), p. 42.

27. Maurice Denis, "Cézanne" (1907), *Théories, 1890–1910: Du symbolisme et de Gauguin vers un nouvel ordre classique* (Paris, 1920; orig. ed., 1912), p. 251. (Denis, of course, felt that awkwardness could eventually be eliminated from the new "classical" art; see above, part 2, pp. 111–12.) For an earlier statement on "artificial naïveté," cf. É. J. Delécluze, *Impressions*

romaines, ed. Robert Baschet (Paris, 1942), pp. 135–36 (journal entry, 18 February 1824). Cf. also above, chap. 12, note 30.

28. For instances of similar pictorial effects among Cézanne's contemporaries, cf. Renoir's *Victor Chocquet* (Fogg Museum, Cambridge, ca. 1875), Renoir's *Mlle. Jeanne Durand-Ruel* (Barnes Foundation, Merion, Penn., 1876), Puvis de Chavannes's *Jeunes Filles au bord de la mer* (Louvre, 1879), and Van Gogh's various versions of *La Berceuse* (1889).

29. In a letter to his son, 8 September 1906, Cézanne spoke of a multitude of pictorial motifs that seemed to increase with each slight movement of his angle of vision; Rewald, *Correspondance*, p. 288.

30. In a letter to Bernard, 23 October 1905, Cézanne complained of being unable to determine a final contour or limit to forms because of the peculiar character of his "sensations colorantes"; Rewald, *Correspondance*, p. 277. This may be a reference to the transiency of the "sensations" the artist was seeking to record, but it may also represent (as George Heard Hamilton has argued in public lectures) a description of the condition of his vision that his diabetes had caused.

31. Émile Bernard, "Souvenirs sur Paul Cézanne et lettres inédites," *Mercure de France*, n.s., 69 (1, 16 October 1907):395. Cf. Rivière and Schnerb, pp. 815–16.

32. Letters to Louis Aurenche, 25 January 1904, and to Cézanne's son, 8 September 1906, Rewald, *Correspondance*, pp. 257, 288. Cf. also, letter to Roger Marx, 23 January 1905, *Correspondance*, p. 273. Cézanne's custom of referring to his paintings as "studies" may be further indication that he regarded all his work as incomplete; see, e.g., letters to Octave Maus, 27 November 1889, and Egisto Fabbri, 31 May 1899, *Correspondance*, pp. 214, 237.

33. Ernest Chesneau, "Ingres," *Les Chefs d'école* (Paris, 1862), p. 274.

34. See above, p. 168.

35. Rivière and Schnerb, p. 813.

36. Bernard, "Souvenirs sur Paul Cézanne," p. 614. Cf. Émile Bernard, "Paul Cézanne," *L'Occident* 6 (July 1904):25; Émile Bernard, "La Technique de Paul Cézanne," *L'Amour de l'art* 1 (December 1920):275, 278. For a negative appraisal of the signs of Cézanne's incompletion, see Jean Pascal, *Le Salon d'Automne en 1904* (Paris, 1904), p. 11. Here the usual statement—"Évidemment Cézanne, en qui l'on retrouve la gaucherie ingénue des primitifs, n'a pas réalisé ses visions"—is coupled with a criticism of the painter's inadequate composition, color, and drawing. For other references to the "incomplete" appearance of Cézanne's painting, see above, chap. 8, note 42.

37. See, e.g., Joachim Gasquet, "Lettres de Provence," *La Revue naturiste* 2 (October 1897):79. The "naturists" opposed what they referred to as the artificiality of symbolism and the depersonalized observation of naturalism.

38. The motto is from St.-Georges de Bouhélier; see Maurice Le Blond, "Le Mysticisme de la génération nouvelle," *Le Rêve et l'Idée* 1 (May 1894):1.

39. Gasquet, *Cézanne*, pp. 84, 81.

40. Maurice Merleau-Ponty, "Le Doute de Cézanne" (1945), *Sens et non-sens* (Paris, 1966), pp. 15–44, esp. p. 30.

41. Roger Fry, "The Artist's Vision" (1919), *Vision and Design* (New York, 1956), pp. 51–52.

42. Roger Fry, *Cézanne, a Study of His Development* (New York, 1958; orig. ed., 1927), pp. 57, 59–60 (emphasis added).

43. Meyer Schapiro, *Paul Cézanne* (New York, 1962; orig. ed., 1952), p. 10 (emphasis added). This image of Cézanne's growth and change remains pervasive, even fixed. Jack Tworkov, for example, stated in a recent interview: "I was probably influenced as much by Cézanne's devotion to painting as I was by his actual painting . . . when he painted he could think of nothing else. Everything went into it. It was, for him, a search." See Steven W. Kroeter, "An Interview with Jack Tworkov," *Art in America* 70 (November 1982):86.

44. See Gabriel Séailles, review of Roger Marx, *Études sur l'école française, Gazette des beaux-arts*, 3 per., 29 (January 1903):79–81.

45. Roger Marx, "Le Salon d'Automne," *Gazette des beaux-arts*, 3 per., 32 (December 1904):459, 462–64. The metaphor of the evolutionary "link" was common; see, e.g., Gustave Kahn, "L'Art à l'Exposition: La Centennale," *La Plume* 12 (15 June 1900):361.

46. Letter to Roger Marx, 23 January 1905, Rewald, *Correspondance*, p. 273. Cézanne wrote that Marx had mentioned him in *two* articles in the *Gazette des beaux-arts*. The second one may be "Un Siècle d'art," a review of the Centennial Exhibition of 1900 in which Marx described the artist as an impressionist in the manner of Manet. This was reprinted in Marx's *Études sur l'école française* (Paris, 1903), published by the *Gazette des beaux-arts*; the relevant paragraph is on pp. 34–35. Marx had also mentioned Cézanne in articles written for *Le Voltaire* during the late 1890s. Geffroy presented a theory of gradual historical development similar to that of Marx and to that implied by Cézanne's statement; see Gustave Geffroy, "Causerie sur le style, la tradition et la nature," *Revue des arts décoratifs* 18 (July 1898):181. Cézanne's reference to his own "link" in the chain of art history was embellished by Gasquet, who transformed it into a link added to "cette chaîne colorée. Mon chaînon bleu." See Gasquet, *Cézanne*, p. 93.

47. There are some parallels to my argument in Kurt Badt's discussion of the "problem of 'realization'" in his *Art of Cézanne*, trans. Sheila Ann Ogilvie (Berkeley, 1965; orig. German ed., 1956). One of Badt's conclusions is this: "As [the] same beauty is preserved in Cézanne's pictures throughout the whole process of creation, in all the phases of realization right to fulfilment, the fully realized work has also the quality of being true [i.e., as true to its origin in nature as was the work at its very beginning]" (p. 225). Although it may be misleading for him to suggest that Cézanne's paintings become "fully realized," Badt rightly notes that Cézanne's technique (as the artist conceived it) amounts to a continuing process in which one phase does not differ qualitatively from another—just as one moment of a life is as much a part of that life as any other. In general, Badt stands somewhat apart from the critical lineage represented in this chapter by Gasquet, Fry, and Schapiro. In this context, Clement Greenberg's essay on Cézanne should also be mentioned. It approaches the problem of Cézanne's "impressionism" openly and makes the following incisive points: "the Impressionists achieved structure by the accentuation and modulation of points and areas of color and value, a kind of 'composition' which is not inherently inferior to or less 'structural' than the [geometrical, diagrammatic, and sculptural] kind"; "Cézanne [desired] to rescue tradition from—and at the same time with—Impressionist means"; "his focus was more intense and at the same time more uniform than the Old Masters' . . . every visual sensation produced by the subject became equally important." It is, of course, with regard to the importance of this last point that my own interpretation converges with Greenberg's. See Clement Greenberg, "Cézanne" (1951), *Art and Culture* (Boston, 1961), pp. 51, 53–54.

Chapter 15

1. Jules Antoine Castagnary, "Salon de 1863," *Salons*, 2 vols. (Paris, 1892), 1:105.

2. See, e.g., Cézanne's letter to Joachim Gasquet, 8 July 1902, John Rewald, *Cézanne, Geffroy et Gasquet suivi de souvenirs sur Cézanne de Louis Aurenche et de lettres inédites* (Paris, 1959), p. 45; and his letter to his son, 3 August 1906, John Rewald, ed., *Paul Cézanne, correspondance* (Paris, 1937), p. 281. Both Geffroy and Denis wrote of Cézanne's warm praise of Monet: Gustave Geffroy, *Claude Monet, sa vie, son œuvre*, 2 vols. (Paris, 1924), 2:68; Maurice Denis, "Cézanne" (1907), *Théories, 1890–1910: Du symbolisme et de Gauguin vers un nouvel ordre classique* (Paris, 1920; orig. ed., 1912), p. 250. In 1895 Pissarro described his own appreciation of Cézanne's painting, as well as the enthusiasm of Monet and Renoir; letter to Lucien, 21 November 1895, Camille Pissarro, *Lettres à son fils Lucien*, ed. John Rewald (Paris, 1950), pp. 388, 390. For evidence of Cézanne's erratic behavior toward his old friends, however, see, e.g., Pissarro's letters to Lucien, 20 January and 6 February 1896, pp. 396–97, 398–99. On Cézanne's relations with the impressionists, see also Lionello Venturi, *Cézanne, son art, son œuvre*, 2 vols. (Paris, 1936), 1:27–28; John Rewald, *Paul Cézanne: A Biography* (New York, 1968), pp. 180–89; Jean Renoir, *Renoir, My Father* (Boston, 1958), pp. 115, 361. Pierre Francastel is unequivocal in associating Cézanne's mature technical practice with impressionism; see his *L'Impressionnisme: les origines de la peinture moderne de Manet à Gauguin* (Paris, 1937), pp. 79–94, 242, 253–54. Cf. also Clement Greenberg, "Cézanne" (1951), *Art and Culture* (Boston, 1961), p. 53.

3. On the subject of opposing the direct observation of color to the preconceived academic method of employing chiaroscuro, see Cézanne's letters to Pissarro, 24 June 1874 and 2 July 1876, Rewald, *Correspondance*, pp. 121, 127. On both Cézanne's and Regnault's views, cf. above, part 2, pp. 84–87.

4. Cf. Nelson Goodman, *Languages of Art* (Indianapolis, 1976), pp. 34–39.

5. More specifically, both regarded aspects of the technical consequences of the concern for *clarté* as unfortunate. See Eugène Fromentin, *Les Maîtres d'autrefois* (Paris, 1876), p. 287; letter to Theo, autumn (?) 1885, V. W. van Gogh, ed., *The Complete Letters of Vincent van Gogh*, trans. J. van Gogh-Bonger and C. de Dood, 3 vols. (Greenwich, Conn., 1959), 2:420. (Van Gogh had read Fromentin's remarks on contemporary French painting.) Cf. also Théodore Duret, "Claude Monet" (1880), *Critique d'avant-garde* (Paris, 1885), pp. 97–98; Émile Zola, "Édouard Manet" (1884), *Mon Salon, Manet, Écrits sur l'art*, ed. Antoinette Ehrard (Paris, 1970), p. 360. Like other champions of impressionism, Duret and Zola usually endorsed the technical manners associated with *clarté*.

6. See Anatole de Montaiglon, "Salon de 1875," *Gazette des beaux-arts*, 2 per., 12 (July 1875):22 (concerning Corot); Charles Yriarte, "Salon de 1876," *Gazette des beaux-arts*, 2 per., 14 (July 1876):10 (concerning Detaille); Castagnary, "Salon de 1876," *Salons*, 2:213–14 (concerning the impressionists).

7. Georges Guéroult, "Formes, couleurs et mouvements," *Gazette des beaux-arts*, 2 per., 25 (February 1882):175–76 (emphasis added). Cf. Édouard Delaire, *Traité pratique et méthodique de la peinture à l'huile* (Paris, 1878), p. 92.

8. Zola, "Salon de 1866," *Écrits*, p. 70. Cf. also Joris Karl Huysmans, "Le Salon de 1879," *L'Art moderne* (Paris, 1883), p. 36; Duret, "Édouard Manet" (1884), *Critique d'avant-*

garde, p. 123. For examples of the negative evaluation of Manet's *modelé sommaire*, see Georges Lafenestre, "Salon de 1873," *Gazette des beaux-arts*, 2 per., 8 (July 1873):46; Henry Houssaye, "Le Salon de 1882," *Revue des deux mondes*, 3 per., 51 (1 June 1882):563.

9. Zola, "Édouard Manet" (1867), *Écrits*, pp. 100–101.

10. For examples of this critical terminology, see Castagnary, "Salon de 1869," *Salons*, 1:371; Paul Mantz, "Salon de 1872," *Gazette des beaux-arts*, 2 per., 6 (July 1872):43–46; Saint-Cyr de Rayssac, "Les Beaux-arts à l'Exposition lyonnaise," *Gazette des beaux-arts*, 2 per., 6 (October 1872):346; Frédéric Henriet, "Les Paysagistes contemporains: Daubigny," *Gazette des beaux-arts*, 2 per., 9 (March 1874):262; Yriarte, "Salon de 1876," p. 31; Odilon Redon, "Réflexions sur une exposition des impressionnistes" (1880), *A soi-même* (Paris, 1979), p. 163. The uniform light of an overcast day was called "gris clair"; according to Vollard, Cézanne preferred this kind of light for painting. See Ambroise Vollard, *Paul Cézanne* (Paris, 1919; orig. ed., 1914), pp. 127, 137.

11. On the "impressionists" of the Salon exhibitions, see above, chap. 1, pp. 7–8 (n. 28); chap. 2, pp. 14–15.

12. Zola, "Le Naturalisme au Salon" (1880), *Écrits*, pp. 338–44.

13. See, e.g., Charles Bigot, "Jules Bastien-Lepage" (1885), *Peintres français contemporains* (Paris, 1888), pp. 160–61, 178–79; Raymond Bouyer, "Le Paysage dans l'art," *L'Artiste*, n.s., 5 (January 1893):28.

14. See, e.g., Fromentin, p. 237. Cf. Viollet-le-Duc's remarks on the practice of painting in the fourteenth century: "il semble que le peintre ait craint [de] diminuer la valeur [i.e., chiaroscuro] par l'opposition de tons brillants [;] il faudra . . . n'avoir jamais deux tons de valeur égale"; Eugène Viollet-le-Duc, *Dictionnaire raisonné de l'architecture française du XIe au XVIe siècle*, 10 vols. (Paris, 1858–68), 7:68, 82. See also Charles Blanc, *Grammaire des arts du dessin* (Paris, 1880; orig. ed., 1867), p. 555.

15. See, e.g., Eugène Véron, *L'Esthétique* (Paris, 1878), p. 261. French painters and critics of the nineteenth century often used Veronese as an example of an "old master" who had the great distinction of achieving the effect of strong natural light by increasing the intensity of his hues while diminishing the force of his values. See, e.g., Delacroix's letter to Alexis Pérignon, 18 April 1859, Eugène Delacroix, *Correspondance générale*, ed. André Joubin, 5 vols. (Paris, 1935–38), 4:94; Ernest Breton, *Notice sur la vie et les ouvrages de Paul Véronèse* (Saint-Germain, 1866), p. 18; Charles Blanc, "Paul Véronèse," *Histoire des peintres de toutes les écoles: École vénitienne* (Paris, 1868), p. 19.

16. Cf. above, part 2, pp. 81–84. See also Charles Ephrussi, review of Théodore Duret, *Les Peintres impressionnistes, La Chronique des arts*, 18 May 1878, p. 158.

17. See Frédéric Chevalier, "L'Impressionnisme au Salon," *L'Artiste*, July 1877, pp. 35–36; and "Les Impressionnistes," *L'Artiste*, May 1877, p. 331. Concerning the effect of Béraud's painting, cf. the work of another "impressionist" of the Salon, Édouard Detaille, whose *En reconnaissance* (1876; fig. 56) provoked this comment: "[Detaille] se contente de l'impression vraie; il n'arrange point ses personnages, il les saisit au passage." See Jules Claretie, *Peintres et sculpteurs contemporains*, 2 vols. (Paris, 1882–84), 2:267–68.

18. See, e.g., Charles Bigot, "L'Exposition des 'intransigeants,'" *Revue politique et littéraire*, 2 per., 10 (8 April 1876):350–51; Charles Bigot, "L'Exposition des 'impressionnistes,'" *Revue politique et littéraire*, 2 per., 12 (28 April 1877):1046.

19. See, e.g., Houssaye, "Le Salon de 1882," pp. 562–63.

56. JEAN BAPTISTE ÉDOUARD DETAILLE, *En reconnaissance*, 1876. Yale University Art Gallery. Gift of Ruxton Love, Jr., B.A. 1925.

20. Edmond Duranty, *La Nouvelle Peinture: A propos du groupe d'artistes qui expose dans les Galeries Durand-Ruel*, ed. Marcel Guérin (Paris, 1946; orig. ed., 1876), p. 39. Duranty implied that the use of pure, prismatic hues spoke to the fact that the most intense natural light tended toward a uniform whiteness, the optical combination of all brilliant color. (The notion of white light is somewhat contradictory since white is normally conceived only in terms of opacity.)

21. See, e.g., Viollet-le-Duc, *Dictionnaire*, 7:107; J.-D. Régnier, *De la lumière et de la couleur chez les grands maîtres anciens* (Paris, 1865), pp. 28–29, 31. On Cézanne's familiarity with the Régnier text, see Robert William Ratcliffe, "Cézanne's Working Methods and Their Theoretical Background," unpublished dissertation, Courtauld Institute of Art, University of London, 1961, pp. 330–51.

22. Critics often associated Cézanne with both Manet and Courbet. See, e.g., Roger Marx, "Les Salons de 1895," *Gazette des beaux-arts*, 3 per., 13 (May 1895):459–60, 462–63; Roger Marx, "Un Siècle d'art" (1900), *Études sur l'école française* (Paris, 1903), p. 35.

23. The traditional account is given most authoritatively by Pissarro's son Lucien, who stated in a letter to Paul Gachet *fils* (4 November 1927) that around 1872 Cézanne had copied one of Pissarro's paintings in order to test the "new theory." According to Lucien, Pissarro was then beginning to create "la peinture claire" and had eliminated black and the earth colors from his palette; see Paul Gachet, ed., *Lettres impressionnistes au Docteur Gachet et à Murer* (Paris, 1957), pp. 53–54. According to Gasquet, Cézanne himself had referred to Pissarro's advice to paint only "avec les trois couleurs primaires et leurs dérivés immédiats," which (supposedly) the older artist had been doing since 1865; Joachim Gasquet, *Cézanne* (Paris, 1921), p. 90. The same account appears in several sources; its ultimate origin may be Georges Lecomte's brief article on Pissarro, which stressed his achievement of a "peinture blonde": "Depuis 1865, le peintre a expurgé sa palette de noir, d'abord, cette non-couleur;

peu après, les ocres et les bruns ont été proscrits: *il ne peint plus qu'avec les six couleurs de l'arc-en-ciel*"; Georges Lecomte, "Camille Pissaro," *Les Hommes d'aujourd'hui* 8, no. 366 (March [?] 1890). My own observations indicate that during the 1870s Pissarro and Cézanne did not eliminate the use of black and other neutral pigments entirely, but certainly they went very far in minimizing their use. During this period Cézanne also studied the painting technique of his friend Armand Guillaumin; see John Rewald, "Cézanne and Guillaumin," *Études d'art français offertes à Charles Sterling*, ed. Albert Châtelet and Nicole Reynaud (Paris, 1975), pp. 343–53. Eventually, especially during the 1880s, Renoir may have served as an inspiration for Cézanne's practice of "modeling" with contrasts of brilliant greens, reds, violets, and yellows; Renoir and Cézanne were in close communication during 1875–77, 1882, 1885, and 1888–89. On their similar use of color, see Richard Shiff, "Impressionist Criticism, Impressionist Color, and Cézanne," unpublished dissertation, Yale University, 1973, pp. 151–57.

24. Minute quantities of ivory black are also present on the surface in the darkest areas. Meryl Johnson, of the Detroit Institute of Arts, identified the pigments. For information and advice on the matter of pigment composition, I am indebted to a number of conservators who have been most generous: Meryl Johnson, Inge Fiedler, Mary Lou White, Marigene Butler, Jean Rosston, and Victoria Gimbel Lubin.

25. Camille Pissaro, *Artist's Palette with a Landscape*, Clark Art Institute, Williamstown (late 1870s). This work may be the one Pissarro referred to in a letter to Monet (1883 or earlier), where he mentioned having painted a "palette ornée" for a certain collector M. La Place; see Geffroy, *Claude Monet*, 2:10. Jean Rosston has identified the pigments as lead white, chrome or zinc yellow, vermilion, alizarin crimson, ultramarine blue, and emerald green. I wish to thank Beth Carver Wees for facilitating my study of this and other works at the Clark Art Institute.

Pigment analysis conducted by Inge Fiedler on Pissarro's *The Warren at Pontoise in the Snow* (Chicago Art Institute [1879]) has indicated a palette similar to that of the Wiliamstown painting, with a somewhat greater number of "primary" pigments and also small quantities of bone black and yellow ochre. An area of grayish green foliage, for example, is primarily constituted of chrome yellow, lead white, ultramarine blue, alizarin crimson, and vermilion.

26. *Maison de Piette, à Montfoucault*, Fitzwilliam Museum, Cambridge (1874). A very similar (but even more subdued) effect of mixing primary hues is seen in Pissarro's *Piette's House at Montfoucault*, Clark Art Institute, Williamstown (1874). Pissarro later spoke of working to "make dazzling grays"; letter to Lucien, 6 February 1896, Pissarro, *Lettres à son fils Lucien*, p. 399. On gray, bright light, cf. also Cézanne's letter to Pissarro (with Antoine Guillemet's addendum), 23 October 1866, Rewald, *Correspondance*, pp. 101, 103; and the references cited above, n. 10. Gauguin is to be included among those who admired Pissarro's effect of a colored grayness; in a letter of 1883, he referred to his having only rarely seen "une chose aussi grise et aussi colorée" and complimented Pissarro on the achievement. See the quoted excerpt, entry no. 52, *Archives de Camille Pissarro*, auction catalog, Hôtel Drouot, 21 November 1975 (Paris: Maison Charavay, 1975), n.p.

27. My statement is based in part on my own observations and in part on pigment analyses conducted by Meryl Johnson on Cézanne's *Bathers* (Detroit Institute of Arts [ca. 1881–84]) and by Marigene Butler on Cézanne's *Chestnut Trees* (Minneapolis Institute of Arts [mid-1880s]). Although small amounts of black are present in these works, nearly all tones are mixed primarily from such pigments as vermilion, ultramarine, emerald green, and chrome

yellow. Butler reports, for example, that a "dark gray" tree trunk in *Chestnut Trees* consists of lead white, emerald green, ultramarine, vermilion, and viridian; Marigene Butler, "Pigments and Technique in the Cézanne Painting, 'Chestnut Trees,'" *Bulletin of the American Institute for Conservation of Historic and Artistic Works* 13 (1973):84.

28. Letter to Pissarro, 2 July 1876, Rewald, *Correspondance*, p. 127. Cf. above, part 2, pp. 84, 114–15.

29. Much smaller amounts of bone black (as well as traces of other pigments) are also present in these complex patches of color. Inge Fiedler (Chicago Art Institute) performed the analysis of these pigments.

30. This painting, like many other Cézannes of the period, has a gray ground, perhaps to set initially the middle value that characterizes the uniform light of the image. The use of a gray ground was common and had sometimes been recommended for "une peinture blonde et dorée"; see Mme. Marie-Élisabeth Cavé, *La Couleur* (Paris, 1863; orig. ed., 1851), p. 134. On Cézanne's use of colored grounds, cf. Ratcliffe, pp. 61–112. Ratcliffe suggests that this practice "opposed [Cézanne] to his contemporary Impressionists" (p. 61); however, Monet, Pissarro, Renoir, and Sisley also frequently employed colored grounds.

31. Meier-Graefe wrote that Cézanne's "illusion of air" was produced by "chromatically equal planes," and Fry said of this particular painting that "all is continuous." See Julius Meier-Graefe, *Die Entwicklungsgeschichte der modernen Kunst: Ein Beitrag zur modernen Ästhetik*, 3 vols. (Stuttgart, 1904), 1:169; Roger Fry, *Characteristics of French Art* (London, 1932), p. 146.

32. For the early statements on Cézanne's substitution of hue contrasts for chiaroscuro, see Émile Bernard, "Paul Cézanne," *L'Occident* 6 (July 1904):23–24; Maurice Denis, *Journal*, 3 vols. (Paris, 1957–59), 2:29 (entry for 26 January 1906); Denis, "Cézanne," *Théories*, pp. 249–50, 257–59; Émile Bernard, "Souvenirs sur Paul Cézanne et lettres inédites," *Mercure de France*, n.s., 69 (1, 16 October 1907):400; R. P. Rivière and J. F. Schnerb, "L'Atelier de Cézanne," *La Grande Revue* 46 (25 December 1907):814. Cf. also Denis, "Le Renoncement de carrière, la superstition du talent" (1906), *Théories*, pp. 213–14, n.; Maurice Denis, "L'Influence de Cézanne" (1920), *Nouvelles Théories, sur l'art moderne, sur l'art sacré, 1914–1921* (Paris, 1922), p. 125.

The tendency among twentieth-century viewers has been to observe in Cézanne's painting a highly systematized application of color (usually described as a "musical" harmony), which serves to "model" volumes. For successive "rediscoveries" of Cézanne's method, see, e.g., Roger Fry, *Transformations* (New York, 1926), p. 220; Roger Fry, *Cézanne, a Study of His Development* (New York, 1958; orig. ed., 1927), pp. 39, 65, 76–77; Fritz Novotny, *Cézanne und das Ende der wissenschaftlichen Perspektive* (Vienna, 1938), pp. 71–72; Kurt Badt, *The Art of Cézanne*, trans. Sheila Ann Ogilvie (Berkeley, 1965; orig. Ger. ed., 1956), pp. 48, 54–55 (concerning Cézanne's watercolors); Lawrence Gowing, "The Logic of Organized Sensations," *Cézanne: The Late Work*, ed. William Rubin (New York, 1977), pp. 58–61 (primarily concerning watercolors). Badt and Gowing emphasize the "logical order" of Cézanne's method of replacing value with hue across a surface that turns in space from a shaded area (blues, deep greens, violets, dark reds) to an illuminated one (yellows, oranges, light reds, light greens). Their claim for a rigorous application of sequences of color from darker hues to lighter ones is exaggerated even in the case of the artist's watercolors. Cézanne's later oils and watercolors frequently exhibit passages of a full range of hue in *both* the pale interior areas of

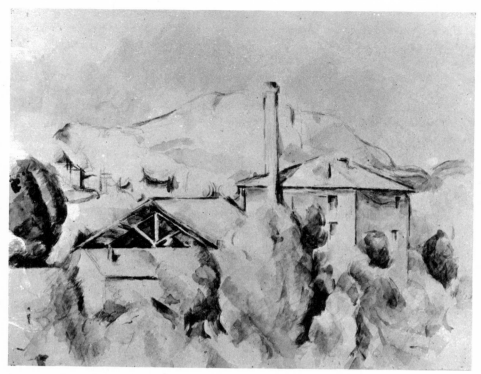

57. PAUL CÉZANNE, *Moulin au Pont des Trois Sautets* (watercolor), ca. 1890–94. Musée du Louvre. Cliché des Musées Nationaux.

"highlighted" forms *and* in the darker "shaded" areas of these forms. For example, in the watercolor *Moulin au Pont des Trois Sautets* (ca. 1890–94; fig. 57), the individual areas of foliage are "modeled" with translucent strokes of blues, greens, yellows, and red-violets that simply become denser (less watery) in the darker areas. Although one can read a sequence of dark and light forms across the surface of the painting, the hues are not correlated with the values, but are used in an independent fashion to form a unifying screen of vibrant "atmosphere."

33. D. S. MacColl, "A Year of 'Post-Impressionism'" (1912), *What Is Art?* (Harmondsworth, 1940), p. 21.

34. See, e.g., Delacroix's journal entry for 10 July 1847, André Joubin, ed., *Journal d'Eugène Delacroix*, 3 vols. (Paris, 1950), 1:234; Félix Bracquemond, *Du dessin et de la couleur* (Paris, 1885), p. 92.

35. The color that identifies a specific object—for example, the deep green of an area of foliage, or the pale yellow of a stuccoed wall.

36. See Denis, "Cézanne," *Théories*, pp. 258–59; Rivière and Schnerb, p. 814. Cf. Fry, *Cézanne*, pp. 77–80; Fry, *Characteristics of French Art*, pp. 145–46. See also above, pp. 172–73.

37. Cf. above, chap. 8, esp. p. 116.

38. See, e.g., Jacques-Samuel Bernard, *Still Life with Violin, Ewer, and Bouquet of Flowers* (private coll., New York [1657], reproduced in Pierre Rosenberg, *France in the Golden Age: Seventeenth-Century French Paintings in American Collections* [New York, 1982], p. 207); An-

toine Vollon, *Still-life with Chinese Rug and Fruit* (Detroit Institute of Arts [ca. 1893], repro-
duced in *Bulletin of the Detroit Institute of Arts* 56 [1978]:222).

39. Cf. above, pp. 180–83. One might argue that Cézanne returned both composition
(or style) and subject matter to nature; Fritz Novotny has made some perceptive remarks on
this matter: "It is precisely in [the] variability and the sometimes excessive obviousness of the
linear composition that we recognize its novelty and its, on the whole, secondary importance
. . . when [Cézanne] continually used [traditional forms of composition] in figure scenes, the
emphasis was transferred to the structural forms he himself had created, which destroyed not
only the forms and formulas of 'idealistic' figure-construction, but composition in general."
See Fritz Novotny, *Cézanne* (Vienna, 1937), p. 14. Cf. also Novotny, *Cézanne und das Ende
der wissenschaftlichen Perspektive*, pp. 96–97.

40. There exists a large group of paintings, primarily still-lifes, that seem—conceptually, at
least—more complex than the painting *Still Life* which I have chosen to analyze. These works
incorporate into their backgrounds elements of the artist's earlier paintings (often including
parts of a large decorative screen, painted ca. 1859–60) so as to create a tension between the
representation of "real" objects and of painted objects. In many cases, the foreground ("real")
elements and the background ("artificial") elements are rendered analogously or linked by
some compositional motif, making the tension especially acute and the contradictory mes-
sage of the rendering pointed. Robert Ratcliffe has systematically identified these complex
motifs; see Ratcliffe, pp. 50–52, 400–402. For a more detailed discussion, see Theodore Reff,
"The Pictures within Cézanne's Pictures," *Arts* 53 (June 1979):90–104.

These thematically complex paintings might be indications of the artist's involvement
with the problem of establishing his *technique* as the equivalent of his *sensation*: his technique is
represented by the colored surface of the painting that he incorporates into the background of
another of his paintings; his sensation is represented by the colors he observes as he paints his
foreground motif "sur nature"; and these two elements merge to become indistinguishable.
Cézanne's "style"—the background painting, painted in the manner of the foreground—and
his immediate visual experience are rendered as one and the same. The artist's many still-lifes
that show fruit and other objects on a table before a papered or patterned wall are examples of
this phenomenon of painting within painting; however, in this form, the point about "style"
can be made only in a generalized or depersonalized manner. Typically, in such works, the
planar wall pattern, indeed the entire wall itself, projects forward as a colored surface having
the same volumetric "reality" (or lack thereof) as the foreground fruit (see, e.g., *Plate of Ap-
ples*; fig. 48, p. 209). The general issue of the confusion of the natural and the artificial—in a
particular painting, a confusion, say, of foreground fruit and a painted backdrop of some
kind—arises among Cézanne's early critics in the form of the issue of nature and style, or the
natural and the classical (cf. above, chap. 9). With regard to specific problematic aspects of the
artist's technique, his early viewers repeatedly noted that he rendered foreground and back-
ground in the same manner even when these "subjects" were very different in their physical
reality. See, e.g., Rivière and Schnerb, p. 814; and cf. above, chap. 12, pp. 172–73 (n. 58),
chap. 15, p. 212 (n. 36). It should be clear that my analysis of *Still Life* (to follow) subsumes
the kind of observation recorded by Rivière/Schnerb and others with regard to Cézanne's ap-
parent integration of volumetric and flat elements within a unified field of color.

41. For a subtle analysis of that effect, see Greenberg, "Cézanne," pp. 54–56.

42. Théodore Duret, "Édouard Manet et les impressionnistes" (1906), Henry Marcel,
ed., *Histoire du paysage en France* (Paris, 1908), p. 316. Cf. Fry, *Cézanne*, pp. 26, 54, 62, 79,
81.

43. Fry, *Cézanne*, p. 81. Fry usually favored simplicity in compositional arrangements; see Roger Fry, "Mr. MacColl and Drawing," *Burlington Magazine* 35 (August 1919):85.

44. William Rubin, "Cézannisme and the Beginnings of Cubism," *Cézanne: The Late Work*, p. 189.

45. Clement Greenberg, "Modernist Painting" (1965), reprinted in Gregory Battcock, ed., *The New Art* (New York, 1966), p. 110. Michael Fried also speaks of the importance of a discovery of artistic value in terms of a "comparison with the painting of both the Modernist and pre-Modernist past whose quality seems . . . beyond question"; Michael Fried, "Shape as Form: Frank Stella's New Paintings" (1966), in Henry Geldzahler, ed., *New York Painting and Sculpture: 1940–1970* (New York, 1969), p. 422, n. 11.

46. One could substitute the term "romanticism" for "modernism" in this formulation, as well as in most of the statements I have made with regard to modernism. I have chosen to use the label "modernism" in order to call attention to the fact that my argument is relevant to current critical debates. Traditionally, Cézanne has been known as a "modernist" master rather than a "romantic" one, but he is both—and, of course, "classic."

Part 4: Conclusion

1. Journal entry for 26 January 1906, Maurice Denis, *Journal*, 3 vols. (Paris, 1957–59), 2:29.

2. Émile Bernard, "Réfutation de l'impressionnisme," *L'Esthétique fondamentale et traditionnelle* (Paris, 1910), p. 139.

3. Roger Fry, *Cézanne, a Study of His Development* (New York, 1958; orig. ed., 1927), p. 78.

4. Statement made to Marius de Zayas (1923), reprinted in Dore Ashton, *Picasso on Art: A Selection of Views* (New York, 1977), p. 3.

5. Cf. Georges Lecomte's comment on an earlier symbolist response to Cézanne's "primitive" distortions: "He was admired for the imperfections (which, with all his strength, he was trying to avoid) as if they had been arrived at deliberately." Lecomte himself felt that the distortions were involuntary. See Georges Lecomte, "Paul Cézanne," *Revue d'art* 1 (9 December 1899):86.

6. Fry, *Cézanne*, p. 59; Meyer Schapiro, *Paul Cézanne* (New York, 1962; orig. ed., 1952), p. 10. Cf. above, part 3, pp. 192–95.

7. R. G. Collingwood, *The Principles of Art* (Oxford, 1938), p. 111.

8. Ibid., pp. 128–30, 273.

9. Ibid., p. 275. Cf. also p. 43, where Collingwood argues that novelty planned and achieved for its own sake represents a falsification of artistic originality.

10. Ibid., pp. 245, 249, 256.

11. The assumption of inherent originality in all artistic acts is a fundamental tenet of modernist art theory, if not all theory of art that distinguishes art from craft. Cf. above, part 2, pp. 65–66, 73–74.

12. Duchamp himself stated in 1961 that "the choice of these 'readymades' was never dictated by aesthetic delectation. This choice was based on a visual indifference . . . a complete anesthesia"; Marcel Duchamp, *Salt Seller: The Writings of Marcel Duchamp*, eds. Michel Sanouillet and Elmer Peterson (New York, 1973), p. 141.

13. Collingwood, pp. 26–29.

14. Of course, some theorists have defended all human making as being of this type, in order to distinguish it from the instinctual acts of, say, bees and beavers. To make something greater than the sum of its parts amounts to what the classical academic theorists often called "invention" (and sometimes "imitation"), a kind of making that is also a finding. Cf. above, chaps. 6, 7. Ingres regarded the art of the past as a necessary part of the art of the present: "*On ne fait rien de rien* et c'est en se rendant familières les idées et inventions des autres, qu'on s'en fait de bonnes"; letter to Gilibert, 1 November 1822, reprinted in Boyer d'Agen, ed., *Ingres d'après une correspondance inédite* (Paris, 1909), p. 91 (emphasis added).

15. Cf., e.g., Thomas Couture's letter to an American patron, reprinted in G. Bertauts-Couture, *Thomas Couture, sa vie, son œuvre, son caractère, ses idées, sa méthode par lui-même et par son petit-fils* (Paris, 1932), p. 89; and the discussion of Picasso in H. W. Janson, *History of Art* (Englewood Cliffs, 1977; orig. ed., 1962), p. 10.

16. See above, part 3, pp. 195–96.

17. It is common for modernist critics to praise artists for having either disguised or suppressed their own craft; Greenberg, for example, writes: "Like Rothko and Still, Newman happens to be a conventionally skilled artist—need I say it? But if he uses his skill, it is to suppress the evidence of it. And the suppression is part of the triumph of his art; next to it, most other contemporary painting begins to look fussy"; Clement Greenberg, "After Abstract Expressionism" (1962–69), in Henry Geldzahler, ed., *New York Painting and Sculpture: 1940–1970* (New York, 1969), p. 370.

18. See above, n. 4.

Index

DATE DUE